MINIMALISM

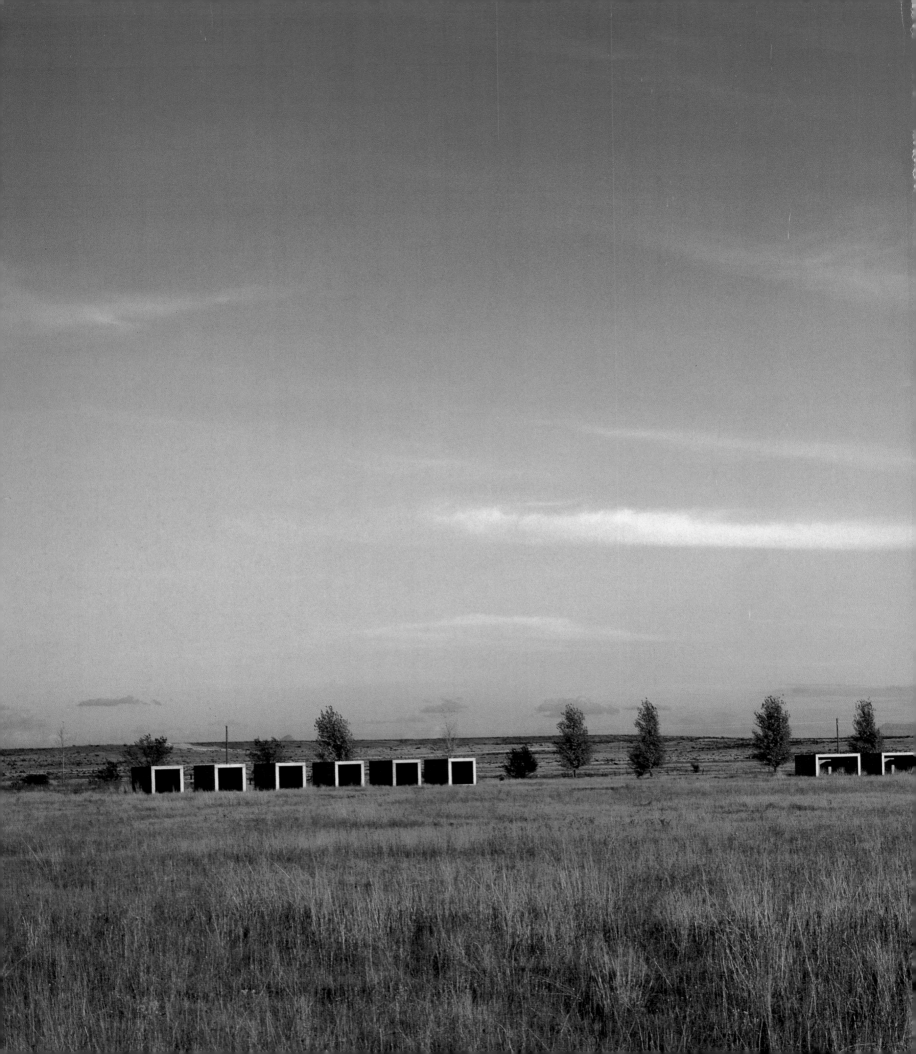

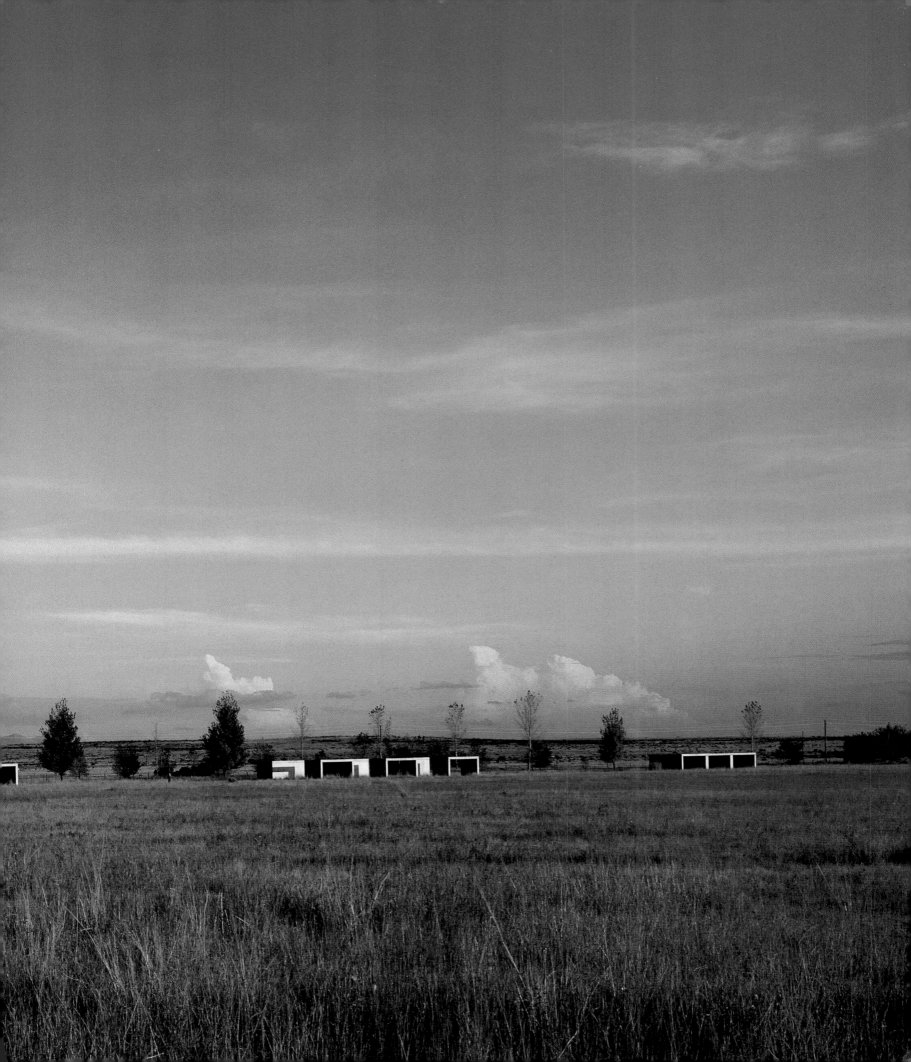

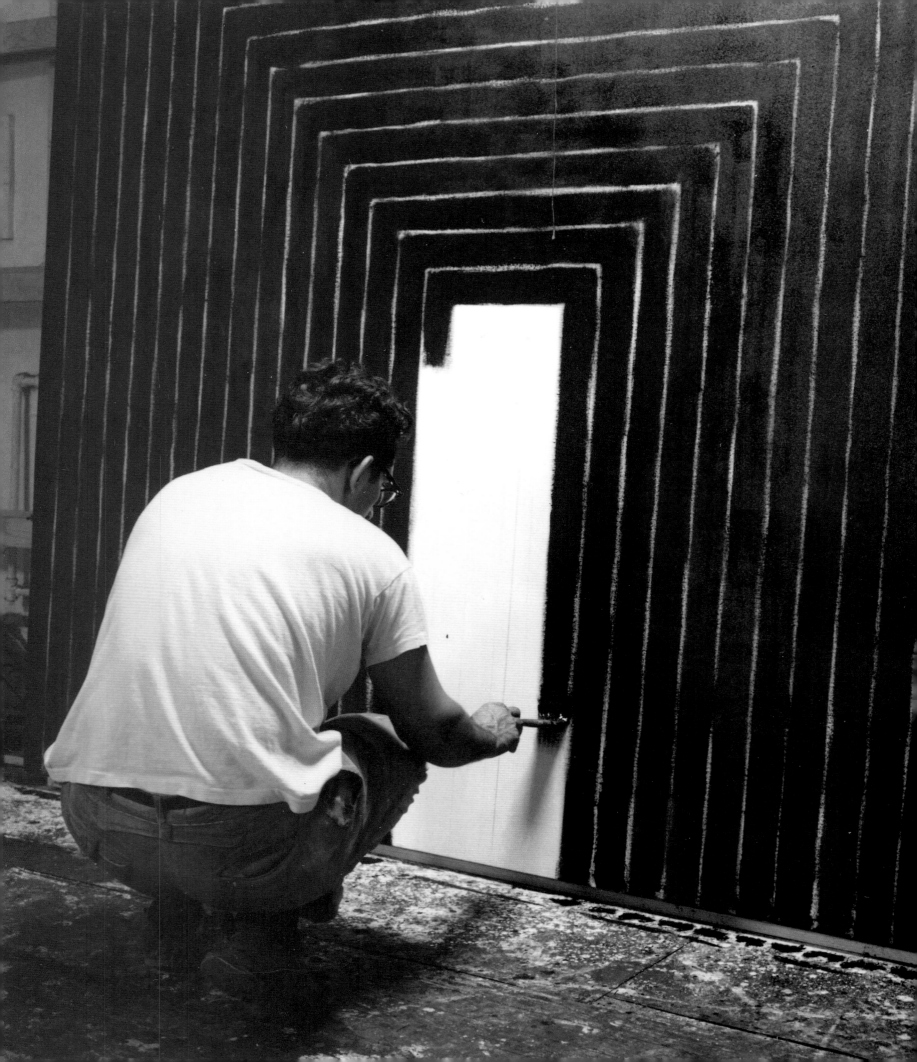

MINIMALISM
EDITED BY JAMES MEYER

WORKS page 46

1967–79 CANONIZATION/CRITIQUE
page 138

1980–present RECENT WORK page 168

PRE-
FACE

BY JAMES MEYER

This book is a reappraisal, from a contemporary perspective, of one of the signal developments of late twentieth-century art.

Tracing the history of Minimal practice and criticism from the late 1950s until the present, it presents Minimalism not as a defined movement but as a debate that surrounded a new kind of abstraction during the 1960s. The whole or serial geometric works of Carl Andre, Dan Flavin, Donald Judd, Robert Morris, Sol LeWitt and such contemporaries as Anne Truitt, Larry Bell, John McCracken, Ronald Bladen and Robert Smithson, often factory-made and scaled to the viewer's body, established a new paradigm of sculpture. The serial, monochromatic painting of Jo Baer, Ralph Humphrey, Brice Marden, Robert Mangold, Agnes Martin, Paul Mogensen, David Novros, Robert Ryman and Frank Stella evoked comparisons to the Minimal object, and was also characterized as Minimalist to a lesser degree.

Chapter One, 'First Encounters', is a survey of early Minimal works and writings. Chapter Two, 'High Minimalism', focuses on the key exhibitions and essays associated with the new art during the mid 1960s, and the establishment of a Minimal 'movement'. The third chapter, 'Canonization/Critique', examines new directions in Minimal practice as artists became exposed to and inspired such developments as post-Minimal and Land art, as well as the critical reception of their work by writers associated with post-Minimalism, Conceptualism and New Left and feminist politics during the late 1960s and 1970s. The final chapter is a survey of recent Minimal work and contemporary analyses of the Minimalist aesthetic.

SUR-
BY JAMES MEYER
VEY

IT ISN'T NECESSARY FOR A WORK TO HAVE A LOT OF THINGS TO LOOK AT, TO COMPARE, TO ANALYSE ONE BY ONE, TO CONTEMPLATE. THE THING AS A WHOLE, ITS QUALITY AS A WHOLE, IS WHAT IS INTERESTING. THE MAIN THINGS ARE ALONE AND ARE MORE INTENSE, CLEAR AND POWERFUL.

Donald JUDD 'Specific Objects', 1965

The Maze and Snares of Minimalism, shown in a New York gallery in 1993, is a little-known work by Carl Andre.[1] This deceptively simple work consists of three open pedestals butted end to end; six more lean against them at even intervals. Completely filling the tiny storefront gallery, Andre's

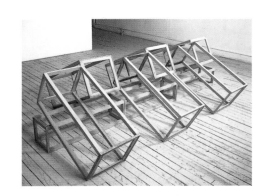

work was difficult to view; the protruding pedestals afforded little room for circulation. Indeed, the farther one penetrated the installation, the harder it was to move about: other viewers blocked one's path. A seemingly benign abstract sculpture, the work was a snare, a trap.

The Maze and Snares of Minimalism had a rather pointed reference: 'Minimalism' itself. What was the meaning of Andre's allegory?

Although never exactly defined, the term 'Minimalism' (or 'Minimal art') denotes an avant-garde style that emerged in New York and Los Angeles during the 1960s, most often associated with the work of Carl Andre, Dan Flavin, Donald Judd, Sol LeWitt and Robert Morris, and other artists briefly associated with the tendency. Primarily sculpture, Minimal art tends to consist of single or repeated geometric forms. Industrially produced or built by skilled workers following the artist's instructions, it removes any trace of emotion or intuitive decision-making, in stark contrast to the Abstract Expressionist painting and sculpture that preceded it during the 1940s and 1950s. Minimal work does not allude to anything beyond its literal presence, or its existence in the physical world. Materials appear as materials; colour (if used at all) is non-referential. Often placed in walls, in corners, or directly on the floor, it is an installational art that reveals the gallery as an actual place, rendering the viewer conscious of moving through this space.

With its modular, repeated units and gallery scale, *The Maze and Snares of Minimalism* was clearly a parody of Minimal art, a Minimal burlesque. 'JuddMorrisAndre LeWitt stripped bare of their MFAs, even', Andre joked.[2] Even the use of pedestals alluded to a central innovation

of Minimalism (an innovation by no means confined to Minimal art), its rejection of the plinth of classical and Renaissance sculpture. Carl Andre, Donald Judd, Robert Morris, Dan Flavin, Sol LeWitt, and their contemporaries Anne Truitt and John McCracken placed the sculptural object directly upon the wall or ground. In the work of these artists, the cubic solid no longer functions as a pedestal, it has itself become sculpture.

A tongue-in-cheek summary of Minimal style, *The Maze and Snares of Minimalism* looked back at this movement's emergence from the vantage of its 'wake'.[3] It implied that Minimalism is no longer an avant-garde style, having been adopted by the museum and written into the annals of art history. Like other avant-garde developments of the 1960s such as Conceptualism and Pop, Minimalism is now viewed as a significant development of twentieth-century art. Ironically, though, the establishment of Minimalism as a historical movement has given it a new lease on life. In the past decade, younger artists including Felix Gonzalez-Torres, Roni Horn, Charles Ray and Janine Antoni have put the geometries and serial syntax of Minimalism to new use. Presented nearly thirty years after his first show, Andre's *Maze* marks the closing of one chapter and the opening of another, the slippage of historical Minimalism into a contemporary neo-Minimalism.

Now, the artist who organizes Minimalism's funeral is an ambivalent mourner: for one whose work has been designated 'Minimal' by the commercial art magazine and gallery, Minimalism's passing may well be a cause for celebration. All of the artists associated with Minimalism rejected the idea that theirs was a coherent movement; there was never a manifesto, they pointed out, only differing or even opposing points of view. They regarded 'Minimalism' as the catchy label of a fashion-hungry art world in search of new trends. As Judd observed at the time, 'Very few artists receive attention without publicity as a new group. It's another case of the simplicity of criticism and of the public ... One person's work isn't considered sufficiently important historically to be discussed alone.'[4] It is this critical construction of Minimalism – a Minimalism of the art magazine, the press release, and art history – to which Andre alludes. For what is the 'maze of Minimalism' but Minimal criticism, the contentious, at times brilliant discourse that developed around this work, evolving into one of the most substantial literatures of post-war American art?

Detractors of Minimal art have said that the voluminous critical writing around this work compensated for its purported lack of complexity (that is, there is much to say about an art that gives so little). However, the generation of writers that emerged simultaneously

with the development of Minimal art – Mel Bochner, Rosalind Krauss, Lucy R. Lippard, Annette Michelson, Barbara Rose and Robert Smithson, among others – saw the need for a new vocabulary that could contend with this austere abstraction. The work of the so-called Minimalists resisted previous critical understanding, throwing criticism itself into a 'crisis'.[5]

The flourishing of critical art debate during the 1960s resulted from other material factors, such as the development of the commercial art magazine in conjunction with an expanding art market. The commercial success of Abstract Expressionism, Colour Field painting and Pop art fostered a growing interest in contemporary art.[6] Inspired by the example of influential critic Clement Greenberg, a leading champion of Abstract Expressionist painting, whose essays achieved an analytical rigour unsurpassed in American criticism, younger critics published increasingly ambitious articles in such journals as *Arts Magazine* (New York), *Art International* (Lugano), *Studio International* (London) and

Willem DE KOONING Merritt Parkway, 1959
Franz KLINE White Forms, 1955
David SMITH 7 Hours, 1961

Artforum (New York).[7] Many of these writers were academically trained art historians.[8] Emulating the formal precision and serious tone of Greenberg's criticism, Krauss, Lippard, Michelson, Rose and the Modernist critic Michael Fried assessed developments in contemporary art with scrupulous attention.

Arts Magazine and *Artforum* also printed the writings of the Minimal artists themselves (in particular Dan Flavin, Donald Judd, Sol LeWitt and Robert Morris) and certain younger artists, such as Mel Bochner and Robert Smithson, who developed powerful and idiosyncratic readings of this work. Following in the tradition of such New York School artists as Barnett Newman, Ad Reinhardt and Mark Rothko, many of the Minimalists also came from a liberal arts education, and their propensity to theorize bespoke an essentially academic background. (By the late 1950s and 1960s, Newman and Reinhardt stood as exemplary figures for ambitious younger artists, both for their work and their writings.)[9] Robert Morris,

a leading polemicist of the new art, studied at Reed College in Oregon, and completed a Masters Thesis on the Romanian sculptor Constantin Brancusi at Hunter College in New York, where his professors included Ad Reinhardt and the art historian Eugene Goossen.[10] Donald Judd was a paradigmatic figure who, after enrolling in the Art Students League, New York, completed degrees in both philosophy and art history at Columbia University.[11] In 1959 he began to write for *Arts Magazine*, elaborating his aesthetic in a series of compelling reviews and articles. Judd made clear his preference for an art of simple design, clean, unmodulated surfaces and bright colour exemplified by the work of Barnett Newman and Kenneth Noland. In contrast, he attacked the 'relational', gestural painting produced by Willem de Kooning, Franz Kline and younger Abstract Expressionists, and the part-by-part, late-Cubist sculpture of David Smith and Anthony Caro. He praised the former as literal or 'specific', and criticized the latter as illusionistic. The clarity and consistency of Judd's point of view brought him acclaim as a critic – indeed, he was better known in the early 1960s as a writer than as an artist. His argument also helped to reconfigure critical debate so that, when he began to show his own work in 1963, he had prepared its receptive context.

The discursive nature of 'Minimalism' became evident early on, as numerous critics attempted to explain the new work. Short reviews of early shows led to longer articles, which in turn led to elaborate essays. It all happened very quickly. The earliest statement concerned with Minimal art is probably Andre's 1959 homage to painter Frank Stella, 'Preface to Stripe Painting',[12] which praises the artist's reduction of painting to its essential formal components. By the mid 1960s the early phase of Minimal criticism had already reached its peak.[13] In 1968 Gregory Battcock's important book *Minimal Art: A Critical Anthology* launched these debates into broader circulation. It also opened up the analysis of Minimal art to a broader number of potential interpretations, encompassing painting, sculpture and even dance. Eventually the term Minimalist was used to describe a wide variety of pursuits such as Yvonne Rainer's choreography, the music of Philip Glass and Steve Reich, the fiction of Ann Beattie and Raymond Carver, and the design of John Pawson. However, the term remained ill-defined, as these highly individual practices were conducted in a variety of different media and thus resist strict comparison.

The artists Jo Baer, Ralph Humphrey, Robert Mangold, Brice Marden, Agnes Martin, Paul Mogensen, David Novros and Robert Ryman, among others, developed a painting of radically simplified form, evident materiality and obvious construction during the 1960s. A few exhibitions, most notably Lawrence Alloway's 'Systemic Painting' at the Solomon R. Guggenheim Museum, New York, in 1966, focused solely on this work. But Minimalism's repudiation of illusion necessarily led to a disavowal of the painting medium by artists like Flavin and Judd. The publication of Judd's influential essay 'Specific Objects' marked this turn of Minimal criticism away from painting in favour of the three-dimensional object.

The question of painting's relevance – or obsolescence – was only one of a number of controversies that raged within Minimal criticism. Even the proper names surrounding this work were under dispute. Initially the objects of Judd, Morris, Andre and others had been called ABC art, Rejective art, Cool

– Carl Andre, 'Preface to Stripe Painting (Frank Stella)', 1959
What was the meaning of the term 'Minimal' as it emerged in the 1960s? While it was never defined, to its detractors it initially implied two kinds of aesthetic lack: on one hand, it suggested an excessive formal reduction, an appalling simplicity (the work's design was pared down to a 'minimum'); on the other hand, it implied a deficiency of artistic labour, a complaint most often levelled at the work of Flavin, made from standard fluorescent lights, at Andre's industrial construction blocks, and at Judd's factory-produced objects. A basic cube, a pile of bricks or a white monochrome canvas offered too little to look at and seemed too easy to make. Presenting itself as formal art – an art of visual complexity in the Modernist tradition of Constantin Brancusi, Pablo Picasso and Jackson Pollock – Minimal work smacked of the readymade, the factory-produced object transformed into art by Marcel Duchamp. When Duchamp placed a bottlerack in a gallery in 1914 he debunked the

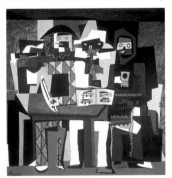
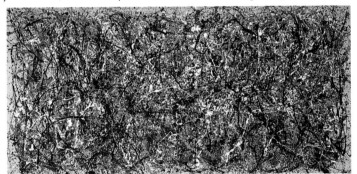

Constantin BRANCUSI Bird, 1940
Pablo PICASSO Three Musicians, 1921
Jackson POLLOCK One (Number 31, 1950), 1950
Marcel DUCHAMP Bottlerack, 1914

art and Primary Structures. By 1967 'Minimalism' was in common use. As this plethora of labels suggests, the definition of the new art was never stable. Was it sculpture or painting? Both or neither? A single shape or modular sequence? Was it brightly polychrome, as Judd argued, or sternly 'Black, White, and Gray', as the curator Samuel J. Wagstaff, Jr, suggested in his exhibition of that name in 1964? Or did it reflect the 'cool' sensibility of an entire generation of younger artists – including the Pop artists Andy Warhol and Roy Lichtenstein – whose recourse to serial procedures and hard-edged design cancelled signs of emotion? Artists, curators and critics debated these questions at length, each defining the new development in a particular way: there was no coherent 'Minimalism', but different, overlapping Minimalisms.

Modernist premise of formal innovation: art could be a declaration, an idea. Dissatisfied with the purely 'retinal' effects achieved by such contemporaries as the Cubists or the Fauves, Duchamp proposed a more 'conceptual' art. The readymade, produced in a factory, bore no trace of the artist's hand; it seemed to lack formal complexity and therefore did not resemble a 'work of art'. Minimal art, however, used factory-made objects to achieve formalist-type reduction. It was thus based on an internal contradiction: presenting itself as 'high', formal art, it was not legible as such; it was not art-enough.[14]

To be sure, the reduction of the artwork to its essential structural components and the use of factory production techniques were hardly new. The Russian avant-garde explored similar concerns, although their historical context – the revolutionary Soviet Union of the 1910s and 1920s – is not comparable to 1960s New York. The Russian Suprematist artist Kasimir Malevich developed a painting of radically

1959–63 First Encounters
'Art excludes the unnecessary.'

simplified means in his *Black Square* (1913–15): the large, centred black square inset in a white ground flattens out Cubism's shallow space of interlocking planes. His monochromatic *White on White* (1917) was even flatter, counterpoising a white figure against a white ground. Malevich simplified pictorial organization as never before (he described the *Black Square* as the 'zero-degree' of painting), yet he still pitted a figure against a ground, suggesting a minimum amount of depth.[15] It was left to the Constructivist Aleksandr Rodchenko to go one step further and rid painting of illusionism or reference of any kind, in an effort to align his art with the materialist values of the new Communist culture. Rodchenko described his monochrome triptych *Pure Colours: Red, Yellow, Blue* (1921) as the 'last painting'. Shown in the famous '5 × 5 = 25' exhibition (1921),[16] this work demonstrated Rodchenko's criticism of the idealism and illusionism of easel painting (its suggestion of a subjectively arranged order or truth) and his identification of art-making with proletarian

of reception to that of previous Western art. Constructivist theory allied the Romantic notion of the artist of nineteenth-century aesthetics with a bourgeois spectator, who allegedly found in the handmade, expressive work an affirmation of his own subjectivity. Even more, it held that the unique art object evoked a contemplative vision, the aesthetic pleasure or expertise of the wealthy connoisseur. Constructivist art voided the work of affect and uniqueness in order to excite a proletarian viewer. Its machine-made appearance and the fact that the work required one to physically activate it in order to complete it were not aimed at aesthetic admiration, but rather at a more physical, interactive response. Vladimir Tatlin sought precisely this effect in his *Complex Corner Relief* (1915), a metal construction suspended from wires that projected into the gallery space, causing an awareness of the actual corner of the room, the presence of the work in three dimensions and the body of the viewer standing before it. Another of Tatlin's works that engage the spectator's body, his famous

Kasimir MALEVICH Black Square, 1913-15
Aleksandr RODCHENKO Pure Colours: Red, Yellow, Blue, 1921
Vladimir TATLIN Monument to the Third International, 1921

labour. Karl Marx's materialist philosophy, the foundation of Soviet socialism, locates the formation of ideas and beliefs in material and economic facts. Thus the Constructivists explored the premises of *faktura* (facture), a revelation of an object's literal materiality, and *konstruktsiia* (construction), an organization dictated by function and the physical nature of the chosen materials.[17] Rodchenko's canvases exemplified these notions: the thickly applied all-over surface highlighted the painting's objectness, while the primary colours generated the work's tripartite structure. As the 'last paintings', the *Pure Colours* marked the moment of transition from painting to the production of objects, from artistic pursuits to practical applications. In the same year Rodchenko produced preliminary models for industrial design, and his contemporaries Varvara Stepanova and Lyubov Popova, who also participated in '5 × 5', created geometric designs for textile factories.[18]

The Constructivists' alternative mode of production, dictated by function and *faktura*, implied an alternative mode

Monument to the Third International (1921), was to be a tower of rotating structures, moving at different speeds, with the movement dictated by the cycles of the calendar. Intended as a vehicle to transport its socialist inhabitants into a dynamic new Marxist future, this fantastical design was only ever built in model form. Rodchenko's *Hanging Constructions* (1920–21) were physically activated by the presence of the viewer: suspended from the ceiling, where they were subject to the slightest breeze, these delicate works moved in sync with one's movements.[19] The exhibition designs of El Lissitzky also transformed the neutral, white-walled gallery, or white cube, developed by Modernist architects in the 1920s into an interactive environment. In his *Abstract Cabinet* (1927–28) at the Landesmuseum, Hannover, the walls of the exhibition space, lined with vertical wooden slats painted black, grey and white, shifted in tone as the viewer walked past. Abstract paintings hung on movable racks that the viewer altered in order to select what would be seen.[20] Forty years later the Minimal

artists would also create a dynamic and embodied viewing experience, inspiring writers to explore analogies between Constructivist and Minimalist practice. Constructivism's use of materials for their innate properties, rather than to refer to something else (such as the carving of marble to make it resemble drapery), its depersonalizing of artistic procedure through the use of industrial production and its activation of the beholder were central concerns of Minimalism as well. However, within the context of 1960s New York, these radical innovations no longer carried the revolutionary political meaning they once possessed.

The Minimal artists were not well informed about their avant-garde precursors, largely due to the suppression of Constructivism during the Cold War by both the US and the Soviet Union.[21] The Director of New York's Museum of Modern Art, Alfred Barr, purchased works by Malevich, Rodchenko, Lissitzky and others during a trip to Russia in 1928, thus introducing key examples of Suprematism and

'organic' shapes and figure/ground play.[25] The subtle illusionism of Reinhardt's 'black' paintings caused his work to have a limited impact on Judd or even Stella.[26] In truth, the work of the neo-Dada artists Jasper Johns and Robert Rauschenberg, and the Abstract Expressionists Barnett Newman and Mark Rothko had a more direct impact, and indeed, individually, the Minimalists developed independent readings of these and other contemporary sources. The path from painting to sculpture in the work of Judd, Flavin, Truitt and others was hardly direct: each artist was motivated by individual concerns, and arrived at a unique destination.

Most accounts of Minimalism rightly begin with Frank Stella's *Black Paintings*. Exhibited in '16 Americans' at The Museum of Modern Art, New York, in 1959,[27] Stella's works announced a turn away from the gestural action painting of the previous generation. Avoiding the rhetorical brushwork of artists such as Willem de Kooning and Franz Kline, which fostered an illusion of spontaneity and individualism, Stella

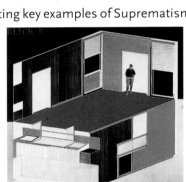

Aleksandr RODCHENKO Hanging construction, 1920–21
El LISSITZKY Sketch for Abstract Cabinet, 1927–28
Ellsworth KELLY White Square, 1953
Ad REINHARDT Black Painting No. 34, 1964

Constructivism into the Museum's collection. Although these works were admired by Andre, Flavin and Stella, they were little understood. It wasn't until the publication of Camilla Gray's *The Great Experiment in Art: 1863–1922* in 1962, the first English-language history of the Russian avant-garde, that the Americans began to understand this history in any depth.[22] Dan Flavin's series of white fluorescent works, *Homages to Vladimir Tatlin* (begun in 1964), Robert Morris' allusions to Tatlin and Rodchenko in his text 'Notes on Sculpture',[23] and later essays by Donald Judd on Malevich and his contemporaries reveal a growing fascination with this avant-garde legacy.[24]

One might imagine that the monochromatic paintings of Ellsworth Kelly and Ad Reinhardt of the 1950s inspired the younger generation of Minimal artists. However, the monochromes Kelly developed in Paris during the early 1950s were largely unknown to the younger artists who only knew his New York work of the late 1950s and early 1960s, which introduced

painted in a methodical manner, filling in regulated patterns with even strokes. Stella's patterns were made up of 6 cm [2.5 in] bands whose width mimicked that of the painting's stretcher bars; the patterns themselves were deduced from the canvas' shape.[28] For example, a vertical rectangle could be divided symmetrically in half (*Arundel Castle* [1959]), (*Marriage of Reason and Squalor* [1959]) or into four quadrants (*Die Fahne Hoch!* [1959]). Simply conceived, the *Black Paintings* aspire to reveal nothing more than the mode of their own organization. As Andre observed in 'Preface to Stripe Painting (Frank Stella)', 'Stella is not interested in expression and sensitivity. He is interested in the necessities of painting.'[29] For Stella, painting stripes on a canvas was a valid enough act in its own right. There was, Andre claimed, 'nothing else' in his work.

Stella did not reject Abstract Expressionism outright. Rather, he and the other Minimalists turned their sights away from the painterly wing of the New York School (de Kooning,

Kline) towards the field painters Barnett Newman and Mark Rothko. The *Black Paintings* recalled the mural scale and symmetrical format of a work like Newman's *Onement I* (1948), but rejected Newman's grand allusions. Where Newman sought to produce an art that transcends its object-ness and points to religious and mythical themes, Stella made the experience of materiality concrete: the paint as paint, the canvas as canvas. In Newman's paintings the thin stripes, called 'zips', flicker against the ground. Stella's stripes, executed in mat latex, lie flat on the canvas, pointing not to a Beyond but to their own congealed presence.

Stella's method also bore some relation to Rauschenberg's *White Paintings* (begun 1951), a series of monochromes premised on an additive logic: the first was a single canvas, the second a diptych and so on (the set concludes with the seventh painting). Casually executed in the same hue, one after the next, the *White Paintings* were purged of subject matter: their concern was nothing more than their

Barnett NEWMAN Onement I, 1948
Robert RAUSCHENBERG White Painting, 1951–68
Jasper JOHNS Three Flags, 1958

own making. In this respect, Rauschenberg's works recalled the aesthetics of process developed by John Cage, a composer who had a considerable impact on younger American artists during the 1950s.[30] In Cage's music, the 'finished' work of classical composition is replaced with an arbitrary, self-exhausting scheme. His most notorious piece, *4'33"*, required the composer to sit in front of the piano for the allotted time without striking a chord, dashing the audience's expectation of a well-wrought work; instead, the restless movements, coughs and whispers of the listeners became the work's focus. But most of all Stella was affected by the early work of Jasper Johns, which brought these process concerns specifically to bear on the problem of pictorial organization. Johns' *Flags* (begun 1954) reduced artistic decision making to the reproduction of an iconic image of repeated stars and (most generative for Stella) stripes. In his *Number Paintings* (1958–59), a sequence of counting numbers arranged in a grid dictated the work's design. For Stella, the no-nonsense logic

of Johns' approach presented a strong alternative to the action painters' 'spontaneous' displays of feeling.[31]

Andre claimed that Stella's work was 'not symbolic' and indeed the Minimal aesthetic fervently rejected allusion.[32] However, the *Black Paintings*, as transitional works emerging from Abstract Expressionism, do contain a residue of subject matter, later erased by the Minimalists.[33] The titles in the series refer to various twentieth-century disasters and 'down-beat themes'; their blackness suggests a Motherwellian pathos, as well as a Beatnik posture of negation.[34] *Morro Castle* (1958), a title supplied by Andre, was the name of a sunken ship; *Getty Tomb* (1959) alludes to a famous mausoleum designed by Louis Sullivan; *Die Fahne Hoch!* (1959) and *Arbeit Macht Frei* (1958) were Nazi slogans; *Seven Steps* (1959) and *Club Onyx* (1959) were the names of lesbian and gay bars in Manhattan, extremely marginal places in the intensely homo-phobic 1950s.[35] It wasn't until he developed the *Aluminum* and *Copper Series* (1959–61) that Stella expunged this tragic subject matter. Metallic stripes were laid down with machine-like precision. Incisions along the edge or in the centre of the canvas stressed the painting's shape and revealed the wall. The Stella canvas was nearly a relief. Judd wrote approvingly in a 1962 review: '*Criticism is pretty much after the fact. Frank Stella's paintings are one of the recent facts. They show the extent of what can be done now ... The absence of illusionistic space in Stella, for example, makes Abstract Expressionism seem now an inadequate style, makes it appear a compromise with representational art and its meaning.*'[36]

It is hard to overstate the impact of Stella's early work on the Minimalist generation. Stella's material surfaces, clarification of process and invention of the shaped canvas were signal developments. Though his work elicited immediate attention, Stella was not unique in developing a Minimal-type painting in the late 1950s, when artists like Ralph Humphrey and Robert Ryman had begun to explore monochromatic formats. Humphrey's early work had thick all-over surfaces, using paint as paint to fill out the canvas rather than as a gestural embodiment of emotion. (Admittedly, his brushwork was more random than Stella's stripe patterns.) Based on a

dominant hue, Humphrey's paintings achieved subtle variations of tone through the admixture of a secondary colour, yet their all-overness cancelled any suggestion of illusion. In an early review, Donald Judd praised the '[raw] ... unique immediacy' of Humphrey's work. Where some critics found Humphrey's paintings 'too simple', Judd suggested that the spareness of Humphrey's formats focused attention on the canvas itself and the simple act of perceiving it.[37]

Ryman also began to produce monochromatic works in the late 1950s; like Humphrey, he applied individual strokes of paint within an all-over format (his first acknowledged painting, *Untitled* [*Orange Painting*] [1955–59], has various shades of a single hue). But Ryman soon enlarged his method, exploring the essentials of the medium through other means: inscription of text (the date or artist's signature), variation of brushstrokes in the same work and use of wallpaper, tracing paper or unstretched linen with raw edges, unconventional materials that stressed the literalness of the

vein, producing gestural drawings brimming with sentiment. In his personal testament, ' ... in daylight or cool white' (1964), Flavin describes seeing a postcard of 'a ten-year old painting by Robert Motherwell which looked strikingly like my last week's work'.[38] In 1961 he abandoned this tragic, Motherwellian mode, and began to produce painting-reliefs that incorporated found objects, including crushed cans. Executed in thick paint applied to masonite, *Apollinaire Wounded* (1959–60) and other similar works stress the painting's physical support. It is perhaps not coincidental that Flavin began to use assemblage, or combining formats – developed by Robert Rauschenberg, Jasper Johns, Jim Dine and others – at this time, while working as a guard at The Museum of Modern Art. The Museum's 1961 exhibition 'The Art of Assemblage', curated by William Seitz, featured these artists.[39] A mixture of painting and relief, the combine introduced found objects within a pictorial or sculptural format, such as in Rauschenberg's *Odalisque* (1955–58) which incor-

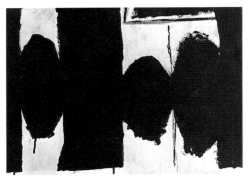 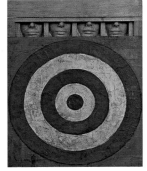

support. As he began to paint in white exclusively and adopt serial formats (in works like *A painting of twelve strokes measuring 11 1/4" × 11 1/4"* [1961]), Ryman regularized the process of painting to an extraordinary degree. Rather than paint in order to express a content or motif, he demonstrated that the simple task of covering a canvas in repeated brushstrokes could stand as the work's 'subject'.

Where Stella, Humphrey and Ryman developed a pared-down, non-illusionistic abstract painting (as would Jo Baer, Robert Mangold, Brice Marden, Paul Mogensen and David Novros), the Minimal object-makers admired the material presence and organization of the new painting precisely because it seemed to spell the medium's conclusion. Dan Flavin and Donald Judd in particular perceived Stella's works as the 'last' paintings that could be made: because the *Black* and *Aluminum Series* rendered illusion and handmadeness passé, they necessarily pointed to the production of objects.

Dan Flavin initially worked in an Abstract Expressionist

porates a rooster and a flickering light bulb. Flavin's *icon* series (1962) also includes incandescent and fluorescent lights, and was the first of his works using what became his signature material. In *icon V* (*Coran's Broadway Flesh*) (1962), the largest and most realized of the group, clear incandescent 'candle' bulbs surround a square sheet of pink masonite, creating a lambent glow that both highlights the work as an object and lifts it off the wall.[40] The works of unmodified fluorescent tubes he began to produce in 1963, such as *the diagonal of May 25, 1963 (to Robert Rosenblum)*, explore this tension of materiality revealed and disassembled. Exhibited on supporting pans with exposed electrical cords, Flavin's lamps are clearly industrial objects, yet the light they project causes the fixtures to dissolve in a pool of intense colour.

Flavin's friend, Sol LeWitt (the two artists met as co-workers at The Museum of Modern Art, New York) also worked in a relief format in the early 1960s. *Wall Structure, White* (1962) and *Wall Structure, Black* (1962) are seemingly

straightforward constructions of masonite and wood. Perfectly square, with thickly painted oil surfaces, LeWitt's works highlight their organization; yet the attached peepholes at their front confound this literalist effect, inviting the viewer to peer into darkness and occluding his or her vision. Other early works by LeWitt reveal the artist's growing fascination with serial method, prompted by the serial images of human and animal locomotion recorded by the nineteenth-century photographer Eadweard Muybridge. These tentative efforts would lead to a more conscious integration of systemic logic by LeWitt in his Minimalist structures of the later 1960s which, based on complex mathematical calculations, manifest the progressive development of a given shape or idea.

Donald Judd began a remarkable sequence of paintings in Liquitex, oil and sand, and reliefs built of aluminium, masonite and wood in the early 1960s.[41] Arranged in simple combinations – a sheet of plywood placed between two cornices, for example – these works made clear their method

Eadweard MUYBRIDGE The Attitudes of Animals in Motion, 1881
David SMITH Cubi XiX, 1964
Anthony CARO Twenty Four Hours, 1960

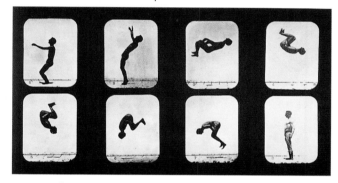

of construction. The largest of these, *Untitled* (1962), adopted the mural-sized scale and symmetrical formats explored by Newman and Stella. Judd observed in 1965 that, 'The main thing wrong with painting is that it is a rectangular plane placed flat against the wall ... In work before 1946 the edges of the rectangle are a boundary, the end of a picture.'[42] Easel painting – or 'European' painting, as Judd called it – was structured on a relational balancing of parts, or a compositional hierarchy. In contrast, the most radical recent painting was based on either a non-hierarchical all-over pattern or predetermined symmetrical divisions. The drip paintings of Jackson Pollock or Newman's vast canvases were legible as 'whole' images, 'intense, clear and powerful'.[43] Where European painting depended on illusionistic space, the new American painting was a unified, literal entity.

Judd next abandoned painting altogether for 'real space'.[44] Three dimensions did not alone guarantee the literal quality he sought, and indeed Judd disliked the work of such

prominent sculptors as David Smith and Anthony Caro, premised on a Cubist balancing of parts. For Judd, the tradition of welded sculpture they exemplified, ultimately derived from Cubist collage, was essentially pictorial. He believed that it was necessary for sculpture to assimilate the flat, rich colour, simple design and scale of the new painting. Judd's earliest objects were coloured cadmium red light (for its visual impact) and built by the artist using industrial materials, including Plexiglas, galvanized metal and plywood. His first solo exhibition, held at the Green Gallery, New York, in the fall of 1963, consisted only of these red works, creating a strong impression. It received favourable reviews from such influential critics as Michael Fried and Sidney Tillim, and established Judd as a leading representative of this emerging literalist tendency.

Among the Minimal sculptors, Andre had the closest relationship with Stella. A classmate of Stella's at Phillips Academy, Andover, Andre had been present during the execution of the *Black* and *Aluminum Paintings*, and cut his first sculpture in Stella's studio in 1959.[45] What did Stella represent for Andre? Unlike Judd and Flavin, Andre did not begin as a painter; he identified himself as a sculptor from early on, and thus was not leaving painting behind in some sort of radical departure into 'real space'. As Andre later recalled, 'It was not basically the appearance of Stella's paintings that influenced me, but his practice'.[46] In other words, Stella's canvases suggested a planned, predetermined way of building sculpture by means of methodically repeated forms. Andre's *Ladders* of 1959 were made of wooden beams with a succession of notches carved repeatedly on one side,[47] and his following series, the *Pyramids* of the same year, were built of identical, stacked, notched beams of progressive length.[48] As he simplified his technique he began to lay blocks of wood directly one upon another or upon the floor. In the *Elements Series* (1960/71) the beams in *Pyre* (1960/71) and *Trabum* (1960) are stacked; in *Inverted Tau* (1960) and *Angle* (1960)

they are placed one on top of the other. The most striking of the *Elements* is *Herm* (1960), which, because it consists of only a single block of wood, bypassed the need for joining or stacking altogether. Released from structural necessity, *Herm* stands alone, subject to gravity's pull. The purest demonstration of Andre's materialism, it manifests the sculptor's desire to reveal 'wood as wood and steel as steel, aluminium as aluminium, a bale of hay as a bale of hay'.[49]

In the art of Andre, Flavin, Judd and Stella, a simplification of format and technique implied that the work harboured no meaning beyond its material components and the facts of its construction. Andre wrote there was 'nothing else' in Stella's art apart from the painted stripes; Stella claimed that in his work 'what you see is what you see'. Abstract Expressionists like Newman and Rothko purged their work of extraneous elements in order to develop an art of transcendental immediacy. Rothko, in a famous statement, argued that only enlarged, simple shapes could convey a 'tragic and timeless'

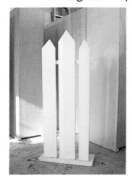

subject matter.[50] The Minimalists, however, rejected the metaphysical claims of the Abstract Expressionists. Admiring the simplicity and scale of Newman and Rothko's work, they studiously avoided the older generation's grandiose themes. Even so, there were some artists associated with Minimalism who did not discount the

expressive potential of pared-down abstraction. Artists Agnes Martin and Anne Truitt, included in the key Minimal shows during the 1960s, admitted subjective experience into their work. At a time when firm definitions of 'Minimalism' were hardly clear, Truitt and Martin seemed to share certain formal affinities with the canonical Minimal artists.[51] Truitt developed a sculpture of unbroken geometric shapes resembling columns and barriers, while Martin produced austere canvases of repeated marks arranged in a grid. However, although their work looked like Minimal art, and was selected by curators for Minimal exhibitions, neither had adopted the literalist agenda key to Minimalism and both retained some form of allusion.

Agnes Martin's earliest Minimal-type painting dates from 1960–62. Executed in graphite, watercolour and washes of ink and acrylic, these delicate and idiosyncratic canvases are the antithesis of Stella's bold compositions. In many works, uneven lines trace the web of the cotton support; the brass

nails in *Untitled* (1962) follow a grid matrix, yet their ever-so-slightly off alignment suggests an arbitrariness and hand-madeness in complete opposition to literalist method. (In Judd's reliefs of the same year, the nails line up with exacting precision.) Instead of revealing the work's organization as material and evident, the all-over patterns point to a transcendent world order.[52] Though her vision of absolute harmony could not be further removed from Rothko's tragic themes or Newman's sublime terror, Martin also holds fast to the Abstract Expressionists' belief that abstraction must point beyond mere material facts, and in this contrasts with the literalist Minimalists such as Andre, Morris and Judd.

Where Martin posits a notion of abstraction as a universal language, Truitt devised a geometric sculpture rooted in personal memory. Her earliest works include *First* (1961), which recalls the picket fences of her home town of Easton, Maryland, and *Southern Elegy* (1962) which mimics the profiles of local tombstones. Though 'Minimal' in appearance, Truitt's practice holds a unique position within the field of Minimal art. Where much Minimal work renders colour and literal shape congruent, Truitt's sculpture retains a measure of arbitrariness: in many works, the colour planes overlap adjacent shapes. Even more, her work is hand-painted, not factory-made. Truitt's allusive content and intuitive approach thus opposed the literalist impulse of much Minimal art. Judd, assessing her first one-person show in 1963, was not charmed by her allusions to tombstones and her instinctive use of colour, but his opinion wasn't widely shared at the time. Truitt's exhibition at New York's Andre Emmerich Gallery won the support of the influential critics Clement Greenberg and William Rubin (curator at The Museum of Modern Art), and the eminent Abstract Expressionist sculptor David Smith. As the 1960s unfolded, however, and Judd's literalist views predominated, Truitt's expressive aims came to seem retrograde.

Robert Morris also fits uneasily in Minimalism, albeit for different reasons. Where much Minimal work developed in response to painting or sculpture, Morris' objects emerged from his involvement in performance. A member of the Judson Dance Theater in Greenwich Village along with dancer/chore-ographers Trisha Brown, Lucinda Childs, Simone Forti and Yvonne Rainer, Morris initially built plywood pieces as stage props. *Column* (1961), a work exhibited in his first show at the Green Gallery (1963), was originally meant to be a container

for a body.[53] *Box with the Sound of Its own Making* (1961), a wooden cube containing a recording of a pounding hammer, forced the viewer to re-experience the work's construction by the artist. Morris described such works as *Column* and *Box with the Sound of Its own Making* as 'Blank Forms', 'essentially empty' sculptures with nothing to say.[54] Like the *White Paintings* of Robert Rauschenberg or Jasper Johns' *Numbers*, *Box with the Sound of Its own Making* suggests the aesthetic of the composer John Cage, whose performances are emptied of feeling and allusion. For Morris, the Minimal work began as the pretext for a bodily encounter; it is a thing to use more than something to look at, a stage prop rather than the finished work of art favoured by Judd, Stella and Flavin, primarily directed to the viewer's gaze. In the years to come, he explored the nature of this encounter in his essay 'Notes on Sculpture', developing a theory of sculpture that remains influential to the present day.[55]

balance: the artist puts 'something in one corner' and 'something in the other', resulting in a harmonious composition. Non-relational organization – the wholistic method of Stella, Judd and Flavin – dispenses with the necessity for compositional harmony. Stella's *Stripe Paintings* are the result of predetermined patterns, symmetrical divisions and shapes, not elements poised in counterbalance. According to Judd, this apparently more direct way of working implied something beyond a shift in technique. Compositional balance was an objectionable relic of 'European' art and its 'rationalistic' philosophy. European painting and sculpture impose a fiction of total comprehension, suggesting that it is possible to represent the world in a singular, coherent and truthful manner. Renaissance one-point perspective typifies this compositional approach, orchestrating the scene in conformity with the spectator's gaze: in a Leonardo or Poussin, every element is carefully arranged in a receding space. Cubism shallowed out perspectival depth, yet retained a

Yvonne RAINER Film About a Woman Who ... , 1974
Piet MONDRIAN Composition C, 1920
Pablo PICASSO Violin and Grapes, 1912

 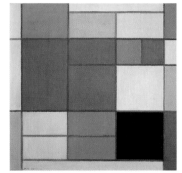 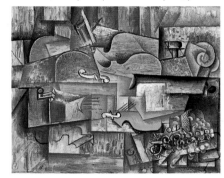

1964–67 High Minimalism

'There isn't anything to look at.'
– Donald Judd, 'Black, White, and Gray', 1964
During the mid 1960s all of the leading Minimal object-makers – Morris, Andre, Judd, Flavin, LeWitt, Truitt, Bell and McCracken – had one-person shows.[56] Mangold, Baer, Marden and Novros started to exhibit work that they had been developing since the early 1960s. As critics began to review and discuss the impact of these exhibitions, the impressions of the early 1960s consolidated into clearer accounts of this emerging development, and indeed the mid 1960s saw the publication of several essays that helped to clarify what came to be known as Minimal art.

In a radio interview conducted by critic Bruce Glaser with Stella, Judd and Flavin in February 1964, a common point of view linking these artists emerged. All of these artists agreed on the distinction between relational and non-relational method. As Stella explained, relational work is premised on

pictorial coherence: the most abstract Picasso depicts something – a figure or still-life – even as it radicalizes the mode of depiction, fracturing the image into many parts. Even Mondrian's abstract canvases of the 1920s were perfectly balanced arrangements, reflecting the artist's theosophical conviction in an underlying world harmony.

It was Judd's opinion that the new American art was more 'advanced' because it did not posit a rational viewer who can discern an ideal order, only one who perceives simple material facts. Prompted by Greenberg and other critics who touted Abstract Expressionism in chauvinistic terms, Judd dismissed centuries of European culture with arrogant assurance. Yet he and Stella were hardly unique at the time in claiming there was no underlying meaning to things, no truth apart from one's immediate encounter with empirical reality. In the French New Novel developed by such writers as Alain Robbe-Grillet and Nathalie Sarraute during the 1950s, for example, narrative climax is absent; expression is negated;

and the reader discerns 'nothing' beyond the narrator's flat descriptions of situations and events. Stella's famous observation to Glaser, 'what you see is what you see',[57] suggests that his work harbours no meaning apart from the facts of its construction. In *For a New Novel* (1965), a discussion of this new type of fiction, Robbe-Grillet similarly observes, 'If art is something, it is everything, which means that it must be self-sufficient and that there is nothing beyond'.[58]

In her seminal essay 'Against Interpretation' (1964), cultural critic Susan Sontag argues for a criticism responsive to this new aesthetic, which she equates with a variety of practices on either side of the Atlantic: Robbe-Grillet's fiction, the New Wave cinema of Alain Resnais and the neo-Dada/Pop of Warhol and Johns.[59] Artists and writers in both Paris and New York were engaged in developing an art concerned with unmasking metaphysical certitudes. According to Sontag, criticism should describe the work as it is sensually experienced by a reader or viewer rather than attempt to decode its

to the Dada heritage of Duchamp and Cage, observing that 'Much of [it] is idea art, as opposed to the retinal or visceral'.[62] As Wagstaff implies, the art in 'Black, White, and Gray' exists on the cusp between the Modernism and Dada, deriving from both the formal and conceptual traditions of twentieth-century art.

Donald Judd found it difficult to accept those works in the show whose drastic simplicity seemed to undermine their status as visual art. Even so, in his review of 'Black, White, and Gray', Judd had to admit that the work does 'exist after all, as meagre as [it is].'[63] Robert Morris and Robert Rauschenberg in particular had developed an art so 'minimal' that it blurred the distinction between Modernism's tendency to formal reduction and Dada's challenge to the definition of art as it had been known. Rauschenberg's *White Paintings* and Morris' bland, grey cubes offered little to 'look at', Judd wrote. In contrast, Judd sought a more deliberate formal complexity in his own work, opting for polychromy, varied materials and

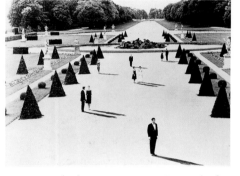
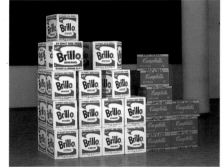

Alain RESNAIS Last Year in Marienbad, 1961
Andy WARHOL Brillo (Boxes), 1964
Robert RAUSCHENBERG Retroactive II, 1964
Robert RAUSCHENBERG Almanac, 1962

underlying meaning. Purged of unnecessary detail, the new art had rendered its form transparent; hence it required a purely formal approach.

'Black, White, and Gray', at the Wadsworth Atheneum in Hartford, Connecticut in 1964, was one of the first shows to examine this new aesthetic.[60] According to the curator, Samuel J. Wagstaff, Jr, an 'affinity' bound together this widely diverse group of artists, which included Pop artists such as Andy Warhol and Robert Rauschenberg and Minimal artists such as Dan Flavin, Robert Morris and Frank Stella. Most of the works incorporated simple, hard-edged shapes; all were executed in black, white and grey, a palette allegedly devoid of feeling.[61] As Wagstaff suggests, the new art was informed by two legacies. On the one hand, he cites the Modernist tradition of formal reduction, exemplified in the exhibition by Newman's and Reinhardt's abstract canvases. On the other, he allies the new art – so apparently indifferent to the traditional premise that art emerges from the hand of the artist –

highly finished surfaces: there was no question that what he was making was 'fine art'.

Judd elaborated this point of view in 'Specific Objects', commissioned by *Arts Magazine* as a wrap-up of contemporary work in New York in 1965.[64] Though ostensibly a long review, its pronouncements became tremendously influential, and this text is often viewed as Judd's manifesto. He proposes an innovative art that is 'neither painting nor sculpture', combining the intense colour and simple design of recent American painting with the use of brand-new materials, such as Plexiglas, steel, iron and plastic. He also advocates a serial distribution of parts, 'one thing after another', that dictates the work's organization in advance of its production. One could easily surmise that Judd is basically advocating his own work, and to a certain extent he is, but a closer examination reveals that an extraordinary variety of practices enter his discussion. Having worked as a reviewer since 1959, Judd had a wide-ranging knowledge of contemporary art; he

discusses the work of Flavin, Newman and Stella in relation to the unlikely and very different practices of John Chamberlain and Claes Oldenburg. Judd does not specify that the Specific Object is necessarily an abstract cube or relief: Oldenburg's soft sculptures resemble real things, such as ice cream cones or hamburgers, but their scale, simplified shapes and synthetic materials relate to Judd's own work. Chamberlain's sculpture made up of crushed metal rejects the part-by-part welding of late Cubist sculpture, such as that of David Smith. Often made from a single sheet of aluminium compressed into a single shape, Chamberlain's works read as whole, distinctive forms. Other practices are less specific. Rauschenberg's work certainly qualifies as 'neither painting nor sculpture', but its relational arrangement of elements is still mired in a collage aesthetic. (When Rauschenberg adopted the photo silkscreen in the early 1960s, his work was all the more pictorial, and therefore objectionable, from Judd's point of view.)

Rose locates these practices within a broader cultural field, citing a *melange* of literary and philosophical sources current in New York intellectual circles, including the widely varying writings of Alain Robbe-Grillet, Samuel Beckett and Ludwig Wittgenstein. The appearance of these citations opened up Minimal criticism to concerns beyond the purely formal or visual. Though loosely applied, Rose's epigraphs are an unusual presence in an art text during a time when close visual analysis, as practised by the Modernist critic Clement Greenberg, reigned supreme. Much Minimal criticism would continue to address formal interpretations of the work, but in the wake of Rose's text, social and philosophical reflection increasingly played a part.

Although Rose declared her support for Minimal work early on, other critics were more equivocal. The reception of early shows associated with the movement was mixed: the work of one artist looked more 'acceptably' Minimal than another's. Robert Morris' installation at the Green Gallery (New York) in 1964 was praised by Lucy R. Lippard, David Bourdon and others who marvelled at the way he revealed the gallery space with simple, grey shapes.[68]





'Specific Objects' established a common formal vocabulary for discussing the new work. In 'ABC Art' (1965), critic Barbara Rose also identified a variety of art historical sources informing Minimal practice.[65] Like Wagstaff, Rose suggested that Minimal work partakes both of the Modernist impulse of formal reduction – exemplified by Malevich's *Black Square* – and the Duchampian readymade's 'kinship to the world of things'. Rose was less concerned with formal specifics than Judd, however, and instead related the new art to a sensibility of 'reserved impersonality'.[66] Her discussion encompasses a variety of styles and media: the geometric forms of Robert Morris, Donald Judd, Carl Andre, Dan Flavin, Anne Truitt and Ronald Bladen; the optical abstraction of painters Walter Darby Bannard and Larry Zox; Pop art; the real time music of John Cage and La Monte Young; and Andy Warhol's anti-narrative cinema. The dance of Merce Cunningham and Yvonne Rainer, whose repeated movements abrogate narrative focus and climax, is another reference.[67] Furthermore,

In contrast, Dan Flavin's early shows of fluorescent lights, at the Kaymar and Green Galleries (both New York), met with confusion. Lippard acknowledged Flavin's desire to make 'fine art' using commercial lamps, but remained unconvinced that he had succeeded in doing so.[69] Bourdon's review was particularly cruel.[70] It describes how after visiting Flavin's show, he is 'startled by the window display' at a local lighting company which looked like Flavin's show in the gallery across the street. The only difference between Flavin's installation and the store display was that Flavin's tubes had been 'put into an art context'. Like Lippard, Bourdon interpreted Flavin's art as a Duchampian gesture: by placing the readymade lamp in a gallery, Flavin declares its status as art. Poor Flavin! As his statement ' ... in daylight or cool white'[71] suggests, he viewed the fluorescent tube not as a conceptual declaration but as the formal vocabulary of an installational art. Rejecting the pictorial format of his earlier *icons* made of painted canvases and lamps combined, he used the lamp

alone to illuminate and disrupt the gallery's parameters. However, during the early 1960s, even the most open-minded critics doubted whether his arrangements could qualify as 'high art'.

Andre's work was also interpreted as a Dadaist exercise. His first exhibition, of stacked polystyrene beams, at Tibor de Nagy Gallery (New York) in 1965, completely filled the gallery space, eliciting comparisons to architecture. Although Lippard acknowledged the physical impact of Andre's works, however, she characterized the show as a conceptual installation. '[Andre's] exhibition at Tibor de Nagy, in this day of conceptual extremism, was one of the most extreme events.'[72] She felt that Andre's method of stacking the units without building a permanent structure implied that the show was the demonstration of an idea: the actual polystyrene beams were beside the point. For Andre, materials are unique. His practice, though interpreted as Conceptual art, is in fact staunchly materialist; the works he developed at this time expose matter

for its own sake, avoiding sculptural techniques that impose an extraneous conceptual or figurative schema (welding, carving, etc.) Years later, Andre distanced himself 'from any Conceptual art or even with ideas in art', insisting that his work springs from his desire to 'have things in the world'.[73]

Just as some viewers perceived an underlying Conceptualism in Andre's work, there were also doubts about Judd's literalist claims.[74] In his essay 'Donald Judd', commissioned for the catalogue of a show at the Philadelphia Institute for Contemporary art in 1965, fellow artist Robert Smithson noted that, 'It is impossible to tell what is hanging from what or what is supporting what. Ups are downs and downs are ups. An uncanny materiality inherent in the surface engulfs the basic structure.'[75] Judd equates these industrial materials – steel, aluminium and Plexiglas – with material specificity, denying the possibility of illusionism. But Smithson challenges Judd's views. Delighting in the gorgeous reflections of these materials, he implies that Judd's embrace of the factory has resulted in works that undermine their specificity: the meticulously finished surfaces of Judd's metal and Plexiglas boxes make them hard to read. In a 1966 essay,

critic Rosalind Krauss also notes this contradiction, discussing how his work derives its power from 'a heightening of illusion', the antithesis of Judd's stated intention.[76] As critics began to look carefully at Minimal practice during the 1960s, they discerned a disparity between the artists' claims and the perceptual experience of the work itself. At the same time, early understandings of Minimalism were challenged as the field of Minimal art evolved and incorporated new practices.

The art of Larry Bell, for example, transformed the visual effects of the Minimal object in new ways. A member of the circle of artists associated with the Ferus Gallery, a centre for avant-garde activity in Los Angeles, Bell worked in a gestural, Abstract Expressionist manner during the late 1950s. An encounter with the artist Robert Irwin, his professor at the Chouinard Art Institute (now CalArts), altered his course. Dissatisfied with his efforts as an action painter, Bell turned his attention to the production of perceptual effects. Starting in 1960, he developed a series of shaped canvases whose irregular polygons and isometric painted figures mimicked and countered the shape of the support, creating false perspectives and optical conundrums. In some works, inserted panes of glass complicated these visual trickeries. Bell then began to make glass sculpture in which illusionism was no longer a matter of depiction, but a perceptual effect of the materials themselves. His early glass and mirror cubes, like *Bette and the Giant Jewfish* (1963), are decorated with etched geometric figures, checkerboards and stripes; by the mid 1960s, they consist entirely of unadulterated glass panes. Tinted in a vacuum chamber, a mechanism that chemically binds vaporized metal to glass, Bell's cubes induce a range of evanescent perceptual qualities.[77]

Classic examples of the so-called Finish Fetish/Light and Space aesthetic of 1960s Los Angeles – which emphasized the illusionistic qualities of shiny, synthetic materials including fibreglass, cast acrylic and polyester resin, and Harley Davidson lacquer – Bell's work has been mythically linked to a culture of cars, plastics and surfboards, and the streamlined aesthetic of the aerospace and defence industries that flourished in Southern California during this period.[78] (In fact, unlike some of his contemporaries, such as the artist Billy Al Bengston who produced highly finished fibreglass reliefs resembling surfboards, Bell was not interested in automobile and surfer culture.) Critics have often

Robert IRWIN Untitled, 1965–67

distinguished Finish Fetish work from New York Minimalism, opposing the pastel hues and illusionism of the work of Bell and McCracken – organically linked to the light and expansive space of Southern California – to the sober palette and plain materiality of Morris and Andre. Certainly, Bell's tendency to 'dissolve the construction into shimmering harmony', to quote John Coplans, opposed the avowedly literalist aims of East Coast artists. However, comparisons of individual works reveal overlapping formal effects. Judd was just as likely to use Harley Davidson lacquer as the Californians, and he, Morris and Smithson shared Bell's predilection for reflective glass (see Morris' *Mirrored Cubes* [1965], or Smithson's *Enantiomorphic Chambers* [1964] and *Glass Strata* [1966]). The East Coast/West Coast divide was hardly an absolute.[79] Southern Californians were familiar with New York-based work through art magazines. Bell and McCracken began to show in New York in the mid 1960s and established friendships with the New York Minimalists.[80] As McCracken has

Billy Al BENGSTON Carburetor 1, 1961
David ANNESLEY Orinoco, 1965

observed:

'*I decided to go to Los Angeles first, because things were really happening there ... but I was paying primary attention to the New York art world ... I felt like the main conversation I was in was with people like Don Judd, Bob Morris, Dan Flavin, Carl Andre and so on.*'[81]

McCracken began to produce Minimal-type sculpture in 1965, having first painted, in 1963–64, a series of hard-edged canvases featuring simplified, heraldic figures – arrows, crosses and chevrons – reminiscent of the Suprematist paintings of Kasimir Malevich and the diagrammatic works of Robert Indiana. His first sculptures, a series of reliefs which he exhibited at the Nicholas Wilder Gallery in 1965 (Los Angeles), were brightly polychrome and built of sheets of masonite coated in layers of automotive lacquer. Other early works alluded to ancient architectural forms such as lintels, pyramids and columns derived from ancient Egyptian architecture. Increasingly, McCracken's shapes became simpler,

his surfaces more polished. He began to use fibreglass for its consistent finish, and in 1966 developed his famous untitled series of highly finished wooden planks. Individual sheets of plywood painted a single hue, these works were viewed by many as the final stage in Minimal art's asymptotical process of formal simplification: a final 'minimum'. Like Andre's *Elements* and Flavin's *Nominal Three*, these works may be counted among the boldest examples of Minimalist 'reduction' of the 1960s.[82]

The show 'Primary Structures', curated by Kynaston McShine at the Jewish Museum, New York, in 1966, heralded the Minimal movement to a broader public. In addition to the artists typically associated with Minimalism – Carl Andre, Dan Flavin, Donald Judd, Sol LeWitt and Robert Morris – it also included figures more tangentially associated with the movement, such as Larry Bell, John McCracken, Robert Smithson and Anne Truitt. The presence of British sculptors such as Anthony Caro, David Annesley and Michael Bolus, whose welded, part-by-part works Minimal work opposed, also demonstrated the general vitality of sculpture at this time. 'Primary Structures', considered the most important show of Minimal art of the 1960s, was actually a broad survey of recent sculpture. Judd, in 'Complaints: Part I', recalled his displeasure with the exhibition which 'started out a year earlier with Flavin, Morris, myself, maybe Andre and Bell' and was transformed into a show with forty-odd artists, many of whom 'had become geometric during that year'.[83] Whom did he mean? Perhaps Judy Chicago, whose *Rainbow Pickets*, a row of prismatically coloured planks arranged in descending height order, suggested a recent assimilation of Minimal style, or Ronald Bladen, whose overscaled *Elements*, three 274-cm [9-ft] rhomboids leaning at a 65-degree angle, dominated the gallery in which the works of Judd and Morris were exhibited. Numerous works by other, younger artists crowded the halls of the Jewish Museum; 'Minimal art' was definitely undergoing an expansion, contaminating the severe (if contrasting) restrictions of Judd, Morris *et al*.

As Minimalism grew in notoriety, some critics attempted to create an artistic hierarchy. Artist and critic Mel Bochner, in his essay 'Primary Structures' published in *Arts Magazine*, hailed Andre, Flavin, Judd, LeWitt, Morris and Smithson as the 'best' artists in the show.[84] Others were less impressed. Hilton Kramer, art critic for the *New York Times*, lamented the

absence of feeling in the new sculpture, although he admitted that 'Primary Structures' was a seminal show. Lack of emotive affect was, of course, the point of serial method and factory production, but Kramer found no solace in Minimalism's anti-subjective impulse. As he suggested, the visitor to 'Primary Structures' was 'enlightened, but rarely moved'.[85]

Responding to critics like Kramer, Robert Morris went on the defence. His 'Notes on Sculpture', published in *Artforum* in 1966, makes a rigorous case in favour of the new sculpture, while distinguishing his work from the practices of the other artists with whom he had become associated in shows such as 'Primary Structures'.[86] He particularly targets Judd's theory of the Specific Object. Where Judd proposes an art that exists between painting and sculpture, Morris characterizes the new work as purely sculptural, recalling Clement Greenberg's Modernist insistence, in his 1940 essay 'Towards a Newer Laocoon',[87] that each medium explore its own formal qualities. According to Morris, the Specific Object has not left behind its pictorial origins; a brightly coloured object or relief, it does not exist fully in the viewer's space. Sculpture in Morris' sense is divested of colour and its pictorial associations – he recommends a bland grey – and strictly three-dimensional. Placed in the centre of the gallery, it requires the viewer's active participation:

'The better new work takes relationships out of the work and makes them a function of space, light and the viewer's field of vision ... [The viewer] is more aware than ever before that he himself is establishing relationships as he apprehends the object from various positions and under varying conditions of light and spatial context.'[88]

Morris theorized the experience of Minimal art in respect to two perceptual models: Gestalt psychology and the phenomenology of Maurice Merleau-Ponty. Gestalt theory, founded by the German psychologists Wolfgang Köhler and Kurt Koffka in the early twentieth century, concerns the isolation and description of discrete perceptual phenomena, or Gestalts. Morris describes a spectator circulating around the Minimal object, comparing his or her perception of its literal shape against the mental image of its form. The goal of the new sculpture is to make this form – the Gestalt – visible to a viewer moving around the work. He then provides a phenomenological explanation of his sculpture inspired by the French philosopher Maurice Merleau-Ponty. Merleau-Ponty, who has been referred to as 'the central philosopher for Minimalist

art',[89] argued that we exist within a constantly unfolding encounter with our surroundings, or being-in-the-world; we come to know ourselves only in relation to what we touch or perceive. 'Our body is in the world as the heart is in the organism. It keeps the visible spectacle constantly alive ... and with it forms a system.'[90] Similarly, Morris describes the experience of his work as a perceptual system – an inextricable relation of the body, the work and the gallery – and describes the temporal nature of this encounter. The viewer of the Minimal work takes in the sculpture's Gestalt from a succession of points of view. This integration of time into Morris' theory of sculpture was altogether consistent with his earlier performance aesthetic, and would radicalize subsequent discussions of his work.

As Minimal criticism began to focus on three-dimensional work and the viewer's physical encounter with the object, the question of painting's status became problematic. However, a number of critics, including Lawrence Alloway and Lucy R. Lippard, saw painting as equally relevant in discussions of Minimal art.[91] Lippard suggested that the new monochrome painting was the Primary Structure's closest counterpart, observing that painters Ralph Humphrey, Robert Mangold, Brice Marden, Paul Mogensen, David Novros and Robert Ryman were creating work capable of meeting 'the challenge of the increasing limitations set by the two-dimensional plane'.[92] Painting associated with Minimalism varied in surface and perceptual effects, as artists explored qualities of illusion to varying degrees. According to Lippard, Mangold's shaped monochromes, such as the *Area* paintings of 1965–66, disrupt the convention of the rectangular canvas and the fictive space it suggests. Projecting complementary after-images on the surrounding wall, they are both literal shapes and sources of retinal play. Humphrey's 'frame' paintings of the mid 1960s have thick, all-over surfaces, yet set up an optical tension of close values and hues.

In contrast, Lippard observed that the painters Brice Marden, Paul Mogensen, David Novros and Robert Ryman produced work that is unequivocally literal. Marden's paintings are covered with a luminescent encaustic mixture of oil and wax thick as butter, but retain an empty bottom edge of drips and smears, revealing the bare canvas. Novros developed a series of L-shaped canvases painted in a mixture of acrylic paint and Marano powder, a light interference material that shifts in tone as the viewer moves past. Distributed

across the wall, the Ls fracture the picture plane into multiple units, casting shadows on to interstitial areas of wall. Paul Mogensen also fragmented the mural canvas of Abstract Expressionism into a multi-panelled assemblage of discrete parts. The relative size of each canvas was calculated according to a progressive schema. In *Copperopolis* (1966), the width and length of the units seem to double from right to left, and from bottom to top. *Standard* (1966) is comprised of four progressively thinner rectangular shapes. Executed in such elemental hues as copper and white, Mogensen's works exemplify the literalist fixation on pure materiality; like Andre's metal plates, each canvas is an individual unit. Much like Minimal sculpture, too, Mogensen's installations – like the polyptychs of Novros – expose the gallery itself as an actual place, inscribing the wall (traditionally a 'neutral' background for painting) as a positive term within the work as a whole. Ryman instead focused on exploring the parameters of his own painterly process. In the *Winsor Series* he developed in 1964–65, named after the white Winsor and Newton paint he used to complete the works, execution is entirely manifest; the all-over patterns of uneven stripes trace the descent of the artist's hand filling the canvas. In other works, such as the *Standard Series* of 1967, he arranged a selection of materials (enamel paint, steel, etc.) into various – and by implication infinite – combinations. Transforming painting into a game with no conclusion, Ryman was concerned with nothing more (nor less) than the activity of painting as such.

The Bykert Gallery in New York hosted a series of shows organized by Klaus Kertess in the late 1960s, which focused primarily on this work. Critic Barbara Rose, in a review of an exhibition of paintings by Humphrey, Marden and Novros at the Bykert in the summer of 1967, claimed that 'the reductive solution' had become a dead end.[93] Although the prospect of Minimal painting had seemed novel during the early 1960s, when Stella was working at the forefront of this pursuit, he soon found the literalist agenda extremely limiting. Slowly but surely during the 1960s, Stella restored polychromy and figure/ground play, as in his *Concentric Squares* (1962) and *Irregular Polygons* (1966). To Rose, who was married to Stella, monochrome painting was definitely old news.

In contrast, artist Jo Baer made a passionate defence of monochrome painting in a letter to the editor of *Artforum* in September 1967.[94] Baer developed a Minimal-type abstraction in 1962–63 of white canvases with black and concentric

coloured borders, and had exhibited in 'Systemic Painting' and in group shows alongside Andre, Flavin, Judd, LeWitt and Morris. She argues, contra Judd, that painting is not inherently pictorial: 'Allusion inheres no more now in paint than in wallpaper'. Nor are new materials necessarily less illusionistic than old ones, as her wicked comparison of Flavin's light to a 'fluffy ... Mazda', a mirage, suggests. Nor are they inherently more radical. Ideas and materials share 'a functional relationship, not an identity'. Though provocative, Baer's analysis failed to spark debate: in the mid 1960s, Judd's claim that painting was obsolete held sway. It wasn't until the Minimal object lost its novelty that the discourse around literalist painting could mature. In the elegant 'Opaque Surfaces' (1973), critic Douglas Crimp connects the 'opaque' canvases of Ryman and Marden both to the heritage of late Modernist painting – Kelly, Newman and Stella – and to Minimalist sculpture, observing that monochrome painting has achieved 'the painted equivalent of sculpture's objecthood'.[95] Crimp's account would be followed by other close analyses as the work of Ryman, Marden, Mangold and Novros received considerable attention in the 1970s and 1980s.[96]

During the late 1960s, the debates around Minimalism began to address the 'serial attitude' manifest in the work of Carl Andre, Dan Flavin and Donald Judd, as well as in the practices of Mel Bochner, Dan Graham, Eva Hesse, Sol LeWitt and Robert Smithson, which used the forms and seriality of Minimalism in support of different ends.[97] LeWitt experimented with serial technique as early as 1962 in his *Wall Structures*, a series of concentric open-ended squares projecting into space from the canvas. In 1965–66 he went on to develop his first open modular cubic structures, initially in black, then in white, which were entirely preconceived according to predetermined mathematical formulas. *Serial Project No.1 (ABCD)* (1966) is a permutation set (a closed, self-exhausting system) consisting of both open and closed cubes arranged on a grid. Constructed for an exhibition at the Dwan Gallery, Los Angeles, in 1967, *Serial Project No.1 (ABCD)* equally existed in the form of the show's invitation (a plan covered with mathematical formulas) as in three dimensions. In LeWitt's project, Minimalism's distancing of the artist's hand reached a new extreme. Not only did the planning occur ahead of the work's execution, the execution itself had become virtually unnecessary: the idea alone was the artwork. Where other Minimalists repressed the conceptual founda-

tions of their art, LeWitt focused on the concept as such; he rendered the finished object prized by Judd secondary to its generating idea.

Mel Bochner, Dan Graham and Eva Hesse also elaborated upon the conceptual, social and metaphorical implications of seriality. Working at the same time as LeWitt, Bochner explored a seemingly endless variety of mathematical formulas such as permutation sets, Fibonacci progressions, rotations and reversals in drawings and small reliefs. Other projects used photographic and xerographic technologies. *36 Photographs and 12 Diagrams* (1966) records the permutational development of temporary sculptures in paired representational systems; the mathematical schema underlying each 'work' is presented next to its image. *Working Drawings or Other Things on Paper Not Necessarily Meant to be Viewed as Art*, an installation presented at the School of Visual Arts, New York, in 1966, examines the social and conceptual underpinnings of seriality.[98] Consisting of four identical photocopy

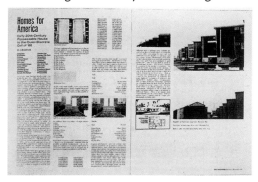

books mounted on white pedestals, it includes photocopies of project drawings by Minimal sculptors shown alongside diagrams from *Scientific American* magazine, architectural plans and the blueprint of the photocopier machine used to reproduce these images. As Bochner suggests, serialism is at once a strategy of avant-garde work and a social logic: the de-subjectivizing techniques of Minimalism have developed in tandem with systematic thinking in mathematics and other disciplines, as well as expanding technologies of reproduction.

Dan Graham's *Homes for America*, a conceptual project originally created for the pages of *Arts Magazine* in 1966–67, also connected serial method to the way in which post-war society had been restructured through new forms of mass production and consumption. A text with photographic documentation, *Homes for America* reveals how the prefabricated housing of the new middle-class suburb had been developed in a systematic manner. For example, a purchaser in Florida's Cape Coral community had to choose between eight housing models and eight exterior colour options. The possible number of combinations of model and colour was predeter-

mined and self-fulfilling: personal choice was confined to a closed set of possibilities. As Director of the short-lived John Daniels Gallery in New York, Graham had exhibited the work of the Minimalists Judd, Flavin and LeWitt. In *Homes for America*, he allies the serial methods favoured by these artists with the production formulas of the most bland tract housing.[99]

Where Dan Graham and Mel Bochner used the tools and techniques of Minimalism in their more Conceptual art, Eva Hesse transmuted the syntax and geometries of Minimalism into a distinctive sculptural language. Handmade from synthetic polymers and fibreglass resins, wires and cords, sculptures such as *Ishtar* (1965) and *Addendum* (1967) transform the modular relief or progression into a sequence of forms reminiscent of breasts and hair. *Accession II* (1967), a metal box threaded with hundreds of rubber tubes, is a Judd gone awry, a Minimal cube rendered uncanny through its conjunction of rigid shape and soft materials. In Hesse's work, Minimalist seriality and wholeness give way to idiosyncratic shape and irregular schemes: the factory-produced, contentless Minimal object is softened and suffused with bodily metaphor.

Robert Smithson also adopted Minimal form to new effect. In his Non-sites, begun in 1966, the Minimal box has become a receptacle for shale culled from quarries; the work is less a thing to be looked at than a reminder of the place from which the material derived. The literal site defined by the work of Morris and Andre has become a non-place, a vector pointing to an elsewhere. In his 1966 essay 'Entropy and the New Monuments',[100] Smithson characterizes the work of Flavin, Judd, Morris and LeWitt as ephemeral and anti-monumental. The once solid Minimal object is on the verge of material breakdown. Flavin's work is exemplary in this respect. His lights are art only when illuminated; after they are turned off, the work no longer exists. Smithson also describes Minimal practice in geological terms, claiming that Judd's untitled pink Plexiglas and steel box with wires of 1965 suggests crystallographical models. He even characterizes Judd as a kind of geologist, citing the older artist's collection of maps and comparing Judd's laconic writing style to the factual descriptions in geology books. Filled with fragmentary observations, 'Entropy and the New Monuments' is an eccentric, brilliant text that speaks more of Smithson's own scientific interests than the stated aims of the Minimalists. The affection was not

Dan GRAHAM Homes for America, 1966–67

always returned: Judd's pithy statement, 'Smithson isn't my spokesman' speaks to a growing frustration with Smithson's imaginative appropriations.[101]

The Modernist critic Clement Greenberg takes a less celebratory view of Minimal practice in 'Recentness of Sculpture' (1967). Greenberg sees Minimalism as a 'Novelty' art, a Dadaist activity whose sole concern is to shock. Where the Modernist work, i.e. a Cézanne or Picasso, has a lasting effect on taste, the novelty item is no more than a momentary surprise. Like Dada, Minimalism blurs the clear distinction between what is art and what is not-art. Preplanned and executed by somebody else, the Minimal work lacks formal complexity and feeling; it is 'too much a feat of ideation', too conceptual. Closer to furniture than to art, it is a kind of Good Design, but nothing more.[102] Where Judd, Flavin, Andre and LeWitt explored factory production to develop an art devoid of feeling, Greenberg held the bias of Abstract Expressionist aesthetics that the 'true' work of art is a handmade expression of the artist's subjectivity.

Critic Michael Fried's 'Art and Objecthood' (1967) also addresses Minimalism's blurring of the border between art and not-art.[103] But where Greenberg equates the Minimal work with Duchamp's readymades, Fried sees Minimalism as an unfortunate outgrowth of Modernism. According to Greenberg, the task of the Modernist work is to explore its medium, whether sculpture, painting or poetry. Painting's salient quality is its flatness, hence it is flatness – the literalness of the support – that Modernist painting should reveal.[104] Fried suggests that Minimal art has brought this investigation too far. Painting's pursuit of flatness has resulted in an unforeseen conclusion: the Specific Object. Judd's coloured relief is neither painting nor sculpture; blurring Modernist distinctions between media, it undermines the Modernist project from within. Where the Modernist canvas points to a beyond (however flat its surface), Minimal art alludes only to itself, to its very objecthood. For Fried, this revelation of objecthood, of literalness for its own sake, has undermined the distinction between art and non-art. A work of art is 'not an object', he writes.[105] In contrast, the Modernist work defeats its objecthood by organizing an ideal aesthetic space. The Modernist paintings of Morris Louis or Barnett Newman construct a purely visual realm of colour. The painted sculptures of Anthony Caro resolve to a pictorial format and transcend their three-dimensionality. Minimal art, instead,

reveals the literal space of the viewer and the viewer's presence in this space. Placed in the centre of the gallery, the Minimal work sets up a 'theatrical' relationship with the spectator, demanding his or her attention, much as an actor does. Theatre in Fried's sense suggests this obtrusive demand for recognition and also the temporal nature of this encounter. It is '[...] as though theatre confronts the beholder, and thereby isolates him, with the endlessness not just of objecthood but of time'.[106] Instead of valuing the crucial role that time plays in the experience of Minimal art – the viewer circulates around the sculpture, perceiving its Gestalt in a sequence of points of view – Fried believed the viewer's important encounter with the Modernist work occurs outside of time. Just as Modernist art exists in an ideal space, its experience is ideal: the spectator sees the work and, like Kant's viewer in the *Critique of Judgement*, is 'forever convinced by it'.[107] Fried describes an exalted moment of recognition – of pure 'presentness' – removed from the mundane encounters of everyday life. The problem with Minimal art is that it destroys this pure recognition, relocating the viewer in real time and space. 'Art and Objecthood' was lambasted by numerous writers for its unapologetic idealism, even though Fried's claim that presentness is only a passing sensation – and one rarely felt – suggests that doubt, not pure conviction, had become the new ground for aesthetic experience in the 1960s.

1967–79 Canonization/Critique

During the late 1960s and mid 1970s, Minimalism acquired an international profile. The Minimal sculptors received one-person shows at such major institutions as the Whitney Museum of American Art, the Solomon R. Guggenheim Museum (both in New York), the Hague Gemeentemuseum and the Tate Gallery, London. Jo Baer, Robert Ryman, Brice Marden and Robert Mangold were also the subject of important mid-career retrospectives at a number of major international museums.[108] The assimilation of Minimal art by the museum and blue-chip gallery marked the passing of its avant-gardist phase.[109] In the process of editing his Minimal Art anthology, which was published in 1968, Battcock lamented that the museum had 'take[n] art away from us' by transforming Minimalism into an art historical movement. Indeed, Eugene Goossen, curator of 'The Art of the Real: USA 1948–1968' which opened at The Museum of Modern Art, New York, and toured to the Grand Palais, Paris, Kunsthalle,

Zurich and the Tate Gallery, London, provided an exalted pedigree for the Minimalists. He juxtaposed works by Carl Andre, Robert Morris and Frank Stella with those of such prominent figures as Georgia O'Keeffe, Ellsworth Kelly, Jackson Pollock and Barnett Newman, thus positioning the younger artists within the narrative of American twentieth-century art history. By so doing he laid claim to an exclusively American artistic phenomenon, observing that the younger artists were the latest avatars of an 'American' impulse to confront 'the experiences and objects we encounter every day'.[110]

Critics had a field day assessing the show. The French writer Marcelin Pleynet, reviewing the installation of 'The Art of the Real' at the Grand Palais, Paris, asked how the notion of the 'real' applied to such diverse practices (O'Keeffe's figuration and Judd's cubes made a strange pair), and why it was that American artists had a greater purchase on the representation of concrete experience.[111] In a biting review of the New York show, Philip Leider, editor of *Artforum*, attacked the

naiveté of Goossen's conception: to present the optical canvases of Noland and Louis side by side with Judd's and Morris' objects was tantamount to a total unawareness of the recent debates between Modernists such as Michael Fried and literalists such as Donald Judd.[112]

Although no longer avant-garde, Minimalism's impact upon subsequent work was considerable. In 1968 the critic Robert Pincus-Witten coined the term 'post-Minimalism' to describe this expanding field of activity that followed in the wake of Minimalism and included Conceptual and process art. As Pincus-Witten suggested, Minimalism's use of factory production and repeated modular forms had led to the serial Conceptualism of Bochner, LeWitt and Graham. But the literalist object was also a springboard for the material process art developed by Eva Hesse, Barry LeVa, Robert Morris, Bruce Nauman, Alan Saret, Richard Serra, Robert Smithson and Keith Sonnier.[113] (Carl Andre's scatter works had destroyed the Gestalt of Minimalism as early as 1966.)

Robert Morris, who went on to become a leading figure of post-Minimalism, argued in 'Anti-Form', published in *Artforum*, New York, in April 1968, that the new sculpture was both an extension and a subversion of the Primary Structure.[114] He notes that the Minimal object jettisoned relational arrangement, making the work's construction explicit. In revealing materials as materials, however, Minimal art did not go far enough. Minimalism's imposition of geometry or serial logic enforced a separation of matter and idea, an order 'operating beyond ... physical things'. Morris argues that the simple act of making is sculpture's concern; the finished object is beside the point. Where LeWitt and Bochner revealed the conceptual underpinnings of Minimal art, Morris proposes a sculpture of pure matter, apparently purged of ideas. He advocates a more bodily relationship to materials – Jackson Pollock and Morris Louis, who dripped and poured paint directly from the tin, are his models – and in this respect 'Anti-Form' marks a return to the process concerns of his *Box*

Ellsworth KELLY Painting for a White Wall, 1952
Kenneth NOLAND And Half, 1959

with the Sound of its Own Making and earlier performances. Morris recommends soft materials – felt, threadwaste, earth, clay and grease – in place of hard metals, casual or chance procedures – piling, throwing, loose stacking, hanging – instead of Minimal preplanning. In his felt works of the late 1960s and early 1970s, evenly spaced incisions in the fabric recall Minimalism's serial methods, yet there is no clear organization as the cloth had been left to tumble arbitrarily to the floor.

Morris' transformation was dramatic but hardly unique. Many of the figures associated with Minimalism moved in new directions or developed concerns implicit in their previous work. Sol LeWitt's development of the wall drawing in 1968 led to a near-complete 'dematerialization of the object', a bare representation of the idea, or concept, marked out in faint pencil. Marden explored lavish, polychromatic combinations in his *Grove Group* (1973–76) and lintel paintings (1979–84), replacing his earlier, sober palette with rich

blues and greens, and vivid reds and yellows. Humphrey abandoned monochrome painting; Novros moved from the shaped canvas to work directly on the wall. Baer produced large, rectangular reliefs decorated with illusionistic geometries before abandoning abstraction altogether. Truitt replaced the bulky forms of her early work with tall, thin columns. Bell, investing in a larger vacuum-coating machine in 1968, developed increasingly elaborate installations of free-standing glass walls. Andre explored a looser distribution of matter in such works as *Joint* (1968), a sequence of bales of hay executed at Windham College in Vermont, as well as a site-specific earthwork, *Stone Field Sculpture* (1977), at Hartford. Flavin expanded his fluorescent syntax, encompassing whole galleries or corridors with intricate arrangements of polychrome lamps. Judd also focused increasingly on the setting of his work, developing site-specific projects (for the 1971 Guggenheim International and the Pulitzer Collection in St Louis) and long-term art installations, begin-

ning with his own loft building in SoHo. As the period of 'High Minimalism' came to a close in the late 1960s and other trends came to the fore – post-Minimal sculpture, Conceptual art, earthworks and site-specific installation – the Minimal artists responded to new developments in distinctive ways, and indeed in some cases were responsible for them (LeWitt was at the forefront of Conceptualism; Andre and Morris of post-Minimalism). Although they still continued to produce Minimal-type work, Andre, Bell, Flavin, Judd and LeWitt were not immune to outside influences. As they explored other avenues during the 1970s, their practices remained innovative and relevant.

The museum acceptance of Minimalism and the emergence of post-Minimalism and Conceptualism coincided with the politicization of the New York art world in the late 1960s. Many of the Minimalists became involved in anti-war and urban politics. Judd, along with his then-wife Julie Finch, was active in the War Resisters' League in 1968 and later in the

Lower-Manhattan Township, an advocacy group that successfully fought the destruction of SoHo by insensitive city planners, leading to the area's designation as a historical and artists' district in 1973. Andre was an original member of the Art Workers Coalition, an activist group founded in 1969 and dedicated to promoting artists' rights, whose protests against the curatorial and financial practices of The Museum of Modern Art and other museums led to a critical analysis of a capital-driven art world. He and LeWitt were among the line-up of presenters at the Speak Out on artists' rights held by the Art Workers Coalition at the School of Visual Arts during the spring of 1969, while Morris, as the group's president, led the 1970 Art Strike on the steps of the Metropolitan Museum of Art, part of a city-wide protest against the war in Vietnam that closed down museums across New York City.

In an interview with critic Jeanne Siegel in 1970, Andre offers a trenchant critique of the contemporary museum.[115] He notes that museum boards in the US consist of wealthy trustees whose taste dictates what is shown (often overlapping with work they themselves collect); that the museum claims to show work on the basis of quality, but this quality is determined by the work's economic value; and that artists (who are rarely trustees) have little say in how the museum is run. Furthermore, Andre questions the supposedly apolitical nature of museums, remarking that they are run by the 'same people' who had devised American foreign policy during the Cold War and Vietnam war era. Siegel challenges Andre's Marxist claims, noting that he sells his works to wealthy collectors and enjoys the support of galleries and museums. Andre, however, makes no apologies for commodifying his work: as an artworker living in a capitalist economy, he is responsible to himself, and must survive through the sale of his labour. Whether or not his work resists the commodity system is not an issue.

In fact, the assimilation of Minimal work into the art and museum establishment was an issue for other observers committed to leftist politics. The political involvement of

Andre, Judd, LeWitt and Morris notwithstanding, the Minimal artists were increasingly associated with the Establishment.[116] As Object art became commodified, younger leftist critics and artists championed ephemeral, 'de-objectified' post-Minimal and Conceptual practices that appeared to resist commodification far better than Judd's elegant boxes or Andre's steel and copper plates.

Although the integration of Minimalism seemed a *fait accompli*, the actual reception of the work during the 1960s and 1970s was more complicated. The most obvious example of the enormous public resistance to Minimal work was the so-called 'Bricks Controversy' that developed around the Tate Gallery's purchase of Andre's sculpture *Equivalent VIII* (1966) in 1976. Seized upon by the British and international press, the acquisition of this work, consisting of 120 identical fire bricks temporarily arranged into a rectangular solid, quickly devolved into a scandal. As critics debated whether Andre's pile of bricks could be considered art, tabloids tweaked the

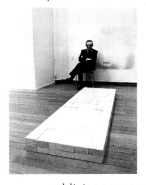 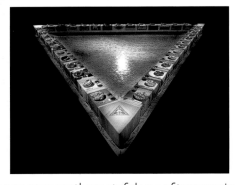

public's anger over an apparently wasteful use of taxpayer's money.[117] Even today, Minimalism represents a popular conception of an elitist art form inaccessible to the common viewer. The pillorying of works by Robert Ryman and Ellsworth Kelly on episodes of the American television news magazine *60 Minutes*, or the pseudo-aesthetic debates of Yasmina Reza's recent play *Art*, in which three men fight over a white monochrome, point to the anxiety of a public afraid of having the wool pulled over its eyes.

With the emergence of feminism in the early 1970s, a new analysis of Minimalism developed. Artist Judy Chicago's autobiography *Through the Flower: My Struggle as a Woman Artist* (1975) is the *locus classicus* of this turn in Minimalist discourse.[118] Her early sculptures, such as *Ten Part Cylinders* (1966) and *Rainbow Pickets* (1966), were built on Minimal-type systems of geometric shape, progressive dimension or interchangeable arrangements of units. Although she received some acclaim for these works, Chicago was never

comfortable with Minimalism. In her autobiography she presents geometric abstraction as something she had to discard. But her account of her engagement with Minimalism is more complex than it initially seems. On the one hand, she characterized Minimalism as a 'male-oriented form language'. Working in a Finish Fetish mode allowed her to explore her 'masculine' side: her assertiveness, her strength, her ability to use industrial tools (Chicago described being the sole woman enrolled in an autobody class). On the other hand, Minimalism represents an absence of gender. The standard geometries, uninflected surfaces and contentlessness of the new sculpture allowed her to mask her gender. In the chauvinistic art world of the 1960s, this was no small thing. For Chicago, learning to make such work was – at least initially – liberating.

Wielding a spray gun or saw like a man, Chicago was able to transcend fixed gender roles, but at a cost. She observed that the gender 'neutrality' of pure abstraction is hardly genderless. The lingua franca of mid 1960s art, Minimalism is 'male-oriented' precisely because it erases gender. Repressing female subjectivity, or any subject matter whatsoever, it affirms a sexist status quo.

In Chicago's narrative, female identity is rediscovered only through its sublimation; the restoration of a 'female' iconography requires Minimalism's repression in turn. She describes how three apparently abstract acrylic domes of 1968–69 subversively allude to female anatomical parts, as well as the classic nuclear family of mother, father and child. The open-ended pastel octagons of the *Pasadena Lifesavers* series (1964), symmetrically arranged in quadrants, refer to wombs and vaginas, yet still mask their content. During the early 1970s, as a result of her involvement with the Feminist Art Program, University of California at Fresno, as well as with Womanhouse, a co-operative women's art space in Los Angeles, Chicago developed a more explicit 'central core' iconography. In her best-known project, *The Dinner Party* (1974–79), erotic imagery and textual inscription, as well as traditionally 'female' handicrafts such as sewing and ceramics, are in direct opposition to the abstract, geometric, industrial Finish Fetish aesthetic. Chicago arrived at a feminist idiom only after having worked through the precepts of California Minimalism.[119] In this respect, her project reflects a larger tendency of early feminist practice to infuse the Minimal and post-Minimal idioms with marks of female subjectivity during the 1970s.[120]

Carl ANDRE Equivalent VIII, 1966
Judy CHICAGO The Dinner Party, 1974-79

While some writers developed social and feminist readings of Minimalism, others explored its philosophical character. Annette Michelson's important catalogue text for Robert Morris' 1969 retrospective at the Corcoran Gallery of Art in Washington, DC, makes the claim that Morris' work enacts a rupture with Modernist aesthetics.[121] Her analysis focuses on a divide between two modes of perception: the instantaneous, ideal aesthetic encounter described by Fried in 'Art and Objecthood' versus the literal spectatorship outlined by Morris, which transpires in real time and space. Where the Modernist work aspires to transcend its materiality, Morris' sculpture is merely itself, 'apodeictic' (self-evident and demonstrable). What is more, it heightens the viewer's sense of him or herself in the act of perceiving. A literalist thing existing in the same space as the beholder, it fosters awareness of oneself as inextricable from other objects and persons. This sense of co-presence, as Michelson describes it, is a phenomenological notion derived from Merleau-Ponty,

Joseph KOSUTH One and Three Chairs, 1965

Douglas HUEBLER Site Sculpture Project Variable Piece No. 1, New York City, 1968

who argues that we come to know ourselves as sentient beings in relation to our daily surroundings.[122] As a phenomenological practice, Morris' art solicits the viewer into a direct and protracted encounter, undermining the ideal aesthetic realm and transcendental immediacy fostered by the Modernist work. Although Fried deprecates this dissolution of boundaries as theatrical, Michelson values Morris' art precisely because it transgresses Modernist protocols.

'Epistemological firstness', a notion developed by the American pragmatist philosopher Charles Sanders Peirce at the turn of the century,[123] also enters her discussion. According to Peirce, experience is different for each individual, and the knowledge gained from that experience leads to an ever-changing and wholly personal understanding of 'truth'. Experience produces different kinds or degrees of knowledge. 'Firstness' denotes the most immediate sensual impressions – a glance or a touch. 'Secondness' is the recognition that follows this encounter, the awareness that one has

seen or touched. Michelson equates firstness with Modernism's aesthetic of immediacy or pure presentness, while implying that Morris' art produces a secondary awareness, a heightened self-consciousness.

In 1973 Rosalind Krauss traced the after-effects of Minimalism in two strands of recent practice in the essay 'Sense and Sensibility: Reflection on Post '60s Sculpture'.[124] The first strand leads from Minimalism to certain post-Minimal activities such as process art or serial-based Conceptualism, as in the felt works of Morris and the mathematical schemas of LeWitt and Bochner. The second is a clear rupture with Minimalism in the form of a language-based Conceptualism (as in the work of Joseph Kosuth, Douglas Huebler and On Kawara, which consists of a linguistically construed declaration of intent such as Kawara's 'I am still alive'). She explains this divide as an opposition of two models of subjectivity. The declarative acts and concepts of language-based Conceptualism reflect a faith that we truly mean what we say, and that the words we use to represent our thoughts are able to convey them with perfect transparency. Kosuth's seemingly radical notion of Art-as-Idea-as-Idea restores a sort of Cartesian ontology, the retrograde belief that the artist is capable of clearly expressing his or her 'ideas'.[125] Krauss, citing the late writings of the early twentieth-century philosopher Ludwig Wittgenstein, argues that we are never masters of our intentions, for we can only formulate our thoughts within socially given systems of representation. Minimalism and practices influenced by Minimalism locate the self in the realm of public language and experience. The serial art of Judd and Andre is not generated by a rational, subjective mind, but by pre-given mathematical formulas. Similarly, in Morris' work, perception is a response to the external world, not private and self-determined. In the years to come, this new notion of selfhood described by Michelson and Krauss as public not private, contingent not whole, would be characterized as Postmodern, as would Minimalism as well.

1980–present Recent Minimalism

Towards the close of the twentieth century, as the artists associated with Minimalism pursued their own paths even more

independently, the differences between their practices became more pronounced. Some remained faithful to the methods they devised during the 1960s; others expanded, or even revised the concerns of their early work. Internationally renowned, with vastly improved financial resources through the support of foundations, museums, galleries and collectors, the most prominent Minimalists gained the freedom to work with an expanding array of materials and techniques, and on a much greater scale.[126] As their work became increasingly monumental, the 1960s notion of Minimalism as a spare, 'reductive' art wore thin.

In the decade and a half before his death in 1977, Dan Flavin designed increasingly complex installations.[127] At the Dia Foundation in Bridgehampton, New York, he installed a line of fluorescent barriers that traversed a long room. Each wall was a densely packed field of vertical lamps arranged according to complementary colour schemes. As the viewer moved from one barrier to the next (from left to right or right to left), a new, dazzling arrangement cancelled the optical impression of the previous one. A second row of barriers stood back to back with the first; their glow penetrated the gaps between each wall. Where Flavin's earliest work focused attention on a few lamps, the Dia show set up complex polychromatic combinations experienced as a sequence of views, each causing a retinal overload.

Sol LeWitt's later work has also grown increasingly elaborate. The irrational, democratizing impulse of his early drawings – works that could be made by anyone – has given way to extensive planning. Trained assistants execute each work with great care. At times during their creation LeWitt will modify the result: the balance of concept and outcome tips in favour of formal resolution. This return of subjective decision making may seem to contradict the aims of his earlier work, but LeWitt has argued that 'one cannot rule anything out. All possibilities include all possibilities.'[128] Where his early projects could exist solely as ideas without having to exist in the world, LeWitt's later works rely on a more bodily impact. The extraordinarily massive, breeze block ziggurats and towers he began to produce in the 1980s suggest a dramatic turn from the 'dematerialized' aesthetic of his 1960s work.

A number of artists, including Carl Andre, Donald Judd, John McCracken, Robert Mangold, Agnes Martin, Robert Ryman and Anne Truitt, further refined their Minimal styles during the 1980s and 1990s. Carl Andre has continued to work with arrangements of repeated identical units, incorporating an expansive selection of materials such as acrylic, plastic, poplar wood, white gas-beton blocks, blue Belgian limestone and red Scottish sandstone. Gathered from local quarries and factories near where the exhibitions are held, these materials have given rise to a remarkably diverse variety of shapes within Andre's characteristic horizontal format which, developed in such works as *Lever* and *Elements I–VIII* in 1966, radically transformed the nature of sculptural syntax. As in those works, identical units lie on the floor in temporary piles which, arranged by the artist, are held in place by gravity alone.

Anne Truitt has continued to explore the columnar format that she developed in earnest in the late 1960s, although her later sculptures are tapered in shape, with even more complex colour arrangements. *Breeze* (1980) is a tall, thin column with stripes of mint and forest green, white and pale blue bracketing a central band of pale yellow. The recent *Elixir* (1997), with different combinations of pink, fuschia, yellow and green on each of the four sides, cannot be seen in one glance, but only in a sequence of views. Her journals, the first of which, *Daybook*, was published in 1982, make clear her belief in the evocative use of colour and shape. Records of daily life, they combine reflections on her art and its reception with more practical meditations.[129]

John McCracken has also sought a lighter touch in his later work. His *Four Part Plank* (1984) divides his weighty planks of the 1960s into several thin beams; reliefs like *Neon* (1989) and *Flame* (1990) hover against the wall. Robert Mangold's *Frame Paintings* (1983–86), *X Series* (1980–82) and *Attic Series* (1990–91) continue to explore the nuanced relations of figure, painted surface, the literal shape of the canvas and the wall developed out of his early paintings. Agnes Martin, in her late eighties, still works in graphite and acrylic washes, producing spare canvases made up of faint horizontal bands. The retrospective of Martin's work at the Whitney Museum of American Art, New York, in 1992, as well as Robert Ryman's one-person show at the Tate Gallery, London and The Museum of Modern Art, New York, in 1993–94, traced the continuity of a pared-down abstraction into the present day. Indeed, it is perhaps Ryman's work that has most come to epitomize a Minimal practice of 'reduction' for contemporary audiences. His work of the 1980s, executed on Lumasite, Plexiglas and aluminium, with exposed bolts and fasteners, reduced painting to its bare bones, removing subjective

marks or excess of any kind. (Ryman's more recent canvases have restored a methodical brushwork.) As Yve-Alain Bois has argued, Ryman's art is an asymptotical reflection on painting's limits, an endgame endlessly deferred.[130] Exploring the monochrome's considerable formal potential, Ryman forestalls indefinitely Judd's conclusion that painting is no longer a viable medium.

The later Judd became involved in a remarkable variety of pursuits. In many ways he remained absolutely consistent, developing objects that were only slight modifications of his early works, or new kinds of boxes and reliefs meticulously executed in European workshops. His interest in installation, which reached an apogee in the 1980s and 1990s, was evident in the careful arrangement of objects in his earliest shows. Now Judd became absorbed in the problem of display as such. Attentive to the detail of materials and production techniques, he was understandably concerned when his works were mishandled during transportation or carelessly

Jeff KOONS New Hoover Convertible, 1980
Haim STEINBACH Untitled (walking canes, fireplace sets) No. 2, 1987
Peter HALLEY CUSeeMe, 1995
Frank STELLA River of Ponds, 1968

 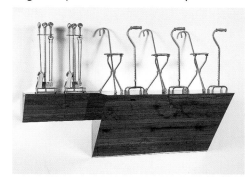

installed. As he observes in 'On Installation' (1982),[131] most displays of contemporary work are 'unsuitable', and this problem can only be ameliorated by the permanent and semi-permanent installation of works. And this is what he did, beginning with the loft building he purchased in SoHo in 1968. At Marfa, a town in western Texas to which he moved in 1973–74, Judd converted a suite of former aeroplane hangars into his personal domicile and exhibition space. His Chinati Foundation, initially established in conjunction with the Lone Star and Dia Foundations,[132] developed permanent installations devoted to John Chamberlain, Claes Oldenburg, Ilya Kabakov and Dan Flavin, as well as long-term shows of work by Roni Horn, Richard Long and Agnes Martin. Chinati includes a large Judd installation of 100 anodized aluminium boxes in two former artillery sheds. Each building is lined with four-paned, square windows through which the natural light casts a dizzying array of shadows and reflections on the sculpture and surrounding architecture. The adjacent fields house

an impressive installation of concrete works developed by Judd during the early 1980s.

As Minimalism evolved during the 1980s, younger artists took an interest in the work of figures like Andre, Flavin and Judd. The so-called Neo-Geo/Cute Commodity artists – Jeff Koons, Haim Steinbach and Peter Halley – infused the vocabularies of Minimalism with 'low' cultural associations. In the work of Koons and Steinbach, the Minimal box was divested of formal complexity and recast as a support for commodity display. Koons stacked vacuum cleaners in transparent cubes lit by fluorescent lights, recontextualizing banal readymades within debased Juddian and Flavinesque forms. Similarly, Steinbach arranged boxes of soap, lampshades and other store-bought items on rectangular reliefs. Equating the repeated geometries of Minimal art with the most mundane commodities, Koons and Steinbach exposed the Dadaist underbelly of Minimalism, its presentation of the readymade unit as fine art. Purely abstract, Minimal work resisted the

mass culture that Pop art purportedly embraced, yet Koons and Steinbach explicitly related Minimal practice to the postwar system of production and consumption from which it emerged.

The painter and critic Peter Halley equates Minimalism with the emergence of Postmodernism in 'Frank Stella ... and the Simulacrum'.[133] Followings the writings of the French cultural critics Guy Debord and Jean Baudrillard, among others, he describes the shift into Postmodernism as an evolution in technology and modes of production in the 1960s. Where Koons and Steinbach relate the Minimal object to the mass-produced commodity developed during those years, Halley links Stella's work to 'the informational culture of the computer and electronics, the interstate highway system, the space programme and satellite reconnaissance'.[134] Stella's *Aluminum Paintings* (1959–61) announced this transition into a post-industrial matrix. Where the *Black Paintings* (1958–59) still resonate with Abstract Expressionist

pathos, the *Aluminum* works are 'cool, even, science fictional'; they are thus not 'pure' painting but reflect a more general cultural logic. The jogs on the sides cause the silvery stripes to shimmer and 'circulate' (Halley compares them to motorway lanes). For Halley, Stella's later work is the ultimate expression of Postmodern sensibility. The Day-Glo *Protractors* (1967–69) and illusionistic metal reliefs that Stella developed in the 1970s and 1980s convey the sensation of Hyperspace, the unreal environment described in Baudrillard's writings: the space of the highway and TV screen, of artifice and spectacle. In hyperspace, 'everything is arranged to maximum effect. Here, like at Disneyworld, Las Vegas or the shopping mall, everything is arranged to entice, seduce and amaze.' No doubt Halley is describing the motivation behind his own Day-Glo geometric paintings, whose allusions to computer cells and conduits point to a circulation of information and energy flow. Even so, his analysis remains compelling, for it offers a new interpretation of Stella's readoption of illu-

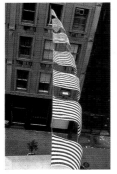

sionism and abandonment of stripe painting during the 1960s and 1970s. Usually described in purely formal terms, Stella's later career emerges in Halley's account as the progressive embrace of a spectacular Postmodern aesthetic.

In his 1986 essay 'The Crux of Minimalism', Hal Foster also identified Minimalism with the shift into Postmodernism, locating it within a genealogy of 'neo' avant-garde practice from the 1960s until the present day.[135] For Foster, the recuperation of this legacy was an urgent task during the neo-conservative Reagan/Thatcher years, when 'a general trashing of the 1960s is used to justify a return to tradition'. During the 1980s Minimalism had become a focus of this trashing, a 'rule-bound' foil for a new pluralism.[136] But, according to Foster, it is the return of figuration and gestural brushwork in the art of the 1980s that is actually regressive. The new generation of neo-Expressionist artists, revitalizing national and regional figurative painting styles, ignored Minimalism's radical critique of illusionism and subjective

expression in favour of older artistic forms. As other leading art critics like Benjamin Buchloh, Douglas Crimp and Craig Owens also argued, this restoration of traditional painterly formulas fed the expanding art market's demands for time-honoured commodity forms. In the Bright Lights, Big City, affluent ambience of 1980s New York, neo-Expressionist painting was 'hot'. This triumph of unbridled feeling and subject matter – ratified by collectors and museums – suggested that Minimalism's relevance had severely diminished since the late 1960s.

According to Foster, however, Minimalism establishes the framework for another kind of Postmodernism: a critical Postmodernism of 'resistance'. Much Minimal work challenges the Modernist dictum of medium-specificity; it introduces factory production into formalist art, collapsing the distinction between the Modernist and Dada traditions, between a hand-made, high art and everyday objects. Minimalism's reinscription of the readymade is thus not a

'hollow' repetition; rather, it makes the legacy of the pre-war avant-garde conscious for subsequent practices, disturbing Modernism's repression of this legacy. Even more, Minimalism disrupts the ideal space and temporality of Modernist sculpture, as Michelson also suggests. Revealing the exhibition space as material and actual, it opens up a critical reflection on the museum and gallery system developed by artists like Daniel Buren and Michael Asher during the late 1960s and 1970s. Their work of this time disrupted the very architecture of the gallery, drawing our attention to both the physical and ideological constraints of the exhibition of contemporary art.[137] Finally, Minimalism's critique of the expressive author of Modernism points to the critical Postmodernism of artists such as Barbara Kruger, Sherrie Levine and Cindy Sherman, whose work denies the fiction of a centred self. The recovery of this 'resistant' legacy is complex, necessitating a detailed genealogy of Minimal discourse. Foster surveys the arguments of Michael Fried, Clement Greenberg, Donald Judd, Robert Morris and Rosalind Krauss, clearly elucidating the nature of

Minimalism's rupture with Modernist aesthetics and its impact on later artists.

Foster's is a dialectical argument, suggesting that Minimalism's rupture with Modernism is not complete. A crux is a cross, a burden or transition, and in certain respects Minimalism remains tied to what it rejects. Minimalism 'threatens' and 'breaks' with Modernist practice, but it also 'consummates it', Foster observes.[138] Its introduction of the readymade and literal experience into fine art undermined Modernist values, even though artists like Judd and Flavin conceived these departures as formal innovations. Even more, Minimalism's repression of subject matter perpetuated Modernism's formal bias: the pure, phenomenological character of Minimal perception 'treated the perceiver as historically innocent, sexually indifferent'.[139] Foster suggests that Minimalism looks forward to the Postmodernist practices of Levine and Kruger, yet it also remains beholden to the Modernist values it rejects.

Rosalind Krauss, who had been suspicious of Minimal practice during the 1960s, emerged as one of its most thoughtful supporters during the 1970s. She came to see Minimalism and work influenced by Minimalism as advanced because it undermines the fiction of a private self. In her 1990 essay, 'The Cultural Logic of the Late Capitalist Museum', the doubt of her earlier writing has returned.[140] Krauss no longer sees the subject as coming to know itself as embodied in respect to the Minimal work; rather, she discusses how present-day installations of Minimal art have deprived the work of its ability to provide that phenomenological encounter. The contemporary museum has created 'oddly emptied yet grandiloquent' spaces to accommodate Minimal work. Placed in these vast, open interiors, the stolid object of Morris or Judd is now a component of an intensely visual spectacle. Flavin's works, in particular, take on a 'disembodied glow'. In the new installation, space is not 'real' but hyper-real; 'simulacral experience' replaces 'aesthetic immediacy'. The lone phenomenological spectator of the 1970s is reconceived as a Postmodern viewer in search of bedazzling visual entertainment.

Peter Halley had equated the visual glow of Stella's paintings with a Postmodernist culture of spectacle. Krauss connects this emergence of art-as-spectacle with particular individuals and institutions, specifically Giuseppe di Panza, a leading collector of Minimal work, and the Guggenheim

Museum, which recently purchased Panza's holdings. As Krauss suggests, it is Panza who realized the spectacular potential of Minimal display in installations at his villa and former stables at Varese, Italy. Isolated in a reflective white room, a single Flavin work loses all semblance of materiality, becoming pure luminosity. The Guggenheim Museum's purchase of Panza's collection is hardly coincidental. As the Guggenheim opens up branches around the globe, becoming a kind of international cultural conglomerate, it has found in Minimalism – in Flavin's lights, Andre's fields of copper and tin, and Judd's gleaming boxes – an art form perfectly suited to the perceptual demands of present-day audiences. Recast within the spaces of the Postmodern museum as visual entertainment, an art that once resisted mass culture and its virtual pleasures has ushered in, or come to exemplify, this experience. Krauss notes how the seeds of this transformation lay dialectically within Minimal practice itself. 'By prizing loose the old ego-centred subject of traditional art, Minimalism unintentionally – albeit logically – prepares for that fragmentation.'[141]

Krauss' text signals the return of a social critique of Minimalism that continued unabated during the 1990s. Perhaps the most controversial of these texts was Anna C. Chave's 'Minimalism and the Rhetoric of Power' (1990).[142] Chave characterizes Minimal art as the very 'face of capital, the face of authority, the face of the father'. Because Minimal art was developed largely by men, it embodies an aggressive masculinity; the 'cold', industrial forms of Judd, Flavin and Andre dominate the viewer, forcing her to submit to patriarchal control. 'The Minimalists perpetrated violence through their work – violence against the conventions of art and against the viewer.'[143] Chave aligns notions of gender and form into binaristic polarities, equating maleness with hard shape, order, factory production and aggression (hence 'femaleness' with soft form, disorder, organicity and passivity). What is more, she compares Minimalism's purportedly masculine geometries with the colonnades of classical and Nazi architecture, even though the serial art of Stella and Judd seeks to avoid hierarchy and rational order. The specific historical and aesthetic contexts that generated these form languages – ancient Paestum, 1930s Berlin and 1960s New York – are subsumed into a continuous narrative of male aggression.

Although problematic in numerous respects, Chave's critique struck a chord during the early 1990s, when younger artists also turned a critical eye on Minimalism's geometric

forms, serial syntax, anti-subjective procedures and revelation of the gallery space. In the work of Charles Ray, Felix Gonzalez-Torres, Roni Horn, Janine Antoni and others, the formal codes of Minimal art have become vehicles of expression and content, much against their original use.

The artist Felix Gonzalez-Torres converted such classic Minimal forms as the corner triangle of Morris, the Andre floor plane or Judd box into piles of sweets to be consumed by a viewer, or a stack of posters to be disseminated and taken home. Supporters of Gonzalez-Torres argued that he had replaced the supposedly cold, unforgiving aesthetic of Minimalism with one of 'generosity and mutual exchange'.[144] Defying Minimalism's anti-symbolic stance, Gonzalez-Torres' works are vaguely allusive; some suggest a quite specific content. His *Untitled* (*21 Days of Bloodwork-Steady Decline*) (1994), a sequence of identical drawings on graph paper in identical frames, is a striking reversal of Minimal technique. Though it mimics the serial grid drawings of

confrontational aspect of Ray's sculpture recalled his earlier performance, which also used the purportedly neutral Minimal Box as a means of unsettling the spectator. In *Clock Man* (1978), the artist's legs were suspended from a box nailed to the wall; his torso and head were hidden behind the clock's face. In another early work, Ray crouched in a wooden box and waved a red flag through a hole in the top.[145] More recently, Janine Antoni used the Minimal cube as a springboard for feminist critique. Her *Gnaw*, exhibited at the 1993 Biennial Exhibition at the Whitney Museum of American Art, New York, were enormous cubes of chocolate and lard. Raw teeth marks indicated that Antoni herself had masticated these blocks of fat; pressing the chocolate into moulds, she exhibited the resulting 'candies' in heart-shaped boxes in vitrines. Antoni's unforgettable piece thematized contemporary female obsessions with overeating and dieting, beauty and thinness, and the masochistic longing for love that propels such obsessions.

 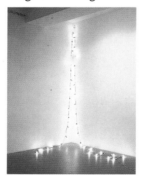 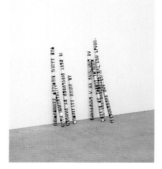

Charles RAY Oh! Charley, Charley, Charley ... , 1992
Felix GONZALEZ-TORRES Untitled (Ishia), 1993
Roni HORN When Dickinson Shut Her Eyes, No. 974, 1994
Janine ANTONI Chocolate Gnaw, 1992

Robert Ryman and Sol LeWitt, rather than documenting the process of drawing as such, the installation traces the decline of the artist's immune system during his battle with AIDS.

The impact of the AIDS epidemic may also be seen in a work by Gonzalez-Torres' colleague Roni Horn, *Gold Mats, Paired* (*For Ross and Felix*) (1995). Two paper-thin sheets of gold laid on the floor, Horn's sculpture recalls Andre's horizontal formats and use of elemental materials, yet its memorial dedication to Gonzalez-Torres and his lover, who both died of HIV, transforms the floor plane into a vehicle of mourning. Its allusion to supine bodies contests Minimalism's aversion to resemblance. Where Gonzalez-Torres and Horn changed the sculptural use of Minimal forms, the artists Charles Ray and Janine Antoni used them as props for performance. The Los Angeles-based Ray also produced a number of Minimal-type objects including *Ink Box* (1986), a cube with an open top filled to the brim with black ink, threatening to stain the unsuspecting viewer. The

Gonzalez-Torres, Horn, Ray and Antoni have perverted the forms of historical Minimalism for their own use. As curator Lynn Zelevansky has suggested, the overturning of Minimalist style by younger artists is equally a homage to the movement. Minimalism, she argues:

'has a place in the second half of the century akin to the one Cubism had in the first half. A high percentage of artists ... have worked with aspects of it ... deliberately violating it and creatively misunderstanding it.'[146]

Now firmly established as an essential lexicon of late twentieth-century art, Minimalism takes on new significance as subsequent generations of sculptors, painters, installation artists and performers continue to mine its forms. Of compelling interest to artists and critics over four decades, Minimalism continues to generate new controversies and uses; its relevance is unlikely to diminish. Whatever else you want to say about it, Minimalism matters.

1 The show was presented at the Julian Pretto Gallery, New York (1993). For a further discussion of the work, see Eva Meyer-Hermann, *Carl Andre Sculptor 1966–1996* (Krefeld: Kunstmuseen; Wolfsburg: Kunstmuseum, 1996) 282.

2 Tim Marlow, 'Interview with Carl Andre', *Tate Magazine* (Summer 1996) 39.

3 A wake 'as in the wake of a ship or funeral'. [From a telephone conversation with Carl Andre, 12 August 1996.]

4 Donald Judd, 'Complaints: Part I', *Studio International* (April 1969) 166–79; reprinted in *Donald Judd: Complete Writings 1959–1975* (Halifax: Nova Scotia College of Art and Design; New York University Press, 1975) 197–99.

5 Annette Michelson, 'Robert Morris: An Aesthetics of Transgression', *Robert Morris* (Washington, DC: Corcoran Gallery of Art, 1969) 13.

6 On this expansion see Clement Greenberg, 'The Jackson Pollock Market Soars', in *Clement Greenberg: The Collected Essays and Criticism*, IV (Chicago and London: University of Chicago Press, 1993) 107–14; Steven Naifeh, *Culture Making: Money, Success, and the New York Art World* (Princeton University Studies in History, 1976); Jennifer Wells, 'The Sixties: Pop Goes the Market', *Definitive Statements: American Art 1964–65* (Providence: Department of Art, Brown University, 1986).

7 The Lugano-based *Art International*, which published the early writings of Michael Fried, Rosalind Krauss, Lucy R. Lippard and Annette Michelson, was founded in 1956. *Arts Magazine*, established in the 1920s, published early writings by Gregory Battcock, Mel Bochner, Michael Fried, Dan Graham, Donald Judd, Sol LeWitt, Ursula Meyer and Robert Smithson. *Artforum*, founded in Los Angeles in 1962, relocated to New York by 1965 where it quickly established itself as an important venue of contemporary criticism and writings on Minimalism in particular, including texts by Mel Bochner, Dan Flavin, Michael Fried, Rosalind Krauss, Robert Morris and Robert Smithson.

8 Michelson, Rose and Judd studied art history at Columbia University with Meyer Schapiro, while Fried and Krauss completed doctorates in the Fine Arts Department at Harvard University. On the Harvard circle see Caroline Jones, *Modern Art at Harvard* (New York: Abbeville Press, 1985) 80–95; and Barbara Reise, 'Greenberg and the Group: A Retrospective View, Parts I and II', *Studio International* (May–June 1968) 254–57; 314–16.

9 See Reinhardt's collected writings, *Art as Art*, ed. Barbara Rose (Berkeley: University of California Press, 1975); Barnett Newman, *Selected Writings and Interviews*, ed. John P. O'Neill (New York: Knopf, 1990). On the significance of these artists during the 1960s, see Elizabeth Baker, 'Barnett Newman in a New Light', *ARTnews* (February 1969); Lynn Zelevansky, 'Ad Reinhardt and the Younger Artists of the 1960s', *American Art of the 1960s* (New York: The Museum of Modern Art, 1991) 16–38.

10 Sol LeWitt graduated from Syracuse University, New York; Anne Truitt studied at Bryn Mawr College, Pennsylvania; Carl Andre attended Phillips Academy in Andover, Massachusetts. Brice Marden and Robert Mangold, two painters associated with Minimalism, attended graduate school at Yale University in Connecticut.

11 His professor, Meyer Schapiro, introduced the young Judd to Thomas Hess, editor of *ARTnews*, launching Judd's career as an art critic. Donald Judd, unpublished interview with James Meyer (Marfa, Texas, 27 October 1991).

12 Carl Andre, 'Preface to Stripe Painting (Frank Stella)', *16 Americans* (New York: The Museum of Modern Art, 1959) 76.

13 Most of the classic texts of Minimalism were published by the 1960s, such as: Donald Judd's 'Specific Objects', *Arts Yearbook*, 8 (1965); reprinted in Donald Judd, *Complete Writings 1959–1975*, *op. cit.*, 181–89; Barbara Rose's 'ABC Art', *Art in America* (October–November 1965) 57–69; Bruce Glaser's 'New Nihilism or New Art: Interview with Stella, Judd and Flavin', originally broadcast on WBAI-FM, New York (February 1964); revised and published in *ARTnews* (September 1966); reprinted in *Minimal Art: A Critical Anthology*, ed. Gregory Battcock (New York: E.P. Dutton & Co., 1968) 148–64; Robert Morris' 'Notes on Sculpture: Part I', *Artforum* (February 1966); reprinted in *Minimal Art*, *op. cit.*; Mel Bochner's 'The Serial Attitude', *Artforum* (December 1967) 73–77; Robert Smithson's 'Entropy and the New Monuments', *Artforum* (June 1966); reprinted in *The Writings of Robert Smithson*, ed. Nancy Holt (New York University Press, 1979); *Robert Smithson: The Collected Writings*, ed. Jack Flam (Berkeley, Los Angeles and London: University of California Press, 1996); and Michael Fried's 'Art and Objecthood', *Artforum* (June 1967); reprinted in *Minimal Art*, *op. cit.*, 116–47.

14 The emergence of the notion of Minimalism during the 1960s is explored in my forthcoming book entitled *Minimalism: Art and Polemics in the 1960s* (New Haven and London: Yale University Press, 2000)

15 For Malevich, the 'zero degree' of painting was a dialectical notion that both implied the medium's demise and heralded its renewal. See Yve-Alain Bois, 'Malevich, le carré, le degré zéro', *Macula*, 1 (1976) 28–49.

16 The exhibition '5 × 5 = 25', held in September 1921 in Moscow, included works by Aleksandr Rodchenko, Varvara Stepanova, Lyubov Popova, Alexandra Exter and Alexander Vesnin. It announced the formation of a Constructivist group committed to the production of three-dimensional objects.

17 The implications of these terms were far more complicated, and in dispute, than my presentation suggests. See Margit Rowell, 'Vladimir Tatlin: Form/Faktura', *October*, 7 (Winter 1978) 83–108; Benjamin H.D. Buchloh, 'From Faktura to Factography', *October*, 30 (Fall 1984) 82–119; Maria Gough, 'In the Laboratory of Constructivism: Karl Loganson's Cold Structures', *October*, 84 (Spring 1998) 91–117.

18 See Christina Lodder, *Russian Constructivism* (New Haven and London: Yale University Press, 1983) 145–55.

19 See Buchloh, 'From Faktura to Factography', *op. cit.*

20 *Ibid.*

21 On the suppression of the Soviet avant-garde in the post-war period, see Benjamin H.D. Buchloh, 'Cold War Constructivism', in *Reconstructing Modernism: Art in New York, Paris, and Montreal 1945–1964*, ed. Serge Guilbaut (Cambridge, Massachusetts and London: MIT Press, 1990) 85–112. The influence of Constructivism on these artists is discussed in Carl Andre and Hollis Frampton, *12 Dialogues 1962–1963*, ed. Benjamin H.D. Buchloh (Halifax: Nova Scotia College of Art and Design, 1980) 23; 34; 37; Maurice Tuchman, 'The Russian Avant-Garde and the Contemporary Artist' in *The Avant-Garde in Russia 1910–1930: New Perspectives* (Los Angeles County Museum of Art, 1980) 118–21; and Hal Foster, 'Some Uses and Abuses of Russian Constructivism', in *Art into Life: Russian Constructivism: 1914–1932* (Seattle: Henry Art Gallery, University of Washington, 1990) 241–53; Hal Foster, 'The Crux of Minimalism', *Individuals: A Selected History of Contemporary Art 1945–1986*, (Los Angeles: The Museum of Contemporary Art; New York: Abbeville Press, 1986) 162–318.

22 See Camilla Gray, *The Great Experiment in Art: 1863–1922* (London: Thames and Hudson, 1962).

23 Robert Morris, 'Notes on Sculpture', *Artforum* (February/October 1966); reprinted in *Minimal Art*, *op. cit.* 222–35.

24 See Donald Judd, 'Malevich: Independent Form, Colour, Surface' in *Donald Judd: Complete Writings 1959–1975, op. cit.*, 211–15; and Donald Judd, 'On Russian Art and its Relation to My Work', *Donald Judd: Complete Writings 1975–1986* (Eindhoven: Stedelijk Van Abbemuseum, 1987) 14–18.

25 Ellsworth Kelly had solo exhibitions at Betty Parsons Gallery in New York in 1956, 1957, 1959, 1961 and 1963, and participated in such group exhibitions as '16 Americans' at The Museum of Modern Art, New York (1959) and 'Abstract Expressionists and Imagists' at the Solomon R. Guggenheim Museum, New York (1961). One of his monochrome polyptychs, *Gaza* (1952–56), appeared in a group show at the Green Gallery, New York (1963) alongside works by Judd, Morris and Stella. Judd remained unconvinced of its relevance, however, declaring Kelly's painting a 'fluke'. [See Donald Judd, *Complete Writings 1959–1975, op. cit.*, 112]

26 For Judd's views on Reinhardt see 'Specific Objects', *op. cit*. On the distinction between Reinhardt's position and that of the Minimalists, see Yve-Alain Bois, 'The Limit of Almost' in *Ad Reinhardt* (New York: The Museum of Modern Art, 1991).

27 '16 Americans', curated by Dorothy Miller at The Museum of Modern Art, New York (16 December 1959–14 February 1960). The show included J. De Feo, Wally Hedrick, James Jarvaise, Jasper Johns, Ellsworth Kelly, Alred Leslie, Landes Lewitin, Richard Lytle, Robert Mallary, Louise Nevelson, Robert Rauschenberg, Julius Schmitt, Richard Stankiewicz, Albert Urban and Jack Youngerman.

28 For a discussion of Stella's technique, see William Rubin, *Frank Stella* (New York: The Museum of Modern Art, 1971) 113 ff; Michael Fried, *Three American Painters* (Cambridge, Massachusetts: Fogg Museum of Art, 1965).

29 Andre, 'Preface to Stripe Painting (Frank Stella)', *op. cit.*

30 See John Cage, 'On Robert Rauschenberg, Artist, and his Work', *Silence* (Middletown: Wesleyan University Press, 1961) 99.

31 See Rubin, *Frank Stella, op. cit.*, 12–13.

32 Andre, 'Preface to Stripe Painting (Frank Stella)', *op. cit.*

33 Brenda Richardson, *Frank Stella: The Black Paintings* (Baltimore Museum of Art, 1976).

34 On the importance of the colour black in Beatnik culture during the late 1950s, see Todd Gitlin, *The Sixties: Years of Hope, Days of Rage* (New York: Bantam Books, 1987) 52. On the metaphysical implications of black in Abstract Expressionism, see Hubert Damisch, 'Mystery Paintings', *Les années 1950s* (Paris: Musée national d'Art Moderne, Centre Georges Pompidou, 1988).

35 See Richardson, *op. cit.*, 22; 26; 34; 36; 40; 44; 46; John D'Emilio, 'The Bonds of Oppression: Gay Life in the 1950s', *Sexual Politics, Sexual Communities: The Making of a Homosexual Minority in the United States, 1940–1970* (Chicago and London: University of Chicago Press, 1983) 40–56.

36 Donald Judd, 'In the Galleries: Frank Stella', *Arts Magazine* (September 1962).

37 Donald Judd, 'In the Galleries: Ralph Humphrey', *Arts Magazine* (March 1960); reprinted in Donald Judd, *Complete Writings 1959–1975, op. cit.* This review is one of Judd's first to distinguish the 'elder Purism' of earlier abstraction – Malevich, Mondrian, Albers – and the new American painting.

38 Dan Flavin, ' ... in daylight or cool white', originally presented as a lecture at the Brooklyn Museum School of Art (18 December 1964); Ohio State University School of Law (26 April 1965); revised and published in *Artforum* (December 1965); revised and reprinted in *Fluorescent light, etc. from Dan Flavin*, ed Brydon Smith (Ottawa: National Gallery of Canada, 1969) 14.

39 'The Art of Assemblage', curated by William Seitz, opened at The Museum of Modern Art, New York (2 October–12 November 1961), and travelled to the Dallas Museum for Contemporary Arts (9 January–11 February 1962); San Francisco Museum of Art (5 March–15 April 1962). This exhibition was a historical survey show and included works by 142 artists from ten countries. See William Seitz, *The Art of Assemblage* (New York: The Museum of Modern Art, 1961).

40 Flavin describes his first fluorescent work, *the diagonal of May 25, 1963* as 'a buoyant and insistent gaseous image which, through brilliance, somewhat betrayed its physical presence'. [Flavin, ' ... in daylight or cool white', *op. cit.*, 18.]

41 For a fine discussion of Judd's early work, see Roberta Smith, 'Donald Judd', in *Donald Judd*, ed. Brydon Smith (Ottawa: National Gallery of Canada, 1975) 6–15.

42 Judd, 'Specific Objects', *op. cit.*, 182.

43 *Ibid.*, 187.

44 *Ibid.*, 184.

45 On the interaction of Stella, Andre, and the photographer and filmmaker Hollis Frampton at this time, see Caroline Jones, *Machine in the Studio: Constructing the Postwar American Artist* (Chicago and London: University of Chicago Press, 1996).

46 Rhonda Cooper, 'An Interview with Carl Andre', *Carl Andre: Sculpture*

(The Fine Arts Gallery, State University of New York at Stony Brook, 1984). Stella's impact was more complicated, as Andre averred in the same context: 'Stella's influence on me was practical and profoundly ethical. What [Stella] demanded from himself and from those for whom he had respect was that an artist must discover between himself and the world that art which is unique to him and then to purge that art of all effects that do not serve its ends.'
In addition to inspiring Andre's anti-compositional method of stacking beams, Stella taught a deeply Modernist lesson: the pursuit of originality (Minimalism's anti-subjective drive did not preclude artistic ambition), and a Minimalist 'purging' of effects extraneous to the medium, a position the Modernist critic Clement Greenberg also advocated.

47 Andre's reading of Stella's method was mediated by another source, the Endless Column of Constantin Brancusi (1918), whose repeated, identical shapes particularly inspired the Ladders.

48 'My Pyramid has the cross section of Brancusi's Endless Column, but the method of building it with identical, repeated units ... derives from Stella.' [Cooper, 'An Interview with Carl Andre', op. cit.]

49 Phyllis Tuchman, 'An Interview with Carl Andre', Artforum, 8: 10 (June 1970) 56.

50 Mark Rothko and Adolph Gottlieb, 'Statement', the New York Times (13 June 1943); reprinted in Theories of Modern Art, ed. Hirschel Chipp (Berkeley: University of California, 1968) 545.

51 They were included in such key exhibitions of Minimalism as 'Black, White, and Gray' at the Wadsworth Atheneum, Hartford, Connecticut (1964), 'Primary Structures' at the Jewish Museum, New York (1966), and '10' at the Dwan Gallery, New York (1966).

52 Barbara Haskell, 'Agnes Martin: The Awareness of Perfection' in Agnes Martin (New York: Whitney Museum of American Art, 1993) 93–117.

53 Morris' intention was to topple the sculpture with the weight of his own body standing inside. However, during a dress rehearsal this proved to be dangerous, hence, during the actual performance he pulled it over with a string.

54 Robert Morris, 'Blank Form', 1960–61, in Barbara Haskell, Blam! The Explosion of Pop, Minimalism and Performance Art 1958–64 (New York: Whitney Museum of American Art, 1984) 101. Word pieces deleted by the artist from planned anthology, 1964.

55 Morris, 'Notes on Sculpture', op. cit.

56 Robert Morris had solo exhibitions at Green Gallery, New York (1964; 1965), Dwan Gallery, Los Angeles (1966), Leo Castelli Gallery, New York (1967). Carl Andre had solo exhibitions at Tibor de Nagy Gallery, New York (1965, 1966), Dwan Gallery, New York (1967). Donald Judd had a solo exhibition at Leo Castelli Gallery, New York (1966). Dan Flavin had solo shows at Kaymar and Green Galleries, New York (1964), and Kornblee Gallery, New York (1967). Sol LeWitt had solo shows at John Daniels Gallery, New York (1965), Dwan Gallery, New York (1966) and Los Angeles (1967). Anne Truitt had a second solo exhibition at Andre Emmerich Gallery, New York (1965). Larry Bell had solo exhibitions at Ferus Gallery, Los Angeles (1965), Pace Gallery, New York (1965, 1967), and a retrospective exhibition at the Stedelijk Museum, Amsterdam (1967). John McCracken had solo exhibitions at Nicholas Wilder Gallery, Los Angeles (1965, 1967), Robert Elkon Gallery, New York (1966, 1967).

57 In Bruce Glaser, 'Questions to Stella and Judd', in Minimal Art, op. cit., 158.

58 Alain Robbe-Grillet, For a New Novel, trans. Richard Howard (New York: Grove Press, 1965) 43.

59 Susan Sontag, 'Against Interpretation', originally published in Evergreen Review (1964); reprinted in Against Interpretation and Other Essays (New York: Farrar, Straus and Giroux, 1966; New York: Anchor Books/Doubleday, 1990) 3–14.

60 'Black, White, and Gray' was curated by Samuel J. Wagstaff, Jr for the Wadsworth Atheneum, Hartford, Connecticut, in 1964. It included: George Brecht, James Lee Byars, Jim Dine, Dan Flavin, Jean Follett, Robert Indiana, Jasper Johns, Ellsworth Kelly, Alexander Liberman, Roy Lichtenstein, Agnes Martin, Robert Morris, Robert Moskowitz, Barnett Newman, Ray Parker, Robert Rauschenberg, Ad Reinhardt, Tony Smith, Frank Stella, Anne Truitt, Cy Twombly, Andy Warhol.

61 Samuel J. Wagstaff, Jr, 'Paintings to Think About', ARTnews (January 1964).

62 Ibid.

63 Donald Judd, review of 'Black, White, and Gray', Arts Magazine (March 1964); reprinted in Donald Judd, Complete Writings 1959-1975, op. cit.

64 Judd, 'Specific Objects', op. cit., 181–89.

65 Rose, 'ABC Art', op. cit.

66 Ibid.

67 Yvonne Rainer elaborates these connections in 'A Quasi Survey of Some "Minimalist" Tendencies in the Quantitatively Minimal Dance Activity Midst the Plethora, or an Analysis of Trio A', in Minimal Art, op. cit., 263–73.

68 Lucy R. Lippard, 'New York Letter: Robert Morris', Art International, 46 (March 1965); David Bourdon, 'Robert Morris', Village Voice (18 March 1965).

69 Lucy R. Lippard, 'New York: Dan Flavin', Artforum, 52–54 (May 1964); and 'New York Letter: Dan Flavin', Art International, 37 (February 1965).

70 David Bourdon, 'Dan Flavin', Village Voice (26 November 1964).

71 Flavin, ' ... in daylight or cool white', op. cit.

72 Lucy R. Lippard, 'New York Letter: Carl Andre', Art International (20 September 1965) 58–59.

73 Carl Andre, 'An Interview with Phyllis Tuchman', Artforum (June 1970) 60.

74 Lippard was not alone in regarding Andre's work as Conceptual. Lever, a line of 137 fire-bricks exhibited in 'Primary Structures', inspired a hostile art professor in Orange, California, to organize a mock-exhibition of projects based on pseudo-serial schemas. See Harold Gregor, Everyman's Infinite Art (Orange, California: Purcell Gallery, Chapman College, December 1966).

75 Robert Smithson, 'Donald Judd', 7 Sculptors (Philadelphia Institute for Contemporary Art, 1965); reprinted in The Writings of Robert Smithson, op. cit., 21–23.

76 Rosalind Krauss, 'Allusion and Illusion in Donald Judd', Artforum (May 1966) 24–26. For a more recent discussion of this subject see Rosalind Krauss, 'The Material Uncanny', in Donald Judd: Early Fabricated Works (New York: PaceWildenstein, 1998) 7–13.

77 John Coplans, 'Larry Bell', Artforum (May 1965) 27–29.

78 Other artists associated with this development included Larry Alexander, Billy Al Bengston, Judy Chicago, Ron Davis, Tony DeLap, Frederick Eversley, Robert Irwin, Craig Kauffman, Helen Pashgian, Kenneth Price and DeWain Valentine. See Finish Fetish: LA's Cool School (The Fisher Gallery, Los Angeles University, 1991); and Art in Los Angeles: Seventeen Artists in the 1960s, ed. Maurice Tuchman (Los Angeles County Museum of Art, 1981).

79 The assumption of an East Coast/West Coast divide in the art of the 1960s is a longstanding cliché perpetuated in the literature. See, for example, the otherwise excellent Peter Frank, 'Larry Bell: Understanding the Percept', Zones of Experience: The Art of Larry Bell (New Mexico: The Albuquerque Museum, 1977).

80 Larry Bell's first solo exhibition in New York was held at Pace Gallery (1965), and was soon followed by John McCracken's New York debut at Robert Elkon Gallery (1966).

81 John McCracken, 'Interview with Thomas Kellein', John McCracken (Basel: Kunsthalle, 1995) 28.

82 McCracken explained: 'After I'd done all the things I call slabs and blocks, I thought, how could I simplify these even more? They seemed almost as simple as they could get, but then I saw that leaning against the wall were the sheets of plywood I used to make these blocks – and that led me to the planks. And I remember thinking, "can I really do this? Can I do something this simple, this dumb?" I did, of course.' [Ibid., 30.]

83 Judd, 'Complaints: Part I', op. cit.

84 Mel Bochner, 'Primary Structures', Arts Magazine (June 1966) 32–35.

85 Hilton Kramer, '"Primary Structures": The New Anonymity', New York Times (1 May 1966) 23.

86 Robert Morris, 'Notes on Sculpture: Part I', Artforum (February 1966); 'Notes on Sculpture: Part II', Artforum (October 1966); reprinted in Minimal Art, op. cit., 222–35.

87 Clement Greenberg, 'Towards a Newer Laocoon', Partisan Review (July–August 1940); reprinted in John O'Brian (ed.), Clement Greenberg: The Collected Essays: Criticism, I (Chicago and London: University of Chicago Press, 1986) 23–37.

88 Morris, 'Notes on Sculpture: Part I', op. cit.

89 The remark is by Benjamin Buchloh. See Discussions in Contemporary Culture, ed. Hal Foster (New York: Dia Foundation for the Arts, 1987) 72. On the various interpretations of phenomenology in discussions of Minimalism, see James Meyer, 'The Uses of Merleau-Ponty', in Minimalism (Ostfildern: Cantz Verlag, 1988) 178–89.

90 Maurice Merleau-Ponty, Phenomenology of Perception, trans. Colin Smith (London: Routledge & Kegan Paul, 1962) 203; originally published as Phénoménologie de la perception (Paris: Gallimard, 1945).

91 In Systemic Painting, Alloway linked the serial canvases of Frank Stella and Kenneth Noland to Minimal sculpture. See Lawrence Alloway, Systemic Painting (New York: Solomon R. Guggenheim Museum, 1966).

92 Lucy R. Lippard, 'Silent Art: Robert Mangold', in Changing: Essays in Art Criticism (New York: E.P. Dutton & Co., 1971) 13.

93 Barbara Rose, 'Group Show: Bykert Gallery', Artforum (November 1967) 59–60.

94 Jo Baer, 'Letter to the Editor', Artforum (September 1967) 5–6.

95 Douglas Crimp, 'Opaque Surfaces', Arte Come Arte (Milan: Centro Comunitario di Biera, 1973).

96 The analysis of Ryman's work has been especially rigorous. See Barbara Reise, 'Robert Ryman: Unfinished I (Materials)', Studio International (February 1974) 76–80; and 'Robert Ryman: Unfinished II (Procedures)', Studio International (March 1974) 122–28. See also Jean Clay, 'La peinture en charpie', Macula, 3/4 (September 1978) 167–85; Yve-Alain Bois, 'Ryman's Tact', Painting as Model, op. cit., 215–26.

97 See Mel Bochner, 'The Serial Attitude', Artforum (December 1967) 73–77.

98 See James Meyer, 'The Second Degree: Working Drawings and Other Visible Things on Paper Not Necessarily Meant to be Viewed as Art' in Mel Bochner: Thought Made Visible, ed. Richard Field (New Haven: Yale University Art Gallery, 1995) 75–106.

99 See Dan Graham, 'My Works for Magazine Pages: A History of Conceptual Art 1965–1969', in Dan Graham, ed. Gloria Moure (Barcelona: Fundació Antoni Tàpies, 1998) 61–66.

100 Robert Smithson, 'Entropy and the New Monuments', Artforum (June 1966); reprinted in The Writings of Robert Smithson, op. cit.; Robert Smithson: The Collected Writings, op. cit.

101 Donald Judd, 'Letter to the Editor', Arts Magazine (February 1967); reprinted in Donald Judd: Complete Writings 1959–1975, op. cit.

102 Clement Greenberg, 'Recentness of Sculpture', 1967, in Minimal Art, op. cit., 180–86.

103 Fried, 'Art and Objecthood', op. cit., 116–47.

104 Greenberg, 'Modernist Painting', in Clement Greenberg: The Collected Essays and Criticism, op. cit.

105 Fried, 'Art and Objecthood', op. cit., 146.

106 Ibid.

107 Ibid.

108 Donald Judd had his first retrospective exhibition at the Whitney Museum of American Art, New York, in 1968. Dan Flavin had a retrospective at the National Gallery of Canada, Ottawa, in 1969. Carl Andre had solo shows at the Gemeentemuseum, The Hague, in 1969 and at the Solomon R. Guggenheim Museum, New York, in 1970. Sol LeWitt also had a retrospective exhibition at the Gemeentemuseum, The Hague, as well as the Pasadena Art Museum, both in 1970. Robert Morris' work was exhibited at the Corcoran Gallery of Art, Washington, DC, in 1969, the Whitney Museum of American Art in 1970, and at the Tate Gallery, London, in 1971. Anne Truitt had solo exhibitions at the Baltimore Museum of Art in 1969, the Whitney Museum of American Art, New York, in 1973, and the Corcoran Gallery of Art, Washington, DC, in 1974. Jo Baer's first museum retrospective was held at the Whitney Museum of American Art, New York, in 1975.

Robert Ryman had solo shows at the Solomon R. Guggenheim Museum, New York, in 1972, and the Stedelijk Museum, Amsterdam, in 1974. Robert Mangold's first major retrospective was held at the Solomon R. Guggenheim Museum, New York, in 1971, and Brice Marden's first retrospective was also held at the Guggenheim in 1975.

109 This is suggested by Gregory Battcock's review of The Museum of Modern Art's exhibition, 'The Art of the Real: The Development of a Style: 1948–1968'. See Gregory Battcock, 'The Art of the Real the Development of a Style: 1948–68', Arts Magazine (June 1968) 44–47.

110 Eugene Goossen, The Art of the Real: USA 1948–1968 (New York: The Museum of Modern Art, 1968) 7.

111 See Marcelin Pleynet, 'Peinture et "réalité"', l'Enseignement de la peinture (Paris: Seuil, 1971) 163–85.

112 Philip Leider, '"Art of the Real", The Museum of Modern Art; "Light: Object and Image", Whitney Museum', Artforum (September 1968).

113 See Robert Pincus-Witten, 'The Seventies' in Eye to Eye: Twenty Years of Art Criticism (Ann Arbor: UMI Research Press, 1984) 123–39.

114 Robert Morris, 'Anti-Form', Artforum (April 1968); reprinted in The New Sculpture 1965–1975: Between Geometry and Gesture (New York: Whitney Museum of American Art, 1990) 100–101.

115 Jeanne Siegel, 'Interview with Carl Andre: Artworker', Studio International (November 1970) 175–79; reprinted in Artwords: Discourse on the 60s and 70s (New York: Da Capo Press, 1992).

116 Ursula Meyer, 'De-Objectification of the Object', Arts Magazine (Summer 1969) 20–21.

117 Carl Andre, 'The Bricks Abstract', Art Monthly, 1 (October 1976) 24.

118 Judy Chicago, Through the Flower: My Struggle as a Woman Artist, (Garden City: Doubleday & Company, 1975).

119 For another account of Chicago's early work, see Laura Meyer, 'From Finish Fetish to Feminism: Judy Chicago's Dinner Party' in Sexual Politics: Judy Chicago's Dinner Party in Feminist Art History, ed. Amelia Jones (Los Angeles: Armand Hammer Museum, University of California, 1996).

120 See Susan Stoops, More than Minimal: Feminism and Abstraction in the 1970s (Waltham, Massachusetts: Rose Art Museum, Brandeis University, 1996).

121 Michelson, op. cit.

122 Michelson quotes from lecture notes taken during a course taught by Merleau-Ponty at the Collège de France in Paris in the 1950s. [Michelson, op. cit.]

123 Charles Sanders Peirce quoted in Michelson, op. cit. For a discussion of 'firstness', see Thomas S. Knight, Charles Peirce (New York: Washington Square Press, 1965) 74–75.

124 Rosalind Krauss, 'Sense and Sensibility: Reflection on Post '60s Sculpture', Artforum (November 1973) 43–53.

125 Joseph Kosuth, 'Art After Philosophy', Parts I and II, Studio International (October–November 1969); reprinted in Idea Art, ed. Gregory Battcock (New York: E.P. Dutton & Co., 1973) 70–101.

126 The non-profit Dia Foundation, founded by Philippa de Menil and the dealer Heiner Friedrich, provided important commissions to artists like Flavin, Judd and De Maria.

127 Robert Rosenblum, 'Name in Lights', Artforum (March 1997) 11–12.

128 Sol LeWitt and Andrea Miller-Keller, 'Excerpts from a Correspondence, 1981–1983', Sol LeWitt Wall Drawings 1968–1984 (Amsterdam: Stedelijk Museum, 1984) 19.

129 Truitt, Daybook, op. cit.

130 See Bois, 'Ryman's Tact', op. cit.

131 Donald Judd, 'On Installation' (Kassel: Documenta 7, 1982) 164–67; reprinted in Donald Judd: Complete Writings 1975–1986, op. cit., 19–24. Originally published under the title, 'The Importance of Permanence', Journal: A Contemporary Art Magazine, 32: 4 (Spring 1982) 18–21.

132 On this history see Donald Judd, 'Statement for the Chinati Foundation', in Donald Judd: Complete Writings 1975–1986, op. cit., 110–14.

133 Peter Halley, 'Frank Stella ... and the Simulacrum', Flash Art (January 1986); reprinted in Peter Halley: Collected Essays 1981–1987 (Zurich: Bruno Bischofberger Gallery, 1988) 137–50.

134 Ibid.

135 Hal Foster, 'The Crux of Minimalism', Individuals: A Selected History of Contemporary Art 1945–1986 (Los Angeles: The Museum of Contemporary Art; New York: Abbeville Press, 1986) 162–83.

136 Ibid.

137 On the development from Minimalism to Institutional Critique, see the important essay by Benjamin Buchloh, 'Michael Asher and the Conclusion of Modernist Sculpture', Performance/Text(e)s/ and Documents, ed. Chantal Pontbriand (Montreal: Parachute, 1981) 55–65.

138 Foster, 'The Crux of Minimalism', op. cit., 162.

139 Ibid., 172.

140 Rosalind Krauss, 'The Cultural Logic of the Late Capitalist Museum', October, 54 (Fall 1990) 3–17.

141 Ibid.

142 Anna C. Chave, 'Minimalism and the Rhetoric of Power', Arts Magazine (January 1990) 51.

143 Ibid., 54.

144 Russell Ferguson, 'The Past Recaptured' in Felix Gonzalez-Torres (Los Angeles: Museum of Contemporary Art, 1994) 29.

145 See Paul Schimmel, Charles Ray (Los Angeles: Museum of Contemporary Art, 1998) 80.

146 See Lynn Zelevansky, Sense and Sensibility: Women Artists and Minimalism in the 1990s (New York: The Museum of Modern Art, 1994) 7. This point of view also appears in Nancy Spector, Felix Gonzalez-Torres (New York: Solomon R. Guggenheim Museum, 1995) 16–17. The topic of neo-Minimalism is also the subject of Alexander Alberro, 'Minimalism and its Vicissitudes' in Minimalisms (Ostfildern: Cantz, 1998) 197–210.

WORKS

CARL ANDRE

JO BAER

LARRY BELL

RONALD BLADEN

MEL BOCHNER

JUDY CHICAGO

WALTER DE MARIA

DAN FLAVIN

EVA HESSE

RALPH HUMPHREY

DONALD JUDD

SOL LEWITT

JOHN MCCRACKEN

ROBERT MANGOLD

BRICE MARDEN

AGNES MARTIN

PAUL MOGENSEN

ROBERT MORRIS

DAVID NOVROS

ROBERT RYMAN

TONY SMITH

ROBERT SMITHSON

FRANK STELLA

ANNE TRUITT

1959–63 FIRST ENCOUNTERS During the late

1950s a new sensibility began to emerge that suggested an alternative to the subjective impulse of Action painting. Using anti-compositional methods of symmetrical division and repetition, and thick, material surfaces, Frank Stella, Ralph Humphrey, Robert Ryman, Robert Mangold and Jo Baer embarked on a radical simplification of painterly process. For Donald Judd, Dan Flavin, Sol LeWitt, Anne Truitt, Larry Bell and John McCracken this reduction led to the production of reliefs and objects that extended the perceptual concerns of painting into three dimensions. Carl Andre developed a materialist sculpture of unadulterated notched and stacked beams, while Robert Morris first created his Minimal works as prop pieces for performances. The influential artist/critic Donald Judd both defined this new literalist tendency in art and began showing his own work during this period.

'16 Americans'
The Museum of Modern Art, New York
16 December 1959–17 February 1960
Installation view
Frank STELLA
Black Paintings
1958–59

This seminal exhibition organized by Dorothy Miller at The Museum of Modern Art, New York, included four of the *Black Paintings* by the then twenty-three year-old artist Frank Stella. Their large scale recalls the size of the Abstract Expressionists' paintings, although their monochromatic palette and symmetry deny the possibility of unexpected chromatic or compositional relationships. Stella used the thickness of the support to dictate the width of the stripes, allowing the material edge of the canvas, rather than spontaneous 'artistic expression', to determine the work's organization. As Carl Andre said of Stella's paintings: 'Art excludes the unnecessary. Frank Stella has found it necessary to paint stripes. There is nothing else in his painting.'
– Carl Andre, *16 Americans* [cat.], 1959

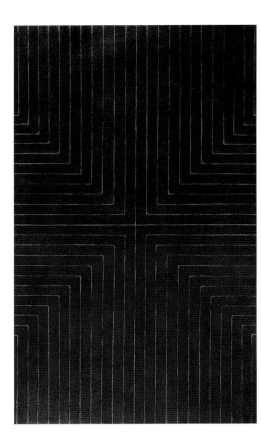

left

Frank <u>STELLA</u>

Die Fahne Hoch!

1959

Enamel on canvas

309 × 185 cm [122 × 73 in]

Collection, Whitney Museum of American Art, New York

Frank Stella, who temporarily worked as a house painter in the late 1950s, began using the house painter's commercial enamels and brushes in his *Black Paintings*. Each black stripe is separated by a thin line of unpainted canvas. The all-over symmetry of the works helps avoid illusionism and pictorial depth. The rectilinear shape of the canvas determines the placement of each hand-painted stripe. The central cruciform lines symmetrically bisect the canvas into quadrants, and each interior stripe reiterates the right angles of the cross. Stella's eschewing of allusions ('What you see is what you see'), however, becomes complicated by his choice of titles. Many of the *Black Paintings* refer to disasters; '*Die Fahne Hoch!*', a refrain from the official marching song of Hitler's stormtroopers, is one of several titles in the series alluding to Nazi subject matter.

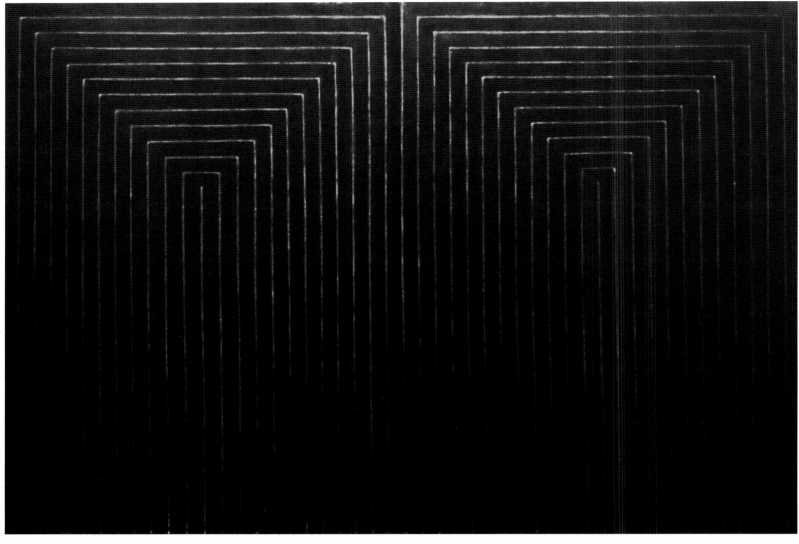

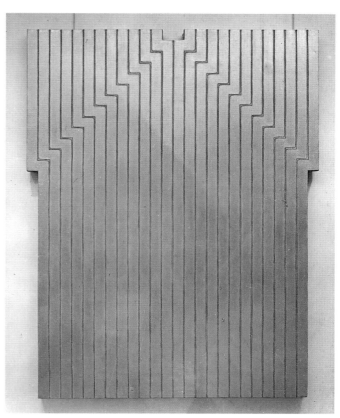

Frank STELLA
Aluminum Paintings
1960
Aluminium paint on canvas
Leo Castelli Gallery, New York
Installation view

The *Aluminum Paintings* were first shown at the Leo Castelli Gallery, New York, in 1960. Each of the twelve large, shaped canvases in the series is covered in stripes of metallic aluminium oil paint. The first three paintings are a darker colour, the remainder are a lighter shade.

Frank STELLA
Luis Miguel Dominguin
1960
Aluminium paint on canvas
244 × 183 cm [96 × 72 in]

Whereas the stripes in Stella's *Black Paintings* directly follow the shape of their support, in the *Aluminum Paintings* the stripes break from the rectilinearity of the canvas and shift direction, or 'jog', to form more decorative patterns. This change caused empty spaces, or squares of exposed canvas that did not fit into the configuration. Stella cut these unpainted areas out, thereby forming the shaped canvas. This was an important innovation in the 1960s, and became the subject of the 1965 group exhibition, 'The Shaped Canvas', at the Solomon R. Guggenheim Museum, New York.

opposite
Frank STELLA
Marriage of Reason and Squalor
1959
Enamel on canvas
230 × 334 cm [91 × 131.5 in]
Collection, The Saint Louis Art Museum

Stella's use of uniform repetition in his stripe paintings influenced many younger artists. Both Stella and the younger Minimalists were united in a rejection of the emotionality of Abstract Expressionism. Stella's close friend Carl Andre helped name this bilaterally symmetric painting, referring to a series of pastels Andre completed in 1957. They were both pleased with the title's allusions to both J.D. Salinger ('For Esmé With Love and Squalor') and William Blake ('The Marriage of Heaven and Hell'), as well as its acute description of the experience of being a young and impoverished artist in New York.

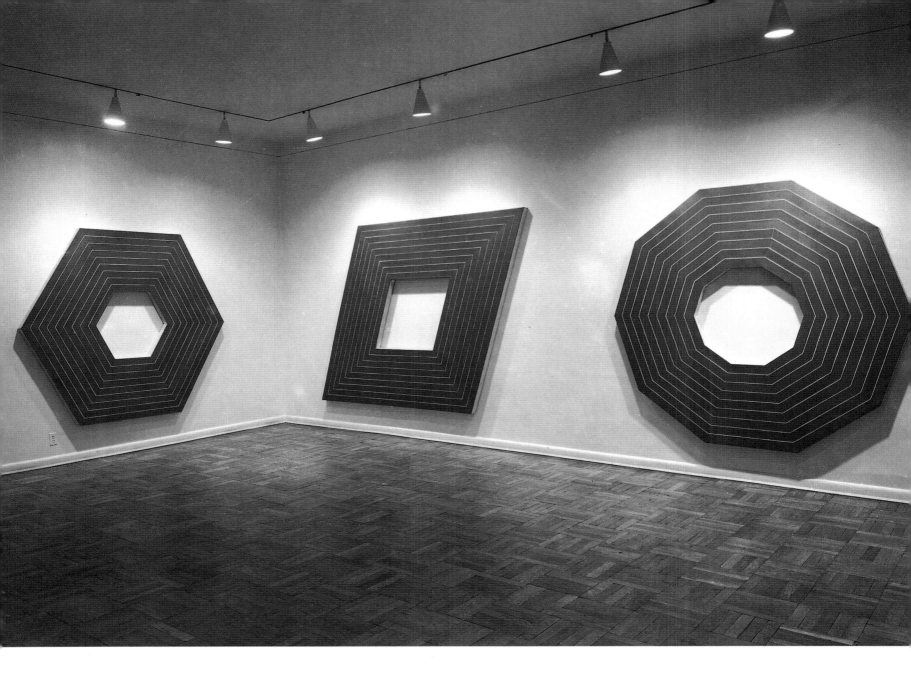

Frank <u>STELLA</u>
Portrait Series
1963
Metallic paint on canvas
Leo Castelli Gallery, New York
1964
Installation view

Stella's *Portrait Series* of 1963 is a group of paintings that protrude from the wall and feature various cut-out shapes. In 1964 Stella exhibited eight of these lavender paintings at the Leo Castelli Gallery, New York. Each work is a shaped canvas whose contours are delineated by painted lines and whose centres remain open. He named them after his friends: the sculptor Carl Andre; the painter – and later Stella's biographer – Sidney Guberman; the gallerists Leo Castelli and Ileana Sonnabend; the photographer and filmmaker Hollis Frampton; Charlotte Tokayer, Henry Garden and D, the nickname of director Emile D'Antonio, whose *Painters Painting* (1970) is a well-known film on the New York art scene of the 1960s. Once again he limited himself to one colour, as in the *Black Paintings*, choosing metallic purple paint for this series. The Minimalists admired the cut-out shapes and the thickness of Stella's stretchers for enhancing the painting's three-dimensional materiality and revealing the supporting wall.

Frank STELLA
Valparaiso Green
1963
Metallic paint on canvas
198 × 343 cm [78 × 135 in]

Part of the *Valparaiso Series*, in which the green paintings were often juxtaposed with orange-coloured, mirrored image copies, it was completed soon after Stella's return to New York from a residency at Dartmouth College, Vermont. This work is made up of bands of paint that form three interlocking triangles, placed so that the apex of each triangle touches the base of the neighbouring triangle. Admired by the artist/critic Donald Judd, it was included in the permanent installation of works by contemporary artists in the loft building at the corner of Spring and Mercer Streets that Judd renovated in SoHo, New York, in the early 1970s.

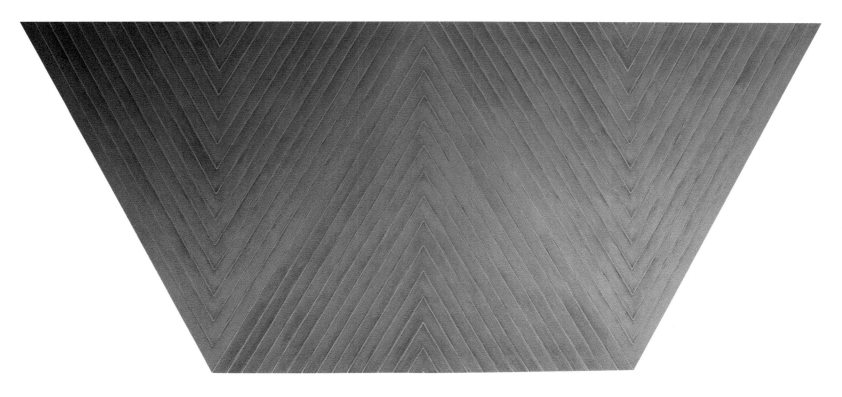

Robert <u>RYMAN</u>

Untitled

1959

Oil on linen

84 × 84 cm [33 × 33 in]

Ryman preferred the neutrality of white because it mimicked most closely the
unpainted canvas and carried no dark, emotive associations. The monochrome colour
allows the texture of the canvas' surface to be a prominent feature, whereas with
multiple colours the viewer's focus would shift to colour relations. The seam calls
attention to the edge of the work, shifting focus away from the traditional centre of the
picture plane. With bright lighting, the pronounced seam creates shadows and
variations in tone on the white surface. Ryman continued to use irregular surfaces
and thick, uneven applications of white pigment throughout the 1960s.

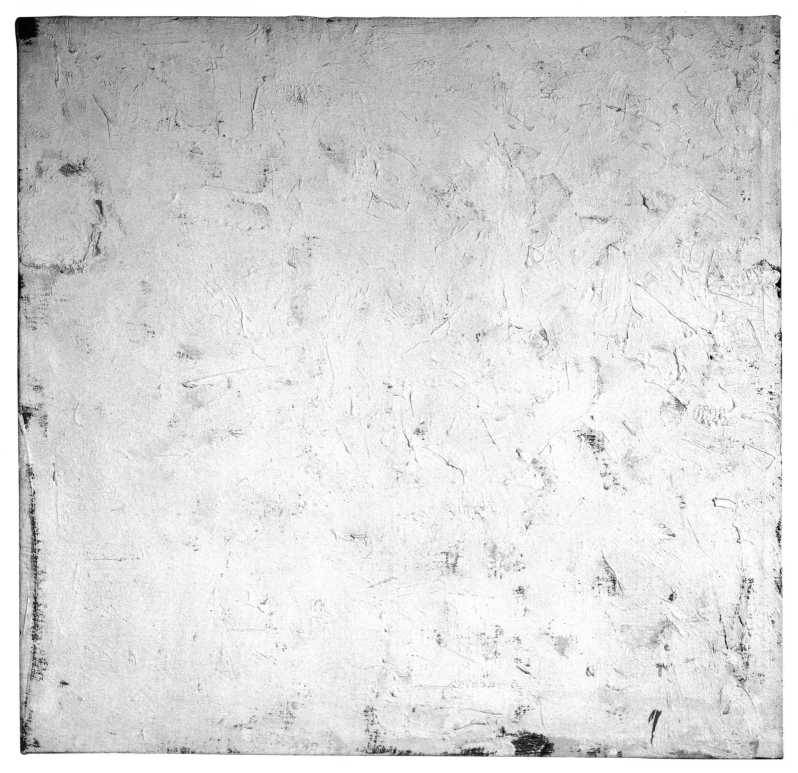

Robert <u>RYMAN</u>

Untitled No. 15

1961

Oil on linen

25 × 28 cm [10 × 11 in]

In this painting, Ryman segments the top half of the stretched linen cloth surface into four square sections painted with a flat, uniform brushstroke. The lower half is a field of painterly, thick strokes. Beneath the white surface a layer of blue paint is visible. Ryman uses the blue underpainting not only to contrast with the white, but also as a tool in building a tactile surface.

Robert <u>RYMAN</u>

Untitled

1962

Oil on linen

43 × 43 cm [17 × 17 in]

This work is built up with layers of colour. First Ryman laid a blue-green colour on the linen canvas, and then overpainted it with loose, thick brushstrokes in white. The openness of the brushstrokes allows the underpainting to show through. He then stapled the canvas on to a board so that its irregular edges remain visible. The areas of unpainted canvas appear to form a border around the central painted section, stressing the materiality of both the paint and support.

Ralph <u>HUMPHREY</u>
Untitled
1954
Oil on canvas
81 × 96.5 cm [32 × 38 in]

Ralph Humphrey's monochrome paintings of the 1950s and early 1960s, such as this rich copper-brown work, were admired by such artists as Donald Judd, Mel Bochner, Brice Marden and Robert Mangold. The purity of the single colour, combined with the thickness of the canvas, appealed to the Minimalists' interest in the basic abstract forms and objecthood, or materiality, of an artwork.

Ralph <u>HUMPHREY</u>
Olympia
1959
Oil on canvas
201 × 142 cm [79 × 56 in]

Ralph <u>HUMPHREY</u>
Atlanta
1958
Oil on canvas
168 × 244 cm [66 × 96 in]

In the late 1950s Ralph Humphrey began creating abstract paintings made up of the subtle gradation of a single colour such as ochre, blue or green. Critics originally dismissed this work as offering 'nothing to look at'. The austerity of these paintings, which did not espouse any emotive content (as found in the work of the Abstract Expressionists who still predominated at the time), as well as their opaque surfaces, were admired by younger Minimalist sculptors and painters. Judd, reviewing Humphrey's 1960 show at Tibor de Nagy Gallery, New York, praised the way the textured, painterly surface and all-over organization of Humphrey's monochrome canvases caused an effect of 'unique immediacy', focusing attention on the simple act of perceiving them.

Agnes <u>MARTIN</u>
Graystone II
1961
Oil and gold leaf on canvas
190 × 187 cm [74 × 73 in]
This large, dense and intricate painting is built up of a grid of small rectangular dabs of blue/purple on a gold leaf surface. The colour is limited to the centre of the canvas, allowing a border of pure gold to frame the work. Although the grid is ordered and geometric, the hand-painted surface and the luxurious materials, reminiscent of the gold used in religious icons, suggest the spirituality Martin often associated with her work.

Agnes <u>MARTIN</u>
Song
1962
Watercolour on canvas
61 × 61 cm [24 × 24 in]
Martin uses the arch here to allude to classical forms, which epitomized, for her, the human attempt to reach towards perfection and the sublime. Only abstract, elementary geometry could refer to a transcendental experience: literally representing nature would be too limiting. The work's title reinforces Martin's desire to reflect the sublimity of nature, poetry and music.

190 × 187 cm [74 × 73 in]

Jo BAER
Untitled
1961
Oil on canvas
183 × 183 cm [72 × 72 in]

Jo Baer's first paintings were iconic, geometric representations, as in this star. Although this work is not completely abstract, it opposes traditional painting's reliance on multiple parts and complex figure/ground relationships. Her use of so basic and fundamental an image filling up the canvas causes it to become a star, rather than merely its representation. The simple geometry allows for an immediacy of perception, which Baer strove to achieve in her future work.

Jo BAER
Untitled
1963
Oil on canvas
183 × 183 cm [72 × 72 in]

Baer surrounded the large white, seemingly empty centre of the canvas with painted borders: a thin stripe of light blue travels around three sides of the canvas, while a thick black stripe borders the entire painting. A small linear design of blue pigment appears in the upper corners of the black border, a simple pattern which seems almost ornate amidst the stark black and white canvas.

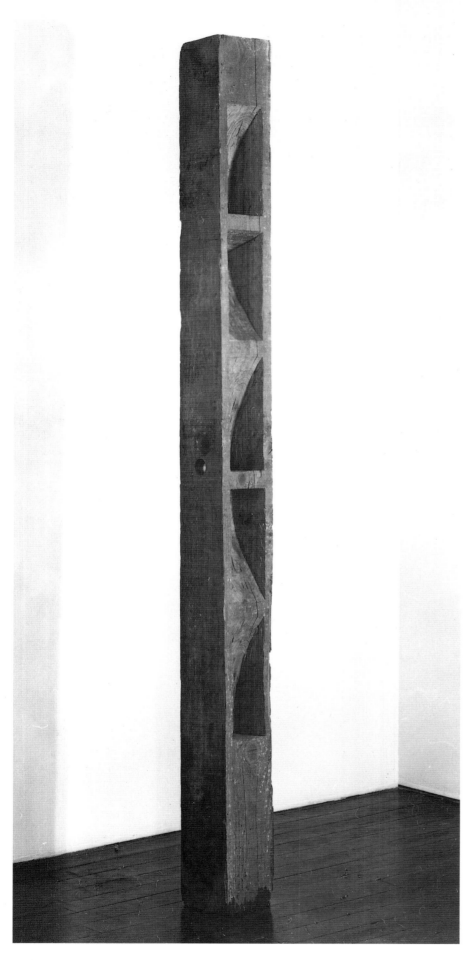

Carl ANDRE
Last Ladder
1959
Wood
214 × 15 × 15 cm [84 × 6 × 6 in]
Collection, Tate Gallery, London

Carl Andre chiselled triangular cuts into one face of the vertical wooden column of his sculpture *Last Ladder*. Its vertical shape and the repeated cuts into the wood relate to the repeated cuts made by Constantin Brancusi in his sculpture *Endless Column* (1938). Andre particularly admired Brancusi's use of cutting into material instead of traditional sculptural techniques such as carving or clay modelling. Eventually Andre abandoned making repeated cuts into solid materials in favour of repeated combinations of identical, discrete units of wood, brick or metal. Of work from this period he said, 'Up to a certain time I was cutting into things. Then I realized that the thing I was cutting was the cut. Rather than cut into the material, I now use the material as the cut in space.'
– Carl Andre, Artist's statement, 1966

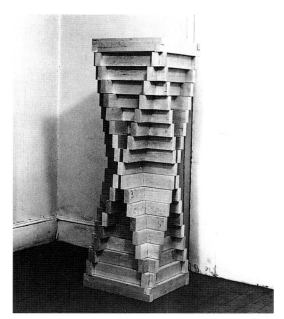

Carl <u>ANDRE</u>
Pyramid (Square Plan)
1959 (destroyed), remade Orleans, Massachusetts, 1970
Eastern pine
74 units, 5 × 10 × 79 cm [2 × 4 × 31 in] each
175 × 79 × 79 cm [69 × 31 × 31 in] overall
Collection, Dallas Museum of Art, Texas

In the *Pyramid Series*, Andre used lengths of wood bought directly from the timber yard, notching each piece with a radial saw and using traditional joinery techniques to connect the units. This work is constructed from seventy-four small beams intersecting at right angles; the beams are progressively longer according to their structural role within the work. Created in Frank Stella's studio at the same time as Stella was working on his *Black Paintings*, the *Pyramids'* serial ordering recalls the stripe patterns of Stella's canvases. Both artists worked with basic geometric units, eschewing ornament and subjective, traditional studio technique.

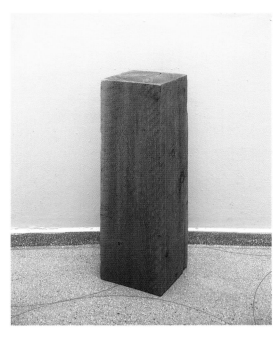

Carl <u>ANDRE</u>
Herm
1960 (destroyed), remade 1976
Western red cedar
91.5 × 30.5 × 30.5 cm [36 × 12 × 12 in]
Collection, Solomon R. Guggenheim Museum, New York

This work is part of the *Elements Series*, originally proposed in 1960. The most simple of a series of basic geometric shapes, it consists of a single cedar timber 91.5 cm [3 ft] high. The title refers to ancient Greek and Roman columnar markers which were accompanied by a bust of the god Hermes or other important gods and ancestors.

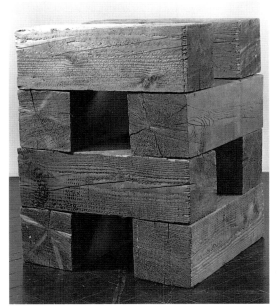

Carl <u>ANDRE</u>
Pyre
proposed New York, 1960, made Minneapolis, 1971
Wood
8 units, 30.5 × 30.5 × 91.5 cm [12 × 12 × 36 in] each
122 × 91.5 × 91.5 cm [48 × 36 × 36 in] overall

This is one of the more complex structures in Andre's *Elements Series*. Eight timber blocks measuring 30.5 × 30.5 × 91.5 cm [12 × 12 × 36 in] form a compact, wall-like structure, with two timbers placed on four levels to form right angles, the centre remaining open.

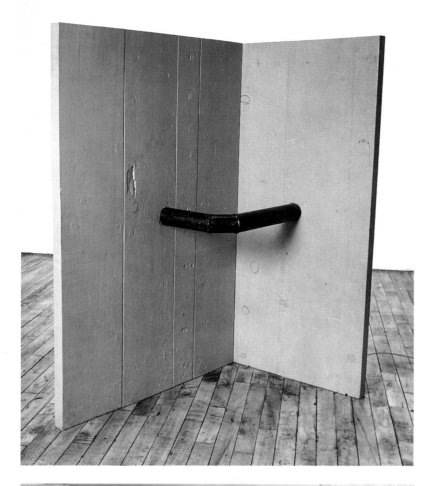

Donald JUDD
Untitled
1962
Oil on wood, metal pipe
122 × 84 × 56 cm [48 × 33 × 22 in]

This work makes apparent Judd's frustrations with painting early in his career. Where a painting or relief is to be viewed straight on, Judd's object is free-standing and meant to be seen in the round; it exists in actual space rather than pictorial space. The pipe is a found object and the piece made according to its dimensions. Other details stress the work's three-dimensional quality. The pipe articulates the cubic volume between the perpendicular planks; the cadmium red surface unifies the work into a single, whole shape. Yet Judd's aim to produce a 'specific' object, an object that is easy to grasp visually, is compromised by crude execution: the red paint cannot mask the grainy, knotted wood. Dissatisfied with the arbitrary appearance of his early works, Judd sought a more pristine effect, developing factory-made works built of anodized aluminium, Plexiglas and other man-made materials.

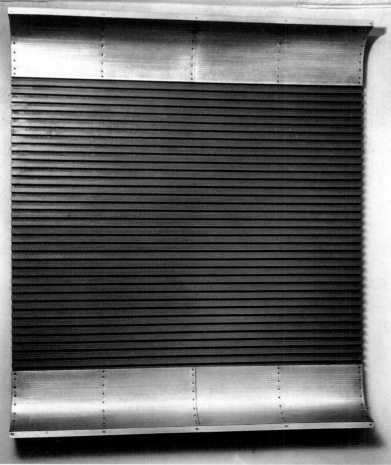

Donald JUDD
Untitled
1963
Oil on wood, galvanized iron, aluminium
127 × 107 × 14 cm [50 × 42 × 5.5 in]

Donald Judd began his professional career as a painter in the late 1950s. In 1961–62 he achieved an amalgam of painting and sculpture using industrial materials, creating reliefs that jut into space. In this piece the edges of the metal strips curve away from the supporting wall, and their texture draws attention to their three-dimensionality. The work is seemingly more a relief than a painting, pointing to his development of three-dimensional objects later that same year. This work was first shown at the Green Gallery in New York in 1963–64, then again in Providence, Rhode Island, in 1965, and was included in 'The Art of the Real' at The Museum of Modern Art, New York, in 1968.

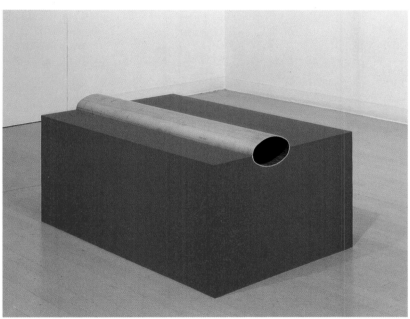

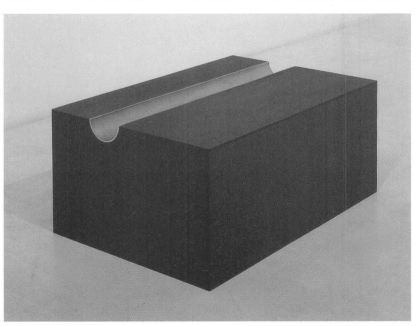

Donald <u>JUDD</u>
Untitled
1963
Oil on wood, enamel on aluminium
183.5 × 264 × 124.5 cm [72 × 104
× 49 in]

Donald <u>JUDD</u>
Untitled
1991 (First type 1963)
Painted plywood, aluminium tube
49.5 × 114 × 77.5 cm [19.5 × 45 ×
30.5 in]

This work consists of a wooden box painted cadmium red with a scooped recession in the top into which Judd placed an aluminium tube. He built the box to the dimensions of the tube's circumference, so that the two elements, the wood and the metal, combine in a wholistic, singular shape. The first piece of this type was included in Judd's first show at the Green Gallery, New York, in 1963. All the works in the show were painted cadmium red to unify the ensemble and to highlight the literal contours of the individual shapes.

Donald <u>JUDD</u>
Untitled
1991 (First type 1963)
Painted plywood, aluminium tube
49.5 × 114 × 77.5 cm [19.5 × 45 ×
30.5 in]

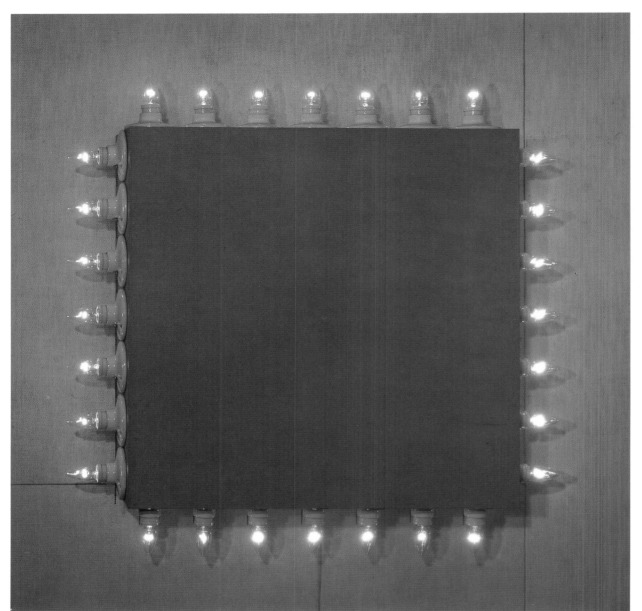

Dan FLAVIN
icon V (Coran's Broadway Flesh)
1962
Oil on masonite, clear
incandescent lightbulbs
107 × 107 × 25 cm [42 × 42 × 10 in]

In the *icon series*, Flavin's first experiments with industrial lighting, he combined the solid, rectilinear form reminiscent of a canvas with various types of lightbulbs, tubes and fittings positioned around the edges of the rectangle. He used the term 'icon' to describe not a religious object but a non-hierarchical arrangement of light and shape. The *icons* were designed to accompany one another in the exhibition space; hence Flavin carefully considered how the illuminating lights of each would interact and affect the ensemble as a whole. Thus *icon V* proved to be prescient of Flavin's installations of the later 1960s: the ambient glow of the many lights surrounding the square dematerializes its geometric form, pointing away from singular, discrete objects towards a more environmental art.

Dan FLAVIN
Untitled drawing
1963
Pencil on paper
28 × 36 cm [11 × 14 in]

In this drawing Flavin has sketched some of his *icons* that were to be exhibited at the Kaymar Gallery, New York, 'some light' show in 1964. Flavin also planned a layout of lights for an entire gallery environment, with white, circular lights attached to a strip of dark blue wall on all four sides of the room, a project that was never executed.

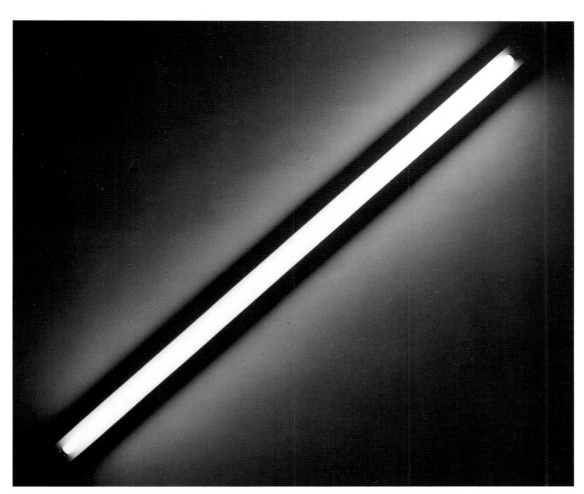

Dan FLAVIN
the diagonal of May 25, 1963 (to
Robert Rosenblum)
1963
Cool white fluorescent light
l. 244 cm [8 ft]

This ground-breaking work, originally a single, gold fluorescent tube affixed to the wall at a 45-degree angle, was first exhibited at the Wadsworth Atheneum in Hartford, Connecticut in cool white. The work transformed the traditional gallery-going experience into one where the viewer did not so much view the work as an object as become enveloped by its play of light and shadow. Inspired by the single straight line and repetition suggestive of continuity of Constantin Brancusi's *Endless Column* (this work was initially dedicated to the Romanian artist), Flavin also used a simple linear form that, because of the glow of the fluorescent light, appears to extend beyond the limits of the physical object. 'A common lamp becomes a common industrial fetish, as utterly reproducible as ever but somehow strikingly unfamiliar now.'
– Dan Flavin, ' … in daylight or cool white', 1964

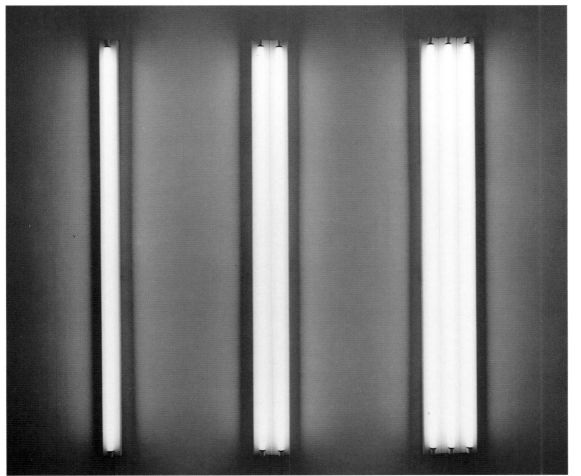

Dan FLAVIN
the nominal three (to William of
Ockham)
1964-69
Cool white fluorescent light
h. 244 cm [96 in]

Dedicated to the fourteenth-century Nominalist philosopher William of Ockham, this work consists of three discrete parts: the first is one lamp, the second, two, the third, three. Limiting the number of elements, Flavin followed the economic mathematics of William of Ockham who stated: 'No more entities should be posited than necessary'. When first installed at the Green Gallery, New York, in 1964 alongside other works, the three elements were arranged closely together. A subsequent installation at the National Gallery of Canada in 1969 demonstrated an increased engagement with the site: the elements were distributed across a large wall, revealing the gallery as a whole.

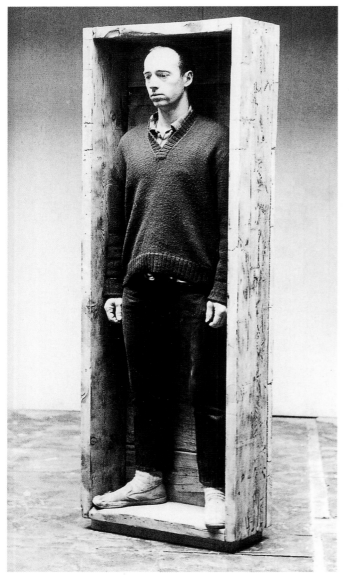

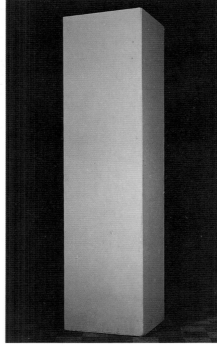

Robert MORRIS
Column
1961
Painted plywood
244 × 61 × 61 cm [96 × 24 × 24 in]

Column, a simplified form based on ancient Egyptian temple architecture, was used as a prop for a performance at the Living Theater in New York. The artist's original intention was to stand inside the sculpture and allow the weight of his body to topple the column. Although the action was finally produced by means of a small rope, the human scale and dynamism of the column still refer to the body's presence.

left
Robert MORRIS
Untitled (Box for Standing)
1961
Fir
188 × 63.5 × 27 cm
[74 × 25 × 10.5 in]

Box for Standing uses the architectural form of a doorway with a back panel creating a space for enclosure and cover. The work was made to fit the dimensions of Morris' own body, much like other early works by the artist built as props for performances.

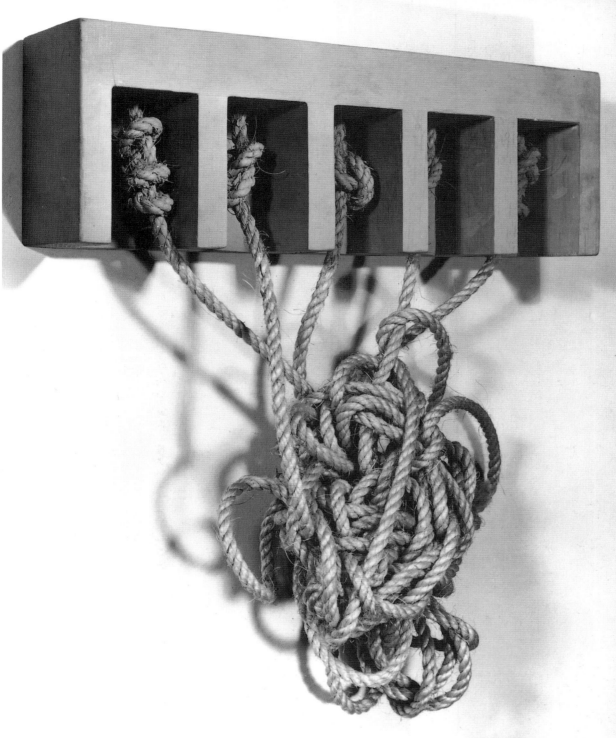

Robert MORRIS
Untitled (Knots)
1963
Painted wood, hemp rope
Wooden structure, 14 × 38 × 8 cm
[5 × 15 × 3 in]

This work was one of a series made between 1962 and 1964 using rope either attached to or piercing a wooden form. A painted wooden relief with five rectangular recesses hangs on the wall. Five strands of hemp are affixed to the recesses. The ends of the rope are knotted together. Morris juxtaposes a pliable material – rope – with the rigid wooden structure. This is one of his first explorations with unstructured forms, a method he would continue to explore in his later 'anti-form' works.

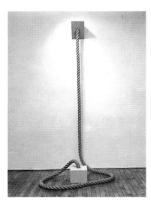

left
Robert MORRIS
Untitled (Rope Piece)
1964
Painted wood, rope
Dimensions variable

This work combines a relief and a free-standing structure, united by a thick rope. A 5.5-m [18-ft] rope extends from a circular hole in a triangular box attached to the wall. The rope coils upon the floor and terminates in a square box that is placed a few feet away from the gallery wall. Both the wooden forms and the rope are painted grey, like the plywood structures that dominated Morris' Green Gallery show in December 1964.

Sol LEWITT
Wall Structure, Black
1962
Oil on canvas, painted wood
100 × 100 × 60 cm [39 × 39 × 23.5 in]

In this work the viewer gazes inside the peephole and sees a metallic silver square. This sets up a more contradictory perception than the literalist canvases of Stella and the early reliefs of Judd, which are to be seen in their entirety at once.

Sol LEWITT
Wall Structure
1963
Oil on canvas, painted wood
157.5 × 157.5 × 63.5 cm [62 × 62 × 25 in]

In the early 1960s LeWitt created a number of wall reliefs, or *Structures*, protruding out from the wall into the space of the viewer. They are neither paintings nor sculptures, but both. This early work was one of his first experiments with seriality, although it lacked the steady progression and precise measurements he was to use in later works.

opposite
Anne TRUITT
Southern Elegy
1962
Painted wood
119 × 53 × 18 cm [47 × 21 × 7 in]

Although Truitt was moving into a more abstract style by 1962, her earliest sculptures, such as this work or *First*, still retain allusions to fences, tombstones and other architectural details recalled from the artist's childhood in Easton, Maryland.

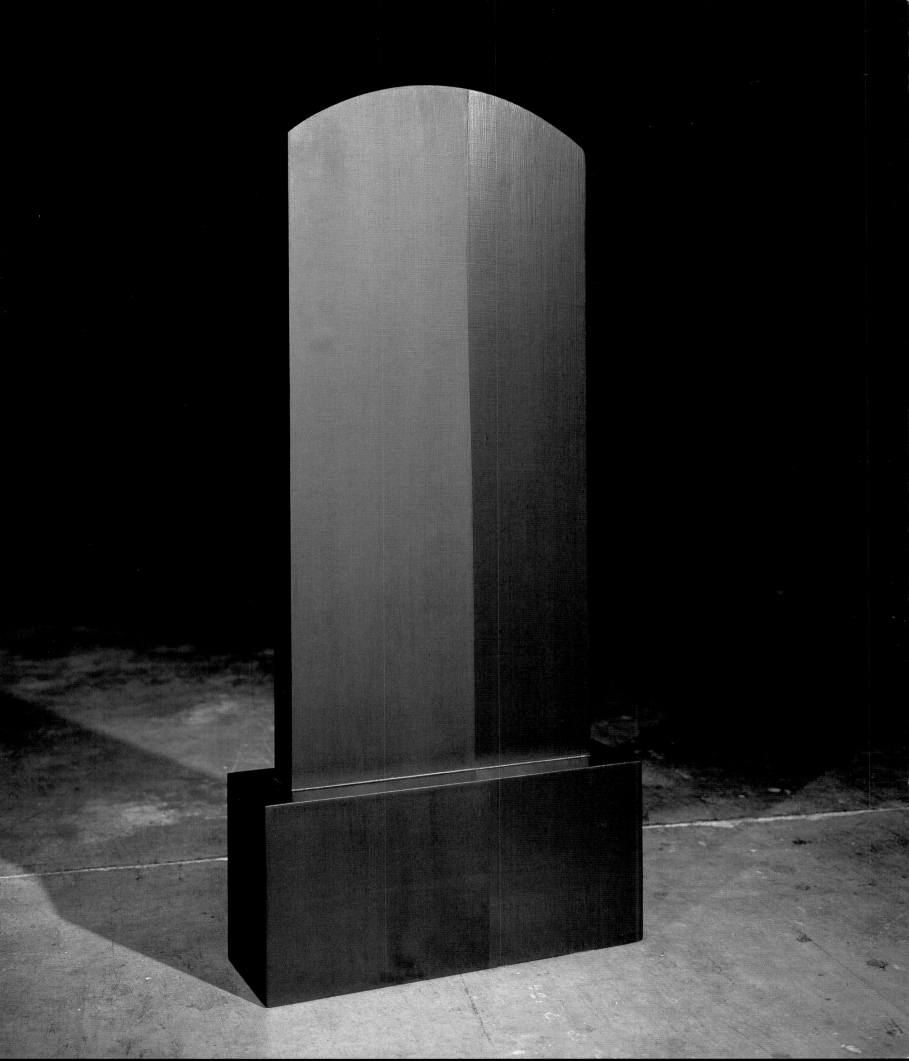

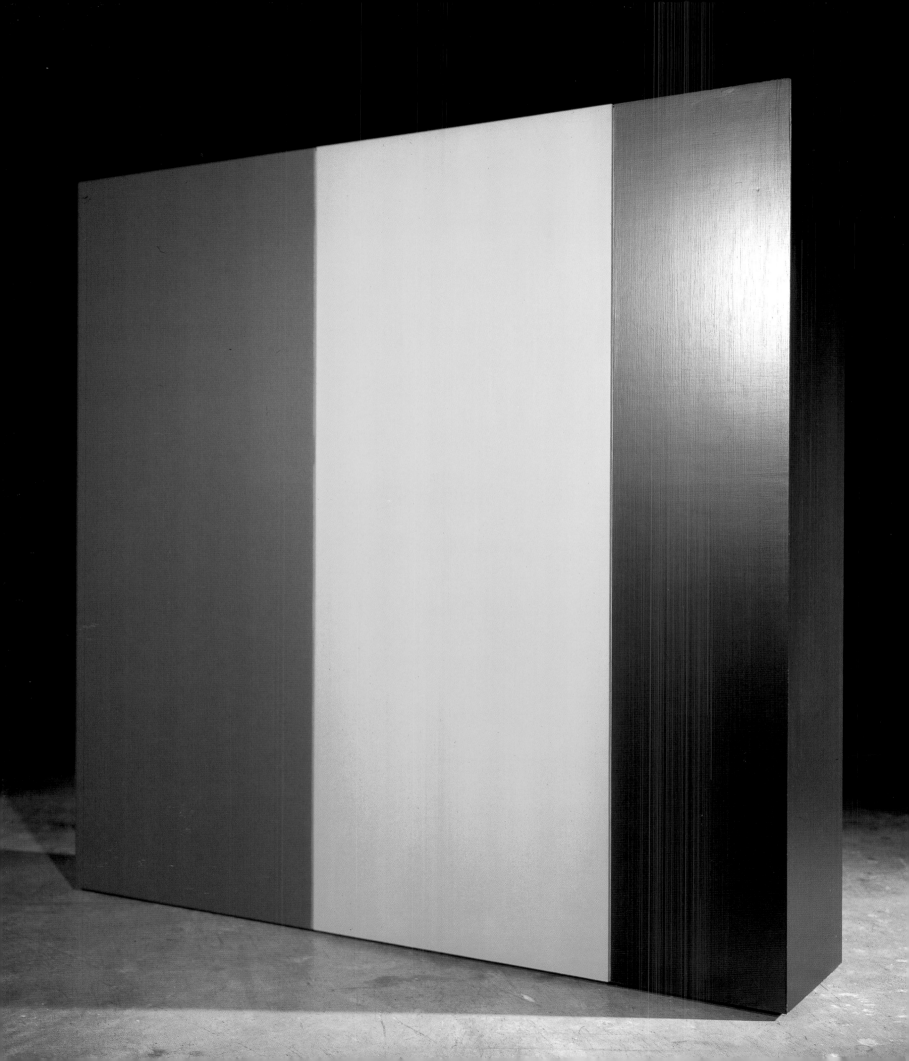

opposite

Anne TRUITT

Knight's Heritage

1963

Painted wood

152 × 152 × 30.5 cm

[60 × 60 × 12 in]

Truitt was inspired by Barnett Newman's use of simple divisions and great expanses of saturated colour, as well as his allusions to the sublime. Truitt also imbued her sculpture with allusion, yet hers is to personal memory, rather than to transcendent, grand themes.

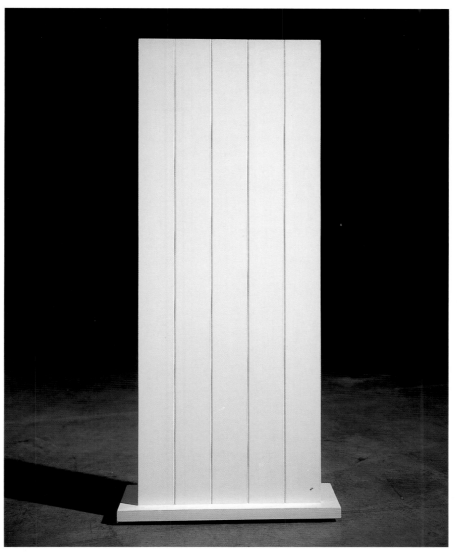

Anne TRUITT

White: Five

1962

Painted wood

137 × 59 × 20 cm [54 × 23 × 8 in]

In 1962 Truitt began her first series of abstract sculptures. The title *White: Five* refers to the colour and number of elements that make up this work. She soon abandoned this focus on pure seriality and uniform colour, preferring variations of both colour and shape, and naming her work in such a way as to evoke a highly personal subject matter.

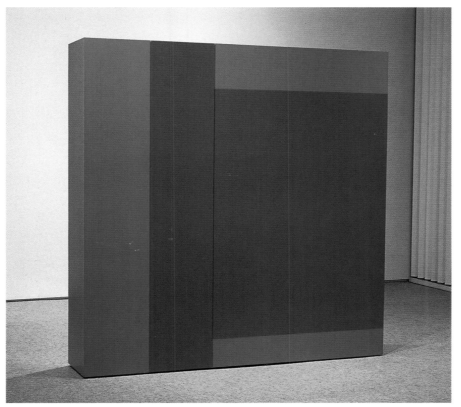

Anne TRUITT

Valley Forge

1963

Painted wood

154 × 152 × 30.5 cm [60.5 × 60 × 12 in]

Truitt constructed this work to approximate human scale, just short enough to allow the viewer to peer over the top. It is segmented into geometric divisions with lines incised into the wood and distinct colour divisions. The title refers to the American Revolutionary battle site at Valley Forge, Pennsylvania, where General George Washington was stationed in 1777–78.

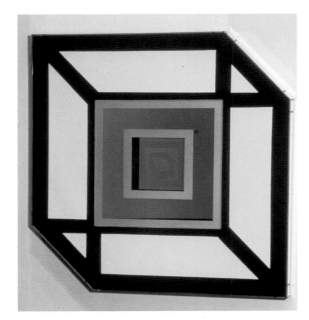

Larry <u>BELL</u>
Ghost Box
1962-63
Paint on canvas and glass
122 × 223.5 × 8 cm [48 × 88 × 3 in]

This mirrored relief combines painting on canvas and three types of glass – mirrored, vacuum-coated and sandblasted – in order to suggest contradictory forms of illusion. The central panel neutralizes the isometric reading of the outer black frame, proposing a shallow, fictitious depth of 'receding' squares. These contradictory impressions of volumetric space make for a work of surpassing visual complexity.

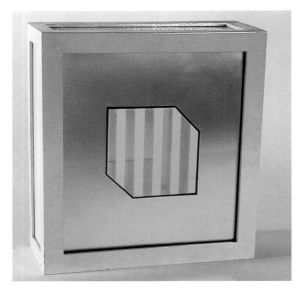

Larry <u>BELL</u>
Untitled No. 7
1961
Mirror, wood, paint
30.5 × 30.5 × 13 cm [12 × 12 × 5 in]

Untitled No. 7 is one of Larry Bell's earliest glass boxes. A rectangular solid, it consists of six mirrored panes inset in a white wooden frame. On the front side, Bell has scraped the mirroring off the glass. This transparent section, a square zone with truncated corners, opens on to the box's interior, revealing a pattern of mirrored stripes on the rear panel that fragments the viewer's reflection.

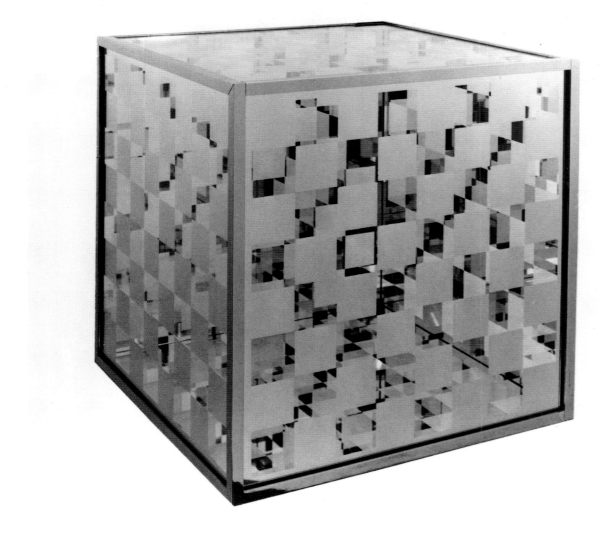

Larry BELL
Bette and the Giant Jewfish
1963
Vacuum-coated glass, chrome-
plated metal
42 × 42 × 42 cm
[16.5 × 16.5 × 16.5 in]

In this sculpture, one of Bell's most arresting works, the surface pattern was applied by silkscreen, then washed off after the glass was vacuum-coated with aluminium. The resulting checkerboard patterns are layered and visually complex. The screened areas are transparent, allowing the viewer to peer inside the cube; the aluminium-coated squares reflect his or her body. Bell eventually jettisoned patterning from his work, yet continued to explore this contradiction of transparency and reflection in his all-glass cubes and installations. The sculpture refers to an old postcard which, bearing the legend 'Bette and Giant Jewfish', was used as the announcement of Bell's second show at the Los Angeles Ferus Gallery in 1963.

John <u>MCCRACKEN</u>
Untitled
1963
Oil on paper
127 × 127 cm [50 × 50 in]

In this painting the pattern of intersecting post and lintel forms refers to ancient
Neolithic architecture, a primary source of McCracken's work. Here McCracken allows
the pattern to comprise the entire painting, negating traditional figure/ground
relationships and suggesting a continuation beyond the limits of the work.

John MCCRACKEN
Horizon
1963
Acrylic on canvas
56 × 51 cm [22 × 20 in]

John McCracken, a native of California, began as a painter before moving to more sculptural forms. In this work McCracken's process of paring painting down to its most basic geometric elements is apparent: the rectangular shapes that proceed in a horizontal line across the painting mimic the shape of the canvas itself, calling attention to the fundamental materials of painting; the colours are limited to black and white.

John MCCRACKEN
Black Cross
1963
Acrylic on canvas
56 × 56 cm [22 × 22 in]

This is one of several paintings completed by McCracken in 1963–64 incorporating such emblems as arrows, crosses and chevrons. Inspired by the diagrammatic works of Ellsworth Kelly, Robert Indiana and Kenneth Noland made during the late 1950s and early 1960s, as well as the Supremacist paintings of Kasimir Malevich, McCracken began to use emblematic formats in order to simplify and strengthen the visual impact of his work. This painting alludes to Malevich's famous *Black Cross* (c. 1913).

1964–67 HIGH MINIMALISM

During the mid 1960s, group shows such as 'Black, White, and Gray' and 'Primary Structures' established Minimal art as a significant new movement. Each of the leading figures associated with Minimalism developed a style of austere, serial or whole geometric forms. Donald Judd began to use factory production, creating boxes and stacks in iron, anodized aluminium and Plexiglas; Robert Morris built all-grey plywood pieces and mirrored cubes; Dan Flavin mounted fluorescent lamps on the wall and floor. Carl Andre's brick pieces and metal planes, Sol LeWitt's open cube lattices, Anne Truitt's asymmetrical metal solids, Larry Bell's glass boxes and John McCracken's lacquered works were also developed during these years. Younger artists including Robert Smithson, Mel Bochner and Eva Hesse transformed the serial logic and geometric forms of the new sculpture into highly distinctive idioms. When Frank Stella, the painter most associated with Minimalism, rejected his stripe format in 1966, it was left to Robert Ryman, Jo Baer, David Novros, Robert Mangold, Ralph Humphrey, Agnes Martin, Paul Mogensen and Brice Marden to breathe new life into the monochrome canvas.

'Black, White, and Gray'
Wadsworth Atheneum, Hartford, Connecticut
9 January-9 February 1964
Tony SMITH
Die
1962
Steel
183 × 183 × 183 cm [6 × 6 × 6 ft]

Tony Smith's *Die* was fabricated by professional steelworkers, thus ensuring that any possibility of a reading of the object as a direct result of the individual artist's touch was completely removed. The title makes reference both to its resemblance to a playing die, and to the imperative tense of the verb 'to die', while its scale makes obvious reference to the human form, thus creating a sense of foreboding. The expressive quality of Smith's colour and allusions distinguished his work from the avowedly contentless, literalist art of the younger Minimalists.

This exhibition, curated by Samuel J. Wagstaff, Jr, sometimes referred to as the 'first' Minimal show, included the work of the Minimal artists Robert Morris, Anne Truitt and Dan Flavin alongside that of the Pop artists Andy Warhol and Roy Lichtenstein as well as their influential predecessors Robert Rauschenberg and Jasper Johns. The black geometric sculpture of Tony Smith was also presented for the first time in a museum. All of the work in the show was extremely limited in colour: only work in black, white and grey was included. Although stylistically diverse, this disparate group of artists was identified as epitomizing an emerging 'cool' sensibility.

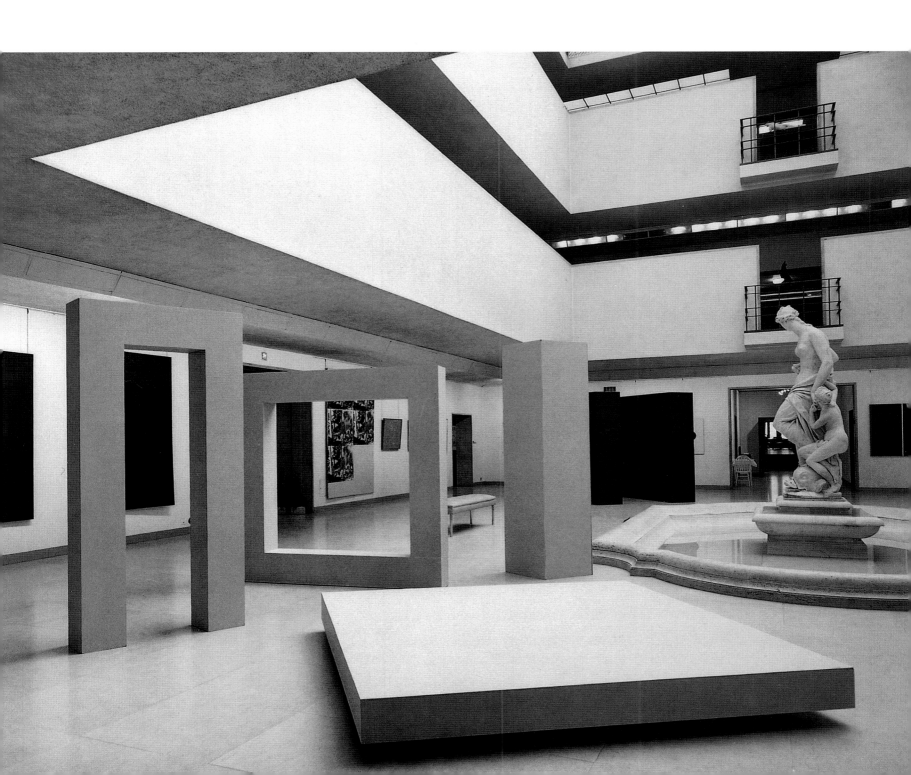

'Black, White, and Gray'
Wadsworth Atheneum, Hartford, Connecticut
9 January-9 February 1964
Installation view

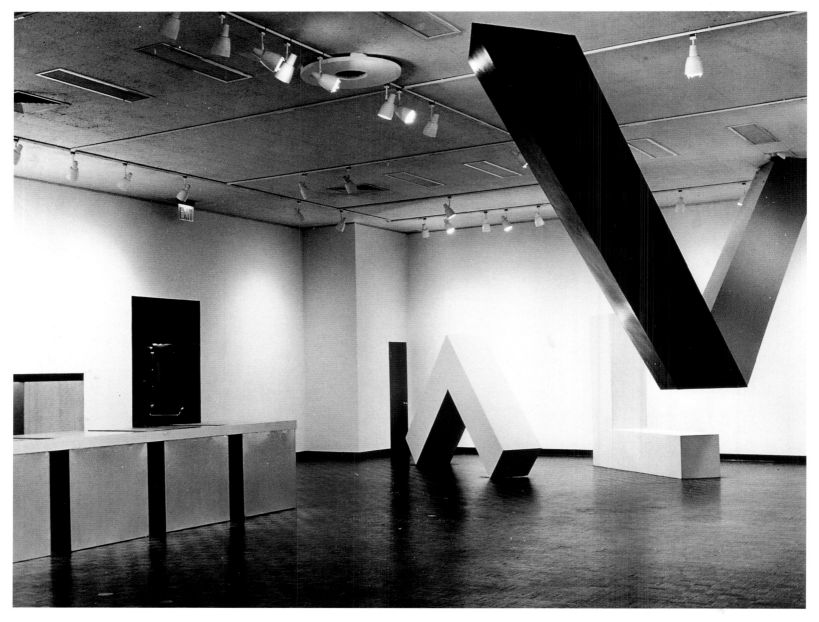

'Primary Structures'
Jewish Museum, New York
27 April–12 June 1966
Installation view

Often considered the exhibition that ushered in Minimalism as a movement, 'Primary Structures' actually included a wide range of works by forty-two American and British artists. This exhibition, organized by Kynaston McShine, received extensive publicity in both the specialist and popular press, including *Newsweek* and *Life* magazines. Although they did not necessarily receive the most congratulatory reviews, Andre, Flavin, Judd, LeWitt and Morris, who were all in this show, soon emerged as Minimalism's key figures.

opposite
'Primary Structures'
Jewish Museum, New York
27 April–12 June 1966
Dan FLAVIN
monument 4 those who have been killed in ambush (to P.K. who reminded me about death)
1966
Red fluorescent light
3 units, 244 cm [96 in] each; 345 cm [136 in] overall

First shown at 'Primary Structures', this construction of red fluorescent tubes demarcates a gallery corner. Two tubes are hung on adjacent walls meeting in the corner and a third spans the corner, creating a triangular projection into real space. The red glow from the lights illuminates that entire portion of the gallery, extending beyond the physical boundaries of the tubes themselves, and moreover reveals the corner as a place of display. Both the title and the red colour reflect Flavin's awareness of the growing death toll of the burgeoning Vietnam war. Following the Jewish Museum show, it was then hung in the back room at Max's Kansas City, a famous bar where many New York artists used to congregate during the 1960s and 1970s.

Walter DE MARIA
Cage
1961-65
Stainless steel
216 × 37 × 37 cm [85 × 14.5 × 14.5 in]

Walter De Maria began constructing geometric sculptures in the early 1960s, including his famous steel *Cage* shown in 'Primary Structures'. Unlike many of the Minimalists, he did not intentionally seek a refinement of the object pared of all metaphorical allusions. *Cage* both refers to the composer John Cage, whose aesthetic of 'meaninglessness' is suggested by the work's simple, repetitive structure, and an actual cage, or a constricting, barred environment. 'By meaningless work I simply mean work which does not make you any money or accomplish a conventional purpose. For instance, putting wooden blocks from one box to another, then putting the blocks back to the original box, back and forth … '
– Walter De Maria, Artist's statement, 1961

above left and right
'Systemic Painting'
Solomon R. Guggenheim Museum, New York
21 September-27 November 1966
Installation in progress

Lawrence Alloway organized 'Systemic Painting' for the Solomon R. Guggenheim Museum in New York, which opened in September 1966. It included works by twenty-eight artists, including Jo Baer, Ralph Humphrey, Ellsworth Kelly, Robert Mangold, Agnes Martin, David Novros, Robert Ryman and Frank Stella. Alloway defines 'systemic' as a type of painting that moves away from expressionism by using single fields of colour, often repeated, or grids and geometric shapes. The systemic painter knows the final result of the work before its completion; the planning occurs conceptually and in preliminary sketches, not on the canvas itself.

'Systemic Painting'
Solomon R. Guggenheim Museum, New York
21 September-27 November 1966
Jo BAER
Primary Light Group: Red, Green, Blue
1964
Oil and synthetic polymer on canvas
Triptych, 153 × 153 cm [60 × 60 in] each
Collection, The Museum of Modern Art, New York

In the catalogue for 'Systemic Painting', Baer states that the three canvases are part of a series of twelve primary-coloured paintings, yet each canvas is a different size and shape: small squares, large squares, vertical rectangles and horizontal rectangles. The canvases in this work are large squares, measuring 153 × 153 cm [5 × 5 ft]. Baer focuses on the variations in the appearance of the canvases when the black border is juxtaposed with a different primary colour, as well as the immense number of permutational possibilities in a series of twelve canvases: the works could be arranged in 831,753,600 different combinations of shapes and primary colours.

HIGH MINIMALISM

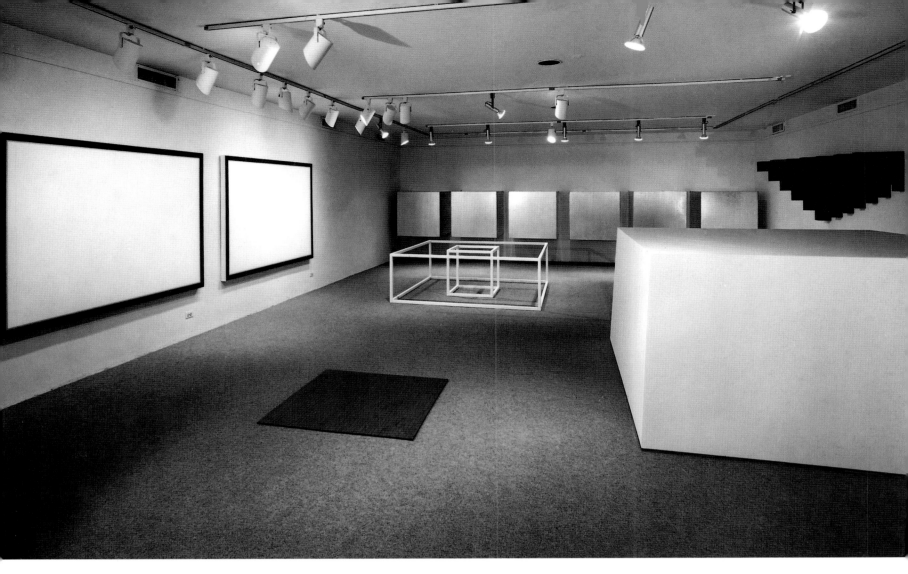

'10'
Dwan Gallery, New York
4-29 October 1966
clockwise l. to r.,
Carl <u>ANDRE</u>
Field
1966
Jo <u>BAER</u>
Horizontal Flanking: large scale
1966
Donald <u>JUDD</u>
Untitled
1966
Sol <u>LEWITT</u>
A5
1966
Robert <u>SMITHSON</u>
Alogon
1966
Robert <u>MORRIS</u>
Untitled
1966

In the autumn of 1966 art dealer Virginia Dwan brought together the ten painters and sculptors most associated with the new pared-down geometric style. This important exhibition placed such emerging artists as Andre, Baer, Flavin, Judd, LeWitt, Morris, Smithson and Michael Steiner alongside such established figures as Agnes Martin and Ad Reinhardt.

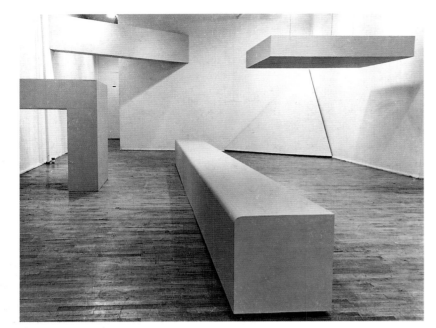

Robert MORRIS
Green Gallery, New York
1964
Installation view

For this solo exhibition, Robert Morris installed seven grey geometric plywood structures. The massive structures occupied the actual physical space of the gallery, forcing the viewer to be aware of his or her position in space in relation to the artwork as well as in relation to the volume of the room itself. *Untitled (Corner Piece)* fit in to the corner of the gallery. The back and sides of the work disappeared in to the wall. By filling the negative space of the corner, Morris' sculpture made the usually overlooked corner visible as a literal space and altered the room's volume.

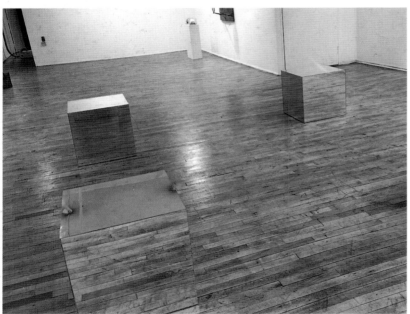

Robert MORRIS
Mirrored Cubes
1965
Plexiglas mirrors, wood
21 × 21 × 21 cm [53 × 53 × 53 in]
Installation view

In this second solo exhibition at the Green Gallery, New York, Morris continued to work with structures designed to affect the viewer's experience of the space, this time filling the gallery with a series of his cast lead wall reliefs and four *Mirrored Cubes*. The *Cubes* were arranged in a grid pattern across the gallery floor, creating obstructions. Their mirrored sides caused the cubes to appear to dissolve in to the wooden floors and white walls, and cast the viewer's reflection back upon him or herself.

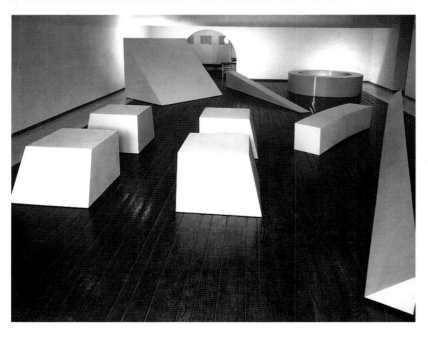

Robert MORRIS
Dwan Gallery, Los Angeles
1966
Installation view

Morris exhibited six works at the Dwan Gallery, Los Angeles, in 1966, all of which were untitled. They were constructed from wood and fibreglass, rigid materials he used to create familiar, weighty shapes. The one broken circle in the show incorporated a fluorescent light. The two grey hemispheres are placed with a thin gap separating them; the light in between reveals each form as distinct while at the same time dissolving the clear contours of their individual shapes.

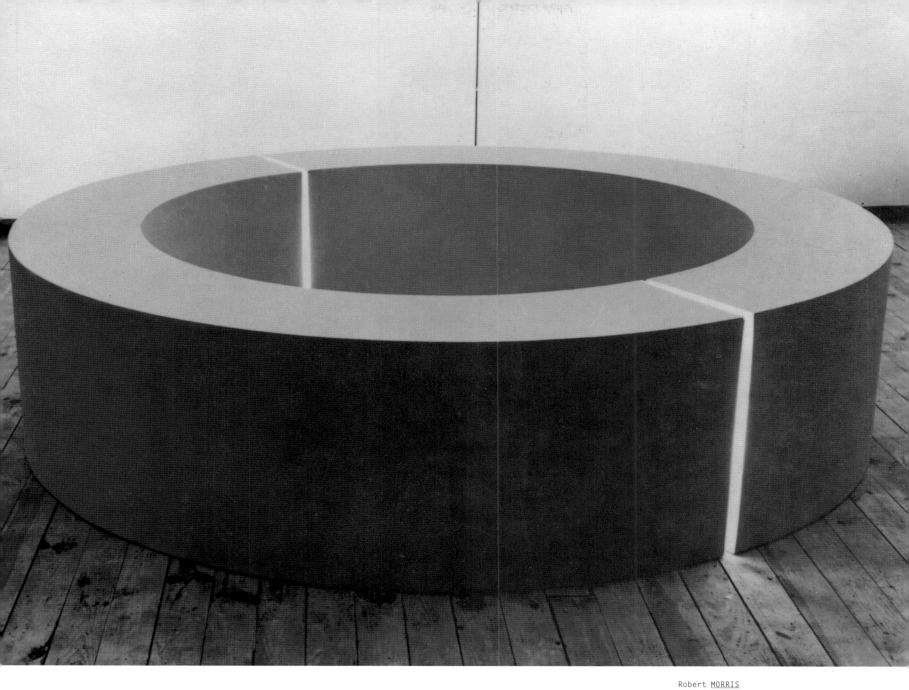

Robert MORRIS
Untitled (2 Half-Circles with
Light)
1966
Painted wood, fibreglass,
fluorescent light
61 × 244 cm [2 × 8 ft] each

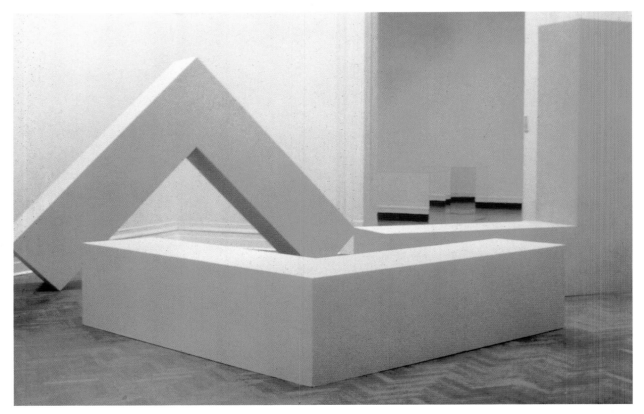

Robert <u>MORRIS</u>
Untitled (L-Beams)
1965-67
Fibreglass
2 units, 244 × 244 × 61 cm [96 ×
96 × 24 in] each
Installation view, Stedelijk Van
Abbemuseum, Eindhoven, 1968

Morris originally planned to construct a series of nine *L-Beams*, grey fibreglass structures with a 90-degree angle halfway down their length. Initially only three were built: although the work now exists in different versions, it is always shown with three units. The positioning of the structures causes them to appear to be different forms, although they are identical in every way. The viewer is aware of having contradictory impressions of the scale of each *L-Beam*.

Robert <u>MORRIS</u>
Untitled (Quarter-Round Mesh)
1967
Steel grating
79 × 277 × 277 cm [31 × 109 × 109
in]
Installation view, Stedelijk Van
Abbemuseum, Eindhoven, 1968
Collection, Panza Collection,
Solomon R. Guggenheim Foundation,
New York

By the mid 1960s Morris had begun to move away from making only solid, rigid structures. With *Quarter-Round Mesh* he introduced the use of an open material that would allow the viewer to see inside the structure yet could still retain a solid form. The structure was fabricated at the Lippincott factory in Connecticut from Morris' design. It has a flat, square base, four rounded sides and an open centre. Morris called this form 'toroid'.

Robert <u>MORRIS</u>

Untitled (Stadium)
1967
Steel
8 units, 119 × 122 × 119 cm [47 ×
48 × 47 in] each
Collection, Panza Collection,
Solomon R. Guggenheim Foundation,
New York

In his *Permutation* works of 1967, Morris constructed a number of wedge-shaped units in fibreglass, steel and aluminium. These were intended to be rearranged on a daily basis in a variety of round, linear and rectangular configurations, following a schematic plan. In the first few days of March the units were arranged into a square, in mid March an oval, then into a sphere and eventually a straight line. Although the wedges are geometric and painted a neutral grey as in his earlier structures, the units can no longer be seen as individualized and singular, but as parts of a serial cluster of constantly changing formations.

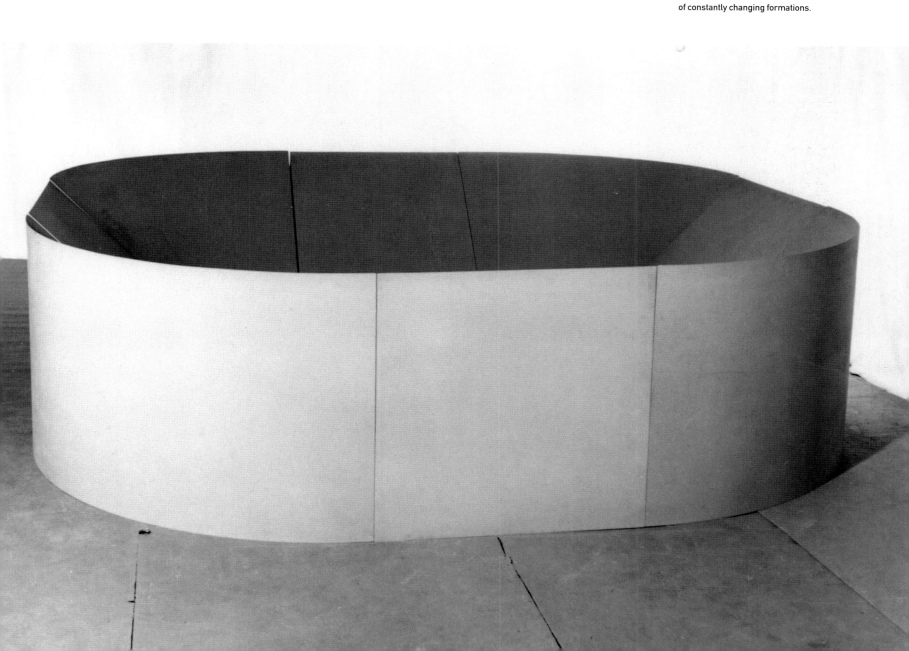

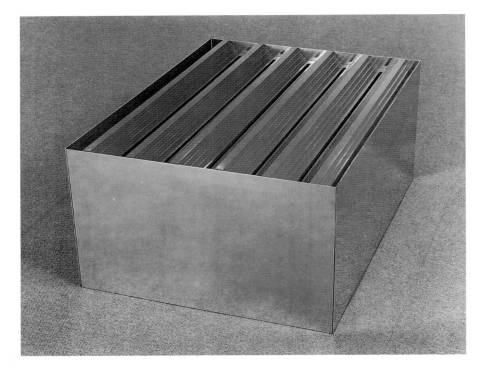

above
Donald <u>JUDD</u>
Untitled
1964
Red painted wood, brass
55 × 93 × 125.5 cm [21.5 × 36.5 × 49 in]
Judd began fabricating objects in March of 1964, first with the assistance of his father, then by employing professional industrial fabricators. He was frustrated with the lack of precision of his earlier handmade wooden objects. The perfect finish of the industrially fabricated metal focuses the viewer's attention on the work itself rather than the artistic craftsmanship or subjective motivations of the artist. This brass box is mounted on top by six identical wooden struts whose cadmium red enamel finish contrasts with the sheen of its brass support, stressing the difference between the different materials in the work.

opposite top
Donald <u>JUDD</u>
Untitled
1964
Light cadmium red enamel, galvanized iron
39.5 × 236 × 198 cm [15 × 93 × 78 in]
Soon after his December 1963 exhibition of wooden sculptures and reliefs at the Green Gallery, New York, Judd commissioned his first metal objects. At first he designed wooden works covered in a metal skin, then soon fabricated completely iron pieces, such as this 1964 work. He continued to use the cadmium red paint here, but now Judd avoids the graininess and mass of the wooden structures, preferring the even metal surface and the seemingly lightweight hollow form. Using rounded corners, Judd synthesized a rectangular and an oval form. The work is a dual structure, comprised of both the closed ring and the interior negative space which it demarcates.

opposite bottom
Donald <u>JUDD</u>
Untitled
1965
Galvanized iron, lacquer
38 × 203 × 66 cm [15 × 80 × 26 in]
Collection, Walker Art Center, Minneapolis
These objects were industrially made so as to ensure a smooth, uniform surface, allowing the viewer to perceive the object without any visual distractions.

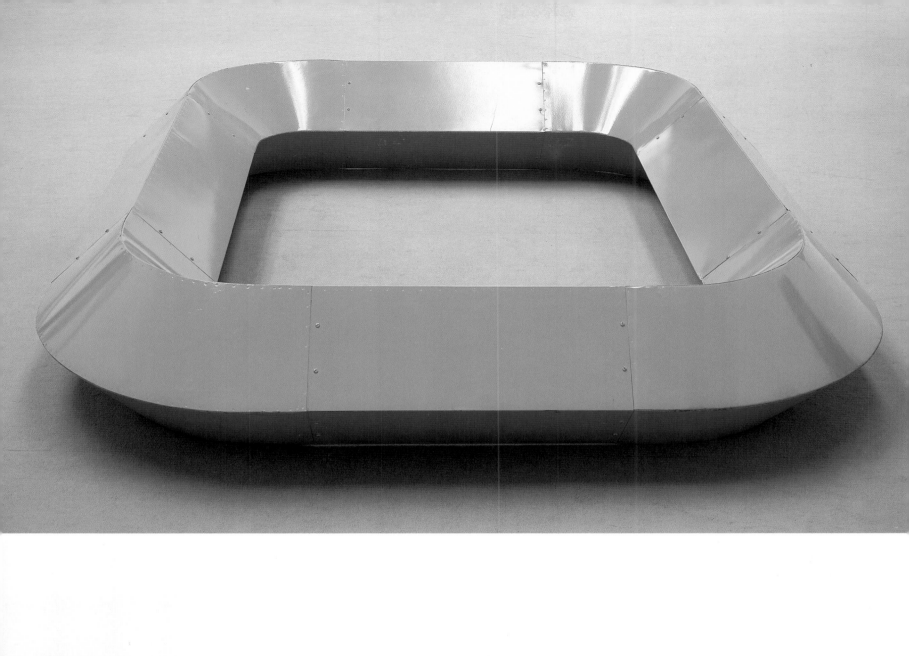

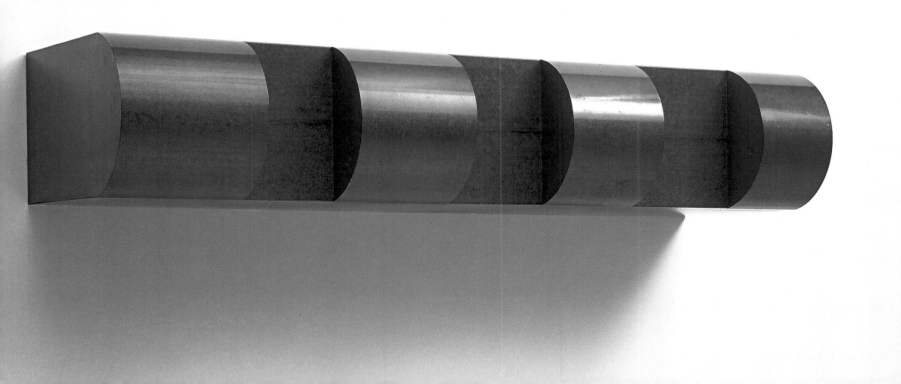

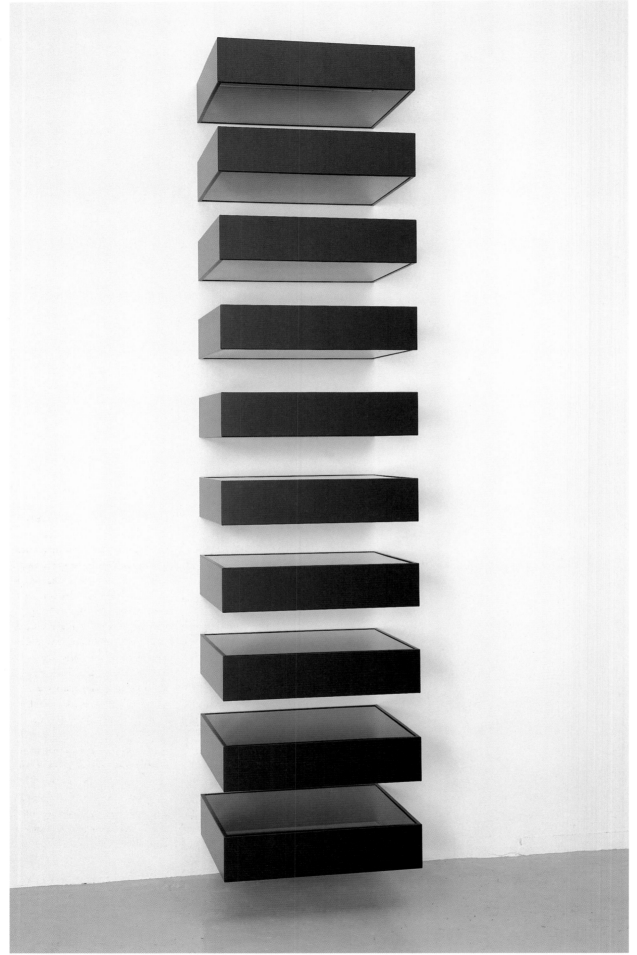

Donald <u>JUDD</u>
Untitled
1990 (First type 1965)
Black anodized aluminium, bronze
Plexiglas
10 units, 15 × 68.5 × 61 cm [6 × 27 × 24 in] each

Judd created the first vertical 'stack' in 1965, and continued to develop this form throughout his career. They usually consist of ten units placed vertically on the wall in a precisely ordered configuration (fewer units may be used if the given space has a low ceiling height). This form makes evident his intention to eliminate any reference to individual craftsmanship or artistic handiwork. The same form is repeated ten times, with the spaces between the units the same as the space occupied by the unit. It is not a complete composition with clearly limited boundaries, but part of a potentially limitless system based on a singular principle of ordering; it avoids part-to-part and figure/ground relationships by repeating 'one thing after another'. Although these structures are technically sculptural reliefs, since they rely upon the gallery wall for support, Judd refers to them as Specific Objects, three-dimensional works that are 'neither painting nor sculpture'.

HIGH MINIMALISM

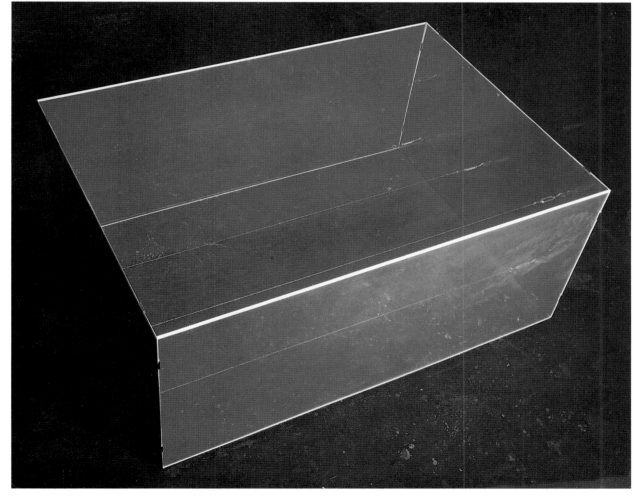

Donald <u>JUDD</u>
Untitled
1965
Red fluorescent Plexiglas, steel
51 × 122 × 86 cm [20 × 48 × 34 in]
Judd's earliest Plexiglas boxes are held stable by tension wires strung inside the structure, which can be seen through the translucent Plexiglas. In this work, first exhibited at the John Daniels Gallery, New York, in 1965, the top and sides are made of coloured Plexiglas, the ends are steel and the bottom is open. The Plexiglas surface has a mechanized sheen; the fluorescent colour is an intrinsic part of the material rather than an applied coating. The artist and critic Robert Smithson praised Judd's use of this transparent material which has the ability to make both the interior and the exterior equally visible. However, the critic Rosalind Krauss accused Judd of creating a type of optical illusionism that contradicts his self-proclaimed belief in a literalist art.

Donald JUDD

Untitled

1965

Perforated 16-gauge cold-rolled steel

20 × 168 × 305 cm [8 × 66 × 120 in]

This work, which exists in several nearly identical versions, was first exhibited at Donald Judd's solo exhibition at the Leo Castelli Gallery, New York, in 1966. Judd designed a wedge-shaped plate of unpainted cold-rolled steel perforated throughout with small holes. The lowest end of the work comes to a narrow point where it meets the gallery floor, while the tallest end of the triangular form stands 20 cm [8 in] high. The object is a whole, singular form, although two lines divide the work into three parts, creating a serial segmentation.

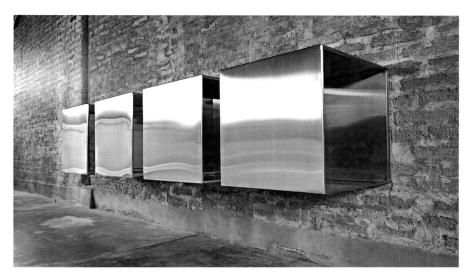

Donald JUDD
Untitled
1966
Stainless steel, amber Plexiglas
4 units, 86 × 86 × 86 cm [34 × 34 × 34 in] each

This work exemplifies Judd's embrace of industrially made materials and factory production in the mid 1960s. It was obvious to Judd that, in order to achieve the high quality he sought, employing specialized workers would produce much better work than he would ever achieve by fabricating it himself. The units project 86 cm [34 in] from the wall, and each of the four identical stainless steel cubes has translucent amber Plexiglas side panels.

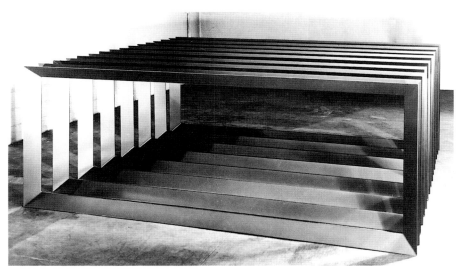

Donald JUDD
Untitled
1966
Turquoise enamel on aluminium
8 units, 122 × 305 × 20 cm [48 × 120 × 8 in] each; 122 × 305 × 305 cm [48 × 120 × 120 in] overall; 20 cm [8 in] spaces between

Judd used repeating turquoise enamelled aluminium rectangles in this work shown at the Whitney Museum of American Art 'Annual Exhibition' in 1966–67. It reduces part-to-part relationships to an elemental series: Judd used an additive schema to determine the total length and the distance of the space between each unit. The application of mathematical systems eliminated any seemingly intuitive artistic intent.

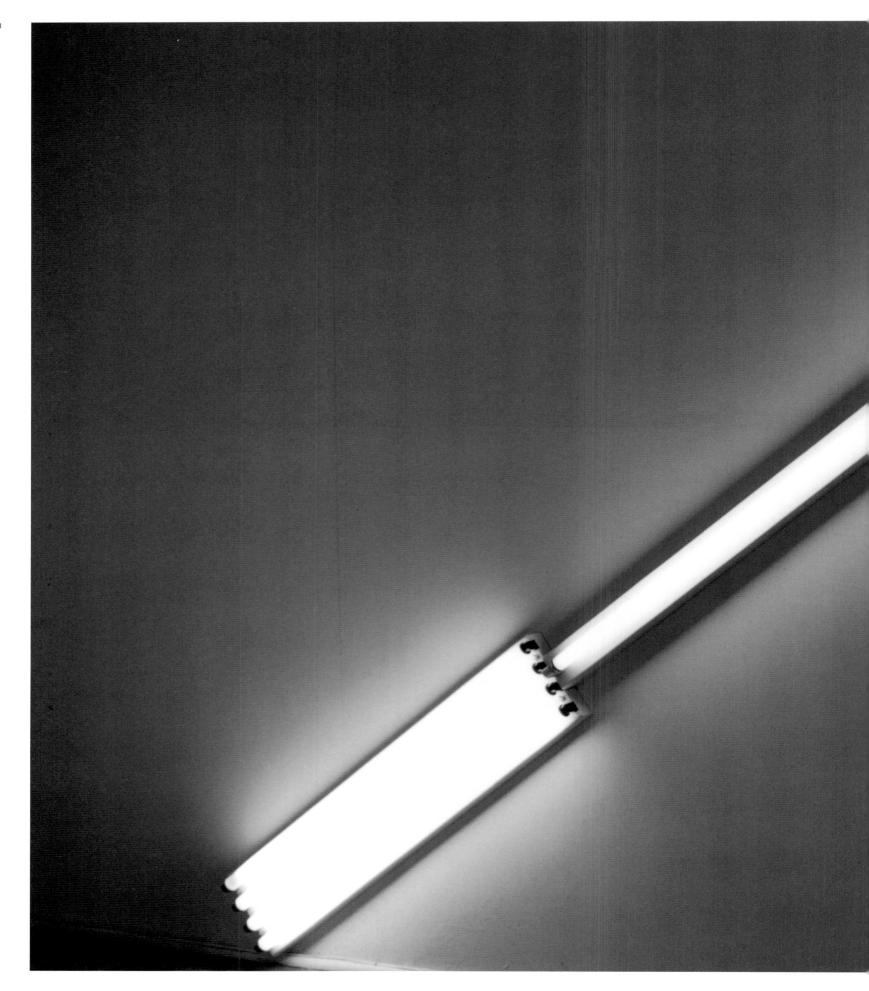

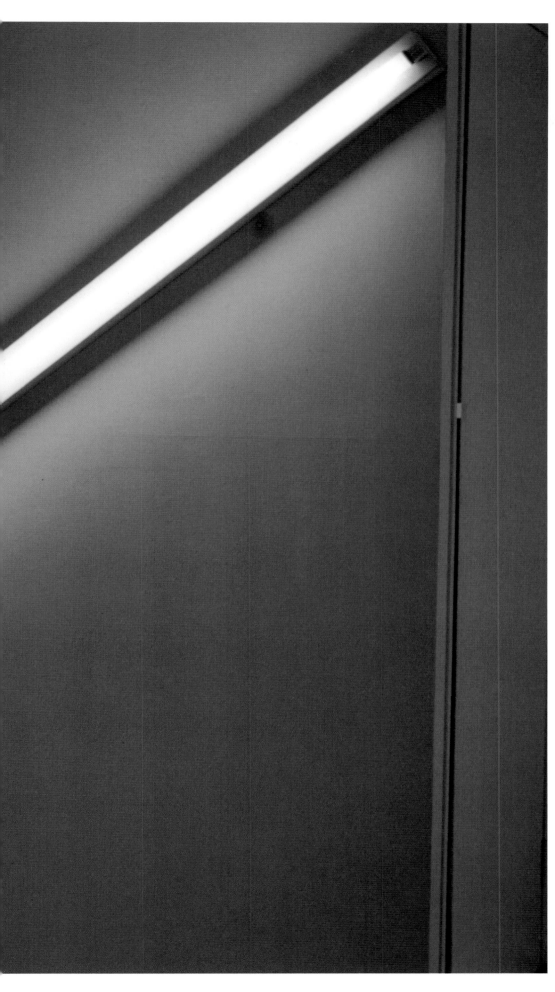

Dan <u>FLAVIN</u>
alternate diagonals (to Don Judd)
1963
Daylight and cool white
fluorescent light
1. 366 cm [12 ft]

WORKS

Dan FLAVIN
'some light'
Kaymar Gallery, New York
5-29 March 1964
Installation view

Six of Flavin's *icons*, chosen from his first series of eight works made using electric lights, lined the wall of his first solo show. Consisting of relief boxes and both incandescent and fluorescent lights, they varied in colour, shape and formal effect. The term 'icon', normally associated with Byzantine religious imagery, has been used by Flavin to name a new abstract art form that stresses perceptual, rather than transcendent, experience.

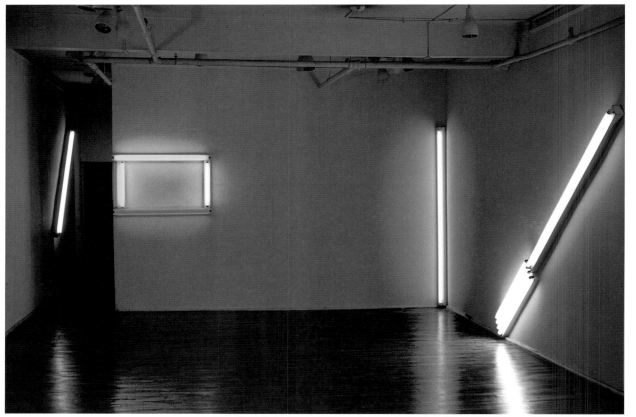

Dan FLAVIN
'fluorescent light'
Green Gallery, New York
18 November-12 December 1964
Installation view

In his first show made solely with fluorescent lights and their fittings, Flavin carefully planned and sketched the placement of each structure within the gallery space, working with the way the experience of the room could be altered through the placement of the individual lights. The white, pink and multicoloured lights reflected off the shiny wooden floors and white walls, causing the entire gallery to become illuminated with their coloured glow. This show marked a shift from the individual *icons* to the creation of an environment of diffused light, expanding the notion of Minimalist art to include installations of artworks created for a specific location.

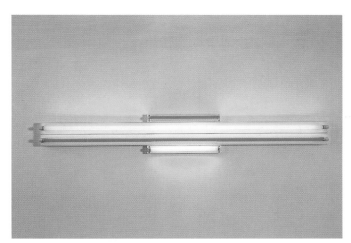

Dan <u>FLAVIN</u>
red and green alternatives (to Sonja)
1964
Fluorescent light
l. 244 cm [8 ft]

Flavin experimented with the juxtaposition of differently coloured fluorescent lights, here placing red next to green. This work was dedicated to Sonja Severdija, then his wife, who installed many of his fluorescent light structures at this time. The juxtaposition of complementary hues caused the red to appear a deeper tone than the bulbs would on their own, while the green remained unaffected. It was included in 'fluorescent light', an exhibition at the Green Gallery, New York.

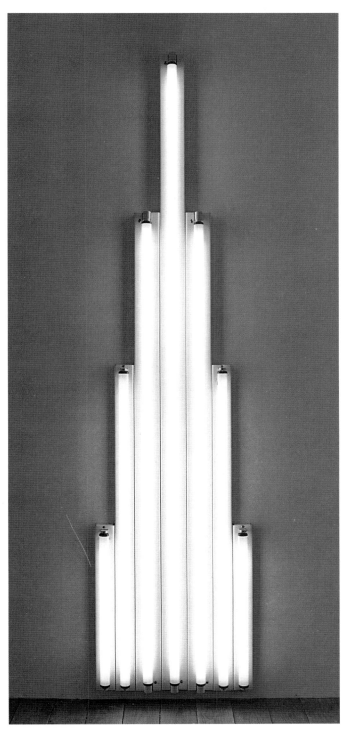

Dan <u>FLAVIN</u>
monument I (to Vladimir Tatlin)
1964
Cool white fluorescent light
h. 244 cm [8 ft]

The first of Flavin's *Monuments to Tatlin* consists of a central, vertically placed fluorescent light flanked on either side by three more fluorescent lights in descending size. This work schematically recalls the Russian artist's famous *Monument to the Third International* (1921), an enormous spiral structure commemorating the Communist Party and intended to serve as an information centre for the new government following the Bolshevik Revolution (it was never built). The dedication to Tatlin in the title and its shape serve as a testament to Flavin's longstanding fascination with Russian Constructivism, an avant-garde art movement associated with the Communist Revolution whose formal innovations anticipated aspects of Minimal practice. Flavin updates the Constructivist emphasis on a simple organization of industrial materials by his use of industrially produced fluorescent lights, yet sublimates the political ambitions of Tatlin's monument in favour of a primarily visual effect.

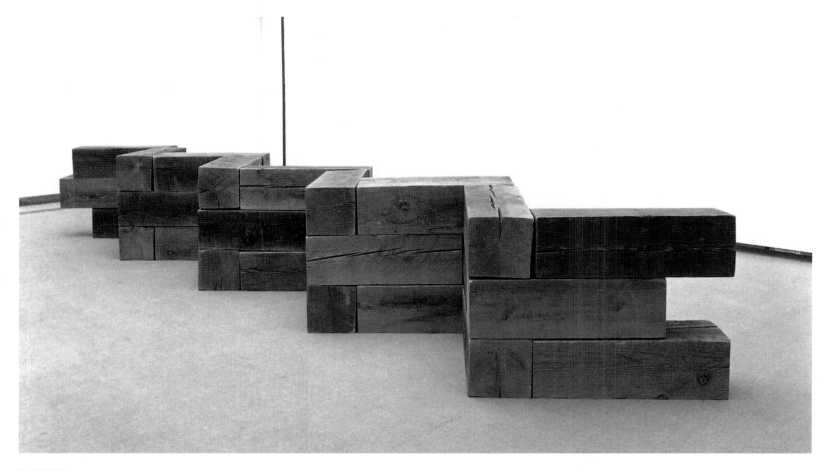

Carl ANDRE
Redan
1964 (destroyed), remade 1970
Wood
27 units, 30.5 × 30.5 × 91.5 cm [12 × 12 × 36 in] each
Collection, Art Gallery of Ontario, Toronto

Redan, first shown in 'Shape and Structure' at the Tibor de Nagy Gallery, New York, in 1965, is constructed from unaltered pre-cut lengths of timber. Andre built a zigzag wall by interlocking the planks at five separate right angles, allowing the ends of the middle tier to project as if ready for further interlocked units. The result is a sculpture that spreads its weight laterally across the floor, anticipating the development of his horizontal works such as *Lever* and *Equivalents* in 1966.

opposite left to right
Carl ANDRE
Crib
1965
Carl ANDRE
Compound
1965
Carl ANDRE
Coin
1965
Installation view, Tibor de Nagy Gallery, New York

Andre's notion of 'sculpture-as-place', or sculpture that reveals its surroundings, was powerfully demonstrated in his first solo exhibition at the Tibor de Nagy Gallery, New York, in 1965. The works in this show filled the gallery, blocking the viewer's vision and mobility, making it difficult to manoeuvre around the room and impossible to view any single work in its entirety. The installation consisted of three massive forms built of 274-cm [9-ft]-long polystyrene planks stacked one on top of another. The tallest structure, *Coin*, was an open latticework of planks, while the shorter *Compound* was made of planks laid horizontally. *Crib* was placed in the middle of the room, the planks placed at right angles to create an open cubic space in the interior of the sculpture.

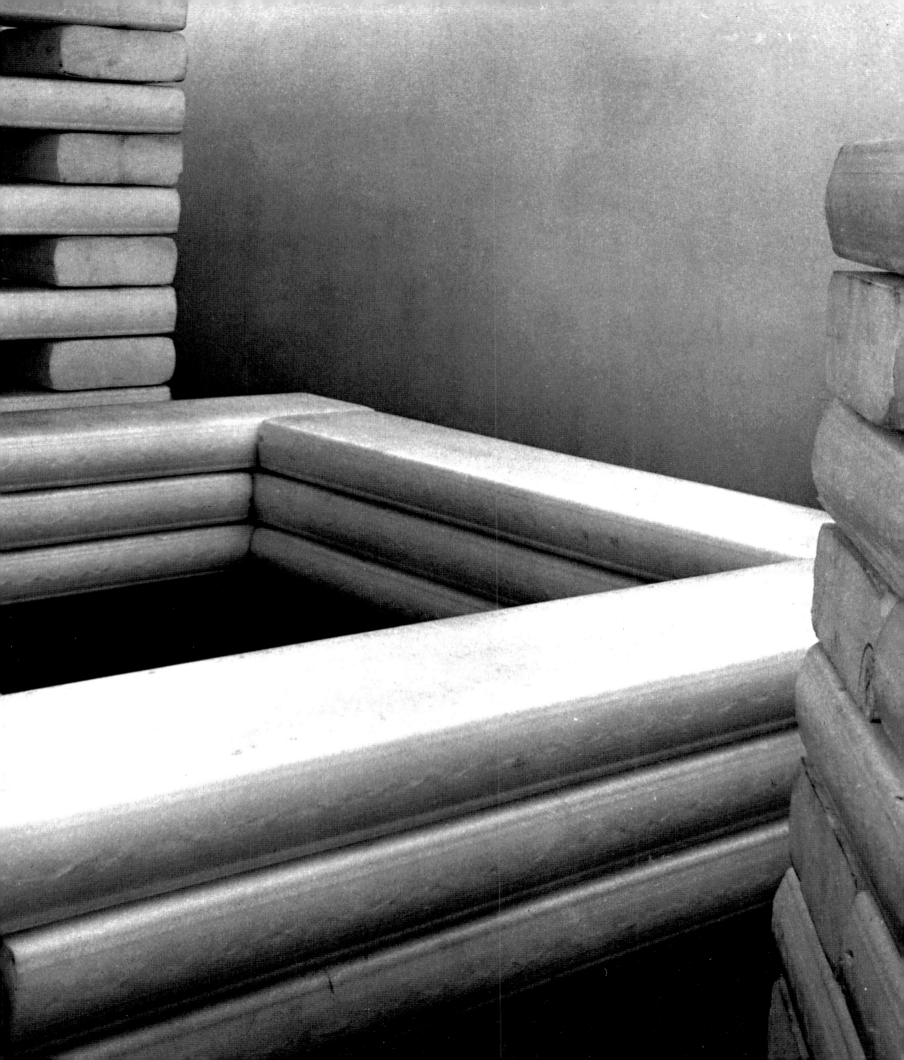

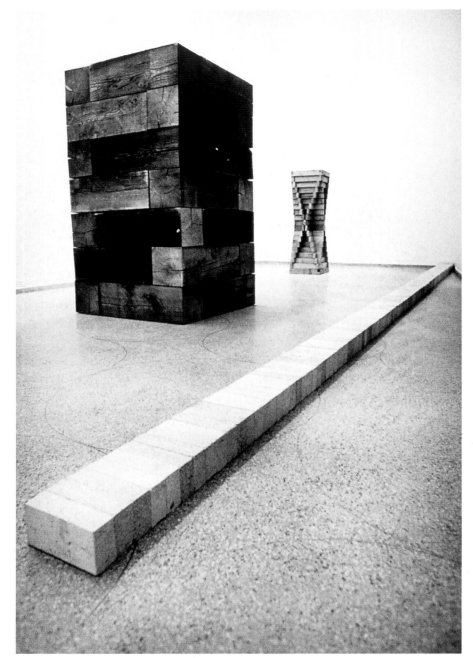

front to back
Carl ANDRE
Lever
1966
Carl ANDRE
Well
1964 (destroyed), remade 1970
Carl ANDRE
Pyramid (Square Plan)
1959 (destroyed), remade 1970
Installation view, Solomon R. Guggenheim Museum, New York, 1970

In 1970 Andre exhibited over sixty artworks completed between 1958 and 1970 at the Solomon R. Guggenheim Museum, New York, including sculptures first exhibited in the Jewish Museum's ground-breaking show of Minimal art, 'Primary Structures'. *Lever* was specifically designed for its site. The work, consisting of 137 firebricks laid in a straight line, was originally intended to span the doorway between two galleries, so that each entrance would offer a unique view of the object. Viewers were shocked that the sculpture consisted of nothing more than bricks placed upon the floor. *Well*, originally constructed in 1964 and remade in 1970, consists of twenty-eight lengths of timber, stacked without the use of mortar. Although the interior is hollow, the height makes viewing the interior impossible, and the work appears to be a solid structure. The 1959 sculpture *Pyramid* (*Square Plan*) was also remade for this exhibition. This work is also made of wooden beams, yet the timbers are more narrow, and have slots cut into each so that they hinge together, tapering inward in the centre to form a cross.

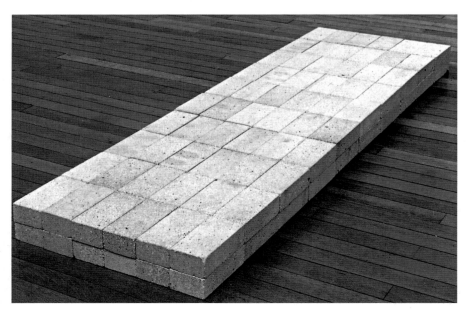

Carl ANDRE
Equivalent VIII
1966
120 fire-bricks
13 × 69 × 229 cm [5 × 27 × 90 in]
Collection, Tate Gallery, London

In the spring of 1966, Andre exhibited eight *Equivalents* at the Tibor de Nagy Gallery, New York. A numerical sequence determines four different arrangements of an identical number (120) of bricks placed directly on the floor: 3 × 20, 4 × 15, 5 × 12, 6 × 10. For each equation, Andre produced two configurations, arranging the bricks both along their short ends and their long ends, two layers deep. Distributed according to a grid plan, the low piles revealed the surrounding floor and the gallery's cubic volume.

Carl ANDRE
Spill (Scatter Piece)
1966
Plastic, canvas bag
Dimensions variable

In this work, gravity and chance alone determine the placement of the 800 plastic blocks spilled from a canvas bag on to the gallery floor. Thus, each time the work is installed, the blocks will create different patterns. Although each individual unit is a Minimalist geometric solid, the action-based installation disrupts the coherence and serial structure usually associated with Minimalism and points to the post-Minimal decomposition of solid, rigid form associated with the felt works of Robert Morris and the sculpture of Eva Hesse.

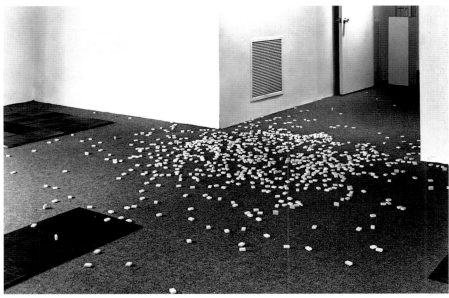

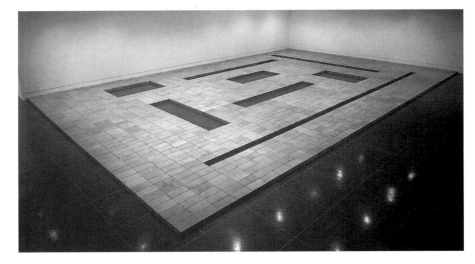

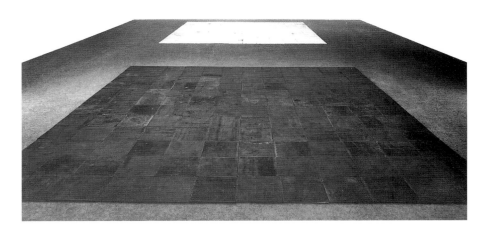

left

Carl <u>ANDRE</u>
8 Cuts
1967
Concrete capstone blocks
1472 units, 5 × 20 × 41 cm [2 × 8 × 16 in] each; 5 × 935 × 1300 cm [2 × 368 × 512 in] overall
Installation view, Dwan Gallery, Los Angeles

At the Dwan Gallery, Los Angeles, in 1967 Andre filled the gallery with a layer of concrete capstone blocks, leaving eight negative spaces in the installation. These spaces corresponded to the configurations of *Equivalents* that he had shown the previous year at Tibor de Nagy Gallery, New York, substituting empty volumes for dense solids. This work overtakes the entire space, forcing the viewer to walk upon the unhinged blocks in order to view the work.

above, foreground
Carl <u>ANDRE</u>
144 Steel Square
1967
Steel
366 × 366 cm [12 × 12 ft]
above, background
Carl <u>ANDRE</u>
144 Aluminum Square
1967
Aluminium
366 × 366 cm [12 × 12 ft]
Installation view, Dwan Gallery, New York

Andre began constructing large metal floor sculptures in 1967. For the first show of those works at the Dwan Gallery, New York, in 1967, he cut the metal plates acquired from the local salvage yard into 366 × 366 cm [12 × 12 ft] units, each unit representing the square root of the overall structure. Arranged in a simple geometric grid directly on the gallery floor, these works invite the viewer to walk upon the sculpture itself, entering into the actual space of the artwork. Andre commented on the unique experience of viewing such a sculpture: 'You can stand in the middle of it and you can look straight out and you can't see that piece of sculpture at all because the limit of your peripheral downward vision is beyond the edge of the sculpture.'
– Carl Andre, 'Interview with Phyllis Tuchman', *Artforum*, June 1970

opposite

Carl <u>ANDRE</u>
5 × 20 Altstadt Rectangle
1967
Hot-rolled steel
100 units, 25 × 25 cm [10 × 10 in] each; 250 × 1,000 cm [98.5 × 394 in] overall

In 1967 Andre made several sculptures composed of steel plates laid directly upon the gallery floor. Andre's first European exhibition, at the Konrad Fischer Gallery, Dusseldorf, in 1967, introduced his work to a European audience. Five plates wide and twenty plates long, it covered the entire expanse of the Fischer Gallery's narrow, rectangular space, perfectly conforming to the gallery's dimensions and defining the contours of the site. In later installations of the work, as pictured here, the sculpture shifted in scale and impact in conformity with the setting.

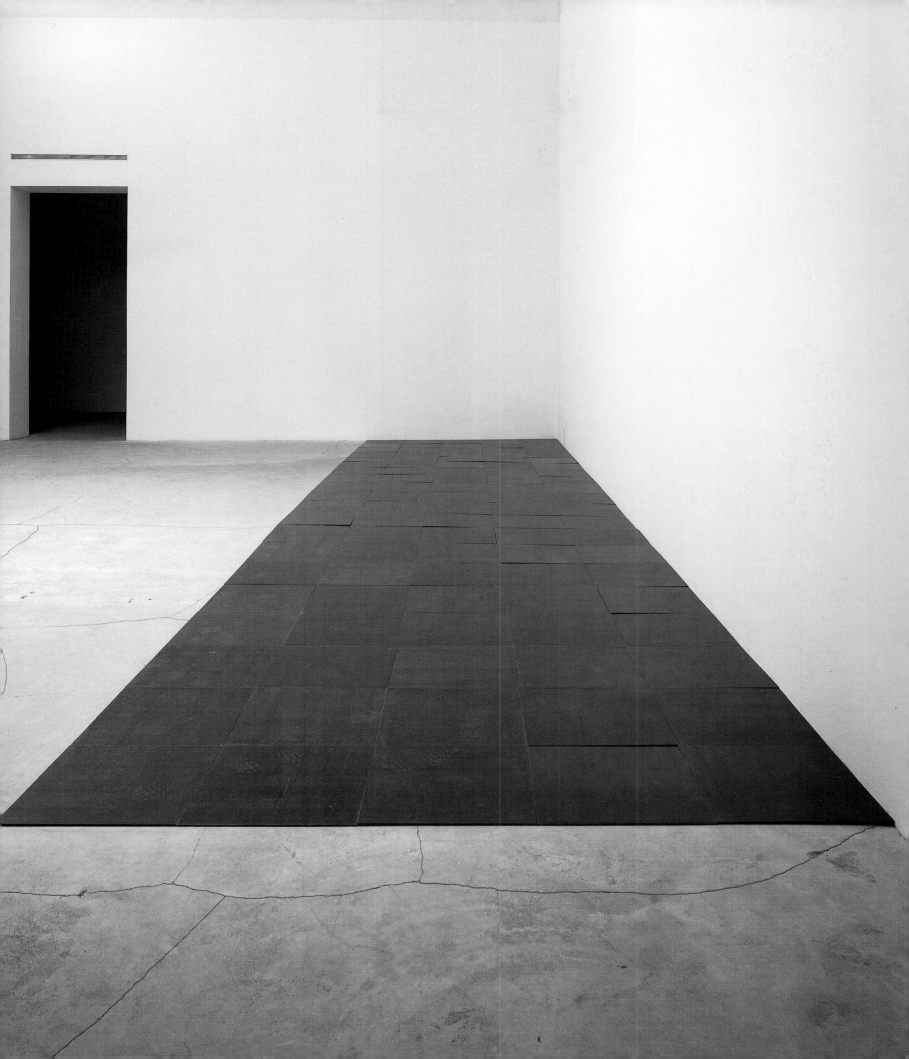

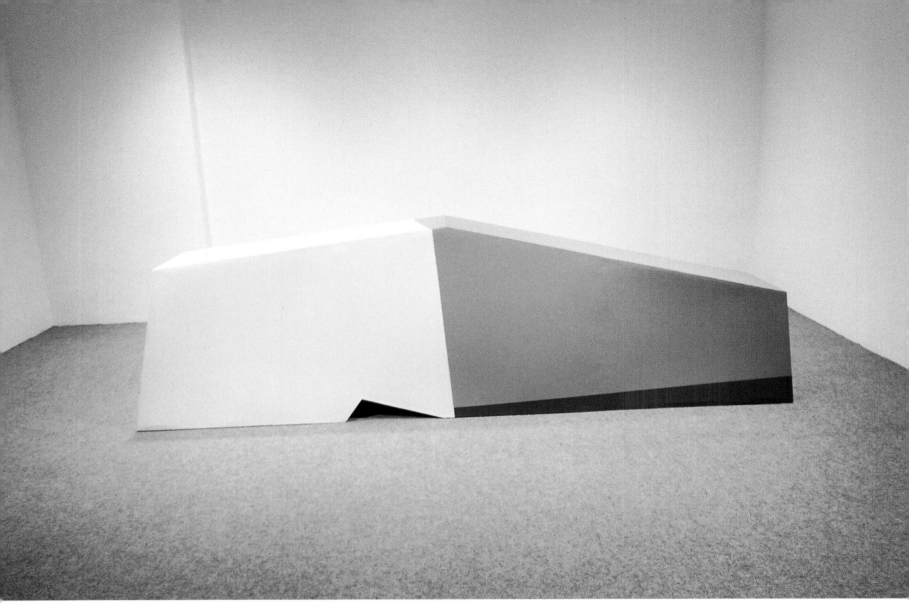

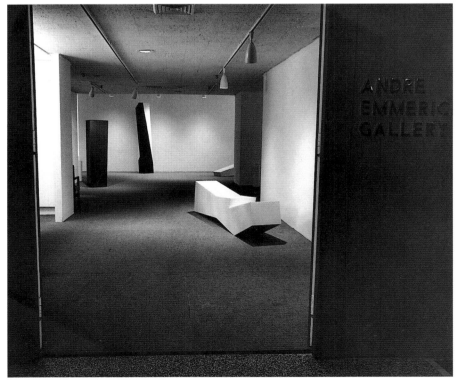

left
foreground
Anne <u>TRUITT</u>
Spring Run
1964
background left to right
Anne <u>TRUITT</u>
Here
1964
Anne <u>TRUITT</u>
Solstice
1964
Installation view, Andre Emmerich Gallery, New York, 1965

For her 1965 show at The Andre Emmerich Gallery, Truitt displayed works that broke from the tall rectangular and cubic shapes she had previously exhibited. The sculptures are more sprawling and irregular; asymmetrical and polyhedral rather than elemental. Instead of using hand-painted wooden objects, Truitt commissioned the works to be constructed in metal. She did not continue to work with industrial fabrication, preferring to return to more hand-crafted structures, even destroying the works in this show because of their disconnection from the artistic process.

opposite
Anne TRUITT
Sea Garden
1964
Metal
244 × 84 cm [96 × 33 in]

This work was exhibited at Truitt's 1965 show at the Andre Emmerich Gallery and at the Jewish Museum's 'Primary Structures' exhibition in 1966. It is one of her few industrially fabricated works. *Sea Garden* forms an irregular geometric shape that stretches 244 cm [8 ft] across the gallery floor, with an irregular bend in the middle. It is painted with vertical striations of white, green, yellow and blue. Truitt, who was living in Japan at the time of 'Primary Structures', sent a poem that attests to the importance of both colour and subtle allusions to nature in her work:

'There was a blue sea, and above it was a yellow hill and beside the hill was a green field.

On the other side of the blue sea was a blue sea, and on the other side of the yellow hill was a yellow hill, and on the other side of the green field was a green field.

And that was a sea garden.'

– Anne Truitt, *Primary Structures* [cat.], 1966

Larry BELL
Untitled Cubes
1965
Installation view, Pace Gallery, New York

Bell's early geometric sculptures, exhibited at the Pace Gallery in New York in 1965, are made of glass etched with illusionistic shapes and patterns, or unadulterated sheets of glass tinted in a vacuum-coating machine. Chemically bonded with various metals, Bell's material is gorgeously reflective. The cubes, placed on Plexiglas pedestals, set up complex reflections that incorporate the viewer and the gallery as part of the work.

Larry BELL
15" Glass Cube
1966
Glass
38 × 38 × 38 cm [15 × 15 × 15 in]

John <u>MCCRACKEN</u>
Manchu
1965
Lacquer, fibreglass, plywood
114 × 157.5 × 37 cm [45 × 62 × 14.5 in]

This work was exhibited in McCracken's first one-person show at the Nicholas Wilder Gallery, Los Angeles, in 1965. The show consisted of lacquered wooden reliefs mounted on pedestals or placed directly on the floor. The Wilder series is significant because it announced McCracken's transition from the production of paintings to objects. Although one of the largest and most massive sculptures in the series, *Manchu* still retains a frontal orientation and a bright, complementary painter's palette of red and green. McCracken's later works – including the well-known planks – continued to explore this overlap of painterly and sculptural qualities.

John <u>MCCRACKEN</u>
Blue Post and Lintel
1965
Plywood, fibreglass, lacquer
259 × 81 × 43 cm [102 × 32 × 17 in]
John <u>MCCRACKEN</u>
Yellow Pyramid
1965
Plywood, fibreglass, lacquer
121 × 183 × 183 cm [47.5 × 72 × 72 in]

McCracken gradually simplified his sculpture to the most basic shapes, such as cubes, pyramids and planks. The forms of these works, including ziggurats, door jambs and lintels, indicate McCracken's longstanding fascination with the architecture of ancient Egypt. Although he continued to admire the powerful scale and simplicity of Egyptian models, McCracken ultimately purged his work of specific allusions and developed a purely abstract art.

John <u>MCCRACKEN</u>
Page from sketchbook
1965
Pencil on paper
35.5 × 28 cm [14 × 11 in]

McCracken sketched many hypothetical, geometric forms composed of only one or two free-standing blocks. This page is a proposal for sculptures in yellow, blue and red, primary hues that McCracken deemed appropriate for his pared-down abstraction.

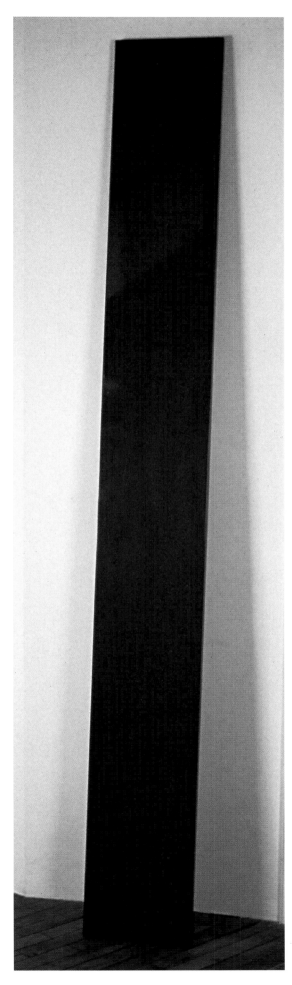

John <u>MCCRACKEN</u>
Blue Plank
1966
Polyester resin, fibreglass,
plywood
244 × 29 × 2.5 cm [96 × 11 × 1 in]

By 1966 McCracken had turned to monochrome planks leaning against the wall. The plank retains ties with the wall – the site of painting – yet it also enters the three-dimensional realm and the physical space of the viewer. Each plank is monochrome and coated in a highly reflective, polished resin surface.

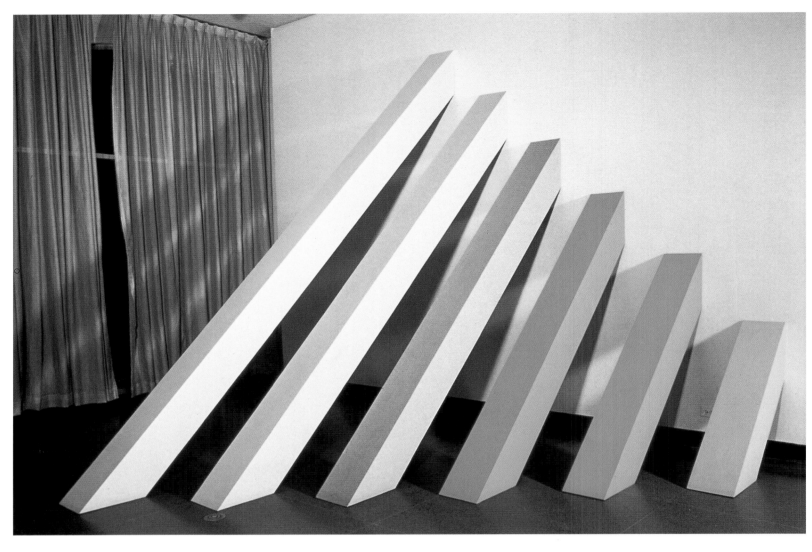

Judy CHICAGO
Rainbow Pickets
1965
Plywood, canvas, latex
320 × 279 × 320 cm [126 × 110 × 126 in]

Rainbow Pickets was first shown at the groundbreaking Minimal art exhibition
'Primary Structures', held at the Jewish Museum in New York. Composed of six
multicoloured planks of increasing height leaning against the wall in the vestibule,
this work integrates the serial methods of New York Minimalism with an allusive
palette of yellow, pink and pale blue.

Judy CHICAGO
Ten Part Cylinders
1966
Fibreglass
305 × 610 × 610 cm [10 × 20 × 20 ft] overall

These cylinders have been compared to the pillars that support the freeways in California. Made of fibreglass and standing as tall as 610 cm [20 ft], the pillars were displayed in a seemingly random configuration a few feet apart from one another. The work was first exhibited at 'American Sculpture of the Sixties' at the Los Angeles County Museum of Art in 1967.

Judy CHICAGO
Cubes and Cylinders (Rearrangeable)
1967
Gold-plated stainless steel
24 units, 5 × 5 × 5 cm [2 × 2 × 2 in] each

Cubes and Cylinders (*Rearrangeable*) is composed of twenty-four gold-plated stainless steel cubes and cylinders that are arranged in various formations, with the cylinders resting on a line with the cubes, or with the cubes resting on top of the cylinders, forming a spherical shape with a hollow centre. The appearance varies depending upon the installation, creating a site-specific arrangement of geometric metal units. Their configuration around a central core was a method the artist continued to use in her later feminist artworks, such as *The Dinner Party* (1974–79). In a re-evaluation of her Minimalist work, Chicago states: 'The hard materials ... perfect finishes and minimal forms in my work in 1966 and 1967 were "containers" for my hidden feelings, which flashed in the polished surfaces, shone in the light reflections and disappeared in the mirrored bases.'
– Judy Chicago, *Through the Flower: My Struggle as a Woman Artist*, 1975

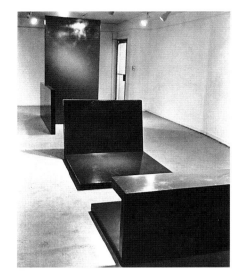

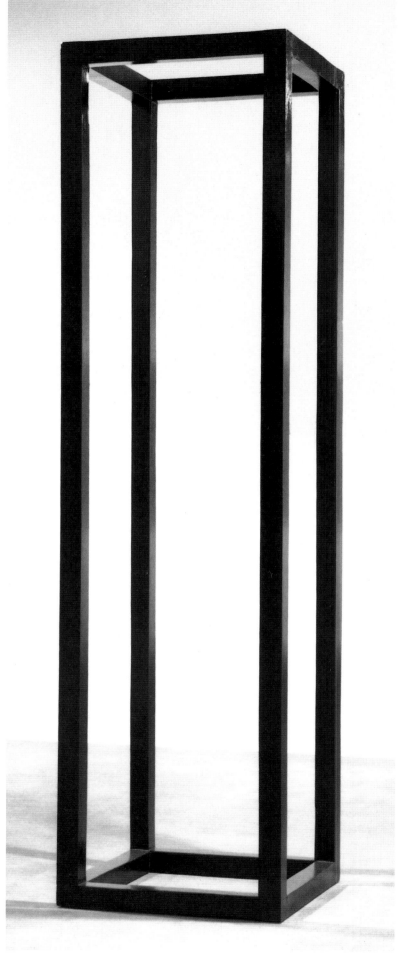

above
Sol LEWITT
John Daniels Gallery, New York
1965
Installation view

LeWitt had his first solo exhibition at Dan Graham's John Daniels Gallery, New York, in 1965. The reliefs and free-standing structures are made of large slabs of plywood that meet at right and oblique angles, forming open cubes. LeWitt used coloured lacquer to disguise the irregular wooden surface, giving the works a more industrial appearance. While the John Daniels Gallery structures are not based on serial systems, they do show his early use of the open cube, the basic modular unit of LeWitt's future work.

left
Sol LEWITT
Standing Open Structure, Black
1964
Paint, wood, steel
244 × 65 × 65 cm [96 × 25.5 × 25.5 in]

LeWitt's first shift from solid objects to the skeletal framework began with this 1964 work. At the 1966 'Art in Process' exhibition at Finch College in New York, he showed this work with its miniature scale model. Sometimes described as the 'telephone booth', this geometric, black wooden structure approximates to the size and stature of the human body.

Sol LEWITT
Floor Structure, Black
1965
Painted wood
47 × 208 × 46 cm [18.5 × 82 × 18 in]

This was one of the last painted wooden structures LeWitt constructed, as he became increasingly frustrated at his inability to disguise the textured surface of wood. Before turning to metal as his primary material (1965–66), he began to experiment with open skeletal forms, emphasizing the shape and form of the structure and diminishing the physical impact of the material.

Sol LEWITT
Modular Wall Piece with Cube
1965
Steel, baked enamel
46 × 46 × 18 cm [18 × 18 × 7 in]

By late 1965 LeWitt began using white paint exclusively. The wall structures completed during this year use the three-dimensional cube form of his earlier reliefs, yet are open skeletal forms rather than solids. *Modular Wall Piece with Cube* is composed of a simple ladder-like form with a projecting three-dimensional cube on one end. LeWitt based the measurements on an arbitrarily established 8.5 to 1 ratio between material and negative space. He continued to use mathematical systems and ratios in his later works, deriving increasingly complex permutations.

Sol LEWITT
Modular Piece (Double Cube)
1966
Baked enamel on steel
274 × 140 × 140 cm [108 × 55 × 55 in]

LeWitt exhibited three white structures in his 1966 solo show at the Dwan Gallery in New York. *Modular Piece* (*Double Cube*) was the tallest in the show, made from an open cube that he arranged three units in width and three in height. He named it *Double Cube* because the entire work consists of two cubes, comprised of the smaller modular cubes, doubled in height. Thus the overall work, a free-standing structure placed in the central area of the gallery, forms a three-dimensional grid.

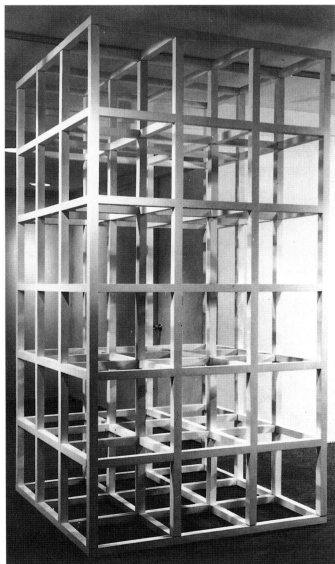

Sol LEWITT

Dwan Gallery, Los Angeles

1967

Poster and invitation card

LeWitt's drawing of the floor plan with explanatory notes for *Serial Project No. 1* (*ABCD*) served as the poster and invitation for his Dwan Gallery, Los Angeles show of 1967. In his notes he explains how the grid system is used to regularize the measurements of each unit and neutralize any spatial differences. This drawing serves as both an explanatory guide to the show and as a testimony to the importance LeWitt placed on the concept, or idea, underlying the completed artwork.

Sol LEWITT
Serial Project No. 1 (ABCD)
1966
Baked enamel on aluminium
51 × 414 × 414 cm [20 × 163 × 163 in]

LeWitt's first serial project is based on a set of permutations, or step-by-step modifications of open and closed cubes. He used painted aluminium in their fabrication in order to minimize apparent surface texture, and based each of the configurations on a grid mapped out on the floor. The project follows a series of four variations (ABCD), beginning with a flat grid and open cubes and ending with three-dimensional closed volumes.

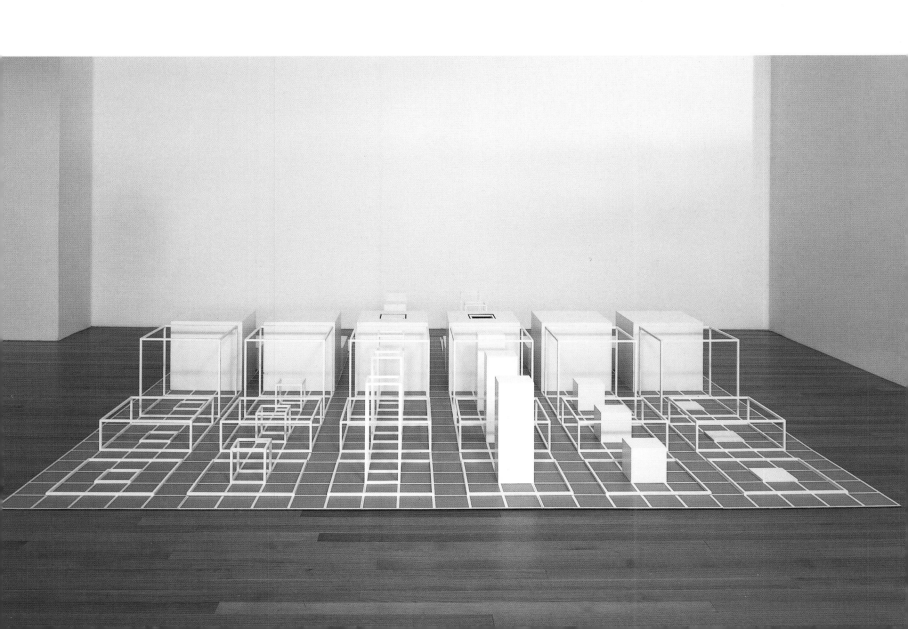

opposite

Mel BOCHNER
Untitled (Study for Three-Way
Fibonacci Progression)
1966
Ink on graph paper
21.5 × 28 cm [8.5 × 11 in]

Bochner based his work on the Fibonacci Progression, a system of mathematical sequence based on a simple principle of addition of the preceding numbers: 1, 1, 2, 3, 5, 8 ... He first mapped his schema on graph paper, joining five interlocking forms according to mathematical sets entitled A, B and C. Each set uses the Fibonacci Progression to determine the depth, height and width of the solid wall relief which was to be constructed in wood and cardboard. For Bochner, the mathematical process and schematic plan recorded on the graph paper is integral to the sculpture, rather than merely a preliminary sketch.

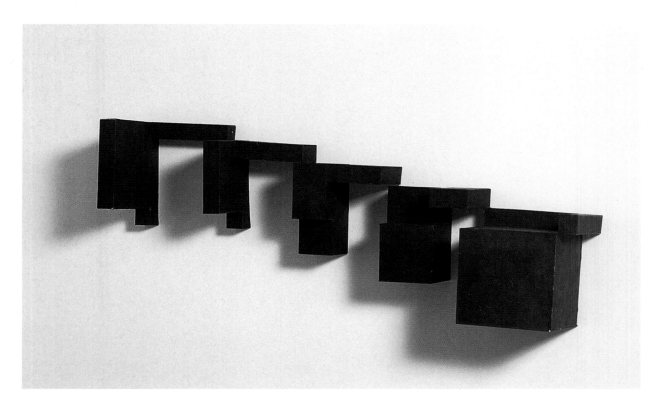

left

Mel BOCHNER
Three-Way Fibonacci Progression
1966
Paint on cardboard, balsa wood
25 × 13 × 69 cm [10 × 5 × 27 in]

In this small work derived from his *Study for Three-Way Fibonacci Progression*, Bochner used casually made, interlocking cubic shapes constructed of cardboard to represent visually a conceptual numerical system. In contrast to the solid, well-made serial objects of Judd and other Minimalists, Bochner produced a temporary construction in order to illuminate a mathematical idea.

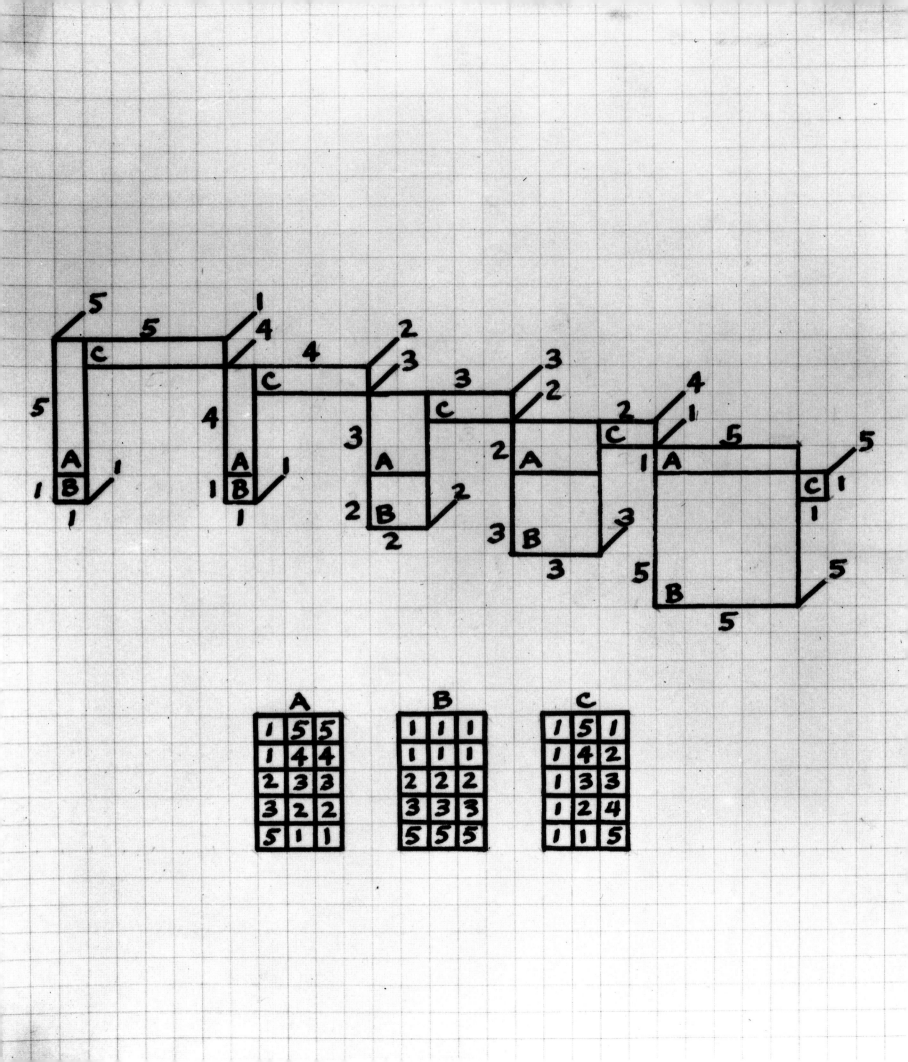

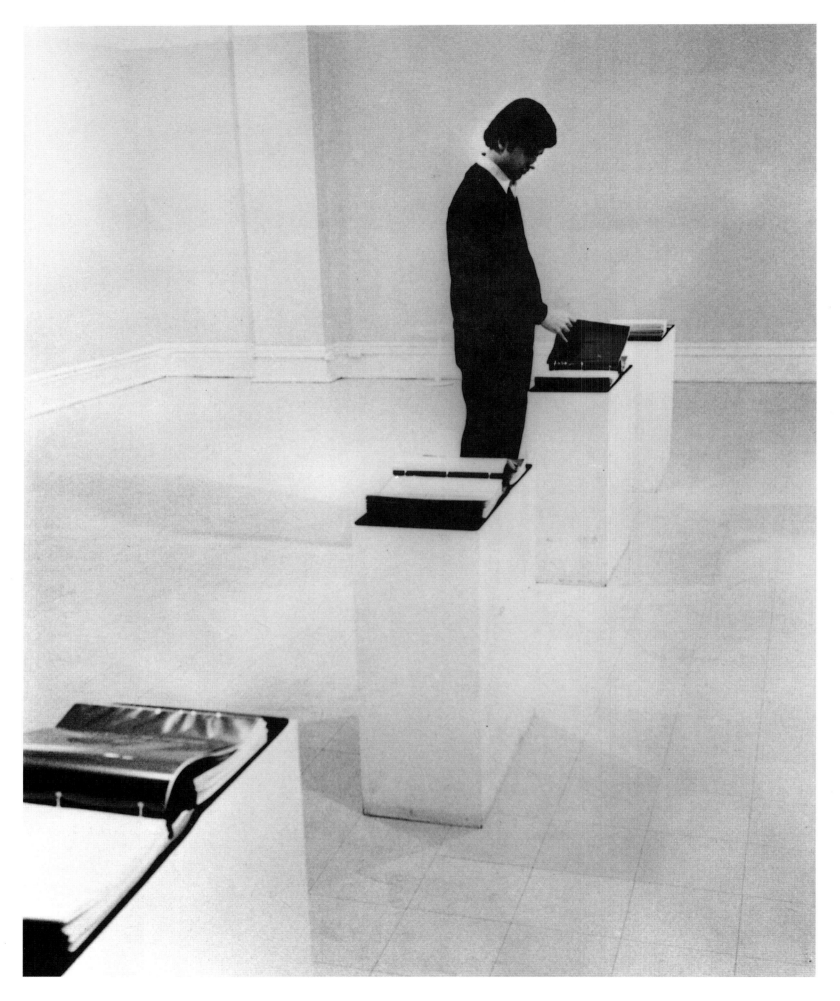

opposite

Mel BOCHNER

Working Drawings and Other Visible Things on Paper Not Necessarily
Meant to be Viewed as Art

1966

4 identical looseleaf notebooks, 100 pages each

4 pedestals

Installation, School of Visual Arts, New York

For his first New York exhibition at the School of Visual Arts in New York, Mel Bochner photocopied 100 pages of studio notes, working drawings and diagrams made by fellow artists including Eva Hesse, Sol Lewitt, Donald Judd and Dan Flavin, pages from *Scientific American*, notations from serial musical compositions, mathematical calculations and other information. These were then bound in four identical looseleaf notebooks and placed on pedestals in the centre of the gallery. By doing this, Bochner allied the systemic techniques of 1960s artists with serial investigations in other disciplines and new forms of reproduction, including photocopying.

Mel BOCHNER

Untitled ('child's play!': Study for Seven-Part Progression)

1966

Ink on paper

14 × 18 cm [5.5 × 7 in]

Bochner, like his friends Sol LeWitt and Eva Hesse, interpreted the number systems underlying Minimal practice as the pretext of a playful – and quite pointless – experimentation with repetition. Where Donald Judd and Dan Flavin used serial formulas to generate definite forms, the title of this drawing makes explicit Bochner's view of seriality as a form of intellectual play. Like a child's game, the work is a temporary arrangement of building blocks that may be constructed and taken apart (and then rearranged once again). It is not a well-made Specific Object, a finished work of art, but a plan for a 'work' that need not be made, an idea.

Mel BOCHNER

Four Sets: Rotations and Reversals

1966

Ink on tracing paper

30.5 × 38 cm [12 × 15 in]

Bochner conceived of this work while experimenting with the type of numbered tracing paper used by schoolchildren. He drew dots on each sheet of paper and stacked the sheets so the full set of dots would be visible. In this image Bochner combines all the dots on one sheet of tracing paper. In each of the four sets of four connected rectangles the pattern of dots in the rectangles connected diagonally are the mirror image of one another.

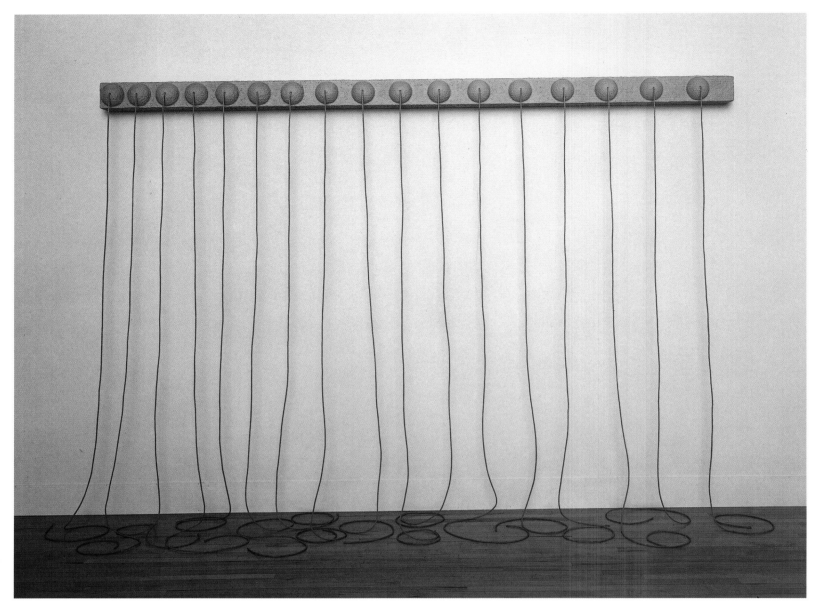

Eva HESSE
Addendum
1967
Papier mâché, wood, cord
Wood, 12.4 × 303 × 12.4 cm [5 × 119 × 5 in]

Eva Hesse's *Addendum* was exhibited in 'Art in Series', in 1967, Finch College, New York's testament to the predominant 'serial attitude' of 1960s visual art. It consists of a horizontal row of unevenly spaced domes, from which long cords extend to the floor below. Although the forms allude to body parts, Hesse carefully kept these organic referents ambiguous. By combining the seriality found in the work of the Minimal artists with soft and irregular materials, she developed a highly personal sculptural idiom.

opposite
Eva HESSE
Accession II
1967
Galvanized steel, rubber tubing
78 × 78 × 78 cm [30.5 × 30.5 × 30.5 in]

Accession II was one of Eva Hesse's few fabricated works. After the steel cube was constructed, she tied rubber tubing into each of the 30,000 holes in the surface, creating a physical, tactile interior at odds with the pure reductionism usually associated with Minimal art. The first version of this work, made with plastic tubing, was shown at the Milwaukee Art Center in 1968, where it was badly damaged when viewers climbed inside the cube.

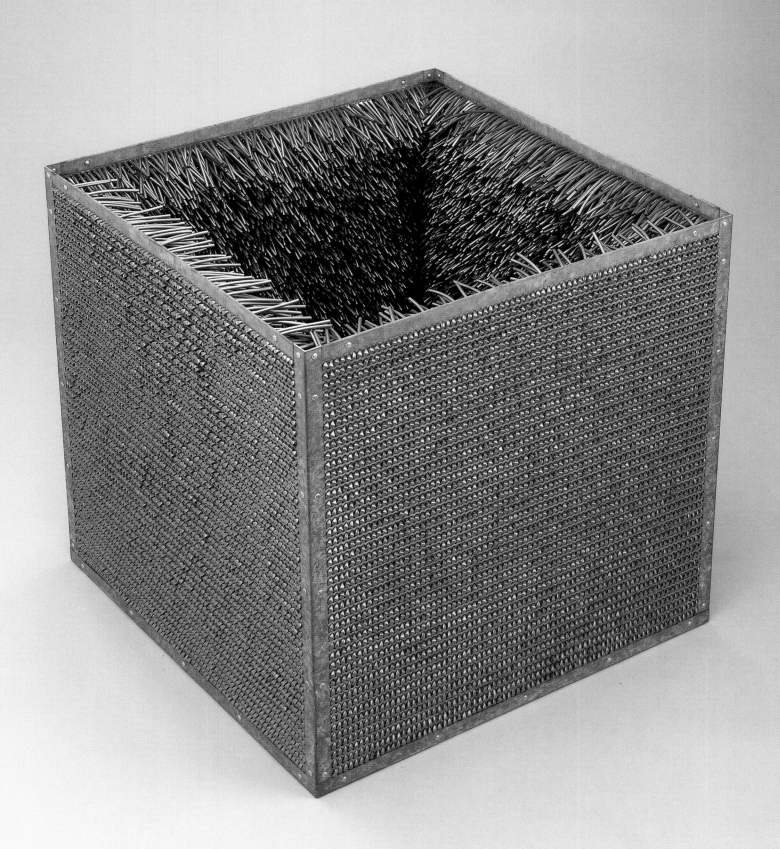

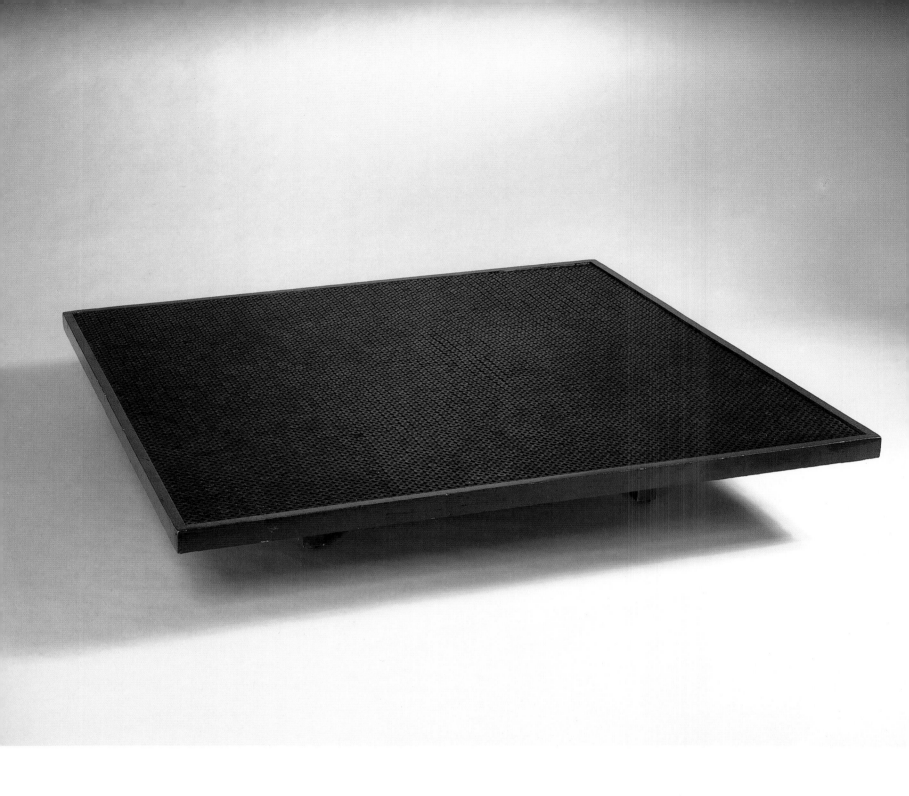

Eva <u>HESSE</u>
Washer Table
1967
Wood, rubber washers, metal
21.5 × 126 × 126 cm [8.5 × 49.5 × 49.5 in]

Eva Hesse was given a square white wooden table by Sol LeWitt which she transformed by methodically covering it with almost 700 black rubber washers and painting the frame in black. Here as in other works integrating identical units by Hesse, the organizing impulse of Minimalism is rendered absurd through pointless repetition.

Eva HESSE
Schema
1967
Latex
144 mounds, ø 6 cm [2.5 in] each
107 × 107 cm [42 × 42 in] overall
Collection, Philadelphia Museum
of Art

One of several floor works based upon
the Minimal grid, *Schema* consists of 144
small latex mounds which rest upon
thin, translucent latex squares. Here
again Hesse worked within the 'schema'
of the Minimalist format, yet the
irregularities of her handmade materials
reflect the painstaking process of their
production.

Eva HESSE
Sequel
1967
Latex and powdered white pigment
76 × 81 cm [30 × 32 in]

Sequel follows on from the previous
work in latex, *Schema*, in which mounds
are arranged on a grid. By adding white
pigment powder to the latex, Hesse
transformed the rubber from a
translucent to an opaque substance.
Hesse cast the spheres from a Spaulding
rubber ball, leaving an open slit in each
unit when she placed the two halves
together. By cutting into and altering the
round spheres and then arranging them
on the latex sheet in a haphazard
fashion, she exposed the potential of
chaos and breakdown integral to ordered
systems.

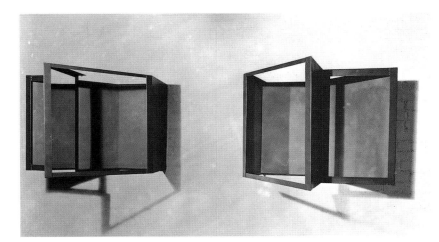

Robert SMITHSON
Enantiomorphic Chambers
1964
Painted steel and mirrors
2 units, 86 × 86 cm [34 × 34 in] each
The word 'enantiomorphic' refers to crystals whose left and right molecular structure is asymmetrical. The molecules do not directly reflect one another. For the viewer, expecting to see a reflection of the room or himself, expectations of experience are not met. Smithson has made the spectator aware of the act of seeing, an experience he likens to blindness: 'To see one's own sight means visible blindness.'
– Robert Smithson, 'Interpolation of Enantiomorphic Chambers', 1964

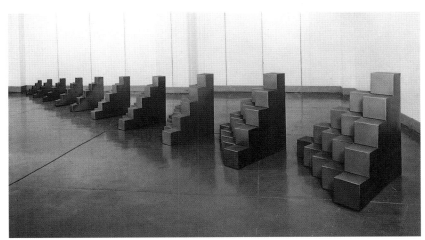

Robert SMITHSON
Alogon No. 2
1966
Painted steel
10 units, dimensions variable
Collection, The Museum of Modern Art, New York
This work, intended to resemble the faceted interior of rock crystal, consists of ten units placed approximately a foot apart, arranged in descending height order. The largest is about 91 cm [3 ft] tall, and the shortest is about 30 cm [1 ft] tall. Each of the ten units was built following one mathematical system and arranged in the gallery following another, contradictory mathematical system. By setting up a contradiction between systems, Smithson challenged any notion of a logical ordering. Even the title is meant to suggest the irrationality inherent within serial progression, just as the word *alogos* is the antithesis of *logos*, Greek for reason.

opposite
Robert SMITHSON
Four Sided Vortex
1965
Stainless steel, mirror
89 × 71 × 71 cm [35 × 28 × 28 in]
Four Sided Vortex was made by inserting an inverted mirrored pyramid into an industrially fabricated steel cube. The structure was based on the configuration of crystal planes, reflecting Smithson's longstanding fascination with geological forms; unlike the abstract shapes of Donald Judd and Robert Morris, Smithson's Minimalism alludes to crystallographic sources. The word 'vortex' in the title refers to centrifugal phenomena such as whirlpools or hurricanes, mimicked by the sculpture's rotational structure.

Frank <u>STELLA</u>
Fez
1964
Fluorescent alkyd paint on canvas
198 × 198 cm [77 × 77 in]

Fez is one of a series of twelve paintings that Stella completed between 1964 and 1965,
each named after a city in Morocco. These brightly coloured works are divided into
symmetrical sections with the stripes in each quadrant going in a different direction,
creating a strong optical pattern. They indicate Stella's turn towards optical and
illusionistic effects during the mid 1960s as he progressively distanced himself from
the austere monochromy of the *Black* and *Aluminum Paintings*.

HIGH MINIMALISM

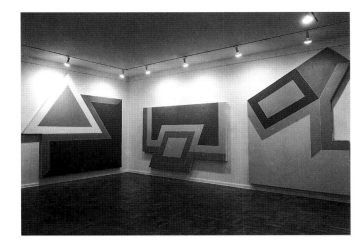

Frank <u>STELLA</u>
Irregular Polygons
1966
Installation view, Leo Castelli Gallery, New York

In the *Irregular Polygon Series*, exhibited in 1966 at the Leo Castelli Gallery, New York, Stella sought a balanced composition of complex shapes and colours. For each of the eleven works in the series Stella first constructed four copies of each differently shaped canvas. He then experimented with different combinations of colours to create a composition of interpenetrating shapes, exhibiting the most successful version.

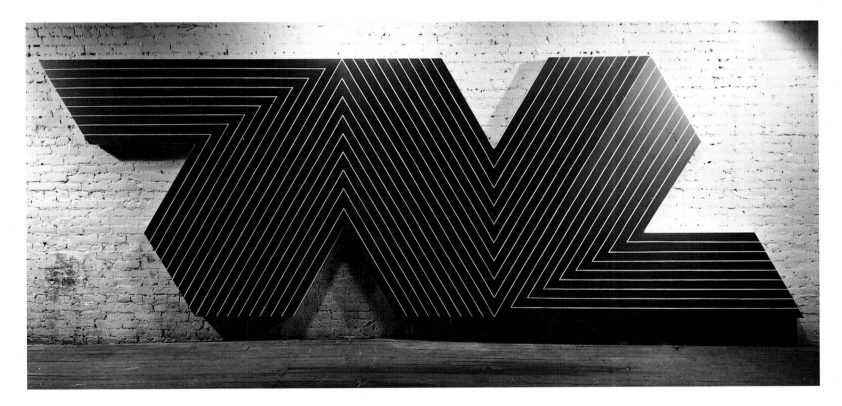

Frank <u>STELLA</u>
Empress of India
1965
Metallic powder in polymer emulsion on canvas
198 × 569 cm [77 × 224 in]

The enormous scale of this painting suggests Stella's mounting ambition as he monumentalized his stripe format in 1964–65. *Empress of India*, part of what has become known as the *Notched-V Series*, is made of striped V-shaped canvases attached to one another. This painting stretches almost 569 cm [19 ft] across and is mural-like in scale. Stella used subtle gradations of brown, red and orange to delineate both the individual stripes and the separate quadrants.

opposite

Jo BAER

Untitled (White Square Lavender)

1964-74

Oil on canvas

183 × 183 cm [72 × 72 in]

Baer, like the other Minimal painters, distilled painting to its most essential aspects: form, shape, structure and surface. Throughout her work of the 1960s she emphasized the work's edge with concentric coloured and black bands painted around the perimeter of the canvas; the bands were often painted in secondary hues including red, green, blues or in the case of this work, lavender. Baer used paint economically, ensuring that the surface did not show perceptible painterliness. However, the irregularity of the hand-drawn line distinguishes her working process from that of the Minimal sculptors whose work had an industrially perfected appearance.

right top and bottom

Jo BAER

Untitled (Stacked Horizontal Diptych - Green)

1966-68

Oil on canvas

Diptych, 132 × 183 cm [52 × 72 in] each

This work consists of two identical canvases, designed to be hung one above the other, separated by several inches. In opposition to traditional painting, where the focus of the work usually appears in the centre of the canvas, Baer pushes the focus to the edges of the work, emphasizing the geometric shape of the canvas.

Agnes <u>MARTIN</u>
Leaf
1965
Acrylic on canvas
183 × 183 cm [72 × 72 in]

Both the title and the seemingly endless expanse of the drawn grid in *Leaf* allude to Martin's belief in the grandeur and majesty of nature. The subtly shifting white paint across the surface of the canvas has a number of slight changes in tone, gradually darkening towards the outer edges. This is overlaid with a delicate rectangular grid pattern in faint pencil suggesting a subtle optical effect.

Ralph <u>HUMPHREY</u>
Camden
1965
Oil on canvas
168 × 168 cm [66 × 66 in]

Humphrey responded to the objectness of Minimal painting by referencing both framing devices and physicality in his work of the mid 1960s. Minimal paintings often eschew frames; in this work Humphrey alluded to this convention by painting a framing band around the edges of the canvas. Also, other Minimal paintings were made on extra-thick stretchers, projecting into the viewer's space like a wall relief, while Humphrey's 'frame' canvases are made on thin stretchers and with thin washes of oil paint, declaring their identity *as* paintings.

Ralph <u>HUMPHREY</u>
Rio
1965
Oil on canvas
178 × 152 cm [70 × 60 in]

Robert RYMAN
Untitled
1965
Enamel on linen
29 × 29 cm [11 × 11 in]

In 1965 Ryman completed a series of small square linen canvases that were later exhibited at the Solomon R. Guggenheim Museum, New York, in 1972. In this work, Ryman applied the white enamel paint in thin layers, so that the brushstrokes are indiscernible within the centre of the painting; the smooth surface contrasts with the sliver of brown, textured linen visible at the outermost edges.

opposite
Robert RYMAN
Winsor 34
1966
Oil on linen
159 × 159 cm [63 × 63 in]

The *Winsor Series*, named after the Winsor brand of oil paint, consists of four works whose uneven brushstrokes allow areas of the raw canvas to remain visible. Each painting in the series was a different size and made with a different type of paint. *Winsor 34* was made by loading the brush with white oil paint and painting horizontal bands from left to right, continuing each stroke until the brush was dry. This technique emphasized the alterations in the thickness of paint, from thick on the left to thin on the right.

Robert RYMAN
Untitled
1965
Oil on linen
26 × 26 cm [10 × 10 in]

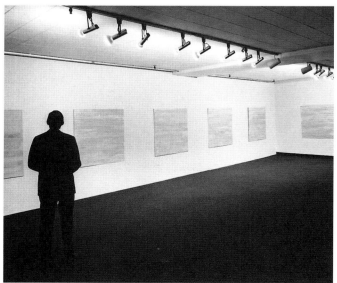

Robert RYMAN
Standard Series
1967
Installation view, Paul Bianchini Gallery, New York

For this series, exhibited at the artist's first solo exhibition at the Paul Bianchini Gallery in New York in 1967, Ryman painted white enamel on to cold-rolled steel by swabbing the metal with thin coats of enamel that he then treated with chemical solutions in order to adhere the paint to the slick surface. Ironically, none of the works in the show sold, and Ryman was allowed to keep the series intact.

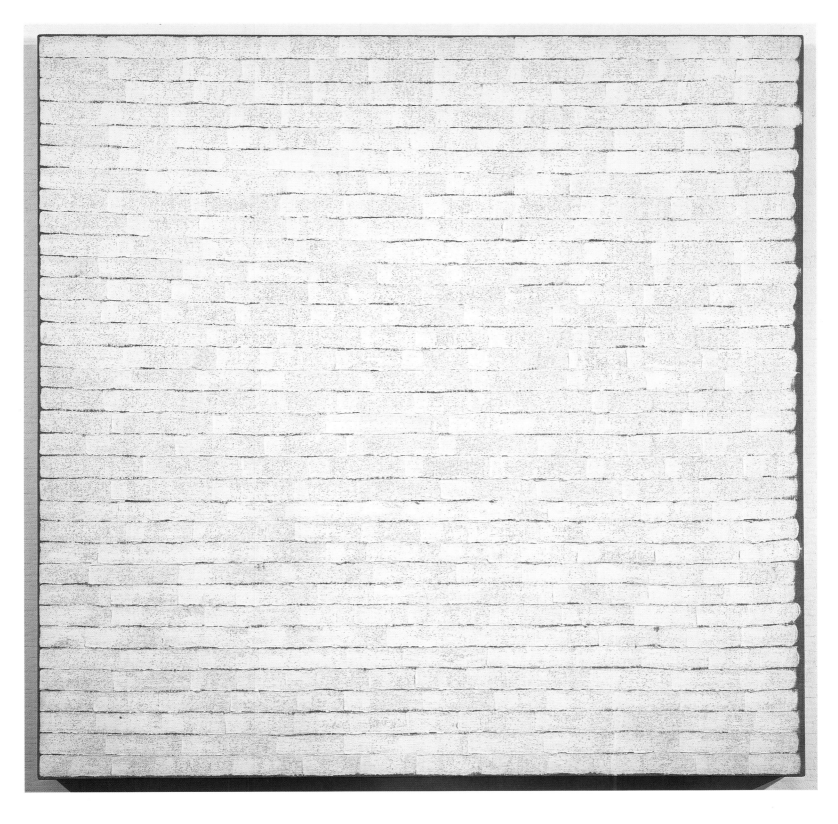

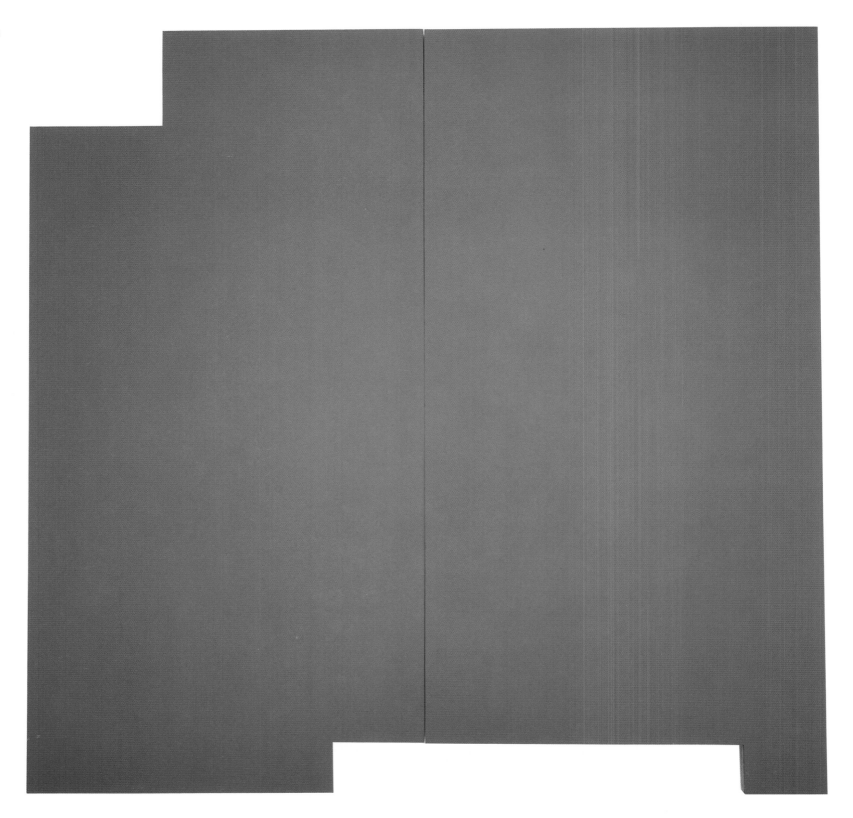

opposite

Robert MANGOLD

Red Wall

1965

Oil on masonite

244 × 244 cm [96 × 96 in]

In 1965 Lucy R. Lippard wrote in the catalogue of *Robert Mangold: Walls and Areas* for his exhibition at the Fischbach Gallery, New York: 'The *Walls* refer obliquely to prefabricated building in that their cut-out silhouettes suggest windows, doors or stairwells, and some edges are left raw and unpainted to imply further additions'. Mangold's own statements can be compared with those of another painter associated with Minimalism, Frank Stella, who influenced Mangold's straightforward approach. Mangold: 'I wanted the application of paint to be "matter of fact", to cover the surface. I wanted to paint the surface with the same attitude and care that you would have if you were painting a real wall in a loft or apartment, no more or less artful than this.'
– Robert Mangold, 'Interview with Michael Auping', 1988

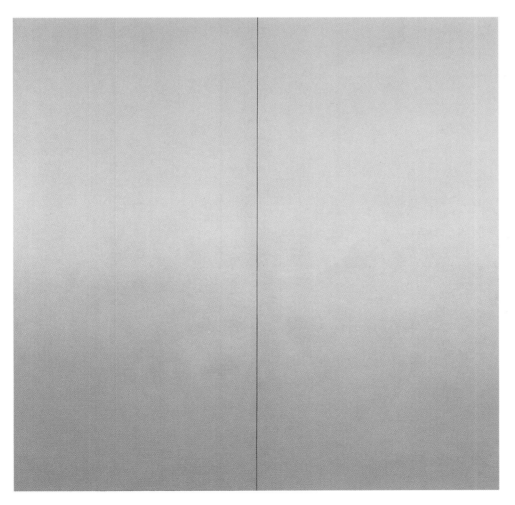

Robert MANGOLD

Manila Area

1966

Oil on masonite

122 × 122 cm [48 × 48 in]

Mangold's earliest mature works were a series of *Walls* and *Areas* (1964–65), in part influenced by the visual experience of living in the industrial ambience of New York. Executed in such colours as 'paper bag brown', 'file cabinet grey' and 'manila envelope tan', these works reflected the artist's view of New York as 'an image-rich situation, a material-rich situation. Not [rich] with natural colour … but the scale and colour of industry, of commerce [that] surrounded you.'
– Robert Mangold, 'Interview with David Carrier', 1996

Robert MANGOLD
1/2 Blue-Gray Curved Area (Central Section)
1967
Oil on masonite
183 × 183 cm [72 × 72 in]

Mangold's curved *Areas*, which he started to develop in 1966, marked a shift with respect to the earlier *Areas*. They continued to insist on the essential formal relation of the support and surrounding wall, yet now each work consists of multiple-shaped panels. Foregoing the traditional, Renaissance-derived format of the rectangular canvas as a 'window on to the world', Mangold, in the later *Areas*, secured a multipart arrangement of juxtaposed, shaped panels. The flatness and literalness of the ensemble was stressed, the surrounding wall revealed.

Brice MARDEN
Private Title
1966
Oil and wax on canvas
122 × 244 cm [48 × 96 in]

This work was exhibited at Marden's debut exhibition at the Bykert Gallery, New York, in the autumn of 1966. All of the paintings in the show were rectangular in shape, and referred to a person important to Marden's life in New York, such as his wife Helen Harrington; many of these works have private dedications. Marden often associates individuals and personal memories with particular works, and colour arrangements with powerful sentiments.

D'après la Marquise de la Solana
1969
Oil and wax on canvas
195.5 × 297 cm [77 × 117 in]
Collection, The Panza Collection,
The Solomon R. Guggenheim Museum,
New York

Marden began to create multi-panel paintings in the late 1960s. In this work, each panel is separated by a few millimetres, with the right panel spaced slightly further away than the left. This decision draws attention to the thickness and materiality of the paint and the support, rendering the muted hues of grey, lavender and pink distinct.

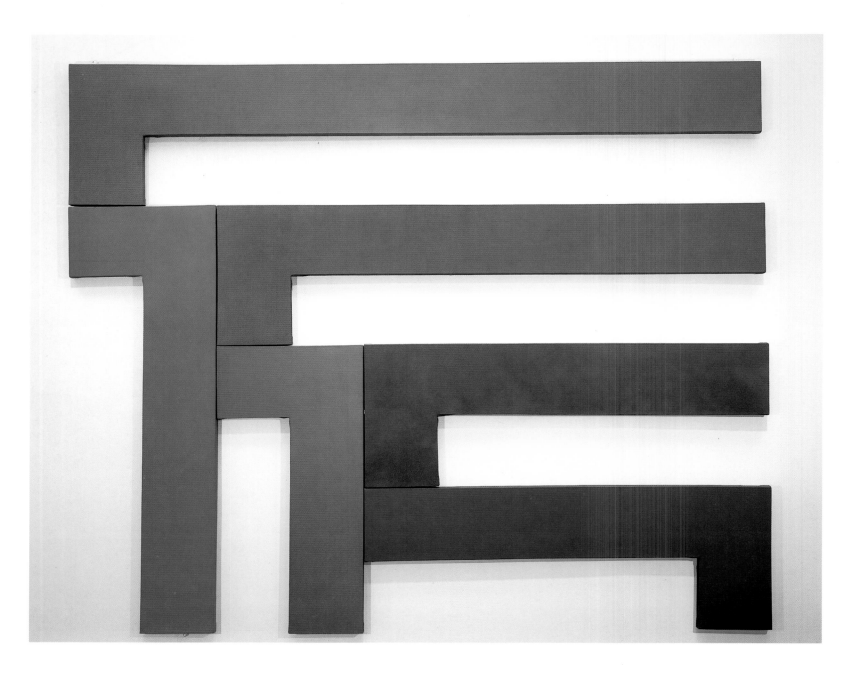

David <u>NOVROS</u>
6:59
1966
Vinyl lacquer on canvas
290 × 686 cm [9.5 × 22.5 ft]

Novros arranged rectangular canvases in a ziggurat formation that invites the viewer to experience it horizontally. The canvases were painted in light tints which he then covered with an all-over pearl lacquer. The monochrome lacquer unifies the separate canvases, while the distinctions in hue visible underneath encourage the viewer to experience the work by walking along it laterally, noting the variations in colour and shape.

opposite
David <u>NOVROS</u>
Untitled
1965
Acrylic lacquer on canvas
305 × 366 cm [120 × 144 in]

David Novros became known for working with the shaped canvas which acts as a coloured surface in its own right rather than an illusionistic ground on which images are drawn. Novros' paintings are assemblages of discrete, interlocking units arranged on the wall. This untitled work consists of several separate L-shaped canvases in colours ranging from reds to blues to browns. They are arranged in a square configuration with the long legs of the Ls leading the eye both vertically and horizontally.

Paul <u>MOGENSEN</u>
Standard
1966
Acrylic lacquer on Dacron
244 × 244 cm [96 × 96 in]

Mogensen demonstrates his interest in mathematics and formulas in this work, where he juxtaposes four black canvases of the same width in an elementary progression: each canvas becomes taller as you progress towards the top of the arrangement, and the intervals between canvases are in a 1:1 ratio with the size of the panels beneath. The use of the title *Standard* suggests that this ratio is fundamental, or the foundation for further experiments with multi-panel, serial configurations.

Paul <u>MOGENSEN</u>
Untitled
1967
Acrylic lacquer on canvas
203 × 330 cm [80 × 130 in]

In this painting, Mogensen combines two schemes – the Golden Section and a rotational format. The Golden Section, a system of proportions that artists have used for centuries, holds that A is to B as B is to the sum of A and B. (Mathematically, the relation is 0.616 is to 1.000 as 1.000 is to 1.616, and so on into infinity.) Here, a tiny rectangle of wall is left bare in the centre of six juxtaposed canvases. Its proportion to the square canvas to the right is the same as that of both areas to the square canvas above. The other canvases become progressively larger, neatly filling out the rectangle in a spiral arrangement. Mogensen exhibited this and other works based on the Golden Section in a show at the Bykert Gallery the following year.

Paul <u>MOGENSEN</u>

Copperopolis

1966

Acrylic lacquer and copper on canvas

335 × 335 cm [132 × 132 in]

Mogensen favoured richly saturated colours, blacks and whites in his paintings of the 1960s and 1970s. The uniform copper surface in this work increases in intensity in juxtaposition with the white gallery wall. Colour is presented in its most essential or fundamental form, unmixed and undiluted. A serial logic of progressive width from right to left and from top to bottom organizes the sequence of monochrome canvases.

1967–79 CANONIZATION/CRITIQUE

During the late 1960s Minimal art received major exhibitions in the United States and Europe, becoming established as a leading contemporary movement, yet artists associated with Minimalism began to transform their work in concert with such developments as post-Minimal sculpture, Conceptualism and Land art. Where the work of Donald Judd became more monumental, and even moved outdoors, Sol LeWitt developed a Conceptual art that stressed idea over execution, reflecting the late 1960s impulse to 'dematerialize' the work of art. Carl Andre produced outdoor works incorporating wood, bales of hay and boulders. Robert Morris made perhaps the most radical departure of all in his 'anti-form' felt and scatter works, which sought to critique the geometrical, factory-made Minimal object of the mid 1960s. Others continued to refine their methods: John McCracken's lacquered planks, Larry Bell's glass partitions and Anne Truitt's columns suggest a continued commitment to whole geometric form. The work of Robert Ryman, Brice Marden and Robert Mangold became increasingly visible in museum exhibitions, consolidating the notion of a Minimal-type painting.

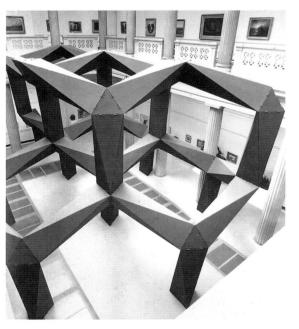

'Scale as Content'
Corcoran Gallery of Art, Washington, DC
1–30 November 1967
left
Tony SMITH
Smoke
1967
opposite
Ronald BLADEN
X
1967

'Scale as Content' announced the emergence of an oversized sculpture of primary forms, bringing the Minimal investigation of environmental scale to a new monumentality. Tony Smith made the enormous *Smoke* to fill the two storeys of the museum's atrium using a tetrahedral plan reminiscent of the molecular configurations found in crystalline forms. Ronald Bladen's *X* also spanned the two-storey gallery; its wooden skeletal structure was constructed off-site and erected *in situ*, finally clad in a black skin. The viewer could easily walk through the sculpture's lower extensions, experiencing the physical impact of its looming presence within the Corcoran's Neoclassical interior.

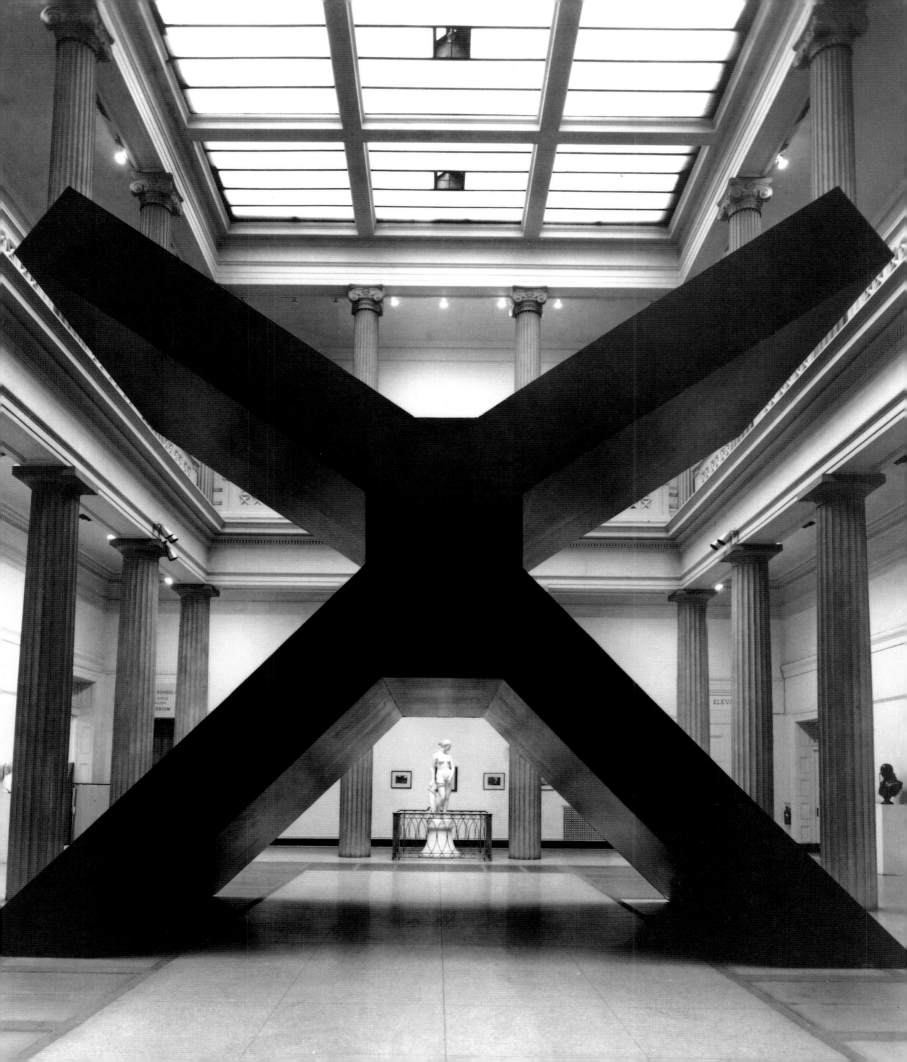

'The Art of the Real'
The Museum of Modern Art, New York
3 July-8 September 1968
Installation view
Carl ANDRE
Fall
1968
Hot rolled steel
21 units, 183 × 71 × 183 cm [72 × 28 × 72 in] each

Eugene C. Goossen curated this exhibition, which included a wide array of artists working between 1948 and 1968, such as Georgia O'Keeffe, Jasper Johns, Ellsworth Kelly, Jackson Pollock and Frank Stella, and the Minimalist sculptors Carl Andre, Donald Judd, Sol LeWitt, John McCracken, Robert Morris, Tony Smith and Robert Smithson, claiming that all of the artists in the show had rejected the depiction of symbolic and metaphysical subject matter in favour of a representation of the 'real'. Carl Andre constructed an installation in the garden of The Museum of Modern Art, lining the path and one exterior wall with plates of hot-rolled steel. The plates meet at the intersection of the ground and the museum wall, creating a dark channel of metal that leads the viewer towards the terrace above.

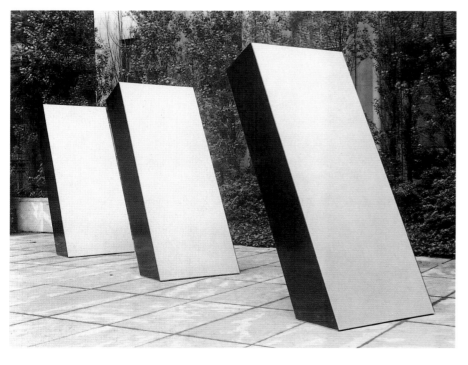

Ronald BLADEN
Three Elements (originally Untitled)
1965
Painted aluminium
3 units, 284 × 122 × 61 cm [112 × 48 × 24 in] each
Installation view, The Museum of Modern Art, New York, 1968

This series of three highly polished and reflective leaning rhomboid monoliths is held together by a system of internal weights. This causes them to appear to threaten imminent collapse. They were installed in the sculpture garden at The Museum of Modern Art, New York.

Donald <u>JUDD</u>
Untitled
1970
Aluminium
21 × 642.6 × 20.3 cm [8 × 253 × 8 in]

This work consists of a hollow thin tube of aluminium that is attached to the wall. Aluminium boxes arranged according to a progression of decreasing width are hung below the tube with increasing amounts of space between the boxes. This arrangement creates a dynamic progression formed only by the changes in dimension and spatial relationships. Judd's use of materials made by industrial fabrication creates a streamlined work composed of clean, sharp forms.

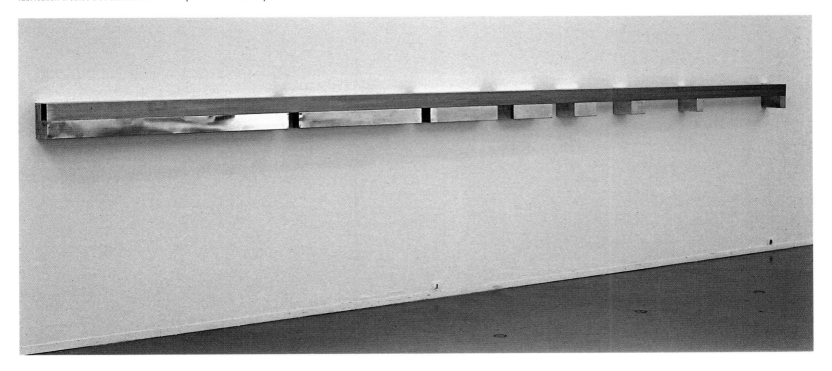

Donald JUDD
Galvanized Iron Wall
1974
Galvanized iron
h. 152.5 cm [60 in]; distance from wall 20 cm [8 in]

In the 1970s Judd began to design installations for specific locations, such as this
work, first shown at the Leo Castelli Gallery, New York (1970), and then at the
Pasadena Art Museum, California (1971), and the Panza Collection in Varese, Italy
(1974). Rather than creating a wholistic object that has precedence over the
vicissitudes of the site, the rectangular iron panels in the Castelli show partially lined
three walls of the front room, projecting 20 cm [8 in] out from the gallery walls. The
panels are of the same height, yet of different widths so that they perfectly fit the space
of the room and engage the gallery space.

Donald <u>JUDD</u>
Bern Piece No. 3
1976
Plywood
No longer extant, dimensions unknown
Installation view, Kunsthalle, Bern

This work is one of five numbered objects that Judd exhibited at the Kunsthalle, Bern;
they are designed to fill an entire room, leaving walking space only around the
perimeter. Here Judd expands the scale of his previous Specific Objects, and also
experiments with unpainted plywood, rather than the pristine metal surfaces he had
used throughout the late 1960s and 1970s. The top is raised a few inches above its
base, creating a two-part structure within the rectangular form. Judd designed the
works specifically for the gallery space, as a cohesive group: the objects are
low enough to allow the viewer to perceive all the works together.

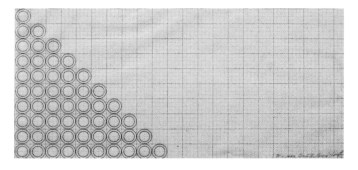

Dan <u>FLAVIN</u>
the final finished diagram of the triangularly massed cool white
fluorescent light dedicated, '(to a man, George McGovern) 1'
1972
Graphite and pencil on vellum
26 × 56 cm [10 × 22 in]

Throughout his career Flavin perceived a reciprocal relationship between his drawings and sketches for installations and the finished sculptures, carefully planning the placement of the works within the room and the interaction of their diffused lights. This drawing is a plan for his installation at the Leo Castelli Gallery, New York, in the autumn of 1972. Sonja Severdija, Flavin's wife at the time, mapped the circular tubes on to graph paper, following his rough notebook sketches.

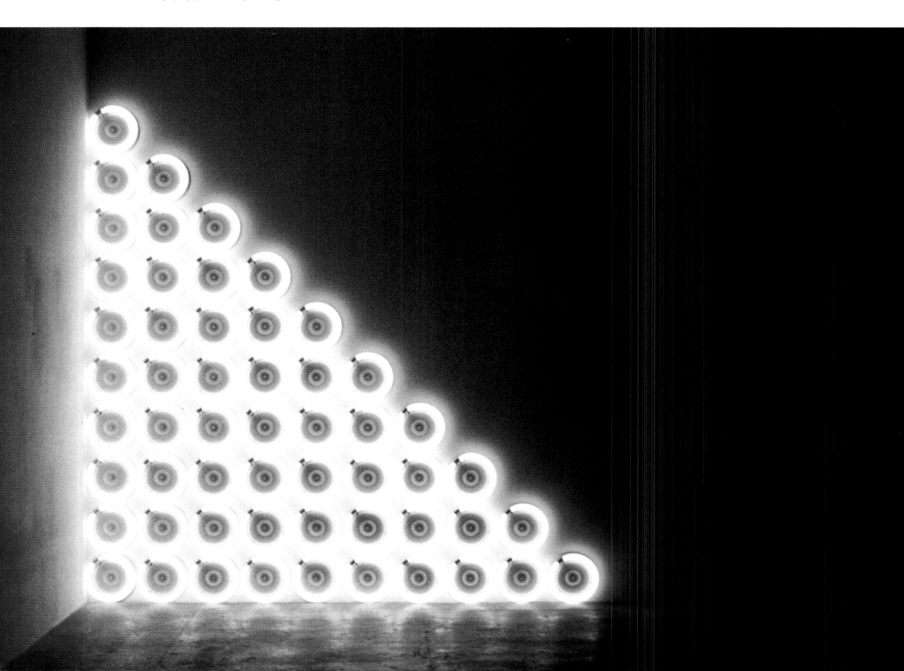

Dan FLAVIN
untitled (to Jan and Ron Greenberg)
1972-73
Fluorescent light
2 views, 244 × 244 cm [96 × 96 in]

In the mid 1970s Flavin designed installations of multiple fluorescent light tubes placed in square configurations. In this work, Flavin used green lights on one side and yellow on the other. The tubes are butted together, forming a type of barrier that both blocks most of the emission of the coloured light from the other side of the configuration and prohibits pedestrian traffic between two spaces of the room. Only a sliver of open space at the side of the wall allows the viewer to glimpse the coloured glow from the other side.

opposite
Dan FLAVIN
untitled (to a man, George McGovern)
1972
Fluorescent light
310 × 310 cm [122 × 122 in]

This work is part of a series of three, each of which uses the same triangular configuration of circular fluorescent tubes, yet differs in hue. Flavin used cool white in one sculpture, warm white in the next and daylight in the third. In this installation, dedicated to the unsuccessful Democratic presidential candidate of 1972, whom Flavin admired, the two legs of the triangle converge at the corner of the gallery space, mimicking the configuration of the room.

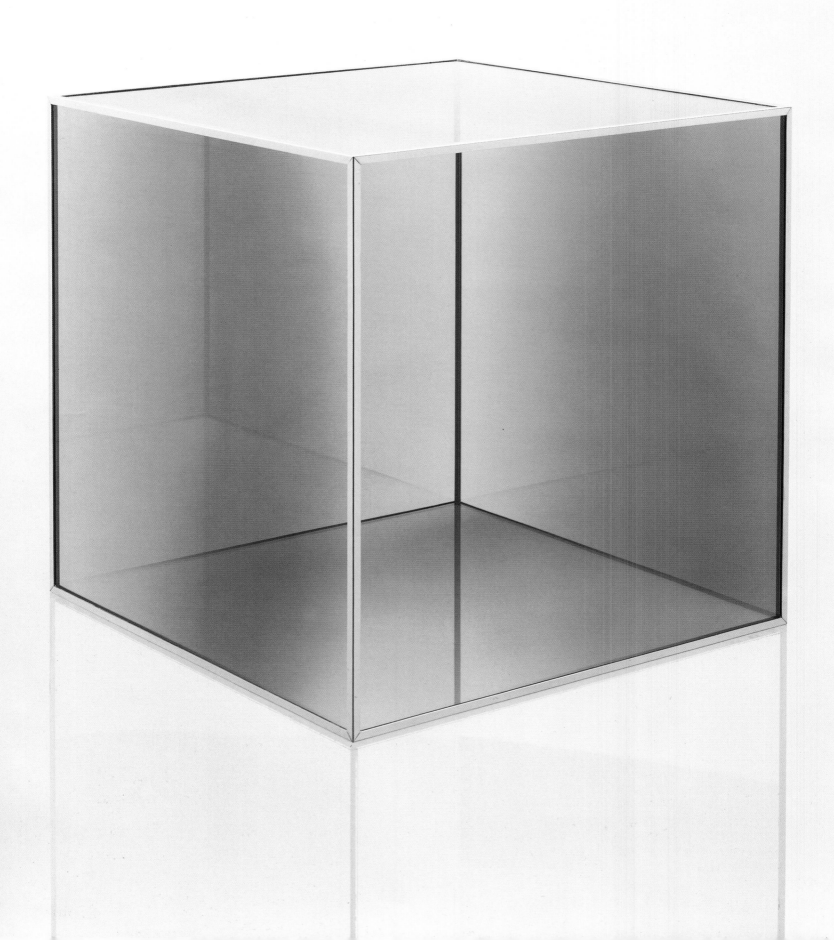

Larry BELL
The Iceberg and Its Shadow
1974
Inconel-coated glass
56 units, dimensions variable
Installation view, Massachusetts Institute of Technology, Cambridge

While working in Taos, New Mexico, Bell began designing asymmetrical sculptures with planes that were not parallel to either the floor or the ceiling. For this, the most monumental of these asymmetrical works, Bell created fifty-six planes of glass coated in a layer of quartz deposits that gave the work a bluish sheen. Each of the triangular and trapezoidal plates may be installed differently, creating faceted shapes that reflect light at oblique angles with prismatic transparency: the other viewers and the surroundings visible through the planes are distorted and fragmented.

Larry BELL
Untitled
1977
Inconel-coated glass
4 units, 244 × 152.5 cm [8 × 5 ft] each
Installation view with Andy Warhol, Denver Art Museum

As Bell became more interested in the appearance of the edges of his cubes and the gradations in colour at different points on the panels, he developed new techniques that allowed him to create larger structures without the brass strips to hold the glass panels together, thus creating uninterrupted plays of coloured light and unobstructed transparency. This shot records the artist Andy Warhol's fascination for Bell's glass environments which surround the viewer with multi-panel reflections.

Larry BELL
20" Glass Cube
1968
Vacuum-coated glass
51 × 51 cm [20 × 20 in]

Bell's glass cubes became larger and larger towards the end of the 1960s. This vacuum-coated glass box rests upon a clear pedestal of the same width and depth, clouding the distinction between support and artwork. The sides of the cube are covered in chromium-plated brass, calling attention to the edges of the work and the subtle diminishing of the coloured coating in the perimeter of each glass panel. Bell used the cube as the foundation of his work during this period because the 90-degree angle is one of the most basic forms in our visual vocabulary, a ubiquitous element of our built environment and our architecture.

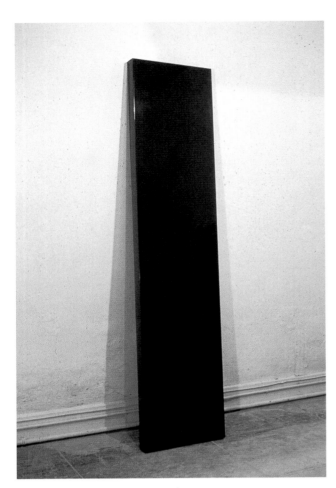

John <u>MCCRACKEN</u>
Untitled (Dk Blue)
1970
Polyester resin, fibreglass,
plywood
244 × 56 × 8 cm [96 × 22 × 3 in]

The plank leaning against the wall became McCracken's prototypical form by the late 1960s. The plank is sculptural, yet it retains ties to the pictorial by physically touching the site of painting, the gallery wall. McCracken's work also refers to that fundamental of architecture, the carpenter's plank. The sculpture's polymer resin surface creates a seamless veneer: the rich blue colour seems indivisible from the form rather than applied, stressing the wholeness and indivisibility of the rectangular shape.

John <u>MCCRACKEN</u>
Untitled
1975
Polyester resin, fibreglass,
plywood
25 × 41 × 41 cm [10 × 16 × 16 in]

In this free-standing sculpture McCracken places a yellow pyramid shape upon a white block of wood, creating a form that mimics an edifice, with the pyramid serving as the uppermost section, or the roof, of the standard square architectural base. Yet the coloration of the work separates the two forms, creating a two-part structure and also referring to the exhibition of traditional sculpture upon neutral pedestals. The emphasis on colour as an intrinsic part of sculpture and as a device to explore human perception characterizes the work of many of the California Minimalists, such as McCracken, Larry Bell and Judy Chicago.

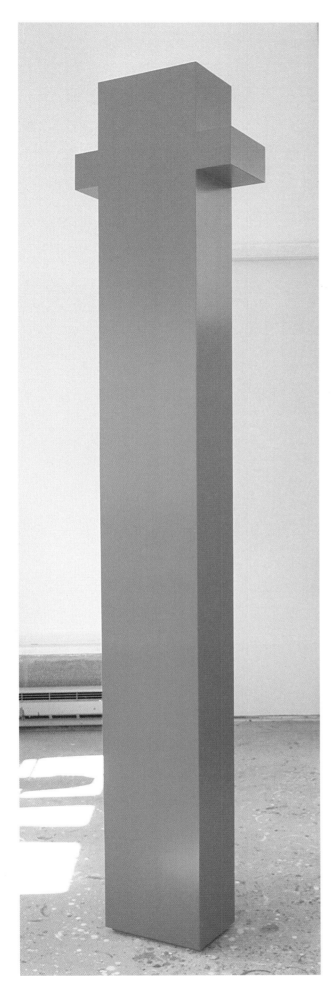

Anne TRUITT
King's Heritage
1973
Painted wood
244 × 48 × 20 cm [96 × 19 × 8 in]
This work, a rectangular shaft with a cruciform top, departs from the standard columnar format of Truitt's later work. Painted bright red and 244 cm [8 ft] tall, it is one of Truitt's boldest sculptures. This is part of a series of three works bearing chivalric or regal titles, including *Knight's Heritage* (1963) and *Queen's Heritage* (1968).

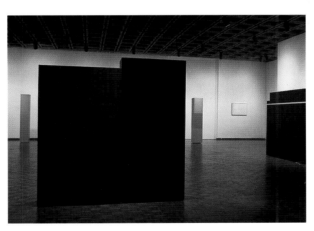

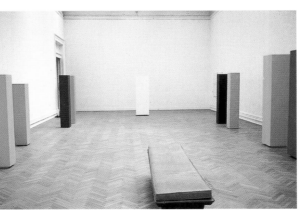

top
Anne TRUITT
Whitney Museum of American Art,
New York
18 December 1973–27 January 1974
Installation view
bottom
Anne TRUITT
Corcoran Gallery of Art,
Washington, DC
21 April–2 June 1974
Installation view
This show, organized by the curator Walter Hopps, was the first retrospective of Truitt's work and established the artist's reputation as a significant figure of Minimal art. The Whitney installation included works from the early 1960s such as *Hardcastle* and *Gloucester*, as well as more recent sculptures, paintings and drawings. An expanded version of the show at the Corcoran Gallery of Art in Washington, DC, featured Truitt's recent columnar sculptures arranged in pairs around the periphery of the gallery space.

Sol LEWITT

Wall Drawing No. 1, Drawing Series II 14 (A&B)

1968

Pencil

No longer extant, dimensions unknown

Installation view, Paula Cooper Gallery, New York

LeWitt returned to working in two dimensions with his series of wall drawings begun in 1968. The first wall drawing was at the Paula Cooper Gallery, New York, and consisted of a four-part grid; each quadrant was further subdivided into four more squares. In each area he alternated vertical, horizontal and diagonal lines of black pencil following the rules of a system he devised which dictated all the possible permutations of lines. This system, which could be completed by anyone, has made the execution a purely 'perfunctory affair'.

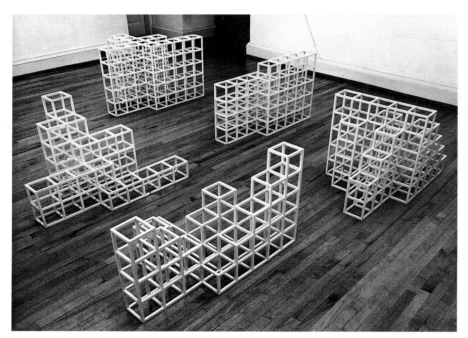

Sol LEWITT

Five Modular Structures (Sequential Permutations on the Number Five)

1972

Painted wood

Dimensions variable

In this series of white wooden skeletal structures LeWitt used permutations, or serial modifications of five cubic units, to develop a sequence of related works. Each of the units has exactly the same dimensions, yet the shape and structure of each sculpture varies, with different levels and arrangements of the five connected cubes forming distinct configurations.

opposite

Carl ANDRE

8006 Mönchengladbach Square

1968

Hot-rolled steel

36 units, 300 × 300 cm [118 × 118 in] overall

The title of this work refers to the Mönchengladbach Museum in Germany, an avant-garde exhibition space run by the noted curator Johannes Cladders, for which Andre specifically designed the sculpture. Built of local steel, the work consists of two identical floor pieces, each comprised of thirty-six metal tiles grouped in a square formation; the two parts are separated by an interval of a few feet.

Carl <u>ANDRE</u>
Joint
1968
Baled hay
183 units, approx. 36 × 46 × 91 cm [14 × 18 × 36 in] each
Installation view, Windham College, Putney, Vermont

With the metal floor pieces Andre began including the possibility of a work's gradual disintegration through being walked upon. This notion of gradual change is made more apparent in *Joint*, constructed specifically for an outdoor site at Windham College, Vermont, of bales of hay. The hay was compacted tightly into squares and placed in a 84-m [274.5-ft]-long structure, uncovered, so that with time and the elements the components would eventually decompose. The name refers to the way the work connects, or joins, the different grades of landscape.

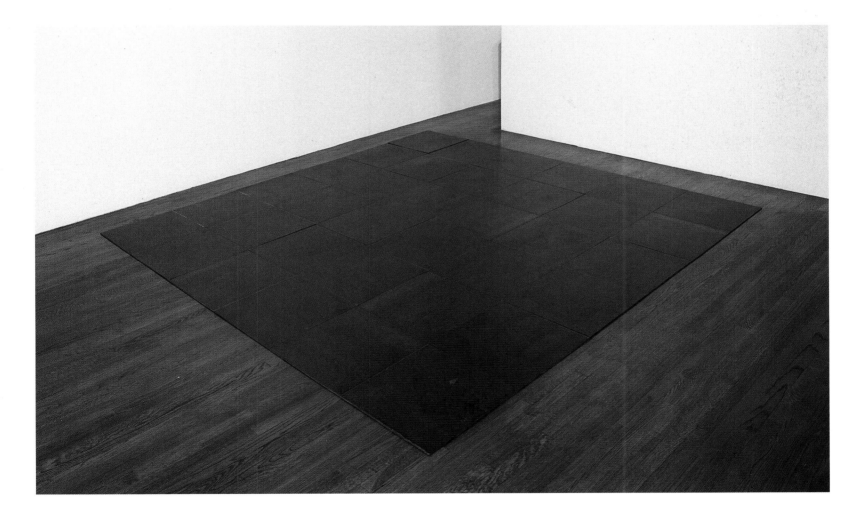

Carl ANDRE

Copper Ribbon

1969

Copper

9 × 1 × 2,100 cm [3.5 × .5 × 827 in]

Collection, Kröller-Müller Museum, Otterlo

Continuing to work with metal, as in his earlier metal floor pieces, Andre has placed a long, thin copper strip on the gallery floor. One end is coiled in the gallery with a long tail stretching out across the expanse of the room. The coiled end can be made larger or smaller depending on the size of the gallery.

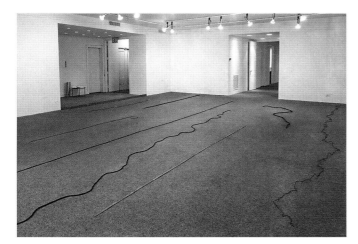

Carl ANDRE
Dwan Gallery, New York
3-23 April 1971
Installation view

This exhibition of thirty of Andre's works included his *Runs* and *Rods*, thin strips of various metals and rubber that coil or stretch across the gallery floor. Several metal tile floor works were also included. Andre highlighted the commodification of art objects in this exhibition by calculating the price of his works in accordance with the buyer's income: the purchaser paid 1 per cent of his annual income for each yard of sculpture. Andre also assumed control over the future resale of works by claiming 10 per cent of any profit made on resale.

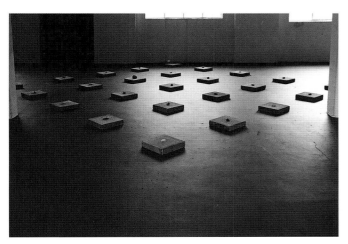

Carl ANDRE
25 Blocks and Stones
1986 (first version 1973)
Concrete blocks, river stone, geological specimens
25 units, 5 × 30.5 × 30.5 cm [2 × 12 × 12 in] each

This work, exhibited in Dusseldorf in 1986, consists of twenty-five concrete blocks arranged in a grid pattern with 91.5 cm [36 in] intervals between blocks. Each block has one geological specimen centred upon it, but for the central block which supports a river stone. The Dusseldorf work is derived from a larger work exhibited in 1973 at the Portland Center for the Visual Arts, Oregon, in which Andre used 144 blocks, rather than the twenty-five shown here.

Carl ANDRE
Stone Field Sculpture
1977
Glacial boulders
Dimensions variable
Installation view, Hartford, Connecticut

This is Andre's most significant permanent outdoor work, made for a lawn in Hartford, Connecticut, next to an eighteenth-century church. Thirty-six glacial boulders of various sizes and types of stone are placed in eight rows, forming a pyramid pattern suggesting the lines of tombstones in the adjacent cemetery. The number of boulders in each row matches the row's line number in the pattern: one stone in row one, two stones in row two, and so on. Perhaps more than any other work by Andre, it reflects the sculptor's abiding interest in such Neolithic monuments as Stonehenge, Avebury and so on.

Carl ANDRE
Flanders Field
1978
Western red cedar beams
54 beams, 91.5 × 30.5 × 30.5 cm [36 × 12 × 12 in] each

This work was constructed in the Netherlands and first exhibited in Dusseldorf, where the gallery was filled with fifty-four identical cedar beams measuring 30.5 cm [1 ft] square and standing 91.5 cm [3 ft] tall. The distance between each of the beams matches the width of the beams, and is sufficient to allow the viewer room to walk through the field of timbers. Filling up the gallery interior, it exemplifies Andre's attempt to develop a sculpture that defines its site of display.

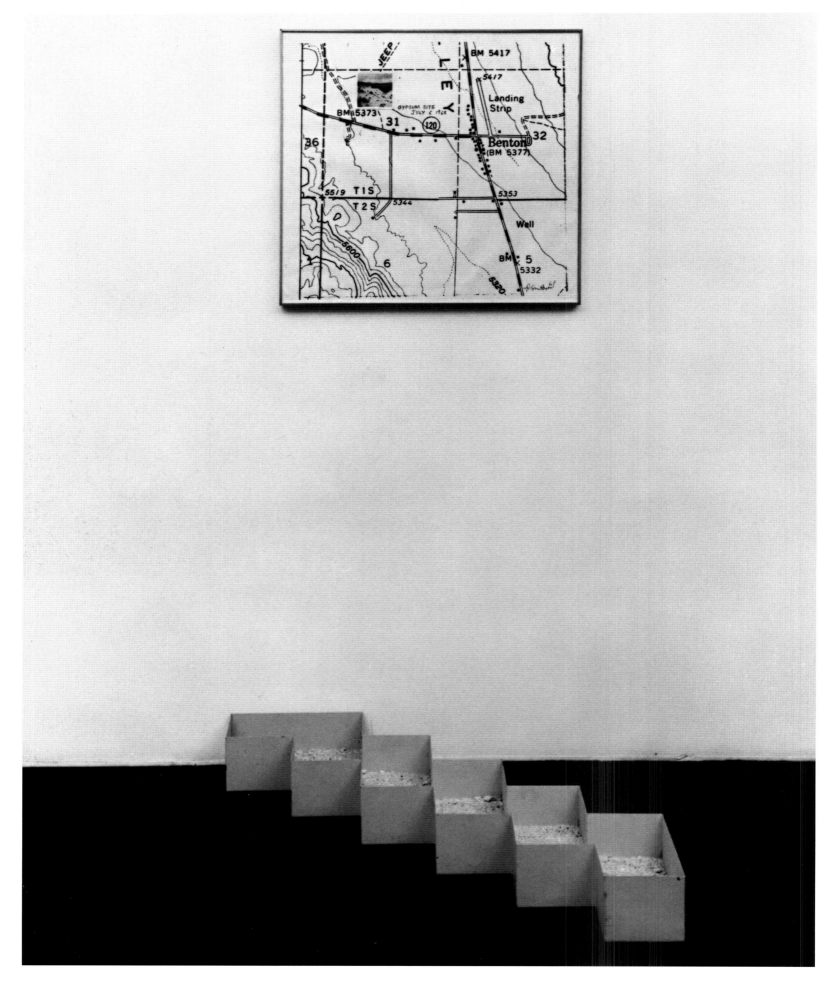

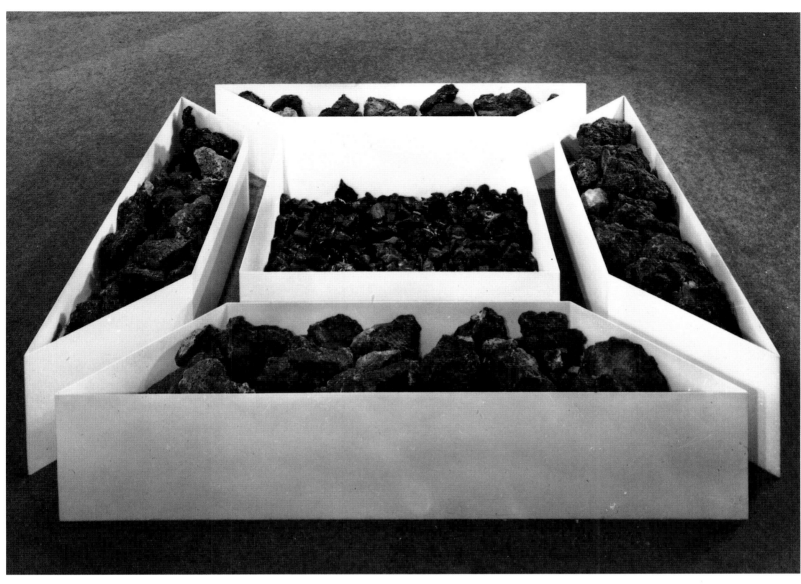

Robert <u>SMITHSON</u>
Double Non-site, California and
Nevada
1968
Steel, obsidian, lava
30.5 × 180 × 180 cm [12 × 71 × 71 in]

opposite
Robert <u>SMITHSON</u>
Gypsum Non-site, Benton,
California
1968
Gypsum, steel, photograph
Dimensions variable
Smithson's 'Non-sites' are sculptural
installations that remind the viewer of a
location far from the gallery. The actual
place, or site, is represented by the Non-
site. Many of these works used pre-
fabricated Minimal-type forms as
containers for rocks or sand taken from
the particular site. For this work,
Smithson used three different elements
referring to a location in Benton,
California. On the floor is a steel
container filled with gypsum specimens;
on the wall is a photograph super-
imposed on a map of this location.

Jo <u>BAER</u>
Untitled (Double Bar Diptych - Green and Red)
1968
Oil on canvas
Diptych, 91.5 × 100 × 4 cm [36 × 39 × 1.5 in] each

The coloured borders usual to Baer's paintings here are simple vertical bars on the left and right edges of each canvas. The right canvas features a black bar with a red edge, and the left canvas a black bar with a green edge. The vertical borders create a strong pattern of retinal after-images on the white ground that contrasts with the side-by-side placement of the canvases. The bands also contrast with – and highlight – the vertical gap between the paired supports.

Jo <u>BAER</u>
Untitled (Red Wraparound)
1970-74
Oil on canvas
122 × 132 × 8 cm [48 × 52 × 3 in]

Baer restretched the canvas so that the vertical black and red bars at the edges of the canvas literally wrap around the support. The colour and dimensions of the border appear to alter once they reach the sides of the canvas, changing the viewer's perception of the work from that of a frontal orientation.

Jo BAER
H. Arcuata
1971
Oil on canvas
56 × 244 × 10 cm [22 × 96 × 4 in]
Baer titled this work after a species of plant, using the letter H to refer to its horizontal
placement on the wall. It was meant to be hung only a few inches from the floor in
order both to challenge the traditional eye-level view of painting and to mimic
sculpture by calling attention to its width.

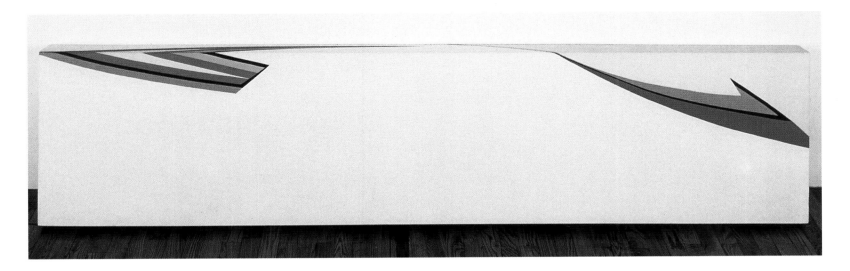

opposite
Robert <u>RYMAN</u>
Concord
1976
Oil on linen, steel
259 × 244 cm [102 × 96 in]

Robert <u>RYMAN</u>
Konrad Fischer Gallery, Dusseldorf
1968
Installation view

Ryman exhibited six paintings at the Konrad Fischer Gallery, Dusseldorf, including the *Classico Series*: acrylic paint on several panels of handmade paper hung in a square format. When Ryman shipped the paintings from his studio to Germany for the exhibition, the customs slip listed the contents of the crate as paper, rather than paintings. The customs officials, as Ryman recalls, determined that the paper was expensive, and asked for high tariffs. The owner of the gallery, Konrad Fischer, declared that the paper was indeed expensive, yet used, and thus the crates arrived at the gallery labelled 'Used Paper'.

Robert <u>RYMAN</u>
Prototype No. 2, 3, 5
1969
Oil on fibreglass
46 × 46 cm [18 × 18 in] each

In the *Prototype Series* Ryman attached thin plastic sheets directly to the wall with tape. He then painted the plastic with a white polymer. When the tape was removed, the plastic still stuck to the wall, because the overlaps of paint on the wall held the thin plastic down. Ryman then stretched the plastic, marred by the tears of the tape, on a red underpainting.

Robert <u>RYMAN</u>
General
1970
Enamel on Enamelac on canvas
124.5 × 124.5 cm [49 × 49 in]

This is one of a series of fifteen paintings from the *General Series*, which were shown together at the Fischbach Gallery, New York, in 1971. They are almost identical in appearance and execution, yet vary in size. Each canvas was first painted in Enamelac, a type of shellac used as a primer-scaler. Ryman then applied six coats of white enamel to the canvas, calculating the size of the square centre in relation to the stretcher. Each coat was sanded after it dried, causing the enamel to appear luminous and reflective in contrast to the mat, Enamelac borders. At Fischbach Ryman emphasized such contrasts by illuminating one wall of works, and leaving the other unlit.

Agnes <u>MARTIN</u>
Untitled No. 3
1974
Acrylic, pencil and shiva gesso on canvas
183 × 183 cm [72 × 72 in]

In 1967 Martin declared her temporary retirement from painting, moving from New York City to New Mexico. She began exhibiting again in 1975 with the Pace Gallery, New York. These later works are distinctly different from her earlier work, emphasizing planes of pale colour rather than the previous grids of pencil lines. The pigment washes are so subtle that the variations in colour, such as the three bands of different shades of pink in *Untitled No. 3*, are barely noticeable from a distance.

below l. to r.,
Robert <u>MANGOLD</u>
W Series Central Diagonal 1 (Orange)
1968
Acrylic on masonite
122 × 183 cm [48 × 72 in]
Robert <u>MANGOLD</u>
W Series Central Diagonal 2
1968
Acrylic on masonite
122 × 244 cm [48 × 96 in]
Robert <u>MANGOLD</u>
1/2 W Series (Orange)
1968
Acrylic on masonite
122 × 244 cm [48 × 96 in]
Collection, The Museum of Modern Art, New York
Installation view, Fischbach Gallery, New York, 1969

Around the time of Mangold's *W, V, X Series*, various permutations based roughly on three letters of the alphabet, Mangold turned to using a roller – rather than a brush – to apply the paint and thus enhance the works' flatness. The *X Series*, moreover, formalized Mangold's method of developing a serial sequence according to a predetermined schema. 'From roughly 1968–70 I worked with a more rigid serial intent, in that I conceived ideas – the *W, V, X Series*, for instance – that attempted to work out all the possibilities of a given idea … For the *W, V, X Series* I lifted colours – a kind of pumpkin orange, a forest green and a blue – from a fabric store window display on the Lower East Side of New York.'
– Robert Mangold, 'Interview with Sylvia Plimack Mangold', 1999

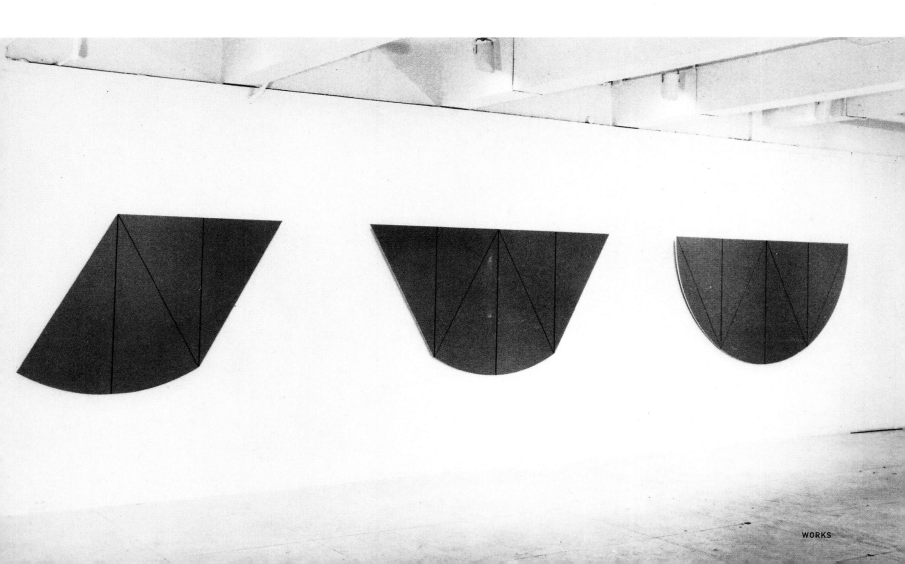

Robert MANGOLD
Distorted Square/Circle (Blue-Green)
1971
Acrylic and pencil on canvas
161 × 161 cm [63 × 63 in]

During the early 1970s Robert Mangold broadened his experimentation into the possibilities of a 'Flat Art' by examining many combinations of basic, two-dimensional geometric shapes – circles, squares, ellipses, curves and triangles – which he overlapped or distorted in monochromatic, single-panel (later multiple-panel) paintings. Works such as his *Distorted Square Circles* have often been compared with Leonardo's image of Vitruvian man, the Renaissance artist's diagram of a man inscribed within a perfect circle and square.

Robert <u>MANGOLD</u>
Painting for Three Walls (Blue, Yellow, Brown)
1979
Acrylic and pencil on canvas
Triptych, 230 × 323 cm [90.5 × 127 in] each
Installation view, John Weber Gallery, New York

Painting for Three Walls, exhibited at the John Weber Gallery, New York, in 1980, is made up of three paintings of different colours – a central bluish-grey trapezoid with a horizontal rectangle inscribed inside, flanked by an olive-brown rhomboid on the right with a vertical rectangle within. On its left is a warm yellow panel of distorted, roughly rectangular shape with a horizontal rectangle drawn inside. Mangold's exploration of the multiple-panel format and architectural scale can in part be attributed to his travels to Italy in the mid 1970s, where he became interested in early Renaissance polyptychs and frescoes, from which he could draw connections to his 'Flat Art'.

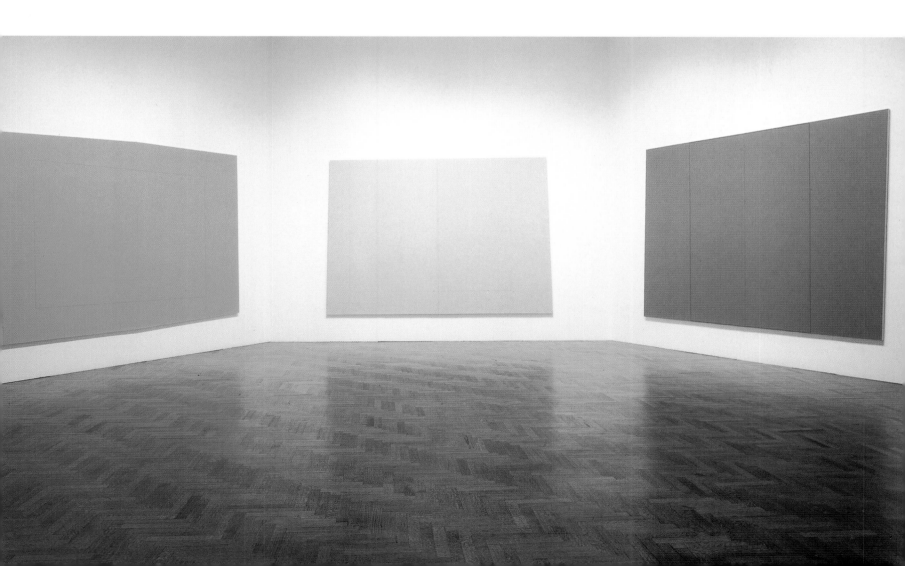

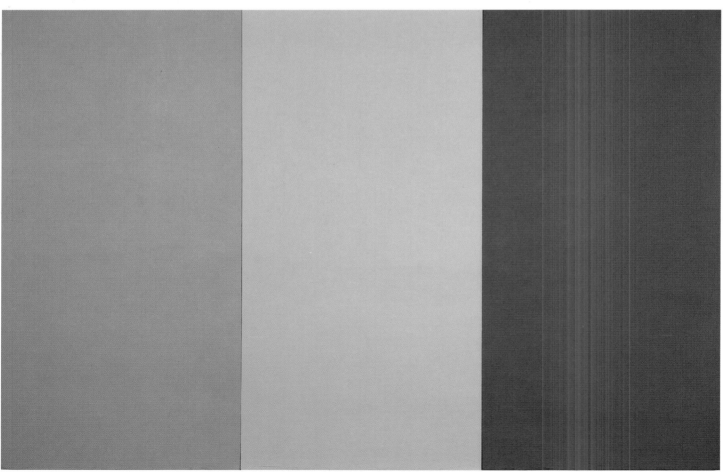

opposite top
Brice <u>MARDEN</u>
Grove Group I
1972
Oil and wax on canvas
183 × 274 cm [72 × 108 in]
Collection, The Museum of Modern
Art, New York

By the 1970s Marden returned to the single monochrome format of his early work in addition to producing multi-panel diptychs and triptychs. The *Grove Group* series, named after an olive grove in his favourite vacation spot on the Greek island of Hydra, includes both formats. The encaustic technique used in those paintings helps to create the thick, tactile surface which viewers found so appealing to the senses. Critic Douglas Crimp commented of Marden's work: 'Its sense of material *qua* material is so strong that … I felt compelled to walk up to a work and smell it.'
– Douglas Crimp, 'Opaque Surfaces', 1973

opposite bottom
Brice <u>MARDEN</u>
Grove Group III
1973
Oil and wax on canvas
183 × 274 cm [72 × 108 in]

Brice <u>MARDEN</u>
Sea Painting
1973-74
Oil and wax on canvas
183 × 137 cm [72 × 54 in]

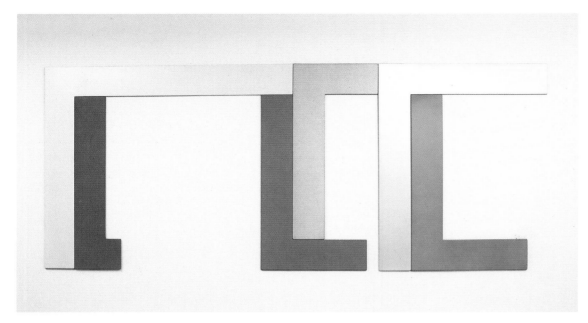

David <u>NOVROS</u>
Untitled
1968-69
Lacquer on fibreglass
183 × 366 cm [6 × 12 ft]

Novros began using fibreglass by the late 1960s because it allowed for a perfect, smooth lacquered surface with no surface grain to detract from the undulating variations of colour. Here he displays L-shaped canvases with legs of varying lengths. Novros juxtaposes light-coloured canvases with darker ones and also places them closer together as the configuration proceeds to the right. This arrangement encourages a mobile, protracted vision in the viewer, who must traverse the entire work in order to take in the complex colour and spatial relationships.

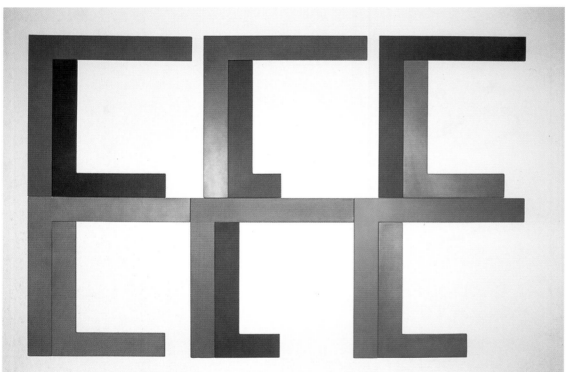

David <u>NOVROS</u>
Untitled
1968
Lacquer and dry pigment on fibreglass
366 × 457 cm [12 × 15 ft]
Collection, The Museum of Contemporary Art, Los Angeles

Novros' use of the shaped canvas allows the blank white space of the wall behind the work to become activated by the play of coloured shapes. In this untitled series Novros arranges twelve L-shaped paintings in a two-level composition. The placement of the multicoloured canvases in pairs causes the interior L-shapes to appear as shadows, creating a dynamic interplay of illusionistic depth and literal materiality.

David <u>NOVROS</u>
Untitled
1972 (destroyed)
Fresco
305 × 914 cm [10 × 30 ft]
Installation view, 'Projects', The Museum of Modern Art, New York

In his previous works Novros sought to activate the negative space of the gallery wall through the placement of coloured, shaped canvases. In this fresco, created for a special project at The Museum of Modern Art, New York, this activation of the gallery wall has been perfected by literally making the wall his canvas, indivisible from the coloured areas. Novros continued to use the geometric shapes of his earlier canvases, but the flat, continuous surface allows an overlap of forms, creating a more complex colour scheme and configuration of shapes. The fresco wall transcends the effect of a single painting, creating an environment that encompasses the viewer.

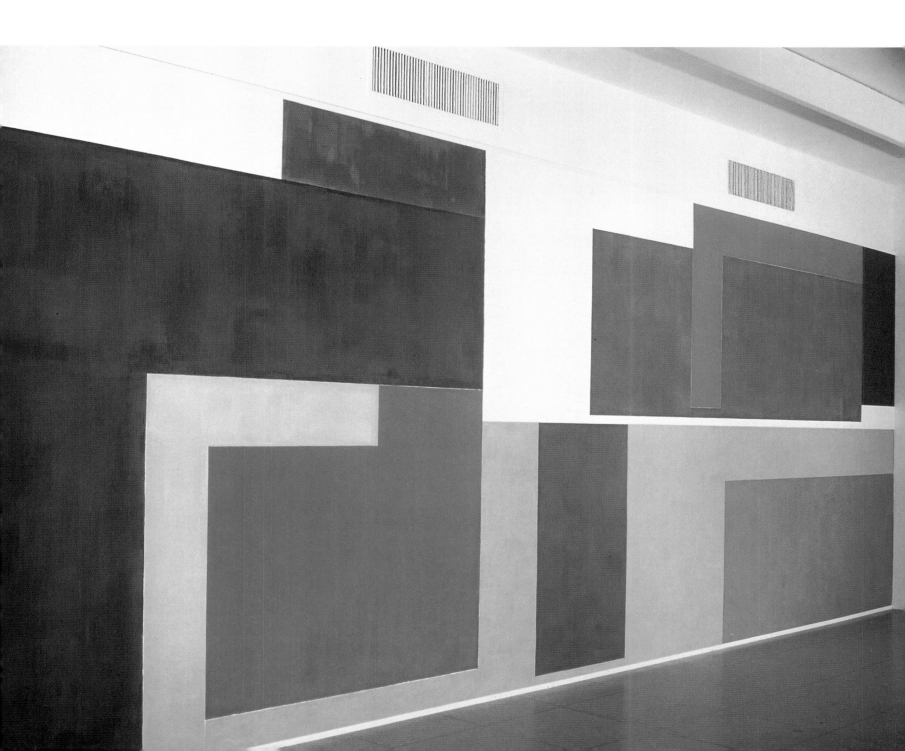

1980-present RECENT WORK In recent years

the artists associated with Minimalism have transformed the austere, geometric style of the 1960s in a number of directions. Whereas figures like Carl Andre, Robert Ryman and Robert Mangold continue to work in characteristic modes, Brice Marden has abandoned the monochrome panel for a gestural, calligraphic manner. Sol LeWitt's ephemeral, pencil wall drawings of the late 1960s and early 1970s have devolved into vast, multi-hued compositions, his simple cubic lattices into ever more intricate structures and polygonal solids. Anne Truitt's sculpture has become flagrantly polychrome, while the later installations of Dan Flavin explored spectacular combinations of colour and shape. Donald Judd's transformation was total, indeed breathtaking: continuing to develop his gallery work in updated materials and colours, he created enormous installations in concrete and aluminium at the Chinati Foundation in Marfa, Texas, extending the premises of wholeness and perspicuity of his early work into the orchestration of a total art environment.

Robert RYMAN
Versions VII
1991
Oil on fibreglass, waxed paper
44 × 41 in [112 × 104 cm]
Between 1991 and 1992 Ryman completed sixteen *Versions* paintings, each of which is a thin membrane bordered with waxed paper. The thinness of the works reacts to the light and space of the surrounding environment, as well as the way the painting reacts with the plane of the wall. Each of the works in the series differs in size and overall appearance. *Versions VII* is a fibreglass panel painted in thick white brushstrokes. The top of the picture plane is bordered with waxed paper, extending the painting visually beyond the fibreglass support.

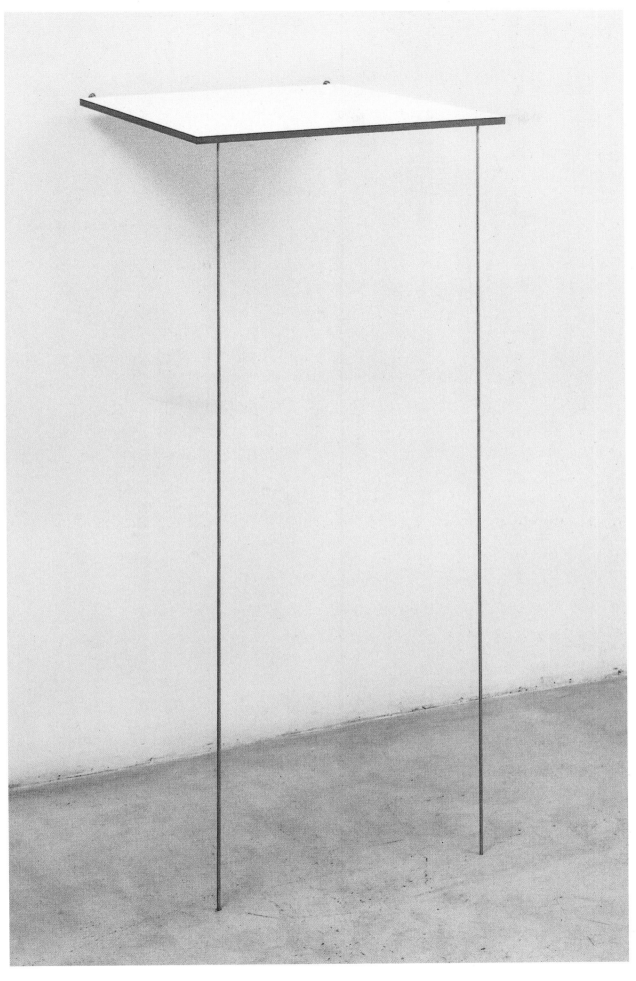

above

Robert RYMAN

Express

1985

Oil on Enamelac on fibreglass, steel bolts

274 × 121 cm [108 × 47.5 in]

Ryman coated a fibreglass panel with a thin layer of Enamelac, a green/yellow mat shellac. He then over-painted the top and bottom in a lighter shade of oil paint in the same colour, exposing the middle horizontal band and the large black steel bolts that hold the panel to the wall.

left

Robert RYMAN

Pace

1984

Acrylic on fibreglass, wood, aluminium

Panel, 66 × 66 × 67 cm [26 × 26 × 26.5 in]

Overall, 151 × 66 × 71 cm [59.5 × 26 × 28 in]

Ryman questions the traditional premise of painting as an object viewed vertically against the wall by butting the thin edge of a painted panel to the wall and supporting it with aluminium rods. The work is thus viewed as a quasi-sculptural form that projects out from the wall into the gallery space at eye level. The viewer sees the red edge of the panel, and the reflection of the gallery lighting bouncing off the top of the work which, painted in reflective enamel, contrasts with the bottom, coated in a mat white varnish.

Robert MANGOLD
X within X (Gray)
1980
Acrylic and pencil on canvas
\, 240 cm [96 in]; /, 203 cm [80 in]

In 1980 Mangold began the *X* and *+ Series* composed of four attached arms forming either an X or a + on the wall. Recalling operations (addition, multiplication) associated with the printed page, these paintings refer to the systems and forms that are part of daily life. They also bear a relationship with Piet Mondrian's *Pier and Ocean Series*, canvases composed of short vertical and horizontal strokes which, similarly, have been described as suggesting mathematical notation, pluses and minuses.

Robert MANGOLD
Attic Series XIV
1991
Acrylic and pencil on canvas
293.5 × 213.5 cm [115.5 × 84 in]

In 1990–91 Mangold produced one of his most ambitious group of paintings, the *Attic Series*, the title of which was inspired by a visit he made to the collection of early classical pottery from Attica at The Metropolitan Museum of Art in New York. This series, which eventually reached eighteen full-scale works, has a fresco-like quality resulting from the thin acrylic paint applied with a roller to the boldly coloured, shaped canvases. Each presents an elegant composition of hand-drawn ovals and figure-8s which allude to classical geometrics. The artist's early interest in his immediate urban surroundings gave way in later years to a broadened interest in art-historical affinities.

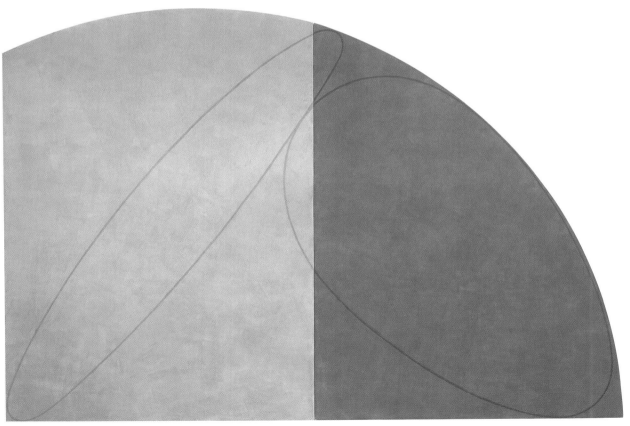

Robert MANGOLD
Curved Plane/Figure IV (Double Panel)
1995
Acrylic and pencil on canvas
249 × 362.5 cm [98 × 143 in]

The *Curved Plane/Figure Series* from mid 1994 to 1995 involved at least two adjacent panels, later extending up to four (and eventually leading to his wall-length *Zone* paintings, which comprised up to five such panels). These asymmetrical works with mismatched ellipses reaching across unequal, differently coloured panels are especially architectural, recalling the lunettes and irregular arching wall segments of Italian frescoed churches of the Renaissance.

Agnes MARTIN
Untitled No. 4
1984
Acrylic, gesso and graphite on canvas
183 × 183 cm [72 × 72 in]

In her early work Martin often gave her paintings titles meant to be evocative of the natural world. In contrast, her later paintings are identified only by number, expanding the interpretative and associative potential by refusing to give the viewer natural referents. This work, with more than ninety evenly spaced graphite lines, is reminiscent of her 1960s canvases of allover grids with wide margins on either side, exposing the pale white ground.

Agnes MARTIN
Untitled No. 1
1988
Acrylic and pencil on canvas
183 × 183 cm [72 × 72 in]

In Martin's recent paintings, the wide horizontal bands are defined through the
simplest of techniques. Here the bands are established by alternating lines of white
acrylic paint and graphite pencil drawn on a pale ground. The strong value contrast
of the acrylic and pencil lines creates the optical illusion that the wide bands beneath
the white lines stand out from the canvas, while the bands beneath the black lines
appear to recede behind the canvas.

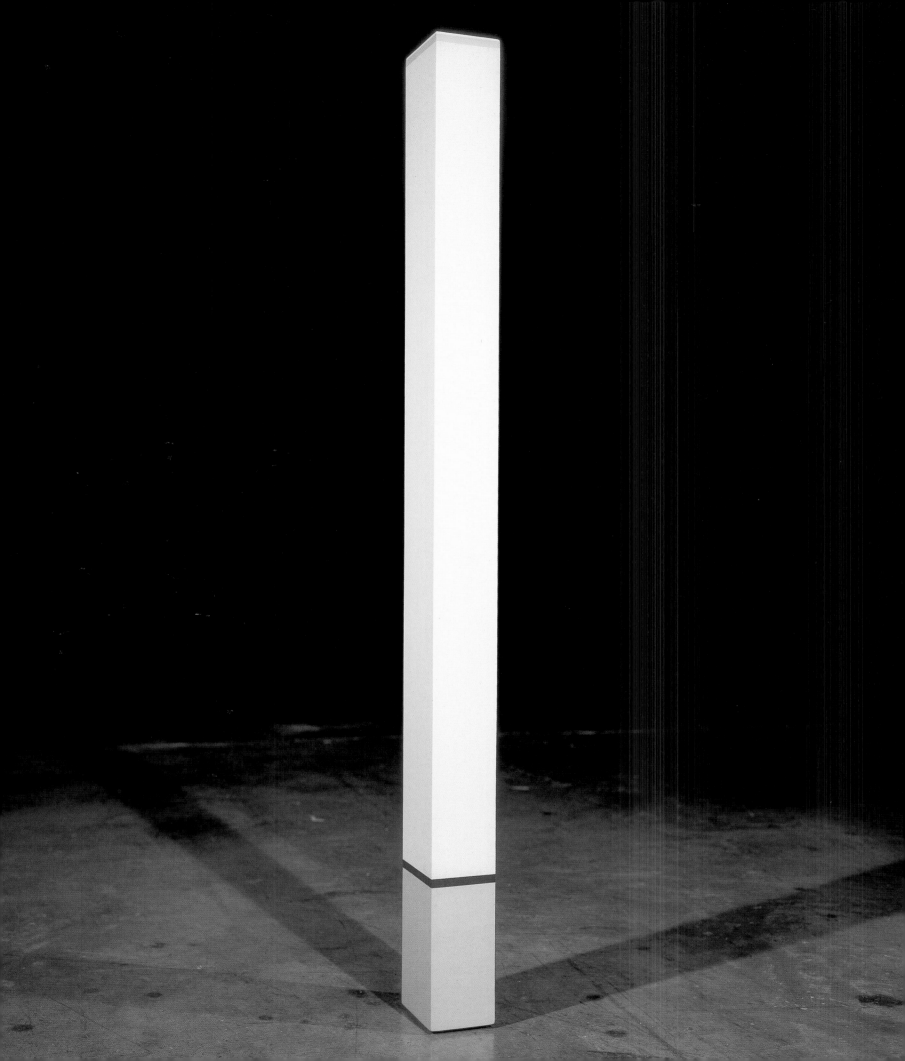

opposite

Anne <u>TRUITT</u>

Breeze

1980

Painted wood

153 × 10 × 14 cm [60 × 4 × 5.5 in]

Truitt's later work is columnar and has a greater emphasis on the effects of colour on a viewer. The tall thin column is painted in blocks and stripes over the entire surface, each patch of colour remaining distinct. The stripes travel the full 360 degrees around the sculpture, eliminating any possibility of a frontal reading and reiterating the three-dimensionality of the column.

Anne <u>TRUITT</u>

Baltimore Museum of Art

14 October–28 November 1992

Installation view

This installation appeared in a group exhibition inaugurating the new wing of the Baltimore Museum of Art in October 1982. It consisted of several columnar sculptures from different phases of Truitt's career, such as *Odeskalki* (1963), *A Wall for Apricots* (1968) and *Nicea* (1977), as well as more recent works. The Baltimore Museum has held several exhibits of Truitt's work over the years, including a show of her *Arundel* paintings in 1975 and a major retrospective in 1992 curated by Brenda Richardson.

Anne <u>TRUITT</u>

Parva XXX

1993

Acrylic on wood

15 × 81 × 10 cm [6 × 32 × 4 in]

Since making her first *Parva* in 1974, Truitt has produced forty-three works in the series. *Parva* is the feminine form of the Latin adjective for small. Works in the series tend to be diminutive in size, in contrast to most of Truitt's sculptures, which are scaled to the human body. Though consistently small, the *Parvas* come in a variety of shapes: this work is one of Truitt's few horizontal sculptures, a group that includes *Sandcastle* (1963), *Milkweed Run* (1974), *Remembered Sea* (1974) and *Grant* (1974). *Parva XXX* has a subtle palette with a thin yellow line dividing the dark bottom from the large pale top.

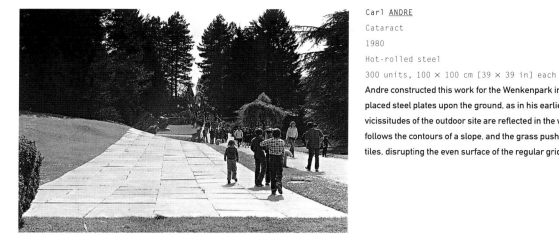

Carl <u>ANDRE</u>
Cataract
1980
Hot-rolled steel
300 units, 100 × 100 cm [39 × 39 in] each

Andre constructed this work for the Wenkenpark in Riehen/Basel, Switzerland. He placed steel plates upon the ground, as in his earlier metal floor works, but the vicissitudes of the outdoor site are reflected in the work's appearance. The sculpture follows the contours of a slope, and the grass pushes up between the edges of the tiles, disrupting the even surface of the regular grid.

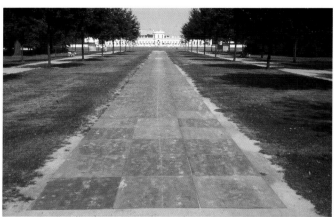

Carl <u>ANDRE</u>
Steel Peneplein
1982
Steel
300 units, 100 × 100 cm [39 × 39 in] each

Part of the international exhibition of contemporary art, Documenta 7, Kassel, Germany, *Steel Peneplein* consisted of 300 steel plates neatly placed on top of a pedestrian walkway in a park surrounded by rows of trees. Leading the viewer from one point to another, the sculpture is no longer a discrete object but a catalyst for movement, sculpture 'as a road'.

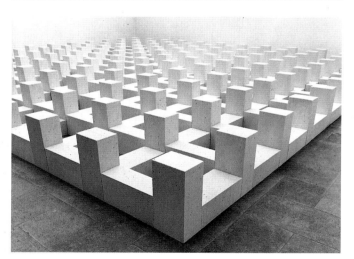

Carl <u>ANDRE</u>
Peace of Munster
1984
Gas-beton blocks
408 unit grid
24 × 18 × 50 cm [9.5 × 7 × 19.5 in] each;
50 × 760 × 850 cm [19.5 × 299 × 334.5 in] overall

The title of this work, exhibited at the Westfälischer Gallery in Munster during the Skulptur Projekte in Münster, refers to the peace treaty signed in that city, ending the Thirty Years War. Andre created a horizontal and vertical pattern from 408 white blocks that are arranged in a twenty-three block square configuration.

below l. to r.
Carl ANDRE
Angellipse
1995
Poplar
28 units, 5 × 127 × 25 cm [2 × 50 × 10 in] each
Carl ANDRE
Angelimb
1995
Poplar
65 units, 5 × 25 × 127 cm [2 × 10 × 50 in] each
Installation view, Paula Cooper Gallery, New York

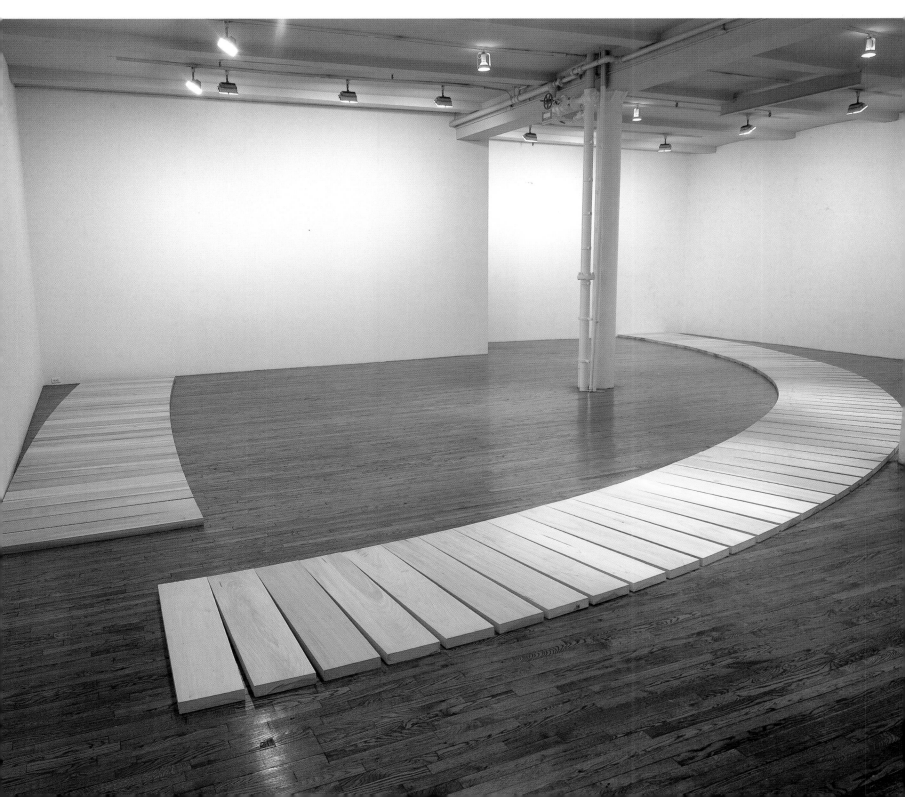

Carl ANDRE
'Pb Cu'
Galerie Tschudi, Glarus
27 May-2 September 1995
Installation view

The title of this exhibition refers to the chemical symbols for the two materials used in the fifteen sculptures included in the show: lead and copper. One section included works with the word 'None' in the title, derived from the Latin for ninth, which is the number of cubes in each. 'None' also is suggestive of their diminutive size. The sculptures in the other section had the word 'Trianone' in the title, alluding to the shape formed by the placement of three of the 'None' configurations in a larger cube formation.

Carl ANDRE
1Cu8Pb None
1995
Copper, lead
30 × 30 × 10 cm [12 × 12 × 4 in]

Andre stacks one cube of copper between eight cubes of lead in this work, juxtaposing the burnished metal with the dark, mat lead. The colour of the copper is similar to the tiles of the gallery floor and thus seems to create a transparent space within the solid square configuration.

Carl ANDRE
Glarus Copper Galaxy
1995
Copper
20 × .05 × 10,000 cm [8 × .02 × 3,937 in]
ø 225 cm [88.5 in]
Collection, Kunsthaus, Zurich

This work, named for the town of Glarus, Switzerland, where it was shown, marks Andre's return to the use of copper coil. He began using this sheet metal in 1969, when he allowed the raw material to coil naturally on the gallery floor. He has returned to working in this material in a much expanded scale, shaping the single sheet of copper into a spiral reminiscent of a 'galaxy' or other cosmological form.

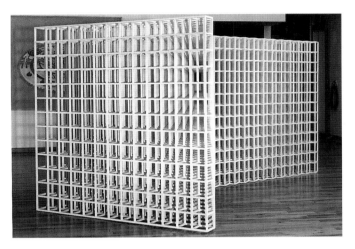

Sol LEWITT
13/11
1985
Painted wood
152 × 305 × 152 cm [5 × 10 × 5 ft]

LeWitt's white structures of the 1970s and 1980s are reminiscent of his earlier modular objects exhibited in 1966 at the Dwan Gallery, New York. However, these are more visually complex than the early works, due to their smaller lattice openings and intricate, layered designs. This piece is made up of two triangular structures of interlocking open cubes stacked thirteen high and eleven deep. The bright lighting creates shadows, confusing the viewer's ability to differentiate the boundaries between the object and its surrounding space and belying the geometric order of the structure.

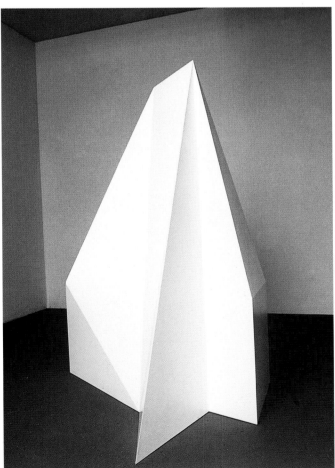

Sol LEWITT
Complex Form
1978–80
Painted wood
Dimensions variable

LeWitt's *Complex Forms* mark a departure from his modular works of the 1960s. His earlier structures, however complex, were based on the simplest of forms – the cube – which could be repeated according to a pre-chosen scheme. In contrast, the *Complex Forms* begin as irregular shapes: each is the projected three-dimensional volume of a two-dimensional figure. LeWitt first draws a polygon and then places a dot somewhere inside the figure; lines running from the vertexes of the polygon to the dot become the volume's multiple edges. Though they are consistently executed in wood painted white, each work is unique. The number of possible shapes is endless: the wildly varied forms in the series include ziggurats, irregular pyramids and polygonal solids too complicated for description.

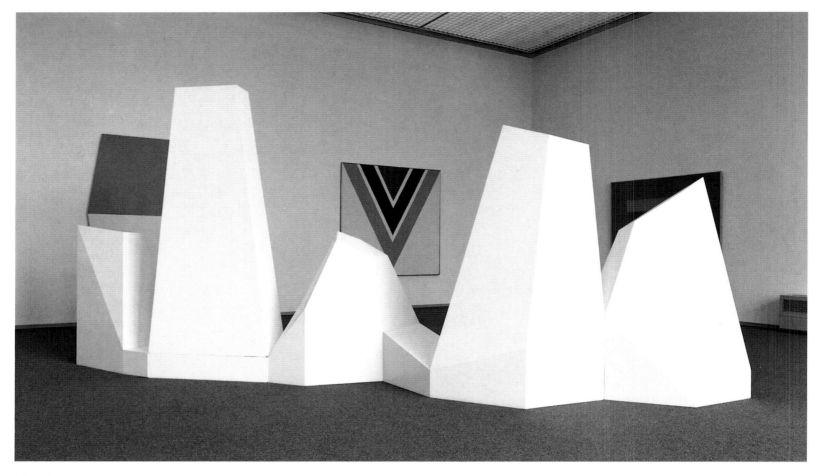

Sol LEWITT
Complex Form No. 8
1988
Painted plywood
305 × 691 × 183 cm [120 × 272 × 72 in]

Complex Form No. 8 consists of five interconnected parts, each of which is a completely different polyhedron structure varying in shape and height from the others. The entire structure resembles an organic, crystalline molecular configuration, with the five forms seeming to 'grow' from each other. It was first exhibited at the 1988 Venice Biennale.

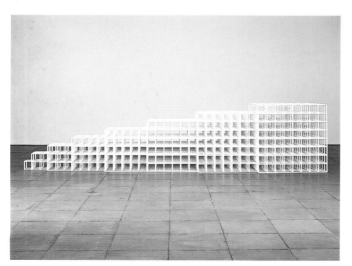

Sol LEWITT
Open Geometric Structure IV
1990
Painted wood
98 × 438 × 98 cm [38 × 172 × 38 in]

In 1990 LeWitt created several of these white wood sculptures, all of which he titled *Open Geometric Structure*. In each he used his signature white cube in a variety of configurations reminiscent of architectural forms, such as stairs. Although the works may allude to architecture, they remain small-scale, measuring only 98 cm [38 in] high.

opposite
Sol LEWITT
New Structures
1995
Breeze blocks
Installation view, ACE Gallery, New York

LeWitt filled the entire gallery with breeze block structures rising from the floor in a pattern of open square forms. At the points where the square bases intersect, towers rise to the ceiling. LeWitt used the same basic form he had chosen in the mid 1960s, the open skeletal cubic shape, yet with an expanded scale. The architectural size contradicts the domestic scale of his earlier geometric forms; the viewer can no longer perceive the works as distinct shapes, but must navigate the crowded gallery space in order to discern a more monumental configuration.

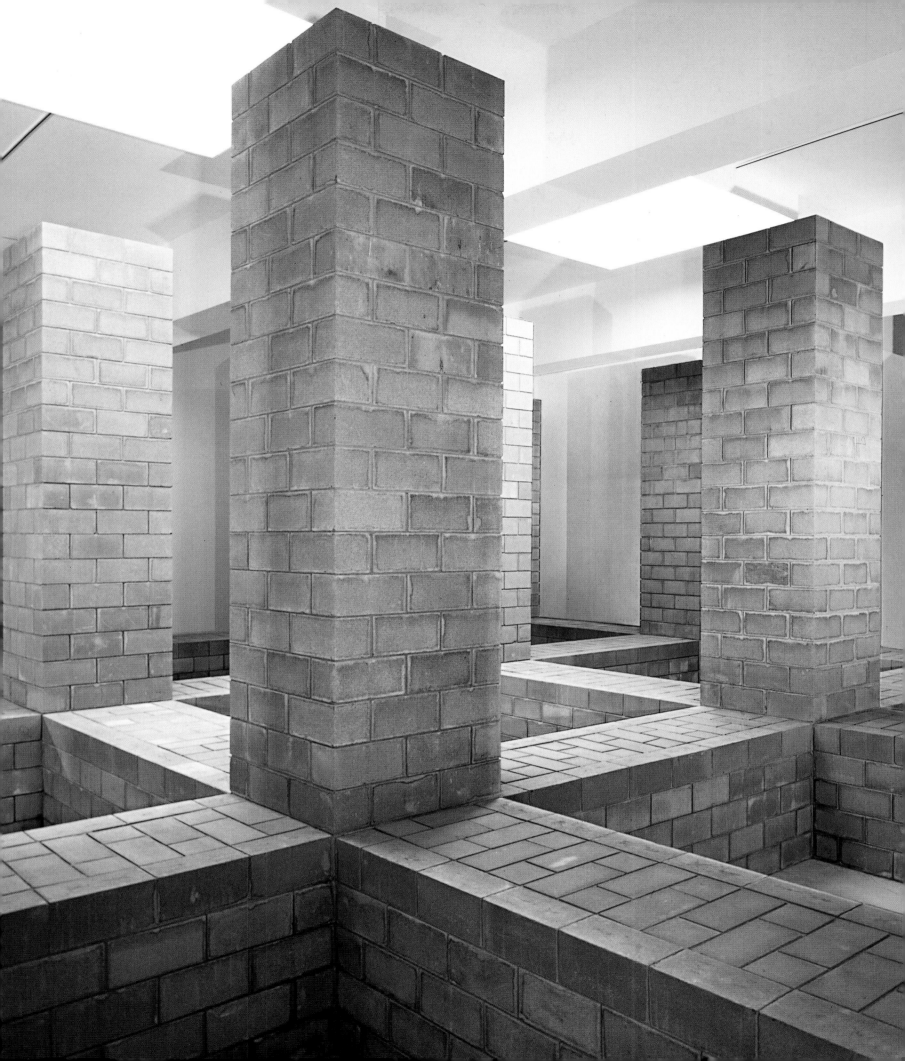

John <u>MCCRACKEN</u>
Hill
1997
Polyester resin and fibreglass on plywood
51 × 245 × 18 cm [20 × 96.5 × 7 in]
In this work McCracken again creates a hybrid between painting and sculpture, as he had done with his *Planks*. Like a painting, *Hill* hangs upon the wall, and is coloured in a rich resin pigment, yet the thickness of the wooden support, which creates shadows upon the gallery wall, and the shaped form testify to the work's sculptural quality. With the title McCracken relates *Hill* to nature and the landscape, yet the work also retains a machine-made quality, with angular edges and smooth resin veneer upon fibreglass.

John <u>MCCRACKEN</u>
One
1997
Polyester resin and fibreglass on plywood
240 × 119 × 23 cm [94.5 × 47 × 9 in]
This sculpture, a flat triangular relief, avoids the rectilinearity and heft of McCracken's classic planks and cubes. It is one of a number of recent works by McCracken that are physically light and idiosyncratically shaped.

Larry BELL
Made for Arolsen
1992
Tempered glass
16 units, h. 183 cm [6 ft] each

This work, exhibited at an outdoor site in Arolsen, Germany, consists of sixteen panels of blue and pink glass, all measuring 183 cm [6 ft] high. Eight of the panels are 244 cm [8 ft] long, and the remaining eight are 122 cm [4 ft] long. Bell arranged them in two concentric rectangular structures, with four of the smaller blue panels forming a box that rests in the centre of a large pink box. The other structure reverses the colour: the small glass box is pink and lies within a larger blue cube. The variation in the placement of colours completely alters the appearance of each object, despite the fact that the same two colours are used in each.

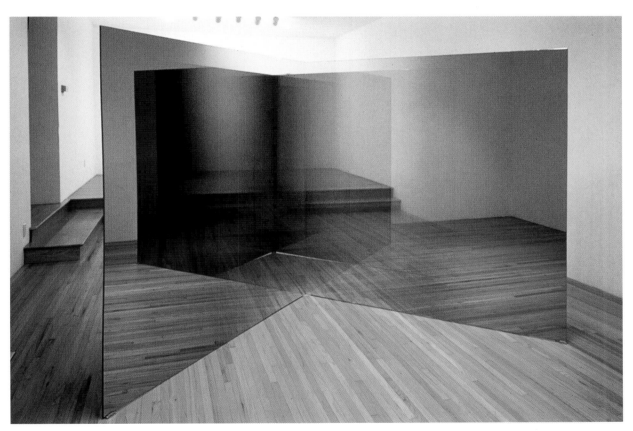

Larry BELL
6 × 8 × 4, 1996
1996
Inconel-coated glass
183 × 244 × 122 cm [6 × 8 × 4 ft]
Installation view, Kiyo Higashi Gallery, Los Angeles

The titles of these works are derived from their dimensions. Arranging large sheets of tinted glass in cubic and cruciform configurations, Bell has created a sculpture that borders on installation. The glass is both transparent and opaque: each wall is visible as itself, yet reveals the other glass sheets and the gallery space beyond. The reflective sheen of the glass causes the walls to mirror each other, the floor beneath and the viewer's body. The spectator of Bell's work is made conscious of his or her surroundings and the act of perception itself.

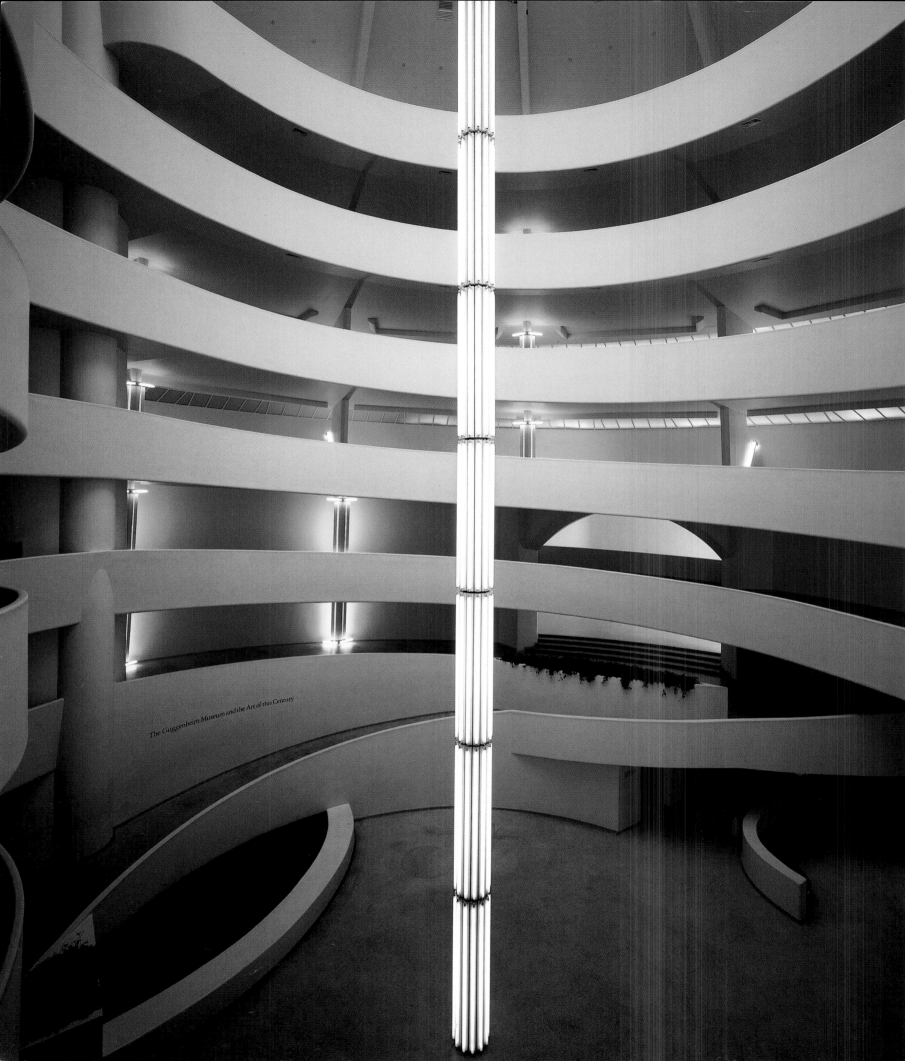

The Guggenheim Museum and the Art of this Century

'The Guggenheim Museum and the Art of This Century: Dan Flavin'
The Solomon R. Guggenheim Museum, New York
22 June-27 August 1992
Dan FLAVIN
untitled (to Tracy, to celebrate the love of a lifetime)
1992
Fluorescent light

Flavin was invited to design an installation for the renovated galleries of the Solomon R. Guggenheim Museum, New York, in 1992. Dedicated to his fiancée, Tracy, this work was an expanded version of his 1971 Guggenheim installation dedicated to the artist Ward Jackson. Each bay of the rotunda was lit by blue, pink, yellow or green fluorescent lights, highlighting the museum's unique architectural design by Frank Lloyd Wright. Flavin also added an immense vertical column of pink fluorescent tubes in the museum's atrium that extended from the floor to the skylight. The colour of the central column changed at different times of day: the daylight caused the lamps to appear off-white, while after dark their pale pink glow became prominent.

Dan FLAVIN
Städtische Galerie im Lenbachhaus, Kunstbau
16 July-6 September 1998
Installation view

In 1998 Flavin designed an installation for an art centre in Munich made from a converted underground station. He replaced the normal utilitarian white fluorescent lights with pink, yellow, blue and green tubes. The lack of natural light in the cavernous space allowed the combination of lamps to flood the entire area with a polychromatic glow, completely transforming the feel of the narrow gallery.

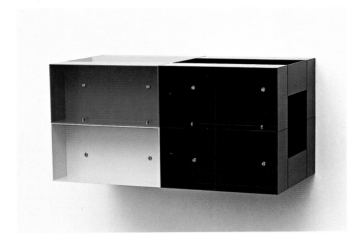

Donald JUDD
Untitled
1985
Enamel on aluminium
30 × 60 × 30 cm [12 × 23.5 × 12 in]

Beginning in 1984 Judd commissioned a factory in Switzerland to produce a new type of aluminium object that could sometimes grow to monumental size; the wall-pieces consist of hollow aluminium boxes bolted together, two high and three deep, with a hollow central core. The boxes were painted a variety of hues – bright orange, yellow, blue, teal, fuschia and red – as well as neutral shades of brown, ochre, black and white, allowing Judd to work with the full spectrum of colours. The aluminium objects are more intuitively conceived than Judd's earlier works. The clear rationale of his classic Minimal objects, which used a few colours at most in order to define a shape, is no longer apparent in these visually complex arrangements.

overleaf and following page
Donald JUDD
North Artillery Shed
1982-86
Installation view, interior

RECENT WORK

opposite top
Donald JUDD
Untitled
1981
Concrete
15 groups, 2.5 × 2.5 × 5 m [8 × 8 × 16 ft] each unit
1.1 km [3,281 ft] overall

Donald Judd passed through western Texas while serving in the army as a young man. Attracted to the region's vast open spaces, he settled in the town of Marfa in the early 1970s. The concrete structures that Judd built on land next to the artillery sheds of his Chinati Foundation are arranged in a linear sequence of individual groups, and consist of both open and closed forms. Those with two open sides allow the viewer to see the landscape beyond; those with one open side are more enclosed and shelter-like. Viewing the entire installation, which stretches across a vast field, is a truly temporal experience involving a bodily encounter with each monumental arrangement.

opposite bottom
Donald JUDD
South Artillery Shed
1982-86
Installation view, exterior

Donald Judd relocated his home and studio to Marfa, Texas, in 1971. Following his belief that the gallery system transforms the experience of art into that of a portable commodity, Judd sought a place to permanently install his and others' work. Between 1982 and 1986, Judd installed 100 identical aluminium boxes in two former military artillery sheds. Despite their identical exterior dimensions and materials, each box is unique. One open panel in each box allows the viewer to peer into an interior divided into varying angles by sheets of aluminium. These works are significant because, unlike the Specific Objects of the 1960s – discrete objects impervious to their environment – now the objects literally reflect their surroundings, the changing angles of the sunlight and the weather: the experience of viewing each box is different and dependent on the external world.

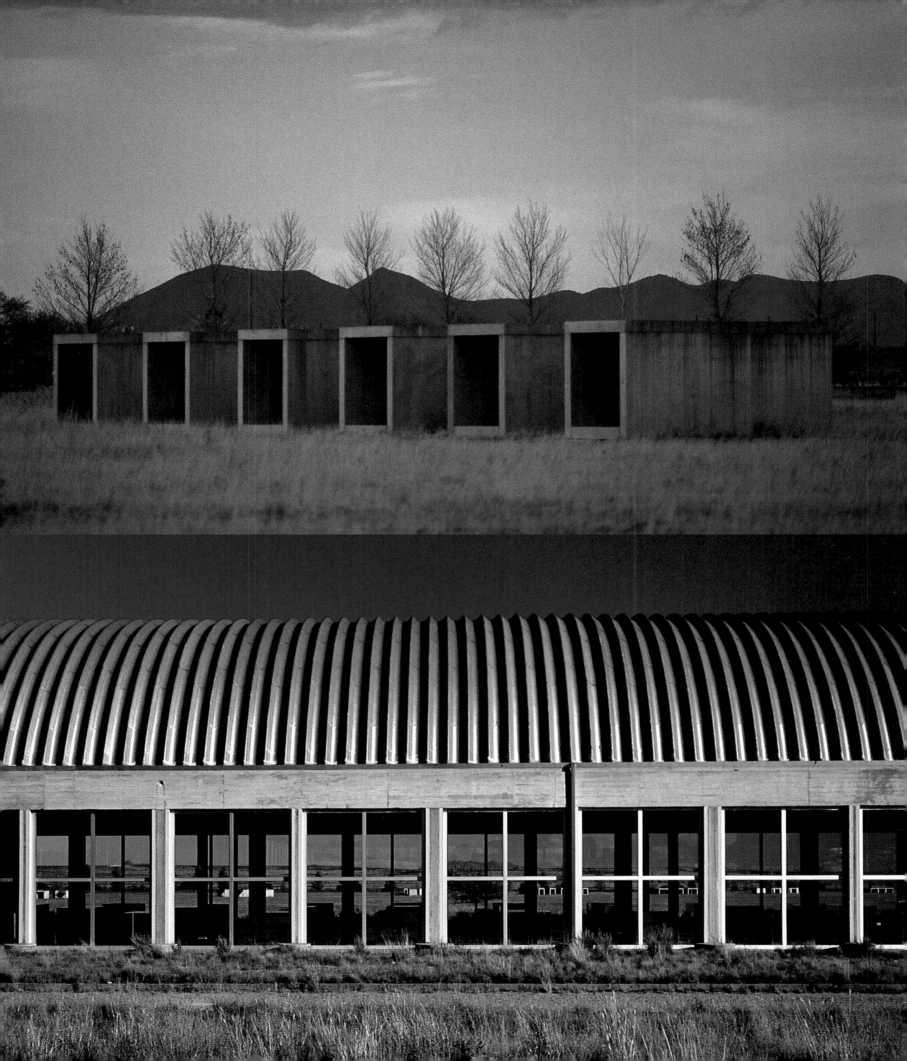

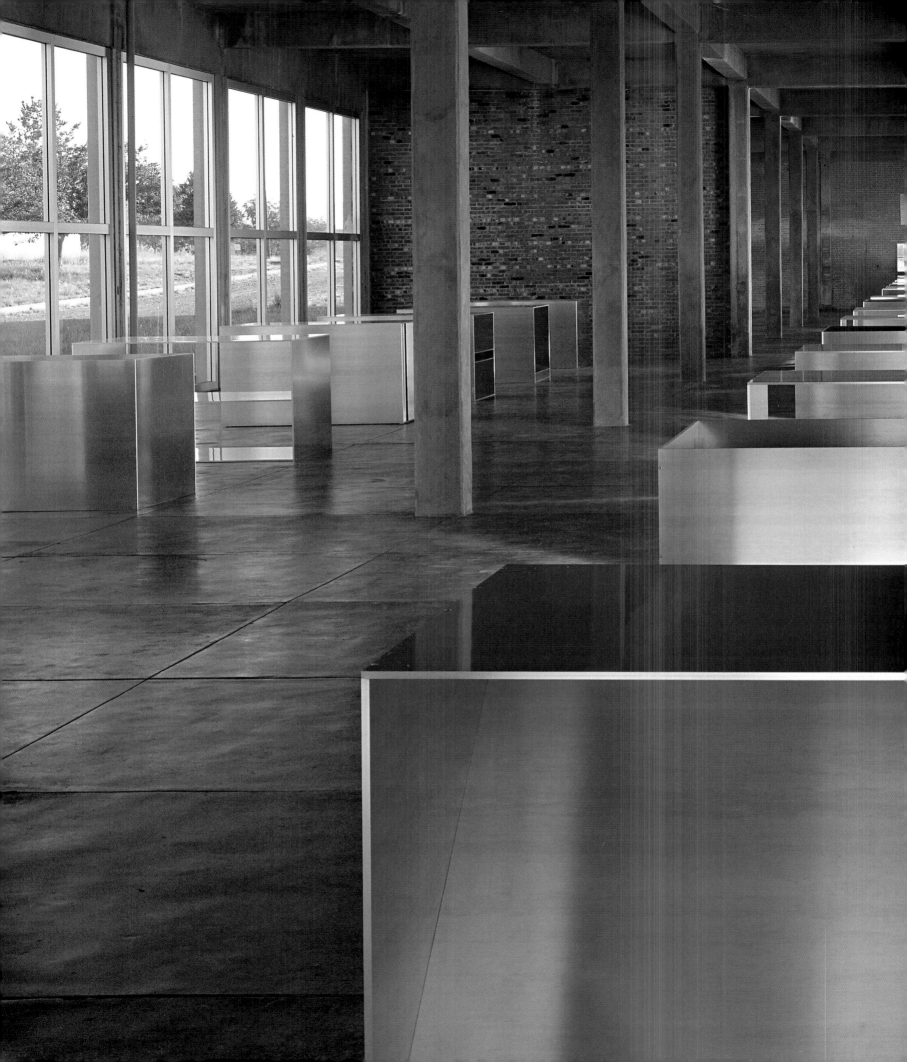

APPEN-
DICES

ARTISTS' BIOGRAPHIES

Carl ANDRE [b. 1935, Quincy, Massachusetts] is a New York-based sculptor and poet and one of the leading figures associated with Minimalism. In 1959 he produced his first signature works of repeated identical units, developing a sculpture characterized by strict attention to the physical properties of materials. Andre's famous horizontal floor planes, including *Equivalents I-VIII* (1966) and *Cuts* (1966-67), blurred the distinction between sculpture and installation. His work has appeared in innumerable exhibitions including 'Primary Structures', the Jewish Museum, New York (1966), 'When Attitudes Become Form', Kunsthalle, Bern (1969), and 'Blurring the Boundaries: Installation Art 1969-1996' (1996). Retrospective exhibitions have been held at the Gemeentemuseum, The Hague (1969), Solomon R. Guggenheim Museum, New York (1970), Museum of Modern Art, Oxford (1975), Kunstmuseum Wolfsburg, Krefeld (1996), and Royal Botanic Garden, Edinburgh (1998). Andre has written catalogue texts for his contemporaries, including Frank Stella (with whom Andre studied) and Bernd and Hilla Becher. He has also contributed to *Artforum*, *Arts Magazine* and *Art in America* on aspects of Modernism and the relation between art, culture and politics.

Jo BAER [b. 1929, Seattle] lives and works in Amsterdam. Her austere, white canvases with coloured bands around their borders were archetypal examples of Minimal-type painting during the 1960s. Baer was included in such important group shows as 'Systemic Painting', Solomon R. Guggenheim Museum, New York (1966), 'Art in Series', Finch College Museum of Art, New York (1967), and '10', Dwan Gallery, New York (1966). Baer has had retrospective exhibitions at the Whitney Museum of American Art, New York (1975), Stedelijk Van Abbemuseum, Eindhoven (1978; 1986), and Stedelijk Museum, Amsterdam (1999).

Larry BELL [b. 1939, Chicago] lives and works in Taos, New Mexico. A central figure of the Los Angeles Finish Fetish 'Light and Space' movement, he developed a method for vacuum-coating glass in 1962, which he then fabricated into cubic solids with highly reflective surfaces. By the late 1960s he had begun producing environmental sculptures of sheets of tinted plate glass. His more recent works have departed from a strictly Minimal idiom. Bell's work has appeared in such group exhibitions as 'The Responsive Eye', The Museum of Modern Art, New York (1965), 'Primary Structures', the Jewish Museum, New York (1966), and Documenta 4, Kassel (1968). His numerous shows include the Stedelijk Museum, Amsterdam (1967), Pasadena Art Museum, California (1972), Fort Worth Art Museum (1975), Detroit Institute of Arts (1982), Museum of Contemporary Art, Los Angeles (1984), Denver Museum of Art (1995) and Museum Moderner Kunst Landkreis Cuxhaven, Germany (1999).

Ronald BLADEN [b. 1918, Vancouver; d. 1988, New York] was an artist and professor at Parsons School of Design, New York. During the 1960s Bladen developed dynamic, monumental shapes which differed dramatically from the static, human-scaled works being done by the Minimalists. His famous *Elements* (1966) was included in 'Primary Structures', the Jewish Museum, New York (1966). Bladen exhibited in such group exhibitions as 'Concrete Expressionism', Loeb Student Center, New York University (1965), and 'Scale as Content', Corcoran Gallery of Art, Washington, DC (1968). His solo shows include the Green (1962) and Fischbach Galleries, New York (1972). A retrospective was held at P.S. 1, New York (1999).

Mel BOCHNER [b. 1940, Pittsburgh] is an artist and critic currently residing in New York. One of the most incisive critics of Minimal art during the 1960s, he became an innovator of Conceptual art in the late 1960s and early 1970s. Bochner's early projects made use of serial methods derived from Minimalism, such as *36 Photographs and 12 Diagrams* (1966), and *Working Drawings and Other Visible Things on Paper Not Necessarily Meant to be Viewed as Art* (1966). Group shows include 'When Attitudes Become Form', Kunsthalle, Bern (1969), 'Information', The Museum of Modern Art, New York (1970), 'L'Art Conceptuel, Une Perspective', Musée d'Art Moderne de la Ville de Paris (1989-90), and '1965-1995: Reconsidering the Object of Art', Museum of Contemporary Art, Los Angeles (1995). Retrospective exhibitions have been held at the Baltimore Museum of Art (1976), Palais de Beaux-Arts, Brussels, and Städtische Galerie im Lenbachhaus, Munich (both 1995-96).

Judy CHICAGO [Judy Cohen Gerowitz] [b. 1939, Chicago] is one of the leading figures of the feminist art movement. Working in a Minimal style in the 1960s under the name Judy Gerowitz, she participated in early Minimal shows including the important 'Primary Structures', the Jewish Museum, New York (1966). A founder of the Feminist Art Program at the California Institute of Arts, and of Womanhouse, Los Angeles (1971), she was instrumental in developing an art based on a female-specific content and iconography. Chicago's best known work is the collaborative *The Dinner Party* (1974-79), a homage to famous women of history and legend. Her solo exhibitions include Rolf Nelson Gallery, Los Angeles (1966), and a retrospective of her work was held at Florida State University Art Museum (1999). She is the author of *Through the Flower: My Struggle as a Woman Artist* (1975), and *The Dinner Party: A Symbol of Our Heritage* (1979).

Walter DE MARIA [b. 1935, Albany, California] has been associated with Minimalism, Conceptualism, Fluxus, Land art and installation art since the 1960s. His Minimal-type sculpture is distinguished by its metaphorical allusions. De Maria participated in 'Primary Structures', the Jewish Museum, New York (1966), and Documenta 5, Kassel (1972); his *Lightning Field* (1977), *New York Earth Room* (1977) and *Broken Kilometer* (1977) are permanent installations housed by the Dia Foundation, New York. Solo exhibitions include the Kunstmuseum, Basel (1972), Moderna Museet, Stockholm (1989), Fondazione Prada, Milan (1999), and Kunsthaus, Zurich (1992; 1999).

Dan FLAVIN [b. 1933, New York; d. 1996, Long Island] developed an installational art of fluorescent lights in 1963 that revealed the physical and perceptual parameters of the gallery environment. His works *the nominal three (to William of Ockham)* (1964-69) and *the diagonal of May 25, 1963 (to Robert Rosenblum)* (1963) are classic works of 1960s Minimalism. Flavin participated in such group shows as 'Black, White, and Gray', Wadsworth Atheneum, Hartford (1964), 'Primary Structures', the Jewish Museum, New York (1966), and 'The Art of the Real: USA, 1948-1968', The Museum of Modern Art, New York (1968). Solo exhibitions include the National Gallery of Art, Ontario (1969), Fort Worth Art Museum (1976- 77), Art Institute of Chicago (1976-77), Staatliche Kunsthalle, Baden-Baden (1989), Dia Center for the Arts, New York (1995), Solomon R. Guggenheim Museum, SoHo, New York (1995), and Fondazione Prada, Milan (1999).

Eva HESSE [b. 1936, Hamburg; d. 1970, New York] was a leading figure of post-Minimal sculpture whose soft, hand-made works broke down the rigidity of Minimal shape and syntax through the use of pliable materials and 'absurd' repetition. Hesse exhibited in numerous group shows including 'Eccentric Abstraction', Fischbach Gallery, New York (1966), 'Art in Series', Finch College Museum of Art, New York (1967), and 'Live in Your Head: When Attitudes Become Form', Kunsthalle, Bern (1969). Her solo exhibitions include Allan Stone (1963) and Fischbach Galleries (1968; 1970), New York. Retrospective exhibitions include the Solomon R. Guggenheim Museum, New York (1972), Whitechapel Art Gallery, London (1979), Yale University Art Gallery, New Haven (1992), IVAM Centre Julio Gonzàlez, Valencia (1993), and Ulmer Museum, Ulm, Germany (1994).

Ralph [Robert] HUMPHREY [b. 1932, Youngstown, Ohio; d. 1990, New York] developed a pared-down Minimal-type painting in the late 1950s. In the mid 1960s he made a series of eleven *Frame Paintings* with a painted border that contrasts sharply with the painted central panel. Group exhibitions include 'Abstract Expressionists and Imagists' (1961) and 'Systemic Painting' (1966), both Solomon R. Guggenheim Museum, New York. Humphrey has had many solo exhibitions at the Tibor de Nagy and Bykert Galleries in the 1960s, and Mary Boone Gallery, New York (1990).

Donald JUDD [b. 1928, Excelsior Springs, Missouri; d. 1994, New York] was an artist and critic and one of the central figures associated with the development of Minimal art. He began writing reviews for *Arts Magazine* in 1959, soon emerging as a leading polemicist of this new work with the publication of 'Specific Objects' (1965). His first show, of cadmium red works, was held at the Green Gallery, New York, in 1963. During the mid 1960s he began creating

the serial, industrially produced works in metal and Plexiglas for which he is most well known. Relocating to Marfa, Texas, in the 1970s, he established a number of permanent installations of his own and other artists' work. Judd appeared in countless exhibitions, including 'Shape and Structure', Tibor de Nagy Gallery, New York (1965), 'Primary Structures', the Jewish Museum, New York (1966), and 'The Art of the Real: USA, 1948-1968', The Museum of Modern Art, New York (1968). Retrospectives include the Whitney Museum of American Art, New York (1968; 1988), Stedelijk Van Abbemuseum, Eindhoven (1970; 1987), National Gallery of Canada, Ottawa (1975), Museum of Modern Art, Oxford (1976; 1994), Kunsthalle, Bern (1976), Staatliche Kunsthalle, Baden-Baden (1989), Museum Wiesbaden (1993), Museum Boymans-van Beuningen, Rotterdam (1993), Gemeentemuseum, The Hague (1993-94), and Sprengel Museum, Hannover (2000).

Sol **LEWITT** [b. 1928, Hartford; d. 2007, New York] lived in Chester, Connecticut and Spoleto, Italy. An innovator of both Minimal and Conceptual art, he began producing Minimalist structures and reliefs in 1962 and developed his well-known series of factory-made, white lattice works by the mid 1960s. His *Serial Project No. 1 (ABCD)* (1966) bridged the gap between formal abstraction and Conceptualism. This was followed by his essay 'Paragraphs on Conceptual Art' (1967) and the development of his Conceptual wall drawings in the late 1960s. LeWitt participated in numerous group exhibitions including 'Primary Structures', the Jewish Museum, New York (1966), 'Minimal Art', Gemeentemuseum, The Hague (1968), Documentas 4, 6 and 7, Kassel (1968; 1977; 1982), International Biennial of São Paulo (1996), and Skulptur Projekte in Münster and Venice Biennale XLVII (1997). Retrospective exhibitions include the Gemeentemuseum, The Hague (1970; 1992), Palais des Beaux-Arts, Brussels (1974), Rijksmuseum Kröller-Muller, Otterlo (1974), The Museum of Modern Art, New York (1978; 1996), Museum of Modern Art, Oxford (1993), and The San Francisco Museum of Modern Art, Museum of Contemporary Art, Chicago, Whitney Museum of American Art, New York (2000), and MASS MoCa (2009).

John **MCCRACKEN** [b. 1934, Berkeley] currently lives and works in New Mexico. In the mid 1960s, in Los Angeles, he began to use geometric forms with richly coloured, lacquered surfaces. In 1966 he developed his well-known leaning planks. McCracken has participated in such group exhibitions as 'Primary Structures', the Jewish Museum, New York (1966), 'The Art of the Real: USA, 1948-1968', The Museum of Modern Art, New York (1968), the Carnegie International, Pittsburgh (1991), and 'Sunshine and Noir: Art in LA 1960-1997' (1997). Solo shows include Nicholas Wilder Gallery, Los Angeles (1965; 1967; 1968), Sonnabend (1970) and David Zwirner (1997; 2000) Galleries, New York , and Galerie Hauser and Wirth, Zurich (1999). Retrospective exhibitions have been held at the Newport Harbor Art Museum (1987), Contemporary Arts Museum, Houston (1987), and the Kunsthalle, Basel (1995).

Robert **MANGOLD** [b. 1937, North Tonawanda, New York] currently lives and works in Washingtonville, New York. Mangold developed a pared-down abstract painting in the mid 1960s, exploring the potential of the shaped canvas in his *Wall* and *Area Series*. His inscription of perceptual uncertainty within the monochrome using drawn line and the literal edge between adjacent supports eventually led to the *X* and polychrome *Frame* works of the 1980s. Mangold's group shows include 'Systemic Painting', Solomon R. Guggenheim Museum, New York (1966), and Documentas 5, 6 and 7, Kassel (1972; 1977; 1982). Solo exhibitions include the Solomon R. Guggenheim Museum, New York (1971), La Jolla Museum of Contemporary Art (1974), Stedelijk Museum, Amsterdam (1982), and travelling exhibitions organized by the Akron Art Museum, Ohio (1984), and Museum Wiesbaden, Germany (1998-99).

Brice **MARDEN** [b. 1938, Bronxville, New York] developed a monochromatic painting style in the mid 1960s. Characterized by thick encaustic surfaces in shades of grey, black, green, blue and brown, and arranged into diptychs and triptychs, his early works are classic examples of Minimalist painting, a manner he left behind in his gestural *Cold Mountain* series of the late 1980s. Marden's work has appeared in numerous group exhibitions including Documenta 5, Kassel (1972), and the Whitney Biennial, Whitney Museum of American Art, New York (1972). Retrospectives include the Stedelijk Museum, Amsterdam (1981), Whitechapel Art Gallery, London (1981), Dia Center for the Arts, New York (1991), Kunsthalle, Bern (1993), Wiener Secession, Vienna (1993), Dallas Museum of Art (1999) and the Hirshhorn Museum and Sculpture Garden, Washington, DC (1999).

Agnes **MARTIN** [b. 1912, Saskatchewan, Canada; d. 2004, Taos, New Mexico] lived and worked in Lamy, New Mexico. She developed her signature abstract painting style in the late 1950s. Often executed in acrylic and graphite, in pale shades of off-white, pastel and grey, Martin's canvases are noted for their delicacy and austerity, and allusions to nature and transcendental experience. She participated in numerous group exhibitions including 'Black, White, and Gray', Wadsworth Atheneum, Hartford (1964), 'The Responsive Eye', The Museum of Modern Art, New York (1965), and 'Systemic Painting', Solomon R. Guggenheim Museum, New York (1966), as well as Documenta 5, Kassel (1972). Retrospectives include the Institute of Contemporary Art, University of Pennsylvania, Philadelphia (1973), Hayward Gallery, London (1977), Stedelijk Museum, Amsterdam (1977; 1991), and a travelling exhibition was organized by the Whitney Museum of American Art, New York (1993-94). Since 2004, the Dia Art Foundation in New York has organized a series of retrospective exhibitions around the artist's work.

Paul **MOGENSEN** [b. 1941, Los Angeles] lives and works in New York. During the 1960s and 1970s Mogensen developed a style of modular painting using richly saturated colours, black and white. Frequently the dimensions of the different sized panels of his work were governed by mathematical rules, as in his Golden Section works exhibited at the Bykert Gallery, New York (1968). Solo shows include the Weinberg Gallery, San Francisco (1974; 1976), and numerous shows at the Bykert Gallery, New York, beginning in 1965. Retrospectives include the Houston Museum of Fine Arts (1978) and Wiener Secession, Vienna (1994).

Robert **MORRIS** [b. 1931, Kansas City] has worked in a variety of media including sculpture and painting, and was involved in the Judson Church dance and performance group. His show of grey, geometric works at the Green Gallery, New York (1964), established him as a key figure in the development of Minimal art. Morris was also a leading theorist of Minimalism, publishing the influential 'Notes on Sculpture: Parts I and II' (1966), only to later reject Minimalism in favour of post-Minimal or 'anti-form' work in the late 1960s. Group exhibitions include 'Primary Structures', the Jewish Museum, New York (1966), 'The Art of the Real: USA, 1948-1968', The Museum of Modern Art, New York (1968), and 'Minimal Art', the Gemeentemuseum, The Hague (1968). Solo shows include the Whitney Museum of American Art, New York (1970), Tate Gallery, London (1971), Corcoran Gallery of Art, Washington, DC (1969; 1990), Solomon R. Guggenheim Museum, New York (1994), and Cabinet des Estampes, Geneva (1999).

David **NOVROS** [b. 1941, Los Angeles] currently lives and works in New York. One of the painters associated with Minimalism, Novros developed a style characterized by a sequence of shaped canvases made of unconventional materials such as vinyl and acrylic lacquer, and Dacron and fibreglass, during the 1960s; he began to produce wall frescoes of geometric design during the 1970s. Solo shows include 'Projects' at The Museum of Modern Art, New York (1972), the Sperone Westwater (1976; 1978) and Mary Boone (1983) Galleries, New York. Group shows include 'Systemic Painting', Solomon R. Guggenheim Museum, New York (1966), Documenta 5, Kassel (1972), and 'Rothko, Marden, Novros', Institute for the Arts, Rice University, Houston (1977).

Robert **RYMAN** [b. 1930, Nashville] emerged as one of the most rigorous Minimal painters during the 1960s. He began painting white, monochromatic canvases in the late 1950s, a format he has developed ever since. Ryman has exhibited internationally in such shows as 'Systemic Painting', the Solomon R. Guggenheim Museum, New York (1966), 'Live in Your Head: When Attitudes Become Form', Kunsthalle, Bern (1969), and Documenta 5, Kassel (1972). Ryman's retrospective exhibitions include Stedelijk Museum, Amsterdam (1974), Kunsthalle, Basel (1975), The Museum of Modern Art, New York (1993), and the Tate Gallery, London (1993).

Tony **SMITH** [b. 1912, South Orange, New Jersey; d. 1980, New York] was a sculptor, painter and architect. An assistant to the architect Frank Lloyd Wright and younger contemporary of the Abstract Expressionists, Smith developed a systemic, geometric sculpture contemporaneously with the emergence of Minimalism. His black Minimal-type work is extremely varied in shape, ranging from the simple cube to complex polyhedron constructions. Group shows include 'Primary Structures', the Jewish Museum, New York (1966), 'The Art of the Real: USA, 1948-1968', The Museum of Modern Art, New York (1968), and 'Minimal Art', Gemeentemuseum, The Hague (1968). Retrospectives include the Wadsworth Atheneum, Hartford (1964), Westfälischer

Landesmuseum, Munster (1988), and The Museum of Modern Art, New York (1971; 1998).

Robert **SMITHSON** [b. 1938, Rutherford, New Jersey; d. 1973, Amarillo, Texas] was an innovator of Land art as well as a prolific artist-writer during the 1960s and 1970s. A generation younger than the Minimalists Andre, Judd and LeWitt, Smithson's early abstract sculptures are based on crystalline forms. His later Non-sites transformed the Minimal object into a container bringing the site into the gallery, anticipating his later *Spiral Jetty* (1970). Smithson's essays of the late 1960s, such as 'Entropy and the New Monuments' (1966), announce a post-Minimal destruction of the Minimal object. Group exhibitions include 'Primary Structures', the Jewish Museum, New York (1966), and 'Minimal Art', Gemeentemuseum, The Hague (1968). Retrospectives include Cornell University Art Gallery, Ithaca (1980), Wallach Gallery, Columbia University, New York (1991), Los Angeles County Museum (1993), the National Museum of Contemporary Art, Oslo (1999), and the Museum of Contemporary Art, Los Angeles (2005) which travelled to the Dallas Museum of Art, Dallas and the Whitney Museum of Art, New York (2005).

Frank **STELLA** [b. 1936, Malden, Massachusetts] lives and works in New York. The exhibition of Stella's *Black Paintings* (1958-59) at 'Sixteen Americans', The Museum of Modern Art, New York (1959), heralded the emergence of Minimalism in the visual arts. Based on a deductive format of painted stripes that follow the shape and edge of the canvas, they pointed towards the development of the Minimal object. Stella's restoration of a compositional method in his *Irregular Polygons* (1966) marked a rupture with Minimalism. Group exhibitions include 'New York Painting and Sculpture 1940-70', The Museum of Modern Art, New York (1969), and the Venice Biennale (1964; 1970). Retrospectives include The Museum of Modern Art, New York (1987), Museo Nacional Centro de Arte Reina Sofía, Madrid (1995), and the Walker Art Center, Minneapolis (1997). Stella delivered the Charles Eliot Norton Lectures at Harvard University in 1983-84, subsequently published as *Working Space* (1986).

Anne **TRUITT** [b. 1921, Baltimore; d. 2004, Washington, DC.] lived and worked in Washington, DC. She was one of the first artists to develop a Minimal sculpture of whole geometric shapes, and had the first solo exhibition of Minimalist work at the Andre Emmerich Gallery, New York (1963). Group exhibitions include 'Primary Structures', the Jewish Museum, New York (1966), and 'The Art of the Real: USA, 1948-1968', The Museum of Modern Art, New York (1968). Retrospectives include the Whitney Museum of American Art, New York (1973), Corcoran Gallery of Art, Washington, DC (1974), the Baltimore Museum of Art (1974; 1992), the Museum of Contemporary Art, Los Angeles (2004), and the Hirshhorn Museum and Sculpture Garden, Washington, DC (2009-10).

BIBLIOGRAPHY

Agee, William, *Don Judd*, New York: Whitney Museum of American Art, 1968

Alloway, Lawrence, *The Shaped Canvas*, New York: Solomon R. Guggenheim Museum, 1965

_____, *Systemic Painting*, New York: Solomon R. Guggenheim Museum, 1966

_____, 'Agnes Martin', *Artforum*, no 11, April 1973, 32-37

Andre, Carl, *Carl Andre: Sculpture 1958-1974*, Bern: Kunsthalle, 1975

_____, *Carl Andre: Wood*, Eindhoven: Stedelijk Van Abbemuseum, 1978

_____, *Carl Andre*, The Hague: Gemeentemuseum; Eindhoven: Stedelijk Van Abbemuseum, 1987

_____; Frampton, Hollis, *12 Dialogues 1962-1963*, ed. Benjamin H.D. Buchloh, Halifax: Nova Scotia College of Art and Design, 1981

Antin, David, 'Art and Information I: Grey Paint, Robert Morris', *ARTnews*, no 65, April 1966, 23-24; 56-58

Artstudio, 'Art Minimal: Carl Andre, Dan Flavin, Donald Judd, Sol LeWitt, Robert Morris, Tony Smith', *Artstudio*, no 6, Autumn 1987

Ashton, Dore, 'The Anti-Compositional Attitude in Sculpture', *Studio International*, no 172, July 1966, 44-47

_____, 'New York: "The Art of the Real" at The Museum of Modern Art', *Studio International*, no 176, September 1968, 92-93

Baer, Jo, 'Art and Politics/On Painting', *Flash Art*, no 37, November 1972, 6-7

_____, 'I am no longer an abstract artist', *Art in America*, no 71, October 1983, 136-37

_____, *Jo Baer: Paintings from the 1960s and early 1970s*, New York: Paula Cooper Gallery, 1995

Baker, Amy, 'Painterly Edge: A Conversation with Ralph Humphrey', *Artforum*, no 8, April 1982, 38-43

Baker, Elizabeth C., 'Judd the Obscure', *ARTnews*, no 67, April 1968, 44-45; 60-62

Baker, Kenneth, 'Ronald Bladen', *Artforum*, no 10, April 1972, 79-80

_____, 'Material Feelings: Ralph Humphrey', *Art in America*, no 72, October 1984, 162-67

_____, *Minimalism: Art of Circumstance*, New York: Abbeville, 1988

Banes, Sally, *Greenwich Village 1963: Avant-Garde Performance and the Effervescent Body*, Durham: Duke University Press, 1993

Bann, Stephen, *Brice Marden: Paintings,*

Drawings, Etchings 1975-1980, Amsterdam: Stedelijk Museum, 1981

Bannard, Darby, 'Present-Day Art and Ready-Made Styles', *Artforum*, no 5, December 1966, 30-35

Barette, Bill, *Eva Hesse: Sculpture*, New York: Timken, 1989

Batchelor, David, 'Within and Between', *Sol LeWitt: Structures 1962-1993*, Oxford: Museum of Modern Art, 1993

_____, *Minimalism*, London: Tate Gallery, 1997

Battcock, Gregory (ed.), *Minimal Art: A Critical Anthology*, New York: E.P. Dutton & Co., 1968

Bell, Larry, *Larry Bell: The 1960s*, Santa Fe: Museum of Fine Arts, 1982

_____, *Zones of Experience: The Art of Larry Bell*, Albuquerque Museum, 1997

Belloli, Jay, *Dan Flavin: installations in fluorescent light 1972-1975*, Texas: Fort Worth Art Museum, 1977

_____; Rauh, Emily S., *Dan Flavin: drawings, diagrams and prints 1972-1975*, Texas: Fort Worth Art Museum, 1977

Berger, Maurice, *Labyrinths: Robert Morris, Minimalism, and the 1960s*, New York: Harper and Row, 1989

Berkson, Bill, 'Ronald Bladen: Sculpture and Where We Stand', *Art and Literature*, no 12, Spring 1967, 139-50

_____, *Ronald Bladen: Early and Late*, San Francisco: Museum of Modern Art, 1991

_____; Blok, Cor, 'Minimal Art at the Hague', *Art International*, no 12, May 1968, 18-24

Blok, Cor [see Berkson, Bill]

Bochner, Mel, 'Art in Process - Structures', *Arts Magazine*, no 40, September-October 1966, 38-39

_____, 'Systemic', *Arts Magazine*, no 41, November 1966, 40

_____, 'Serial Art, Systems: Solipsism', *Arts Magazine*, no 41, Summer 1967, 39-43

_____, *Working Drawings and Other Visible Things on Paper Not Necessarily Meant to be Viewed as Art*, Geneva: Cabinet des estampes du Musée d'Art et d'Histoire, 1997

Bois, Yve Alain, 'Ryman's Tact', *Painting as Model*, Cambridge, Massachusetts and London: MIT Press, 1990

_____, 'Surprise and Equanimity', *Robert Ryman: New Paintings*, New York: Pace Gallery, 1990

_____, 'The Inflection', *Donald Judd: New Sculpture*, New York: Pace Gallery, 1991

Bourdon, David, *Carl Andre Sculpture 1959-1977*, New York: J. Rietman, 1978

Chicago, Judy, *Through the Flower: My Struggle as a Woman Artist*, Garden City: Doubleday & Company, 1975

Clarke, David, 'The Gaze and the Glance: Competing Understandings of Visuality in the Theory and Practice of Late Modernist Art', *Art History*, no 15, March 1992, 80-98

Clay, Jean, 'La Peinture en charpie', *Macula*, nos. 3-4, September 1978, 167-85

Colpitt, Frances, *Finish Fetish: LA's Cool School*, Los Angeles: Fisher Gallery, University of Southern California, 1991

_____, *Minimal Art: The Critical Perspective*, Ann Arbor: UMI Research Press, 1990

Compton, Michael; Sylvester, David, *Robert Morris*, London: Tate Gallery, 1971

Cooper, Helen, *Eva Hesse: A Retrospective*, New Haven: Yale University Art Gallery, 1992

Coplans, John, 'Three Los Angeles Artists', *Artforum*, no 1, April 1963, 29-31

_____, 'Serial Imagery', *Artforum*, 7, October 1968, 34-43

_____, 'An Interview with Don Judd: "I am interested in static visual art and hate imitation of movement."' *Artforum*, no 9, June 1971, 44

Crow, Thomas, *The Rise of the Sixties*, New York: Abrams, 1996

Danieli, Fidel, 'Bell's Progress', *Artforum*, 5, Summer 1967, 68-71

De Duve, Thierry, 'Ryman irreproductible: nonreproductible Ryman', *Parachute*, no 20, Fall 1980, 18-27

_____, 'The Monochrome and the Blank Canvas', *Reconstructing Modernism: Art in New York, Paris, and Montreal 1945-1964*, ed. Serge Guilbaut, Cambridge, Massachusetts, and London: MIT Press, 1990

Develing, Enno, *Minimal Art*, The Hague: Gemeentemuseum, 1968

Didi-Huberman, Georges, *Ceci que nous voyons, ce qui nous regarde*, Paris: Editions Minuit, 1992

Dreishpoon, Douglas, *Ronald Bladen: Drawings and Sculptural Models*, Greensboro: Weatherspoon Art Gallery, University of North Carolina, 1995

Droll, Donald; Necol, Jane, *Abstract Painting 1960-1969*, New York: P.S.1, 1983

Dwan Gallery, *Ten*, New York: Dwan Gallery, 1966

_____, *Virginia Dwan: Art Minimal - Art*

Conceptuel - Earthworks, Paris: Galerie Montaigne, 1991

Elliott, David; Fuchs, Rudi, *Jo Baer: Paintings 1962-1975*, Oxford: Museum of Modern Art, 1977

Fer, Briony, 'Bordering on Blank: Eva Hesse and Minimalism', *On Abstract Art*, New Haven: Yale University Press, 1997

Field, Richard, *Mel Bochner: Thought Made Visible 1966-1973*, New Haven: Yale University Art Gallery, 1995

Flavin, Dan, *'monuments' for V. Tatlin from Dan Flavin, 1964-1982*, Los Angeles: Museum of Contemporary Art; Chicago: Donald Young Gallery, 1989

_____, 'some remarks … excerpts from a spleenish journal', *Artforum*, no 5, December 1966, 27-29

_____, 'some other comments … more pages from a spleenish journal', *Artforum*, no 6, December 1967, 20-25

_____, 'several more remarks', *Studio International*, no 177, April 1969, 173-75

Foster, Hal, 'Some Uses and Abuses of Russian Constructivism', *Art into Life: Russian Constructivism 1914-1932*, Seattle Henry Art Gallery, University of Washington, 1990

_____ (ed.), 'The Reception of the Sixties', *October*, no 69, Summer 1994, 3-21

Frampton, Hollis [see Andre, Carl]

Fried, Michael, *Three American Painters*, Cambridge, Massachusetts: Fogg Art Museum, Harvard University, 1965

_____, 'Shape as Form: Frank Stella's New Paintings', *Artforum*, no 5, November 1966, 18-27

_____, *Art and Objecthood*, Chicago: University of Chicago Press, 1998

Friedman, Martin, 'Robert Morris: Polemics and Cubes', *Art International*, no 10, December 1966, 23-27

Fuchs, Rudi [see Elliott, David]

Gibson, Eric, 'Was Minimalist Art a Political Movement?', *The New Criterion*, no 5, May 1987, 59-64

Goossen, Eugene C., *Eight Young Artists*, Yonkers: Hudson River Museum, 1964

_____, *The Art of the Real: USA 1948-1968*, New York: The Museum of Modern Art, 1968

_____, 'The Artist Speaks: Robert Morris', *Art in America*, no 58, May-June 1970, 102-11

_____, *Eight Young Artists: Then and Now, 1964-1991*, New York: Hunter College, 1991

Graham, Dan, 'Carl Andre', *Arts Magazine*, no 42, December 1967-January 1968, 34

_____, *Rock My Religion*: *Writings and Art Projects 1965-1990*, ed. Brian Wallis, Cambridge, Massachusetts, and London: MIT Press, 1993

Green, Eleanor, *Scale as Content*: *Ronald Bladen*, *Barnett Newman*, *Tony Smith*, Washington, DC: Corcoran Gallery of Art, 1968

Greenberg, Clement, *The Collected Essays and Criticism*, *1986-1993*, ed. John O'Brian, vols. I-IV, Chicago: University of Chicago Press, 1993

Hanhardt, John; Haskell, Barbara, *Blam! The Explosion of Pop*, *Minimalism*, *and Performance 1958-64*, New York: Whitney Museum of American Art, 1984

Harrison, Charles, *Essays on Art and Language*, Oxford: Basil Blackwell, 1991

Haskell, Barbara, *Larry Bell*, Pasadena Art Museum, 1972

_____, *Jo Baer*, New York: Whitney Museum of American Art, 1975

_____, *Donald Judd*, New York: Whitney Museum of American Art, 1988

_____, *Agnes Martin*, New York: Whitney Museum of American Art, 1992

_____ [see Hanhardt, John]

Held, Jutta, 'Minimal Art: eine amerikanische Ideologie', *Neue Rundschau*, no 83, 1972, 660-77

Hobbs, Robert, *Robert Smithson*: *Sculpture*, Ithaca: Cornell University Press, 1981

Hopps, Walter, 'Boxes', *Art International*, no 8, March 1964, 38-41

_____, *Anne Truitt*: *Sculptures and Drawings 1961-1973*, Washington, DC: Corcoran Gallery of Art, 1974

Insley, Will, 'Jo Baer', *Art International*, no 13, February 1969, 26-28

Jones, Caroline, *Machine in the Studio*: *Constructing the Postwar American Artist*, University of Chicago Press, 1996

Judd, Donald, 'Aspects of Flavin's Work', *fluorescent light, etc. from Dan Flavin*, Ottawa: National Gallery of Canada, 1969

_____, *Donald Judd*: *Complete Writings 1959-1975*, Halifax: Nova Scotia College of Art and Design; New York University Press, 1975

_____, *Donald Judd Furniture*: *Retrospective*, Rotterdam: Boymans-van Beuningen Museum, 1993

_____, *Zeichnungen/Drawings 1956-1976*, Basel: Kunstmuseum, 1976

_____, *Donald Judd*: *Complete Writings 1975-1986*, Eindhoven: Stedelijk Van Abbemuseum, 1987

_____, *Architektur*, Munich: Westfälischen Kunstverein, 1989

_____, *Räume*: *Kunst + Design*, Stuttgart: Cantz, 1993

_____, 'Some Aspects of Color in General and Red and Black in Particular', *Artforum*, no 32, Summer 1994, 70-79; 110; 113

Karmel, Pepe, *Robert Morris*: *The Felt Works*, New York University, Grey Art Gallery, 1989

Kellein, Thomas, *Walter De Maria*, Stuttgart: Staatsgalerie, 1987

_____, *McCracken*, Basel: Kunsthalle, 1995

Kertess, Klaus, *Brice Marden*: *Paintings and Drawings*, New York: Abrams, 1992

Kingsley, April, 'Ronald Bladen: Romantic Formalist', *Art International*, no 18, September 1974, 42-44

Kosuth, Joseph, *Art After Philosophy and After*: *Collected Writings*, *1966-1990*, ed. Gabriele Guercio, Cambridge, Massachusetts, and London: MIT Press, 1991

Kramer, Hilton, 'Art: Constructed to Donald Judd's Specifications', *The New York Times*, 19 February 1966

_____, '"Primary Structures" - The New Anonymity', *The New York Times*, 1 May 1966

_____, 'An Art of Boredom?', *The New York Times*, 5 June 1966

Krauss, Rosalind, 'Robert Mangold: An Interview', *Artforum*, no 12, March 1974, 36-38

_____, *Passages in Modern Sculpture*, Cambridge, Massachusetts, and London: MIT Press, 1977

_____, *The Originality of the Avant-Garde and Other Modernist Myths*, Cambridge, Massachusetts and London: MIT Press, 1985

_____, 'Overcoming the Limits of Matter: On Revising Minimalism', *American Art of the 1960s*, ed. John Elderfield, New York: The Museum of Modern Art, 1991

_____, 'The LeWitt Matrix', *Sol Le Witt*: *Structures 1962-1993*, Oxford: Museum of Modern Art, 1993

_____, 'The Mind/Body Problem: Robert Morris in Series', *Robert Morris*: *The Mind/Body Problem*, New York: Solomon R. Guggenheim Museum, 1994

_____, 'The Material Uncanny', *Donald Judd*: *Early Fabricated Work*, New York: Pace Wildenstein Gallery, 1998

Leen, Frederik, ' … Notes for an Electric Light Art [Dan Flavin]', *Forum International*, no 15, November-December 1992, 71-81

Leffingwell, Edward, *Heroic Stance*: *The Sculpture of John McCracken 1985-1986*, New York: P.S. 1; Newport Harbor Museum, 1986

Legg, Alicia (ed.), *Sol LeWitt*, New York: The Museum of Modern Art, 1978

Leider, Philip, 'Literalism and Abstraction:

Frank Stella's Retrospective at the Modern', *Artforum*, no 8, April 1970, 44-51

LeWitt, Sol, 'The Cube', 1966; reprinted in Legg (ed.), *Sol LeWitt*, *op. cit.*, 172

_____, 'Paragraphs on Conceptual Art', *Artforum*, no 5, June 1967, 79-83

_____, 'Sentences on Conceptual Art', *Art-Language*, no 1, May 1969, 11-13

_____, *Sol LeWitt*, The Hague: Gemeentemuseum, 1970

_____, 'Doing Wall Drawings', *Art Now*, 3, June 1971

_____, *Sol LeWitt*: *Drawings 1958-1992*, ed. Susanna Singer, The Hague: Gemeentemuseum, 1992

_____, *Sol LeWitt*: *Wall Drawings 1984-1992*, ed. Susanna Singer, Bern: Kunsthalle, 1992

_____, *Sol LeWitt*: *Structures 1962-1993*, Oxford: Museum of Modern Art, 1993

_____, *Sol LeWitt*: *Twenty-Five Years of Wall Drawings 1968-1993*, Seattle: University of Washington Press, 1993

_____, *Sol LeWitt*: *Critical Texts*, ed. Adachiara Zevi, AEIOU, 1994

Lippard, Lucy R., '10 Structurists in 20 Paragraphs', in Enno Develing, *Minimal Art*, The Hague: Gemeentemuseum, 1968

_____, *Eva Hesse*, New York: E.P. Dutton & Co., 1968; reprinted New York University, 1976

_____, *Changing*: *Essays in Art Criticism*, New York: E.P. Dutton & Co., 1971

_____, 'Color at the Edge: Jo Baer', *ARTnews*, May 1972, 24-25; 64-66

_____, *Tony Smith*, New York: Abrams, 1972

_____, *Six Years*: *The Dematerialization of the Art Object from 1966 to 1972*, New York: Praeger, 1973

McCracken, John, *John McCracken*, Paris: Galerie Ileana Sonnabend, 1969

_____, *John McCracken*, Vienna: Hochschule für Angewandte Kunst, 1995

McEvilley, Thomas, 'Grey Geese Descending: The Art of Agnes Martin', *Artforum*, no 25, Summer 1987, 94-99

McShine, Kynaston, *Primary Structures*, New York: Jewish Museum, 1966

Marden, Brice, *Suicide Notes*, Lausanne: Editions des Massons, 1974

Martin, Agnes, *Agnes Martin*, Philadelphia: Institute of Contemporary Art, University of Pennsylvania, 1973

_____, *Agnes Martin*, Munich: Kunstraum, 1973

_____, *Agnes Martin*: *Paintings and Drawings 1957-1975*, London: Arts Council of Great Britain, 1977

_____, *Agnes Martin*: *Paintings and Drawings 1974-1990*, Amsterdam: Stedelijk Museum, 1991

Melville, Robert, 'Planks in a Minimal Program', *New Statesman*, 18 April 1969

_____, 'Minimalism', *Architectural Review*, no 146, August 1969, 146-48

Merleau-Ponty, Maurice, *Phenomenology of Perception*, London: Routledge & Kegan Paul, 1962

Meyer, Franz, *Walter De Maria*, Frankfurt: Museum für Moderne Kunst, 1991

Meyer-Hermann, Eva, *Carl Andre*: *Sculptor 1996*, Cologne: Oktagon, 1996

Michelson, Annette, 'Agnes Martin: Recent Paintings', *Artforum*, no 5, January 1967, 46-47

_____, '10 x 10: "Concrete Reasonableness"', *Artforum*, no 5, January 1967, 30-31

_____, *Robert Morris*: *An Aesthetics of Transgression*, Washington, DC: Corcoran Gallery of Art, 1970

Monte, James; Young, Dennis, *John McCracken*: *Sculpture 1965-1969*, Toronto: Art Gallery of Ontario, 1969

Morris, Robert, 'Notes on Sculpture, Part 3: Notes and Nonsequiturs', *Artforum*, no 5, June 1967, 24-29

_____, 'Notes on Sculpture, Part 4', *Artforum*, no 7, April 1969, 50-54

_____, *Continuous Project Altered Daily*: *The Writings of Robert Morris*, Cambridge, Massachusetts, and London: MIT Press, 1993

Necol, Jane [see Droll, Donald]

Nodelman, Sheldon, *Marden*, *Novros*, *Rothko*: *Painting in the Age of Actuality*, Houston: Institute for the Arts, Rice University, 1978

O'Doherty, Brian, 'Frank Stella and a Crisis of Nothingness', *The New York Times*, 19 January 1964

_____, *Inside the White Cube*: *The Ideology of the Gallery Space*, Santa Monica and San Francisco: Lapis Press, 1976

Oliva, Achille Bonito (ed.), *Ubi Fluxus ibi motus 1990-1962*, Venice: Mazzotta, 1990

Owens, Craig, 'Earthwords', *October*, no 10, Autumn 1979, 120-30

Pagé, Suzanne (ed.), *Un choix d'art minimal dans la collection Panza*, Paris: Musée d'Art Moderne de la Ville de Paris, 1990

Parsy, Paul-Hervé, *Art minimal*, Paris: Musée national d'Art Moderne, Centre Georges Pompidou, 1992

Perreault, John, 'Union-Made: Report on a Phenomenon', *Arts Magazine*, no 41, March 1967, 26-31

Perrone, Jeff, 'Carl Andre: Art Versus Talk', *Artforum*, no 14, May 1976, 32-33

Phillips, Michael, *Ronald Bladen*: *Sculpture*, Hempstead: Hofstra University, 1967

Pincus-Witten, Robert, '"Systemic" Painting',

Artforum, no 5, November 1966, 43

_____, 'Sol LeWitt: Word = Object', *Artforum*, no 11, February 1973, 69-72

_____, *Eye to Eye*: *Twenty Years of Art Criticism*, Ann Arbor: UMI Research Press, 1984

_____, *Postminimalism into Maximalism*: *American Art*, *1966-1986*, Ann Arbor: UMI Research Press, 1987

Ratcliff, Carter, 'Jo Baer: Notes on 5 Recent Paintings', *Artforum*, May 1972, 28-32

Rauh, Emily S., *diagrams from Dan Flavin 1963-1972*, Missouri: St Louis Art Museum, 1973

_____, [see Belloli, Jay]

Reise, Barbara, '"Untitled 1969": A Footnote on Art and Minimal Stylehood', *Studio International*, no 177, April 1969, 166-72

_____, 'Robert Ryman: Unfinished I [Materials]/Unfinished II [Procedures]', *Studio International*, no 197, February-March 1984, 76-80; 122-28

Richardson, Brenda, *Frank Stella*: *The Black Paintings*, Baltimore Museum of Art, 1976

Robbe-Grillet, Alain, *For a New Novel*, New York: Grove Press, 1965

Robins, Corinne, 'Object, Structure or Sculpture: Where Are We?', *Arts Magazine*, no 40, September-October 1966, 33-37

_____, 'The Artist Speaks: Ronald Bladen', *Art in America*, no 57, September-October 1969, 76-81

Rose, Barbara, 'Looking at American Sculpture', *Artforum*, no 3, February 1965, 29-36

_____, 'Los Angeles: The Second City', *Art in America*, no 54, January- February 1966, 110-15

_____, *A New Aesthetic*, Washington, DC: Washington Gallery of Modern Art, 1967

_____, 'Blow Up: The Problem of Scale in American Sculpture', *Art in America*, no 56, July-August 1968, 80-91

_____, *Autocritique*, New York: Weidenfeld and Nicholson, 1988

Rosenblum, Robert, 'Pop Art and Non-Pop Art', *Art and Literature*, no 5, Summer 1965, 80-93

_____, *Frank Stella*, Harmondsworth: Penguin, 1971

Rubin, Lawrence, *Frank Stella Paintings 1958-1965*, New York: Stewart, Tabori and Chang Publishers, 1986

Rubin, William, *Frank Stella*, New York: The Museum of Modern Art, 1970

_____, *Frank Stella 1970-1987*, New York: The Museum of Modern Art, 1987

Ruda, Edwin, 'Park Place 1963-1967: Some Informal Notes in Retrospect', *Arts Magazine*, no 42, November 1967, 30-33

Ryman, Robert, 'Dossier Robert Ryman',

Macula, 3-4, September 1978, 113-85

_____, *Robert Ryman*: *Exhibition of Works*, New York: Solomon R. Guggenheim Museum, 1972

_____, *Robert Ryman* (Amsterdam: Stedelijk Museum, 1974

_____, *Robert Ryman*, London: Whitechapel Art Gallery, 1977

_____, *Robert Morris*: *Mirror Works 1961-1978*, New York: Leo Castelli Gallery, 1979

_____, *Robert Ryman*: *Paintings and Reliefs*, Zurich: Hallen für Neue Kunst, 1980

_____, *Robert Ryman*, Paris: Musée national d'Art Moderne, Centre Georges Pompidou, 1981

_____, *Robert Ryman*, New York: DIA Foundation, 1988

_____, *Robert Morris*: *The Mind/Body Problem*, New York: Solomon R. Guggenheim Museum, 1994

Sandler, Irving, 'The New Cool-Art', *Art in America*, no 53, February 1965, 96-101

_____, *American Art of the 1960s*, New York: Harper and Row, 1988

Schjeldahl, Peter, *Ralph Humphrey - Frame Paintings*: *1964 to 1965*, New York: Mary Boone Gallery, 1990

Schwarz, Dieter (ed.), *Agnes Martin*: *Writings/ Schriften*, Winterthur: Kunstmuseum, 1992

Serota, Nicholas, *Carl Andre Sculpture 1959-1977*, London: Whitechapel Art Gallery, 1978

_____ (ed.), *Eva Hesse*: *Sculpture*, London: Whitechapel Art Gallery, 1979

_____ (ed.), *Brice Marden*: *Paintings, Drawings and Prints 1975-80*, London: Whitechapel Art Gallery, 1981

Shapiro, Gary, *Earthwards*: *Robert Smithson and Art After Babel*, Berkeley: University of California Press, 1995

Sharp, Willoughby, 'Points of View: A Taped Conversation with Four Painters', *Arts Magazine*, December 1970-January 1971, 41-42

Shearer, Linda, *Brice Marden*, New York: Solomon R. Guggenheim Museum, 1975

Smith, Brydon, *fluorescent light, etc. from Dan Flavin*, Ottawa: National Gallery of Canada, 1969

_____, *Donald Judd*, Ottawa: National Gallery of Canada, 1975

Smith, Roberta, 'Brice Marden's Painting', *Arts Magazine*, no 47, May-June 1973, 36-41

_____, 'Jo Baer: Whitney Museum of American Art', *Artforum*, no 1, September 1975, 73-77

Smith, Tony, 'Statement on *Die*', *Art Now*, no 1, November 1969

Smithson, Robert, *The Writings of Robert*

Smithson, ed. Nancy Holt, New York University Press, 1979

_____, *Robert Smithson*: *The Collected Writings*, ed. Jack Flam, Berkeley, Los Angeles and London: University of California Press, 1996

Sontag, Susan, *Against interpretation and other essays*, New York: Farrar, Straus, Giroux, 1966; reprinted New York: Anchor Books/Doubleday, 1990

_____, *A Susan Sontag Reader*, New York: Farrar, Straus, Giroux, 1982

Spector, Buzz, *Objects and Logotypes*: *Relationships Between Minimal Art and Corporate Design*, The Renaissance Society, University of Chicago, 1980

Stemmrich, Gregor (ed.), *Minimal Art*: *Eine kritische Retrospektive*, Dresden and Basel: Verlag der Kunst, 1995

Stich, Sidra, *Made in USA*: *An Americanization in Modern Art*, *the 1950s and 1960s*, Berkeley: University Art Museum, University of California, 1987

Storr, Robert, *Robert Ryman*, London: Tate Gallery; New York: The Museum of Modern Art, 1993

_____, *Tony Smith*: *Architect, Painter, Sculptor*, New York: The Museum of Modern Art, 1998

Strickland, Edward, *Minimalism*: *Origins*, Bloomington: Indiana University, 1993

Sylvester, David [see Compton, Michael]

Truitt, Anne, *Anne Truitt*: *Sculpture 1961-1991*, New York: André Emmerich Gallery, 1991

_____, *Daybook*: *The Journal of an Artist*, London and New York: Penguin, 1984

_____, *Turn*: *The Journal of an Artist*, New York: Viking Penguin, 1986

_____, *Prospect*: *The Journal of an Artist*, London and New York: Scribner, 1996

Tuchman, Maurice (ed.), *American Sculpture of the 1960s*, Los Angeles County Museum of Art, 1967

_____ (ed.), *Art in Los Angeles*: *Seventeen Artists in the Sixties*, Los Angeles County Museum of Art, 1981

Tuchman, Phyllis, 'An Interview with Carl Andre', *Artforum*, no 8, June 1970, 55-61

_____, 'An Interview with Robert Ryman', *Artforum*, no 9, May 1971, 46-53

Tucker, Marcia, *Robert Morris*, New York: Whitney Museum of American Art, 1970

Varian, Elayne, *Art in Process*: *The Visual Development of a Structure*, New York: Finch College Museum of Art, 1966

Wagstaff, Samuel J., Jr, 'Talking with Tony Smith', *Artforum*, no 5, December 1966, 14-19

_____, *Tony Smith*: *Two Exhibitions of Sculpture*, Hartford: Wadsworth Atheneum;

Philadelphia: Institute of Contemporary Art, University of Pennsylvania, 1966

Waldman, Diane, 'Finch College Museum's "Art in Process"', *ARTnews*, no 65, September 1966, 72

Wallis, Brian, 'Notes on [Re]Viewing Donald Judd's Work', *Donald Judd*: *Eight Works in Three Dimensions*, Charlotte: Knight Gallery, 1983

Wilson, Ann, 'Linear Webs: Agnes Martin', *Art & Artists*, no 1, October 1966, 46-49

Wilson, William S., 'Ralph Humphrey: An Apology for Painting', *Artforum*, no 3, November 1977, 54-59

Wollheim, Richard, 'Minimal Art', *Arts Magazine*, no 39, January 1965, 26-32

Young, Dennis [see Monte, James]

INDEX

PUBLISHER'S ACKNOWLEDGEMENTS
We would like to thank all those who gave their kind permission to reproduce the listed material. Every effort has been made to secure all reprint permissions prior to publication. However, in a small number of instances this has not been possible. The editors and publisher apologize for any inadvertent errors or omissions. If notified, the publisher will endeavour to correct these at the earliest opportunity.

We would like to thank the following for their help in providing images:
Ace Gallery, New York; AKG, London; Albright-Knox Art Gallery, Buffalo; Art Gallery of Ontario, Toronto; Art Resource, New York; Jo Baer, Amsterdam; Baltimore Museum of Art, Maryland; Galerie Beaubourg, Vence; Larry Bell, Taos, New Mexico; Estate of Ronald Bladen, New York; Mel Bochner, New York; Bridgeman Art Library, London; C&M Arts, New York; Leo Castelli Archives, New York; Walter De Maria, New York; Paula Cooper Gallery, New York; The Chinati Foundation, Marfa, Texas; Christie's Images, London; Cunningham Dance Foundation Inc., New York; The Denver Art Museum, Colorado; Des Moines Art Center, Iowa; Detroit Institute of Arts, Michigan; Dia Center for the Arts, New York; Catherine Docter Consulting, Santa Barbara; Documenta Archiv, Kassel; Virginia Dwan Collection, New York; Konrad Fischer Galerie, Dusseldorf; Estate of Dan Flavin, New York; Estate of Hollis Frampton, New York; Gagosian Gallery, New York; Marian Goodman Gallery, New York; Ronald Grant Archive, London; Solomon R. Guggenheim Museum, New York; Krefelder Kunstmuseen, Karlsplatz; Jeff Koons, New York; Kosuth Studio, New York; Kröller-Müller Museum, Otterlo; Kunstmuseum, Wolfsburg; LA Louver Gallery, Venice, California; Fisher Landau Center, New York; Lenbachhaus, Munich; Lisson Gallery, London; John McCracken, Medanales, New Mexico; Matthew Marks Gallery, New York; Metro Pictures, New York; Modern Art Museum of Fort Worth, Texas; Paul Mogensen, New York; Musée de Grenoble; Museum Ludwig, Cologne; Robert Miller Gallery, New York; The Museum of Modern Art, New York; Museum of Modern Art, Oxford; National Gallery of Art, Washington, DC; National Gallery of Canada, Ottowa; Norton Simon Museum, Pasadena; Kenneth Noland, North Bennington, Vermont; David Novros, New York; PaceWildenstein, New York; PA News Photolibrary, London; Philadelphia Museum of Art, Pennsylvania; Raussmüller Collection, Basel; Statens Konstmuseer, Stockholm; Haim Steinbach, New York; Tate Gallery of Art, London; Through the Flower, Belen, New Mexico; Alexandra Truitt and Jerry Marshall, New York; Galerie Tschudi, Glarus; Diane Upright Fine Arts, New York; Wadsworth Atheneum, Hartford, Connecticut; Walker Art Center, Minneapolis; John Weber Gallery, New York; Daniel Weinberg Contemporary Art, San Francisco; Westfälischer Kunstverein, Munster; Whitney Museum of American Art, New York.

PHOTOGRAPHERS
J. Gordon Adams: p. 70 (top and bottom); Eric Baudouin: p. 141; Bernd and Hilla Becher: p. 158 (top); Rudolf Burckhardt: pp. 49 (left), 50, 65 (bottom), 80 (middle), 121; Cathy Carver: pp. 77 (bottom), 145; Gordon R. Christmas: p. 53 (bottom); Geoffrey Clements: pp. 74, 89, 136 (top), 150 (top); Giorgio Columbo: pp. 131, 132–33, 141, 142, 143; James Dee: p. 177; Dan De Wilde: p. 147 (top); Todd Eberle: pp. 2–3, 188–89; Sarah Harper Gifford: p. 53 (top); Tom Haartsen: p. 152; David Heald: p. 184; Hickey-Robertson: p. 93 (bottom); Martin Lauffer: p. 187 (top); David Lubarsky: p. 39 (second to left); Mancia/Bodmer: p. 178 (top, middle and bottom); Douglas M. Parker Studio: pp. 124 (bottom), 158 (bottom); Eric Pollitzer: p. 77 (top); Nathan Rabin: p. 136 (bottom); Walter Russell: p. 153 (top); P. Mussat Sartor: pp. 93 (top), 159; Tom Scott: p. 150 (bottom); Fred Scruton: pp. 14, 179 (top); David Stansbury: p. 116; Joseph Szaszfai: p. 106; Frank J. Thomas: pp. 71, 88; Michael Tropea: p. 160; Ellen Page Wilson: pp. 126, 128, 171 (top and bottom); Gareth Winters: p. 180 (bottom); Wolfgang Woessner: p. 137; Donald Woodman: p. 36 (right)

AUTHOR'S ACKNOWLEDGEMENTS
This book reflects the contributions of many individuals. I am indebted to Iwona Blazwick, who was the commissioning editor, and Gilda Williams, who oversaw the project with judicious care and unflagging counsel and support. Audrey Walen, the project editor, stewarded the project to completion with great professionalism and provided helpful advice. Clair Joy, John Stack, Clare Stent and Zoe Stollery provided meticulous research, and Catherine Caesar authored the pellucid photo captions. Stuart Smith conceived the book's elegant design, Adam Hooper provided expert assistance, and production controller Veronica Price brought it through to the highest standards.

My thanks as well to Jon Ippolito, Alexandra Truitt and Patrick Paul Garlinger, and above all to the many artists and writers who generously contributed images and texts. This book is a tribute to their work.

Phaidon Press Limited
Regent's Wharf
All Saints Street
London N1 9PA

Phaidon Press Inc.
180 Varick Street
New York, NY 10014

www.phaidon.com

First published 2000
Reprinted in paperback 2005
Abridged, revised and updated 2010
Reprinted 2011
© 2000 Phaidon Press Limited
All works © the artists or the estates of the artists unless otherwise stated.

ISBN 978 0 7148 5653 7

A CIP catalogue record of this book is available from the British Library.

Designed by Hoop Design

Printed in China

cover, Carl Andre
Copper Ribbon
1969

pages 2–3, Donald Judd
Concrete Works, Chinati Foundation, Marfa, Texas
1992

page 4, Frank Stella
In his studio working on *Getty Tomb* (second version)
1959